HerausgeberInnen:
Peter Pakesch, Gijs van Tuyl,
Robert Fleck, Veit Görner,
Marie-Claude Beaud
Editors:
Peter Pakesch, Gijs van Tuyl,
Robert Fleck, Veit Görner,
Marie-Claude Beaud

Erschienen im Verlag
der Buchhandlung
Walther König, Köln
Published by
Verlag der Buchhandlung
Walther König, Cologne

d today
ood ton

Marie-Claude Beaud, Robert Fleck,
Veit Görner, Peter Pakesch, Gijs van Tuyl
Vorwort
Foreword

Michel Majerus (1967–2002) war eine herausragende Persönlichkeit der Kunst der letzten Jahre. Wie kaum ein anderer hat er sich mit großer Intelligenz und umfassender Kenntnis dem bis zum Gemeinplatz problematisierten Gebrauch der Malerei zugewandt. Sein virtuoser Umgang mit den Möglichkeiten dieses Mediums und sein Blick für verschiedene Aspekte der heutigen Ikonografie wie auch der der jüngeren Vergangenheit sind besonders auffällige Merkmale seiner künstlerischen Arbeit. Durch sein hohes Bewusstsein um die spezifischen Problemstellungen der neueren Kunstgeschichte verstand es Majerus nicht nur, Grenzen zu durchbrechen, sondern auch malerische Räume auf immer wieder neue Art zu definieren.

Die Gestaltung eines ersten Überblicks über dieses so singuläre Werk, das in relativ kurzer Zeit entstand und durch einen Flugzeugabsturz im November 2002 tragisch abgebrochen wurde, ist eine große Herausforderung und verbindet mehrere Orte und unterschiedliche Formen: Während im Kunsthaus Graz ein Schwergewicht auf die Räume und die installativen Werke gelegt wird – die Architektur von Peter Cook und Colin Fournier ist dafür besonders prädestiniert – und die Deichtorhallen in Hamburg sowie das Stedelijk Museum Amsterdam dies fortführen, wird die kestnergesellschaft in Hannover ausschließlich das malerische Werk vorstellen. Beide Aspekte werden anschließend im Musée d'Art Moderne Grand-Duc Jean (Mudam) in Luxemburg, dem Geburtsort des Künstlers, zusammengefasst.

Im heutigen, distanzierten Rückblick zeigt sich mehr noch als anhand der Ausstellungen und Ausstellungsbeteiligungen zu Lebzeiten – etwa in der Kunsthalle Basel (1996) oder im Kunstmuseum Wolfsburg (*German Open,* 1999) –, dass das Werk von Michel Majerus permanent zwischen Malerei und Installation hin- und herpendelt. Neue Zeichen und Bildräume werden auf der Leinwand entwickelt und gehen dann in Raumgestaltungen über. Verfahren wie Folienschrift oder Computersimulation und der Dialog mit dem architektonischen Raum und den Konstruktionen, die Michel Majerus einbrachte, ergeben in weiterer Folge Transformationen, die wiederum in die Malerei zurückwirken. Diese mediale Parallelaktion stellt ein Spezifikum der künstlerischen Vision von Michel Majerus dar. Sowohl im Kunsthaus Graz als auch im Stedelijk Museum Amsterdam, die beide einen idealen Rahmen für die Präsentation avancierter künstlerischer Positionen des 20. Jahrhunderts bilden, steht dieses gleichberechtigte und dialogische Nebeneinander im Zentrum.

Michel Majerus (1967–2002) was an outstanding figure in the art scene of recent years. More than almost anyone, he addressed painting, which has been so much an issue as to be almost commonplace, with great intelligence and comprehensive knowledge. His virtuoso handling of the opportunities painting offer and his eye for various aspects of iconography of today and in the recent past, are especially striking features of his artistic work. Thanks to his high awareness of the specific problems posed by recent art history, Majerus proved capable not only of expanding frontiers but also of constantly re-defining painterly spaces in a new way.

The design of a first survey of this singular oeuvre, produced in a relatively short time and tragically cut short by a plane crash in November 2002, is a great challenge and involves several locations and differing forms: whereas at the Kunsthaus Graz emphasis is placed on the rooms and the installation pieces – the architecture by Peter Cook and Colin Fournier seems tailor-made for them – as well as at the Deichtorhallen in Hamburg and at the Stedelijk Museum in Amsterdam, the kestnergesellschaft in Hanover will be showing only paintings. Subsequently, both aspects will be joined at Musée d'Art Moderne Grand-Duc Jean (Mudam) in Luxembourg, the city where the artist was born.

With the benefit of hindsight, it is now even more apparent than in his solo shows and exhibition participations during his lifetime – like for example at the Kunsthalle Basel (1996) or at the Kunstmuseum Wolfsburg (*German Open,* 1999) –, that the work of Michel Majerus oscillated permanently between painting and installations. New signs and pictorial spaces were developed on canvas and then transferred into spatial designs. Processes such as foil script or computer simulation and the dialogue between the architectural spaces and the structures that Majerus brought into them, subsequently produced transformations that in turn had an effect on the painting. This parallel action between different media constitutes a specific feature of Michel Majerus' artistic vision. Both at the Kunsthaus Graz and the Stedelijk Museum in Amsterdam, two locations ideally suited for the presentation of advanced 20th century artistic positions, the various parts of the oeuvre enjoy equal status and are in dialogue with each other.

Aus diesem Grund begreifen die Deichtorhallen in Hamburg und die kestnergesellschaft in Hannover ihre Ausstellungen gemeinsam als zweite Station der Retrospektive in jenem Land, das von der Kunsthochschule bis zu Atelier und Galerie das Werk des Künstlers bestimmt hat. In der kestnergesellschaft wird ausschließlich Malerei von Michel Majerus zu sehen sein, während die große Deichtorhalle für Majerus' raumgreifende Arbeiten einen kongenialen architektonischen Rahmen bildet.

Ende 2006 werden die Werke (Malerei und Installationen) erstmalig in einer großen monografischen Ausstellung im neu errichteten Musée d'Art Moderne Grand-Duc Jean (Mudam) in Luxemburg gezeigt. Gleichzeitig wird „Luxemburg und die Großregion, Kulturhauptstadt Europas 2007" eröffnet. Schwerpunkt Luxemburgs bei diesem grenzüberschreitenden Projekt wird das Thema der Migration sein – ein Thema, das nicht treffender das Leben und die Arbeit Majerus' (geboren in Luxemburg, lebte in Berlin und Los Angeles) erfassen könnte. Denn das Werk von Michel Majerus stellt eine Art „urbane Durchmischung" dar, eine Aneignung der Zeichen jener visuellen Welt, in und mit der wir jeden Tag leben. Indem seine Arbeit einige visuelle Elemente transponiert, andere erfindet, spiegelt sie die Spontaneität, die Farbigkeit und die Kraft jener Kulturen und Subkulturen wieder, die die unablässigen zeitgenössischen, migrationsbedingten Hybridisierungen erzeugen.

For this reason, the Deichtorhallen in Hamburg and the kestnergesellschaft in Hanover see their joint exhibitions as the second stop of the retrospective in the country that shaped the artist's work from art college through studio to gallery. At the kestnergesellschaft, the artist's paintings can be viewed while the large Deichtorhalle forms a congenial architectural framework for Majerus' ambitious spatial works.

At the end of 2006, the works (painting and installations) will be shown for the first time in a large solo exhibition at the newly built Musée d'Art Moderne Grand-Duc Jean (Mudam) in Luxembourg. "Luxembourg and the Greater Region, Cultural Capital of Europe 2007" will be opened at the same time. The focus of this cross-border project in Luxembourg will be the subject of migration, which is particularly relevant to the life and work of Majerus (born in Luxemburg, lived in Berlin and Los Angeles). The Luxembourg artist's work constitutes in fact a kind of "urban mix", an appropriation of the signs of the visual world in and with which we live every day. The fact that his work transposes some visual elements and invents others reflects the spontaneity, coloration and strength of the cultures and subcultures that generate the incessant contemporary process of hybridisation produced by migration.

Peter Pakesch

Malerei, um den Raum zu verstehen

Painting as an Explanation of Space

Space01, der obere Saal des Kunsthaus Graz, das nach den Plänen von Peter Cook und Colin Fournier erbaut wurde, ist ein besonderer Ausstellungsraum. Seine außergewöhnliche Form war von Anfang an dazu angetan, große Kontroversen auszulösen, die Möglichkeiten der Bespielbarkeit mit Ausstellungen betreffend. Dies war in erster Linie dem Umstand entsprungen, dass der Raum nicht mehr klassisch-modernen Vorgaben folgt, die im White Cube orthogonalen Strukturen folgen und mit Oberlicht beleuchtet sind. Gemäß verschiedener Forderungen moderner Architektur – hier sei vor allem Friedrich Kiesler hervorzuheben – und getreu ihrer eigenen Positionen aus den 1960er Jahren im Rahmen der Arbeit mit Archigram war es den Architekten ein Anliegen, aus diesem „klassisch-modernen" Raum auszubrechen und neue räumliche Strukturen zu suchen. In meinen Augen liegt es nun an jeder einzelnen Bespielung, deren Tauglichkeit zu hinterfragen und das Potenzial auszuloten. In hervorragender Weise gelang dies dem amerikanischen Künstler Sol LeWitt mit seinem eigens für den Space01 gefertigten Werk *Wall*. Hier konnte ein Bildhauer der Konzeptkunst nicht nur der skulpturalen Architektur etwas entgegensetzen, sondern dieses Werk vermochte es vielmehr, die Architektur weiterzuentwickeln und ihre Möglichkeiten zu kommentieren. Die Frage blieb: Was bedeutet diese Architektur für die Malerei?

„Die Isolation des gerahmten Gemäldes wird in diesen Galaxien durch eine Gruppe von Einheiten ersetzt. Der Rahmen wird ersetzt durch den Raum des existierenden Hintergrunds. Der Abstand zwischen den verschiedenen Gemälden ist von der gleichen inneren Notwendigkeit wie die Atmung für die Realität unserer Körper. Es gibt einer jeden Galaxie das natürliche Maß ihrer Dimensionen. Gleichermaßen wichtig für die Beziehung der einzelnen Gemälde zueinander ist der spezifische Charakter ihrer Details. Detail meint hier nicht das Ergebnis einer Verfeinerung, sondern einer Intensivierung von Schwerpunkten. Das Gleiche gilt für die Farbe. Die strukturelle Kontinuität der Galaxie entspricht somit sowohl der Ausdehnung wie auch der Einschränkung des Zusammenlebens. Jedes Gemälde repräsentiert eine in sich geschlossene Einheit, geradeso wie auch jedes Mitglied einer Familie seine eigene Individualität besitzt. Dennoch ist ihnen ihre feste Fügung (zu einem Ganzen) eingepflanzt, wie heterogen auch immer der Charakter eines jeden Einzelnen sein mag. Unter diesen Umständen scheint es nur natürlich, dass die einzelnen Maleinheiten, vor allem wenn sie von der Wand vorstehen und von der Seite betrachtet werden, auch den Wert plastischer Entitäten einnehmen, ganz

Space01, the upper room at the Kunsthaus in Graz, built to plans by Peter Cook and Colin Fournier, is a very special exhibition space. Right from the start its unusual shape was always bound to stir up controversy with regard to the bold opportunities it offered for exhibitions. This arose principally from the circumstance that the room no longer followed the classic modern model, with the orthogonal structures of the "white cube" layout lit from above. Bearing various requirements of modern architecture in mind – Friedrich Kiesler should be singled out at this point – and faithful to their own thinking in the 1960s as part of their work with Archigram, the architects were anxious to break out of the "classic modern" room concept and look for new spatial structures. In my view, it is now up to every exhibition concept to see how well this novel architecture works and what can be made of it. American artist Sol LeWitt's *Wall*, specially produced for Space01, succeeded admirably. Here was a conceptual art sculptor who had something to match the sculptural architecture, and offered even more – the work proved capable of further developing the architecture and commenting on the opportunities it offered. The question remained as to what this architecture can offer painting.

"In these galaxies, isolation of the framed painting is replaced by a group of units. Framing is replaced by the space of the existing background. The span of the interval between the different paintings is of inner necessity just as breathing is to our body–reality. It provides each galaxy with its natural measure of dimensions. Of equal importance for the correlation of separate paintings is the specific character of their details. Details here are not the result of elaboration but of intensification of focal points. The same holds true of color. As a result, the structural continuity of the galaxy has both the expanse and the limitation of group-living. Each painting represents a definite unit in itself just as in one family each member is of distinct individuality. Yet, their firm cohesion (into one) is inborn no matter how heterogenous the character of the members might be. Under these circumstances, it seems also natural that each painted unit, particularly when protruding from the wall, and viewed from the side, will also assume the value of a plastic entity, very much in the sense of a sculpture, while the aspect of the total galaxy promotes too the idea of an

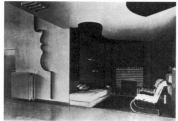

im Sinne der Skulptur. Die Ansicht der Galaxie in ihrer Gesamtheit fördert zudem die Vorstellung einer architektonischen Anordnung, ohne dadurch den Hauptcharakter als Gemälde zu zerstören. Damit wird die traditionelle Trennung der plastischen Künste in Malerei, Skulptur und Architektur umgewandelt und überwunden; und ihre fließende Vereinigung geschieht nun aus sich selbst heraus und nicht durch Kombination von außen." (Zitat aus dem Text von Friedrich Kiesler auf den Einladungskarten zur Ausstellung *Galaxies by Kiesler*, Sidney Janis Gallery, New York, 27. September – 19. Oktober 1954)

„Eine neue Generation der Architektur muss aufkommen, mit Formen und Räumen, die zwar den Grundsätzen der ‚Moderne' eine Absage zu erteilen scheinen, doch in Wirklichkeit an jenen Grundsätzen festhalten. Wir haben es vorgezogen das veraltete Bauhaus-Image, das eine Beleidigung für den Funktionalismus darstellt, zu umgehen. Man kann Stahl ausrollen – in welche Länge auch immer. Man kann einen Ballon aufblasen – in welche Größe auch immer. Man kann Plastik modellieren – in welche Form auch immer. Die Kerle, die die Forth Bridge gebaut haben – die haben sich darum nicht gekümmert." (David Greene, Peter Cook: *Archigram 1*, 1961)

Das erste Mal begegnete ich Michel Majerus' Werk 1994 in den Räumen der Galerie neugerriemschneider in Berlin, wo Majerus damals ausstellte. Die Ausstellung – ein eingezogener Straßenboden, Wandmalerei, Tafelbilder – *war* Raum. Hier wurde ein großes Thema der abendländischen Malerei angerissen, das in der ganzen Moderne eine große Rolle gespielt hat: die Malerei im Spannungsverhältnis zwischen der Bewältigung des Raumes auf der Fläche, ihre Präsenz innerhalb des Raumes und wie sie Raum in der Architektur konstituiert. Majerus präsentierte mit dieser durchaus nicht sehr großen und erstaunlich kompakten Installation in der kleinen Galerie in der Goethestraße einen Beitrag zum Thema der Raumkonstitution, der sich, jetzt retrospektiv gesehen, in die Reihe der wichtigen Positionen im letzten Jahrhundert einordnet; eines Jahrhunderts, das reich ist an bedeutenden Werken und Innovationen gerade in diesem Bereich, wo prominente Maler wie unter anderem Piet Mondrian in seiner Raumgestaltung für Ida Bienert, Oskar Schlemmer im Haus Dr. Rabe, El Lissitzky mit dem *Abstrakten Kabinett* in Hannover, Theo Van Doesburg mit seiner Gestaltung der Aubette in Straßburg und Friedrich Kiesler bei der Ausstellungsgestaltung *Blood Flames* in der Hugo Gallery in New York als Vorreiter neue visuelle Umgebungen formulierten. Ich selbst war damals durch meine Arbeit

architectural coordinate without destroying the main character as a painting. Thus, the traditional division of the plastic arts into painting, sculptures and architecture, is transmuted and over-come; and their fluid unification is now contained within rather that combined from without."
(Friedrich Kiesler, Artist's Statement printed on the exhibition invitation *Galaxies by Kiesler*, Sidney Janis Gallery, New York, 27 September – 19 October 1954)

"A new generation of architecture must arise with forms and spaces which seems to reject the precepts of 'Modern' yet in fact retains those precepts. We have chosen to bypass the decaying Bauhaus image, which is an insult to functionalism. You can roll out steel – any length. You can blow up a balloon – any size. You can mould plastic – any shape. Blokes that built the Forth Bridge – they didn't worry."
(David Greene, Peter Cook: *Archigram 1,* 1961)

The first time I came across Michel Majerus' work was in 1994 in the rooms of the neugerriemschneider gallery in Berlin, where Majerus was exhibiting at the time. The exhibition – a bit of incorporated street, wall paintings and panel paintings – *was* space. A major theme of western painting was staked out here that runs through Modernism as a whole - painting in its struggle to master space on a flat surface, its presence within space and the way it constitutes space in architecture. What Majerus had to show us in this installation – it was by no means large and in fact was astonishingly compact – in the small gallery on Goethestraße was a contribution to the subject of how space should be organised. In retrospect, this can be classified as one of the important positions of the last century. The 20th century was rich in significant works and innovations particularly in this field, where prominent painters such as Piet Mondrian in his room design for Ida Bienert, Oskar Schlemmer in the Dr Rabe House, El Lissitzky in the *Abstract Cabinet* in Hanover, Theo van Doesburg with his design of the Aubette in Strasbourg and Friedrich Kiesler in the *Blood Flames* exhibition layout at the Hugo Gallery in New York pioneered new formulations for visual environments. I myself became better aware of the issues involved through my work on the *Malerei – Wandmalerei* exhibition at the Grazer Kunstverein in

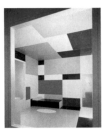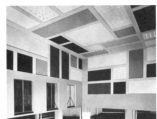

an der Ausstellung *Malerei – Wandmalerei,* die 1986 im Grazer Kunstverein stattgefunden hatte, für diese Fragestellungen sensibilisiert, in der wir vergleichbaren Phänomenen in der neueren Kunst nachgingen. Hier waren vor allem Persönlichkeiten wie Sol LeWitt, Blinky Palermo, Dan Flavin, Günther Förg und Niele Toroni von großer Bedeutung. Waren diese Beiträge, noch weit über die streng raum- und architekturbezogenen Ansätze der Vorkriegsmoderne hinaus, viel struktureller gedacht, gelang es Majerus unmittelbar und ohne Scheu einen viel weiter gespannten Kosmos von Malerei und darin eine ungleich reichere und komplexere Bilderwelt ins Spiel zu bringen. Vielleicht war es der Sprung einer neuen Generation aus der totalen Bildermedienwelt, der es möglich machte, die Welten von Comics, Computerspielen mit der Trivialität von Logos sowie mit der Irritation kunsthistorischer Zitate zu vermischen und damit zuvor abstrakt gedachte Bildräume anzufüllen, in realiter belebte Räume daraus entstehen zu lassen, irgendwo zwischen Pop und Virtualität.

Was für ein Potenzial in dieser Praxis steckte, konnte ich 1996 selbst erleben, als ich Majerus für eine Installation im Oberlichtsaal der Kunsthalle Basel gewann. Kaum je zuvor ist es einer Ausstellung gelungen, diesen Raum malerisch so zu besetzen und zu transformieren wie in diesem Fall. Das geschah mit einfachen, aber fundamentalen Eingriffen, mit der Veränderung des Bodens, mit verschiedenen Wandmalereien und Tafelbildern, die als Raumteiler fungierten. Das waren Bilder, die der Künstler in seinem eher kleinen Atelier, noch ohne die Chance auf eine Ausstellung, in der Zeit davor in Teilen gemalt hatte und erst in dieser Ausstellung in ihrer Gänze zu sehen bekam. Diese Arbeitsweise deutet auf sein außergewöhnliches Bilddenken hin, denn alle diese großen Tafeln vermochten starke und überzeugende Raumwirkungen auf verschiedenen Ebenen zu erzielen. Auffallend war, wie sehr es Majerus vermochte, zwischen malerischen Kategorien des Umgangs mit dem Räumlichen, zwischen Illusionismus und konkreter Raumgestaltung zu changieren und damit als scharfsichtiger Maler der Cyber-Generation zu neuen Ufern aufzubrechen.

Teile des Schaffens dieses außergewöhnlichen Künstlers wollen wir im Kunsthaus Graz wieder entstehen lassen und im vorliegenden Katalog entsprechend dokumentieren.

Es war für Günther Holler-Schuster und mich faszinierend, bei einer ersten Durchsicht der installativen Arbeiten im Archiv des verstorbenen Künstlers die Stringenz nachzuvollziehen,

1986 in which we pursued comparable phenomena in more recent art. This involved major names such as Sol LeWitt, Blinky Palermo, Dan Flavin, Günther Förg and Niele Toroni. Whereas the input of these, going far beyond the strict room and architecture-related approaches of the pre-war Modernists, was more structurally conceived, Majerus was capable of introducing – directly and without inhibition – a much morefar-reaching cosmos of painting and within it an incomparably more complex pictorial world. Perhaps it was the leap of a new generation, born in a totally visual media world that could mix together the realm of comics, computer games, the triviality of logos plus provocative art-historical citations,and thereby transform what previously seemed like abstractly conceived visual spaces into real living spaces, somewhere between Pop and the virtual world.

I was able to experience for myself the potential latent in this approach when I got Majerus to produce an installation for the toplit room at the Kunsthalle Basel. Seldom before has an exhibition of painting been so successful in taking over and transforming this room as on this occasion. It was achieved with simple but fundamental interventions such as changing the floor, and introducing various wall paintings and panel paintings that acted as room partitions. They were pictures that the artist had painted in parts in his rather small studio before there was any chance of an exhibition, and first saw as a totality in the exhibition. This way of working is indicative of his exceptional visual thinking, because all these large panels were capable of achieving powerful and convincing spatial effects on different levels. It was striking how well Majerus managed to oscillate between painterly categories of spatial treatment, between illusionism and specific room design and thereby access new shores as the sharp-eyed painter of the cyber generation.

It is our intention to recreate parts of this unusual artist's oeuvre at the Kunsthaus Graz and to document it in the present catalogue.

It was fascinating for Günther Holler-Schuster and me, when we first looked through the installation works in the archive of the deceased artist, to trace the rigour he developed over the decade of his work. That means it is particularly important for us as curators of the exhibition

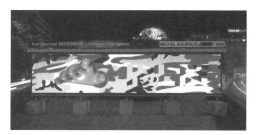

Fig. 6 Michel Majerus, *Hilfe*, 1998
Wiener Secession/museum in progress,
Wien, 1998

Fig. 6 Michel Majerus, *Hilfe*, 1998
Wiener Secession/museum in progress,
Vienna, 1998

die sich aus den zehn Jahren seiner Praxis entwickelt hat. Das bedeutet, dass es für uns als Kuratoren der Ausstellung besonders wichtig ist, Majerus nicht auf Tafelbilder zu reduzieren, sondern der Versuch im Vordergrund stehen muss, Werke, die darüber hinausgehen, auch für die Nachwelt nachvollziehbar zu machen. Gewiss ein schwieriges und durchaus ambivalentes Vorhaben, das in diesem Fall aus mehreren Gründen Chancen hat zu gelingen. So können wir auf diverse persönliche Erfahrungen zurückgreifen und haben ein hervorragend geführtes Archiv zur Verfügung, das eben auch auf Grund unseres Ausstellungsprojekts nochmals vertieft, präzisiert und aktualisiert wurde.

Dieser Blick, mit dem wir über die verbleibenden Tafelbilder hinausgehen, birgt wie gesagt ein Risiko. Es erweist sich aber heute auch als zunehmend wichtig, Formen zu finden, wie Kunst, die klar abgegrenzte Formen sprengt und Situationen thematisiert, sinnvoll bewahrt werden kann. Das Museum war immer auch ein Ort, dem es oblag, historische Räume in der einen oder anderen Form wieder entstehen zu lassen. Hier dient die Praxis der Bewahrung und Präsentation einer bedeutenden Position aktueller Kunst.

not to reduce Majerus to panel paintings. In the foreground must be works that go beyond that, made comprehensible for posterity. No doubt this is a difficult and thoroughly ambivalent undertaking, but in this case it has a good chance of succeeding, for several reasons. We can draw on a variety of personal experiences and have an excellently organised archive to hand, one that our exhibition project has also helped to augment, clarify and update.

The intention of going beyond the remaining panel paintings does entail certain risks, as was said earlier. However, these days it is increasingly important to find sensible ways of preserving art that go beyond clearly demarcated forms and take situations as subject matter. Museums have always had the duty to recreate historic rooms in one shape or another. Here it is a matter of preserving and presenting a major oeuvre of contemporary art.

nstallation
Malerei 91
Installation
Paintings 9

en und
02

s and
1–02

ohne Titel, 1991
Acryl auf Leinwand;
232×196,5 cm

untitled, 1991
acrylic on canvas;
232×196,5 cm

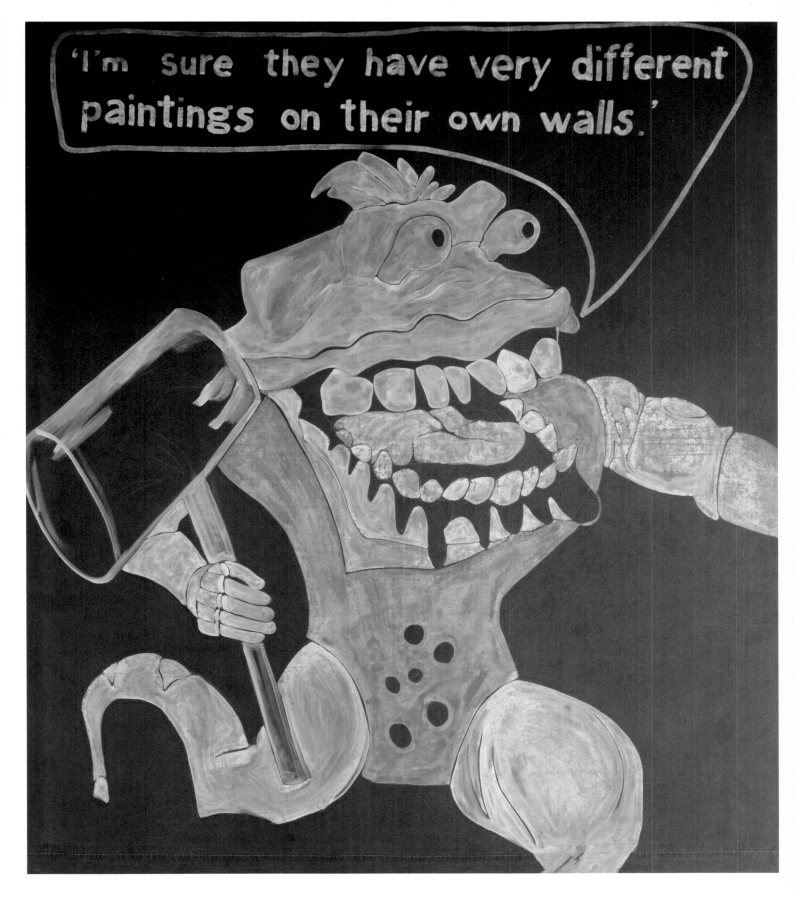

Performance mit Hundemasken, 11.6.1992
in der Installation von Joseph Kosuth,
Documenta 9, Kassel

Performance with Dogmasks, 11.6.1992
in the installation of Joseph Kosuth,
documenta 9, Kassel

22 23

Performance mit Hundemasken, 11.6.1992
in der Installation von Joseph Kosuth,
Documenta 9, Kassel

Performance with Dogmasks, 11.6.1992
in the installation of Joseph Kosuth,
documenta 9, Kassel

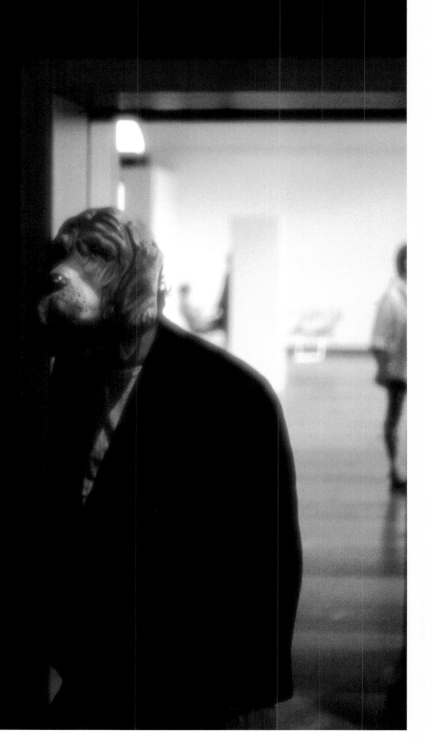

ohne Titel (loss of self-confidence),
(um 1993)
Acryl auf Leinwand; 213×310 cm

untitled (loss of self-confidence),
(around 1993)
acrylic on canvas; 213×310 cm

ohne Titel (loss of self-confidence),
(um 1993)
Acryl auf Leinwand; 213×310 cm

untitled (loss of self-confidence),
(around 1993)
acrylic on canvas; 213×310 cm

LOSS OF SELF-CONFIDENCE
LACK OF CULTURE

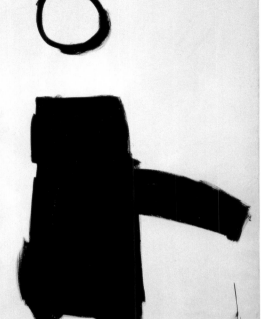

Michel Majerus: *gemälde,*
neugerriemschneider,
Berlin, 1994
Installationsansichten
(S. 26–29)

Sauerei, 1994
Öl und Acryl auf Leinwand;
320×476 cm,
2-teilig, je 320×238 cm
(S. 28/29)

Michel Majerus: *gemälde,*
neugerriemschneider,
Berlin, 1994
installation views
(p. 26–29)

Sauerei, 1994
oil and acrylic on canvas;
320×476 cm, 2 parts,
each 320×238 cm
(p. 28/29)

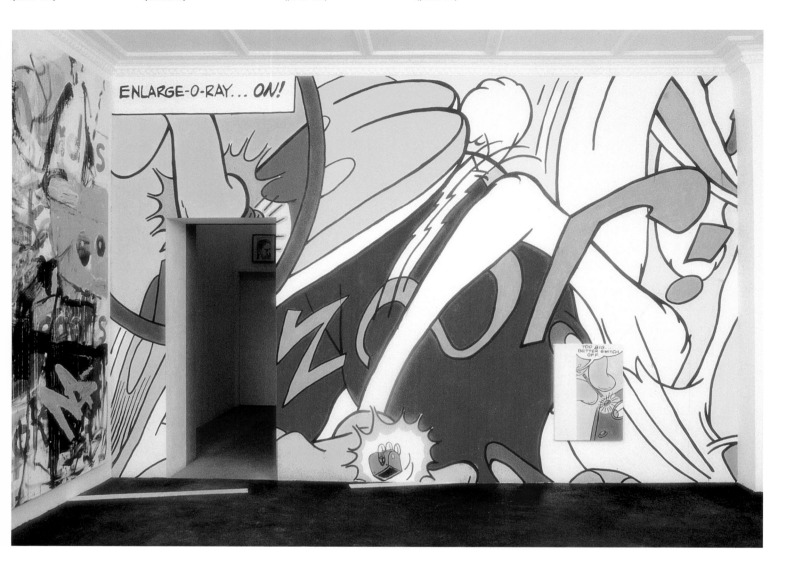

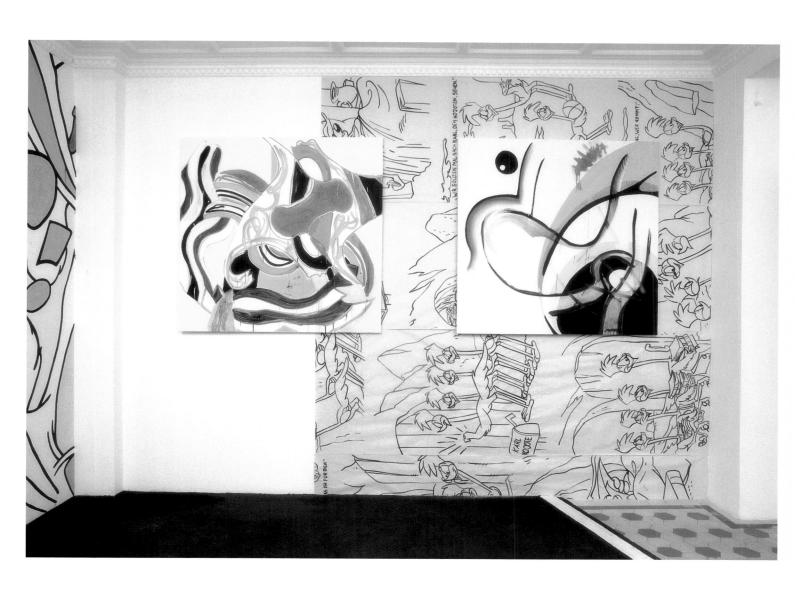

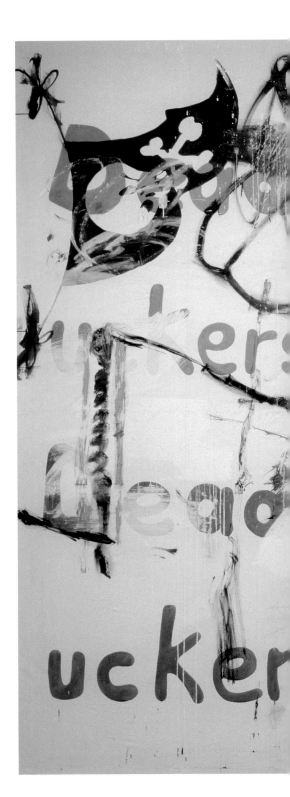

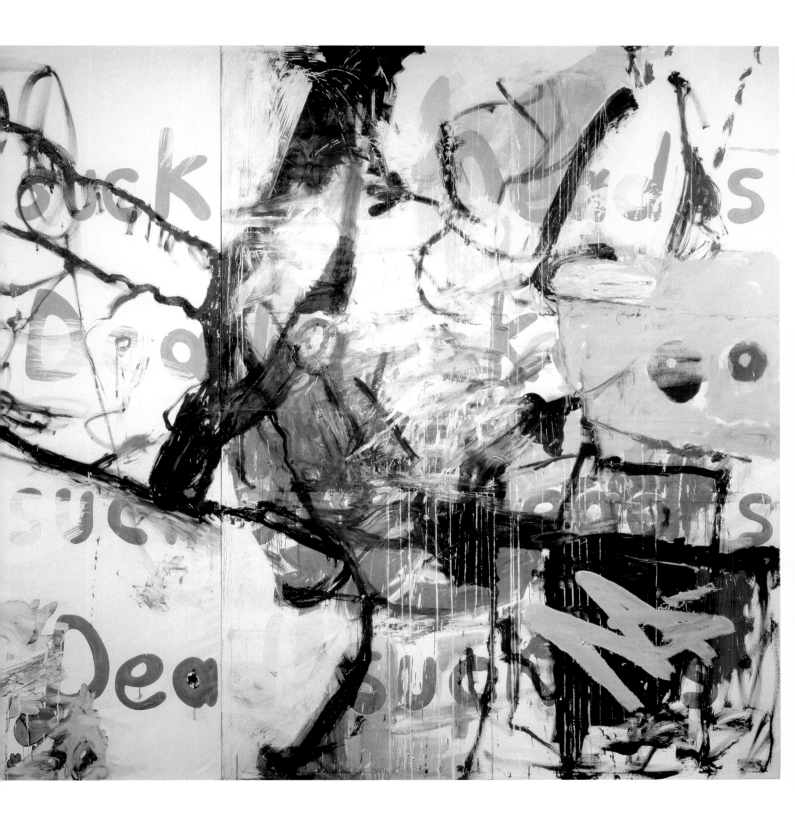

Michel Majerus
Kunstverein Hamburg, 1996
Installationsansicht

Aquarell, 1996
Acryl auf Leinwand;
980×960 cm,
42-teilig, je 140×160 cm

Michel Majerus
Kunstverein Hamburg, 1996
installation view

Aquarell, 1996
acrylic on canvas;
980×960 cm,
42 parts, each 140×160 cm

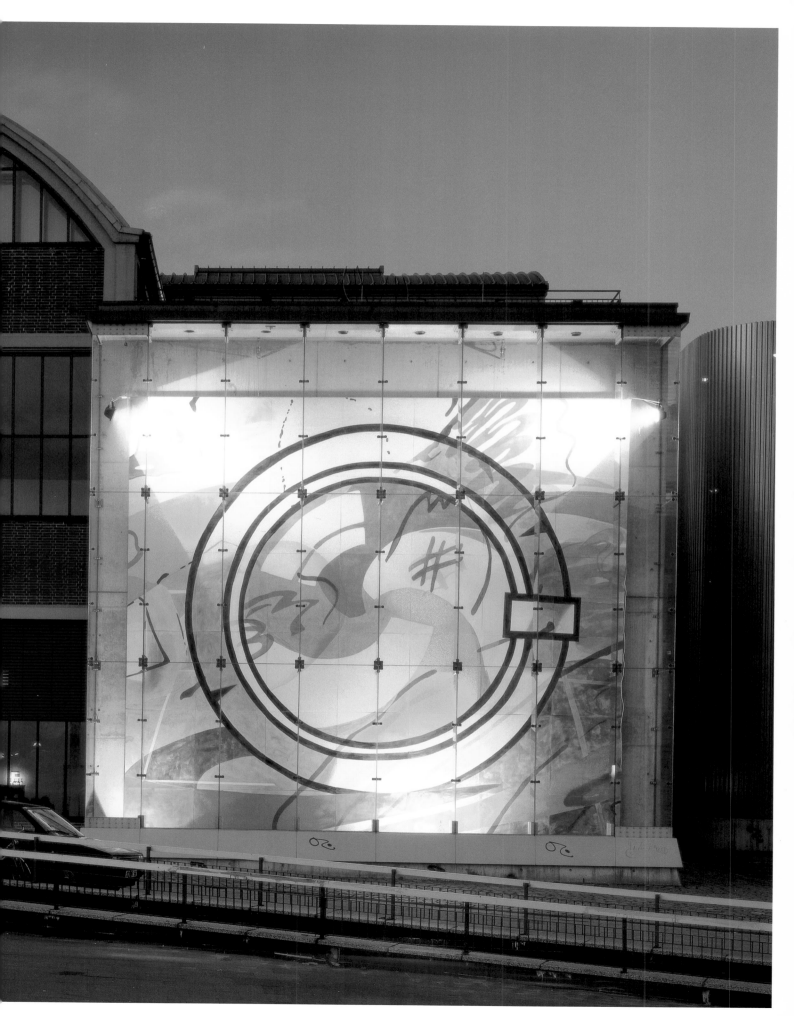

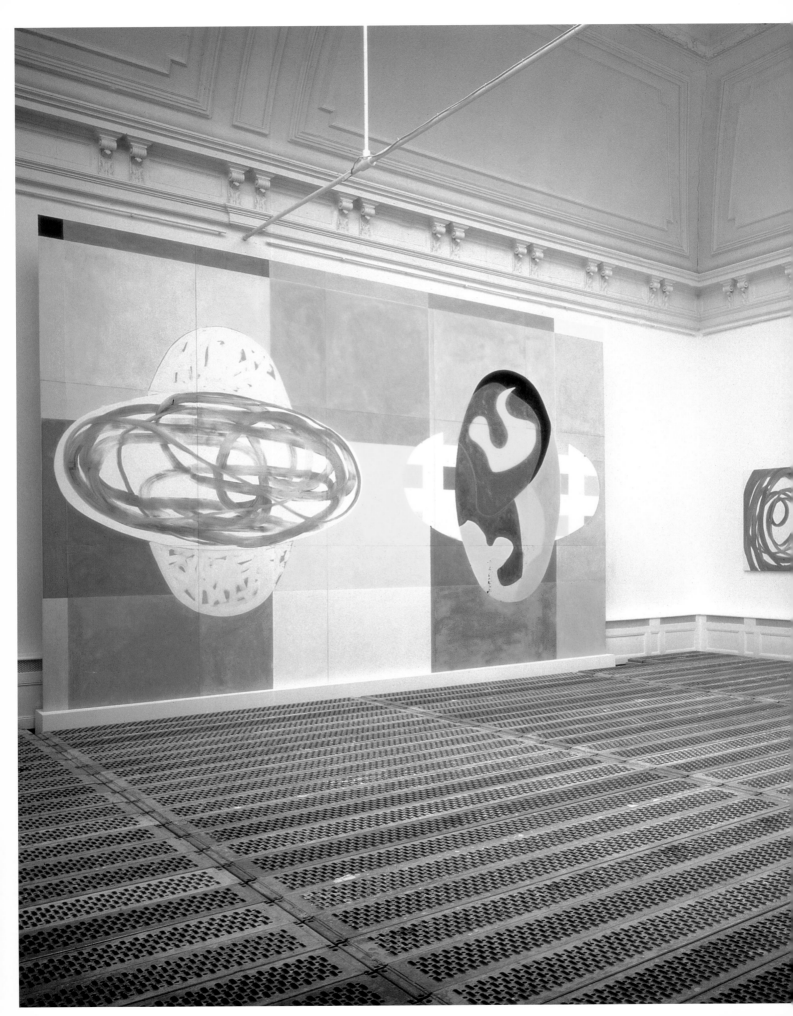

Michel Majerus
Kunsthalle Basel, 1996
Installationsansichten
(S. 32–41)

Michel Majerus
Kunsthalle Basel, 1996
installation views
(p. 32–41)

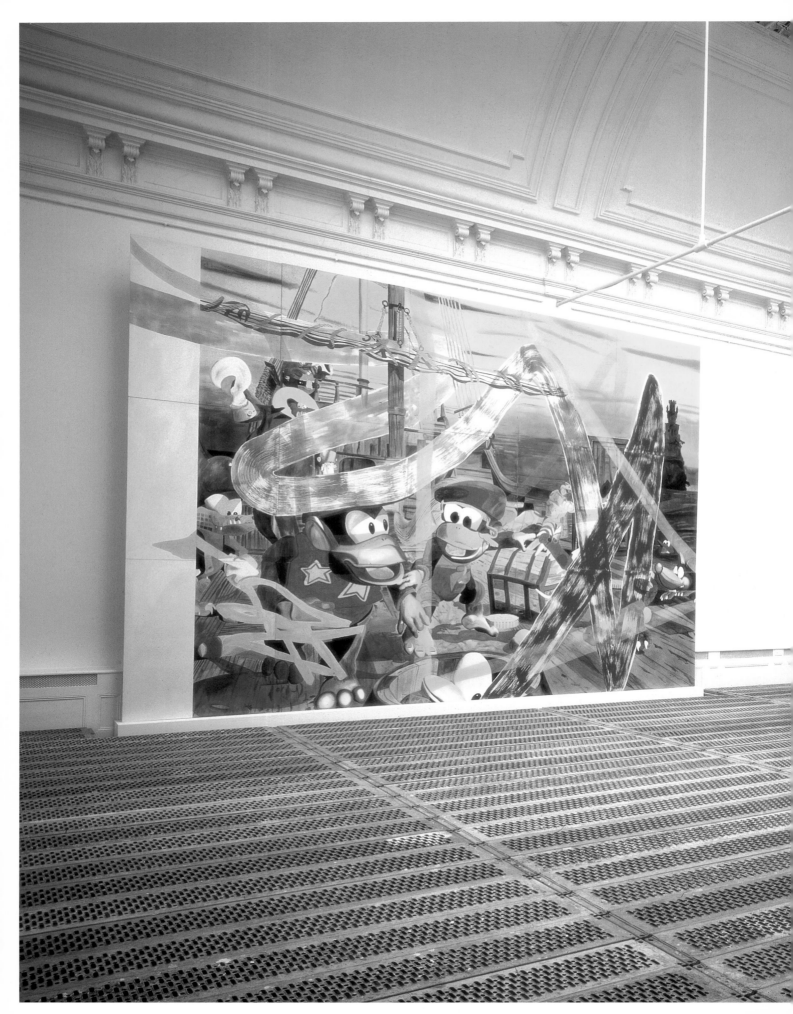

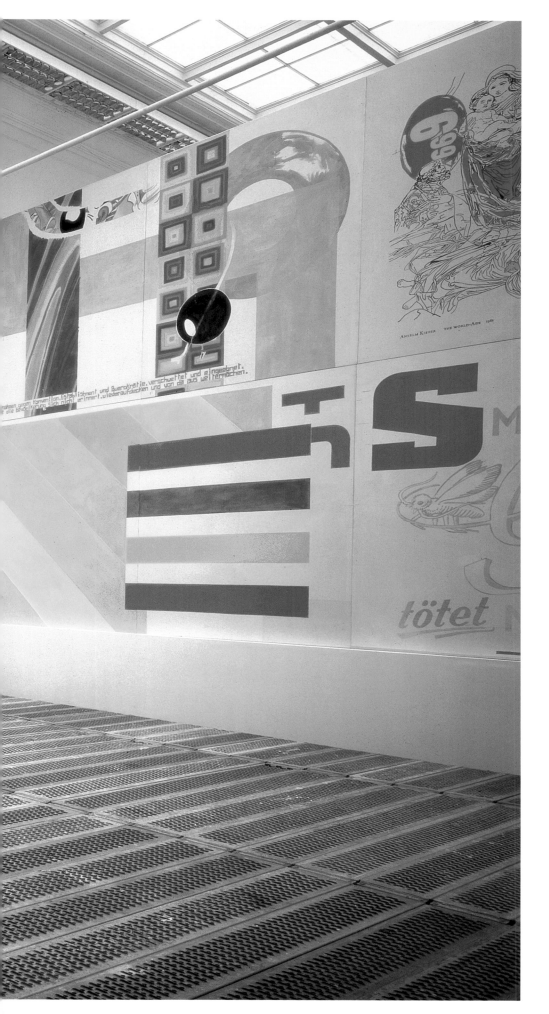

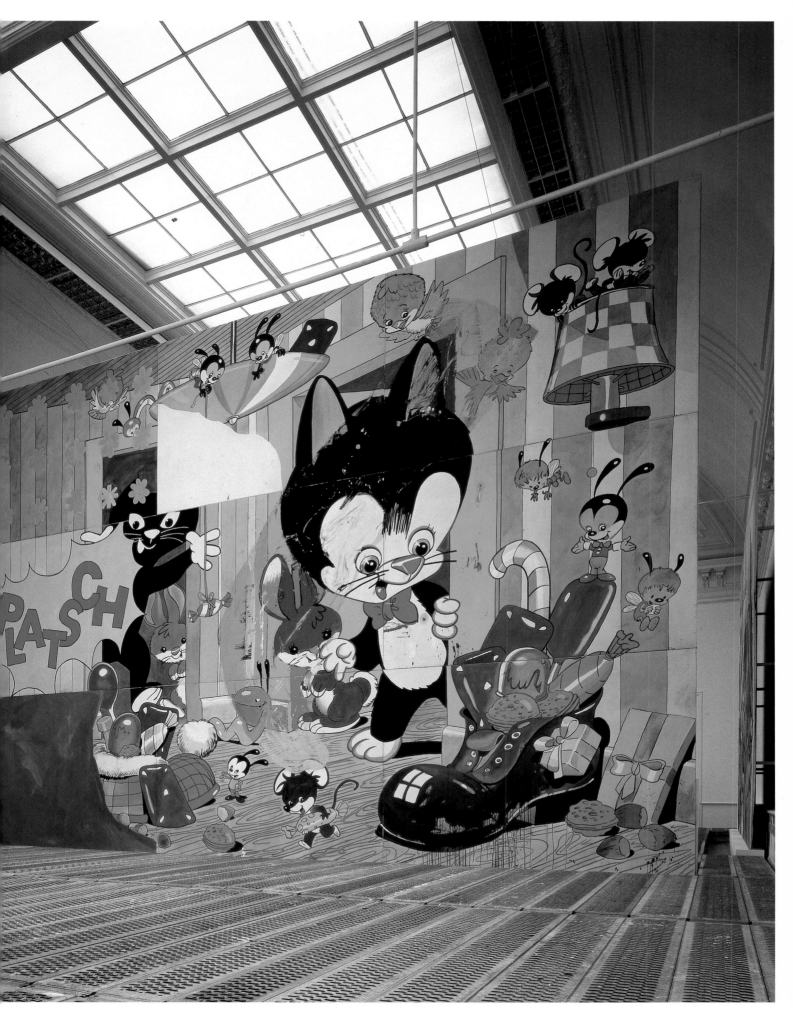

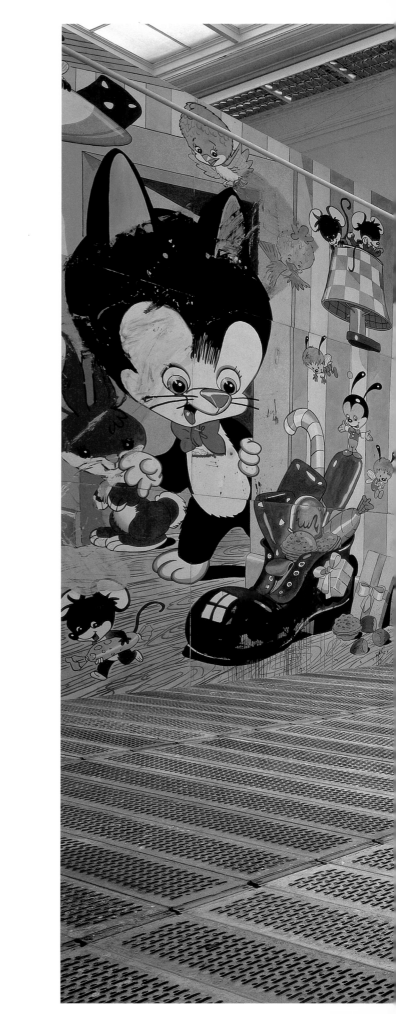

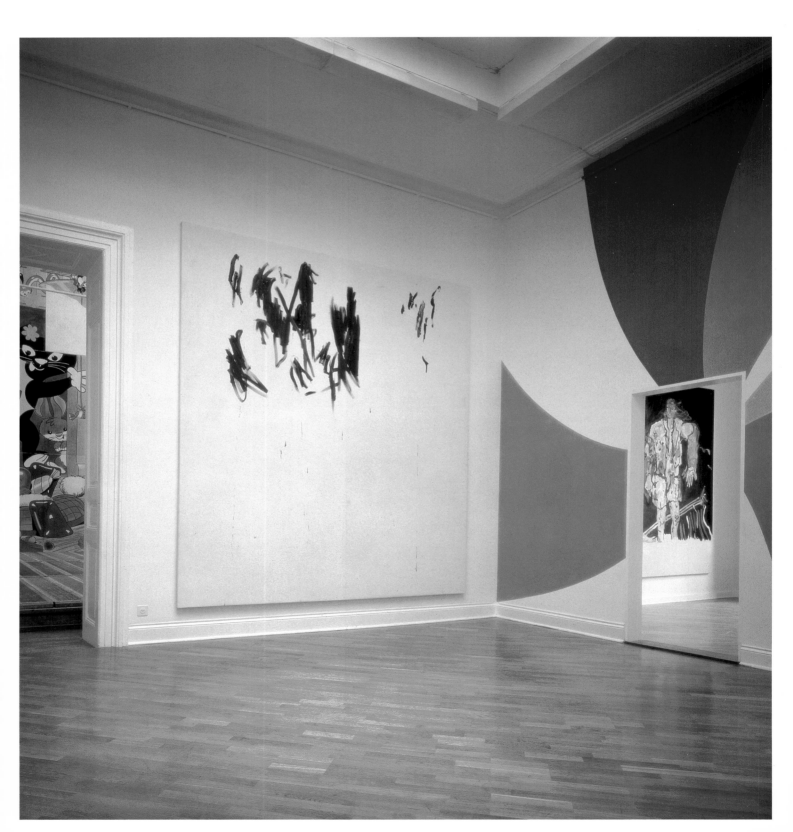

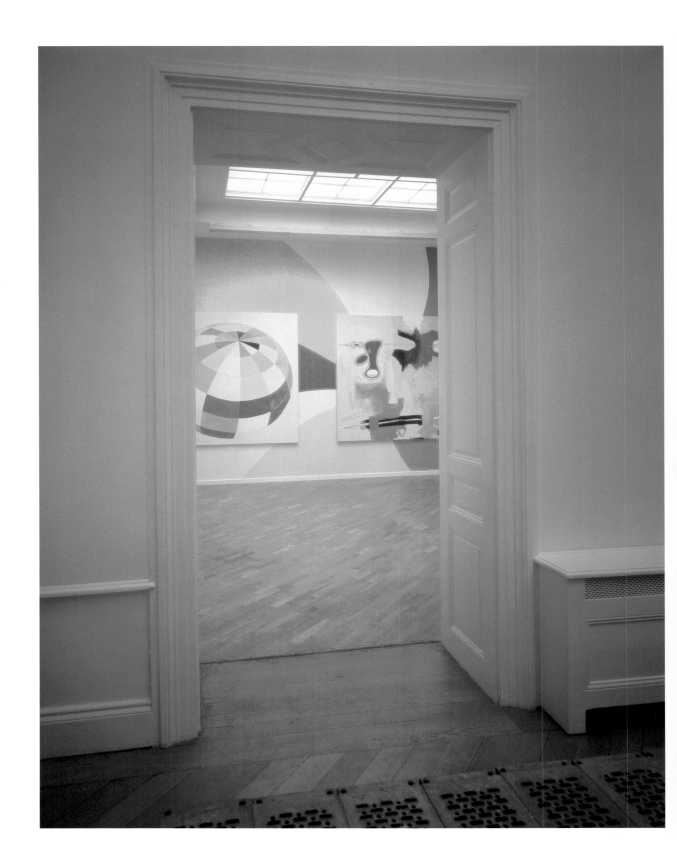

Michel Majerus: *fertiggestellt zur
zufriedenheit aller, die bedenken haben*
neugerriemschneider, Berlin, 1996
Installationsansicht

Michel Majerus: *fertiggestellt zur
zufriedenheit aller, die bedenken haben*
neugerriemschneider, Berlin, 1996
installation view

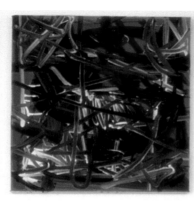
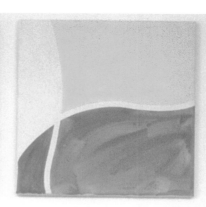
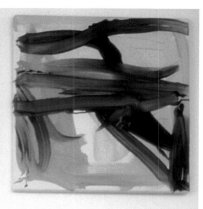

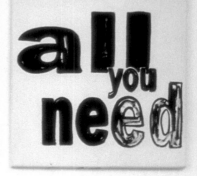

all
you
need

A LINK TO THE PAST

Michel Majerus
Galerie Monika Sprüth, Köln, 1996
Installationsansichten
(S. 44–49)

A 1–7, T 1–7, H 1–7, M 1–7, 1996
Lack und Siebdruck auf Holz;
28 Kisten, je 55×55×75 cm

Michel Majerus
Monika Sprüth Galerie, Cologne, 1996
installation views
(p. 44–49)

A 1–7, T 1–7, H 1–7, M 1–7, 1996
lacquer and silkscreen on wood;
28 boxes, each 55×55×75 cm

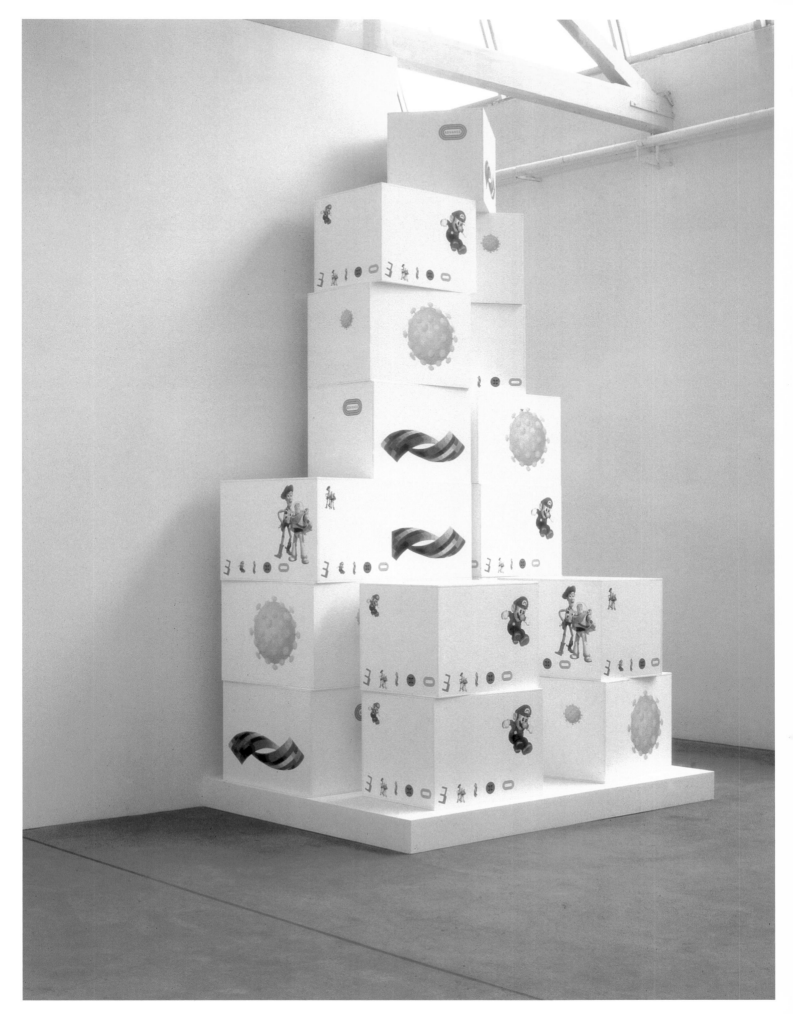

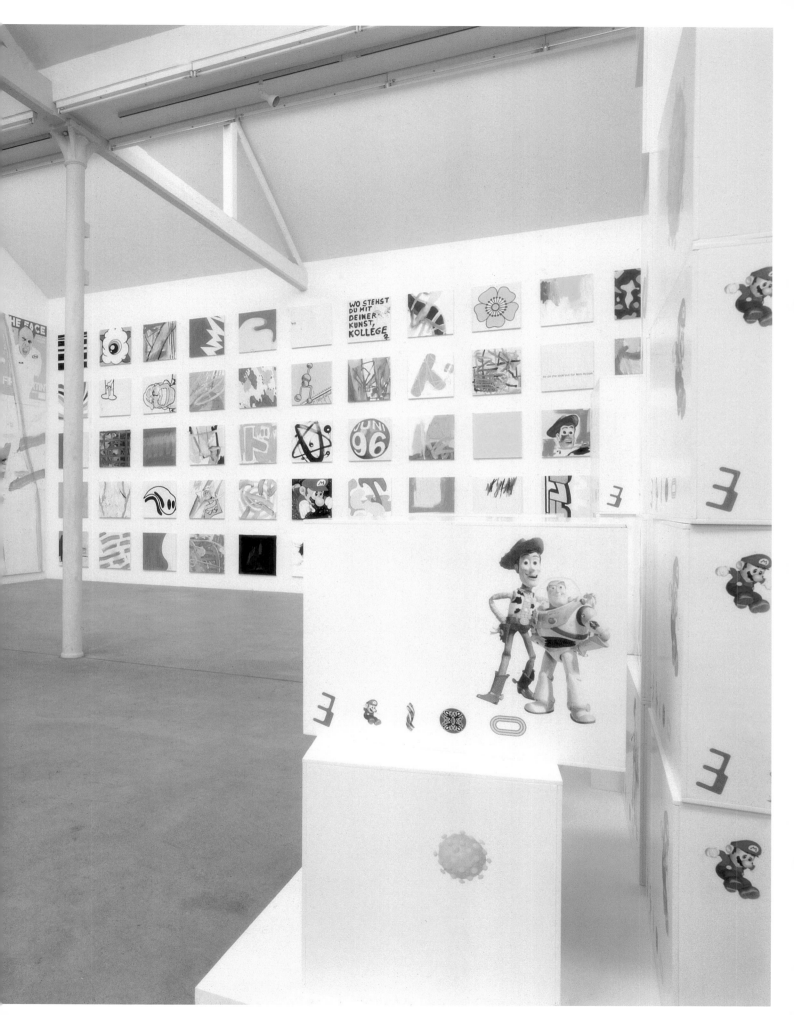

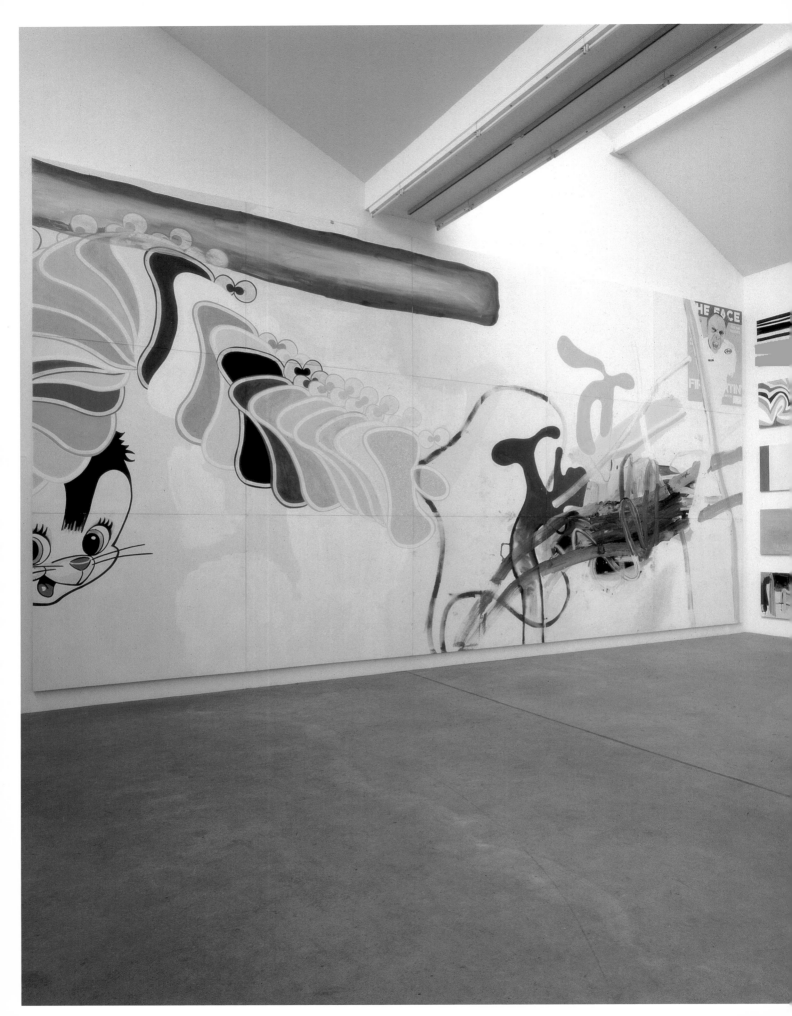

Michel Majerus:
Aesthetic Standard,
Grazer Kunstverein, 1996
Installationsansichten

MoM Block II, 1996
Acryl auf Leinwand;
360×800 cm, 8-teilig,
je 180×200 cm

Michel Majerus:
Aesthetic Standard,
Grazer Kunstverein, 1996
installation views

MoM Block II, 1996
acrylic on canvas;
360×800 cm, 8 parts,
each 180×200 cm

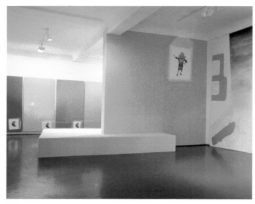

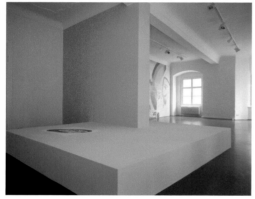

Michel Majerus:
Aesthetic Standard,
Grazer Kunstverein, 1996

MoM Block II, 1996
acrylic on canvas;
360×800 cm, 8 parts,
each 180×200 cm

ohne Titel, 1996
Acryl auf Leinwand;
190×190 cm

untitled, 1996
acrylic on canvas;
190×190 cm

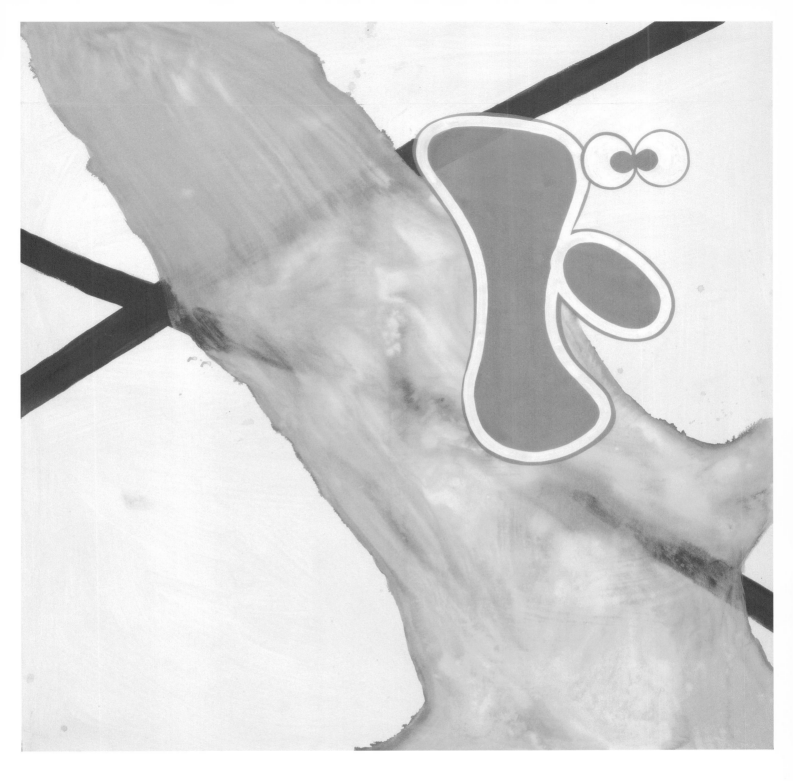

Michel Majerus: *Produce–Reduce–Reuse*
Galerie Karlheinz Meyer, Karlsruhe, 1997
Installationsansichten (S. 54–57)

DECODER, 1997
Dispersionsfarbe auf Wand;
325 × 714 cm (variabel)

Michel Majerus: *Produce–Reduce–Reuse*
Galerie Karlheinz Meyer, Karlsruhe, 1997
installation views (p. 54–57)

DECODER, 1997
emulsion paint on wall;
325 × 714 cm (variable)

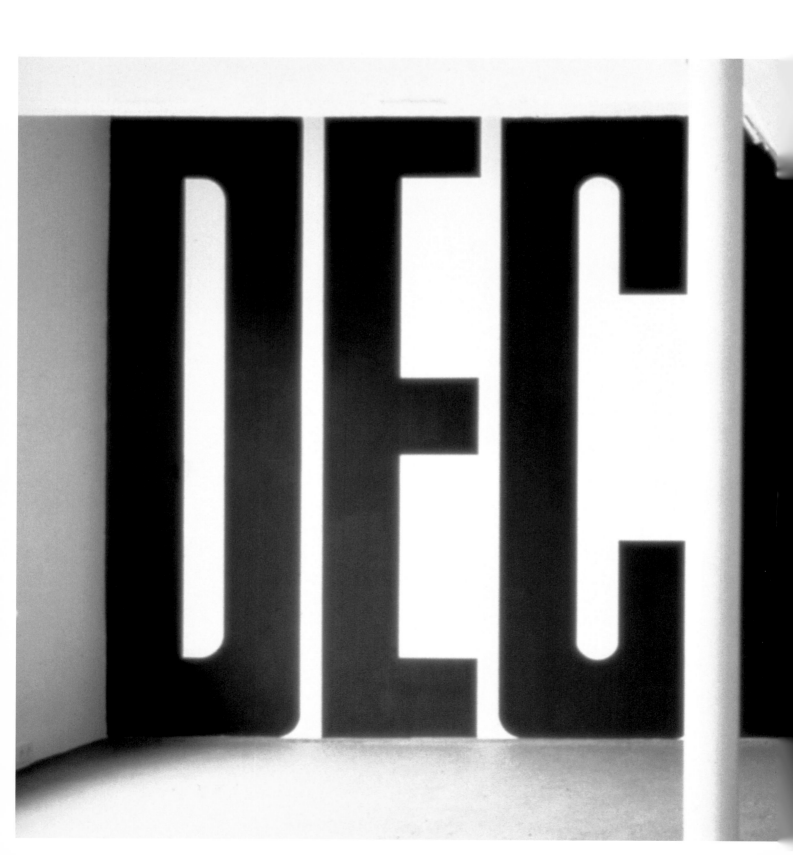

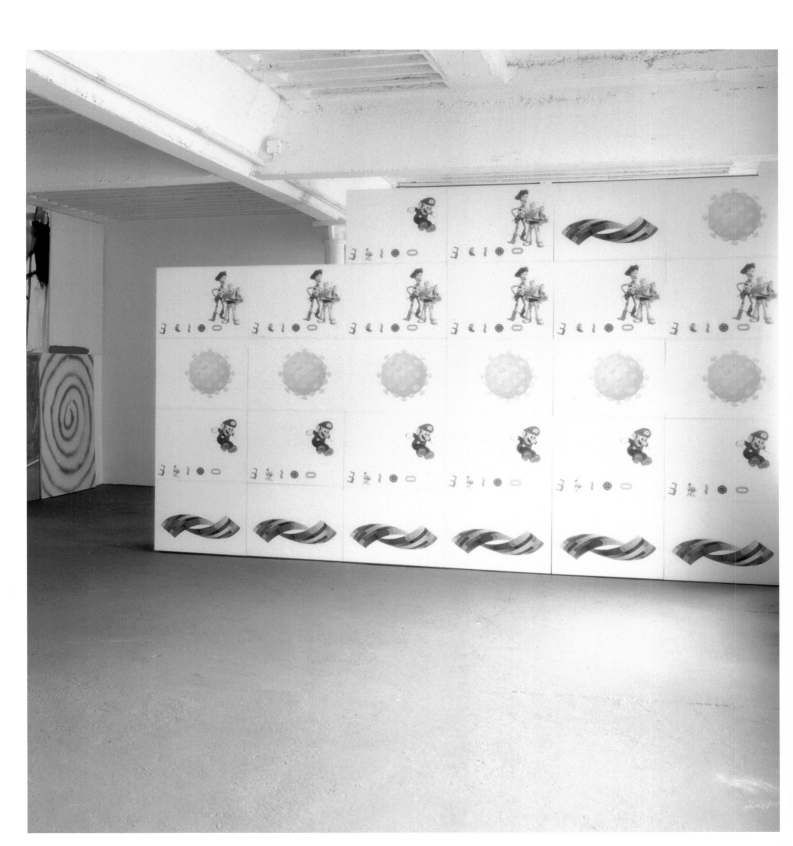

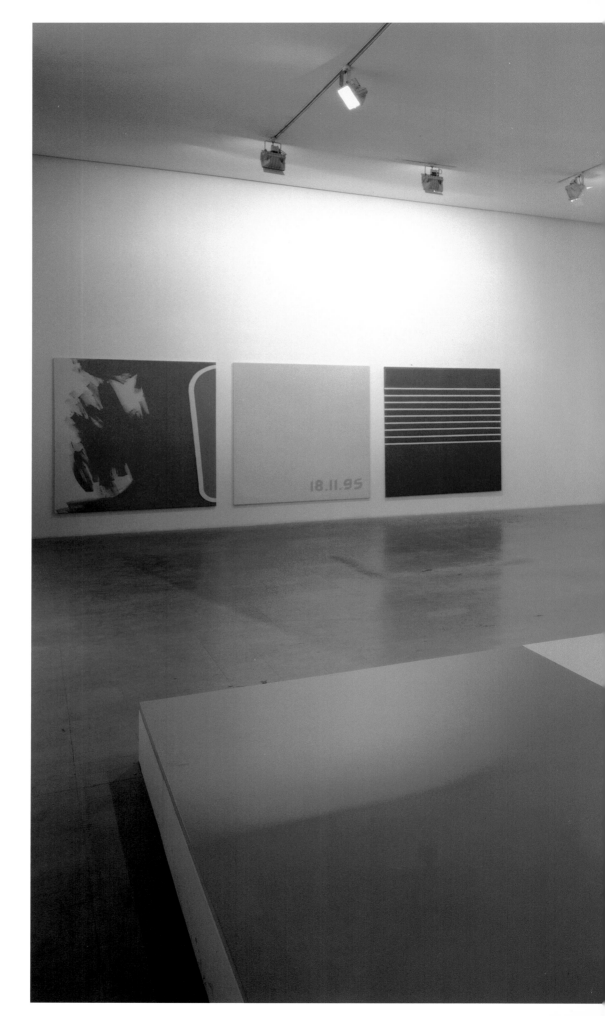

Michel Majerus: *qualified*
Galleria Giò Marconi, Mailand, 1997
Installationsansicht

Michel Majerus: *qualified*
Galleria Giò Marconi, Milan, 1997
installation view

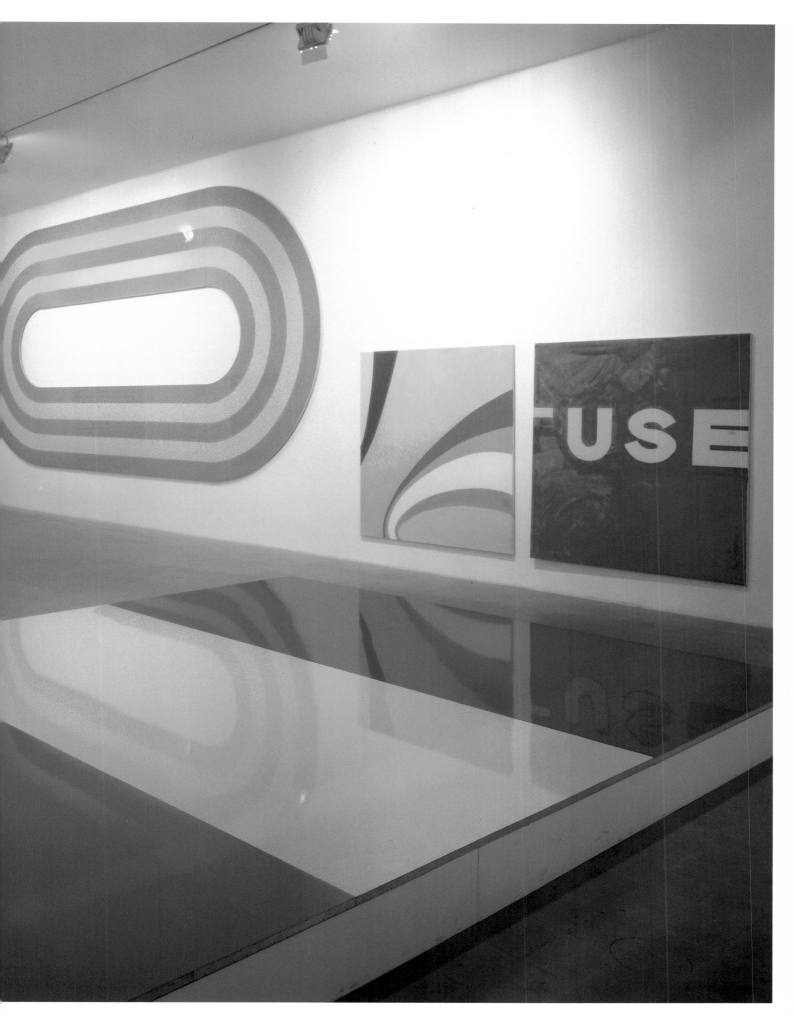

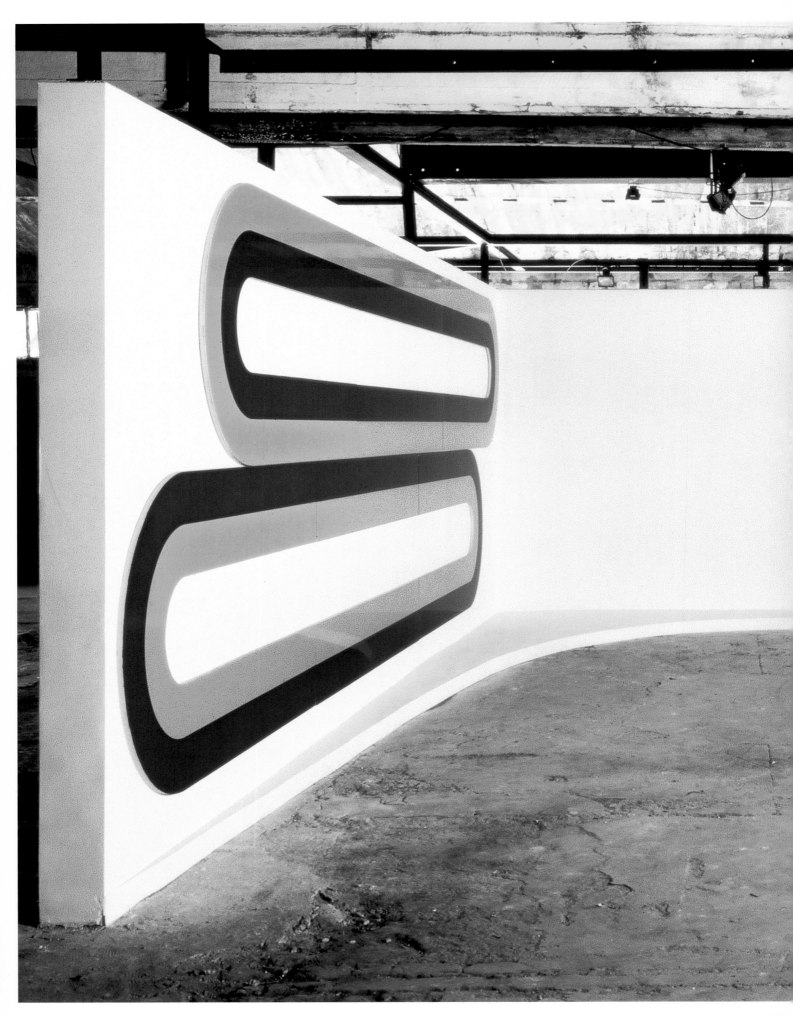

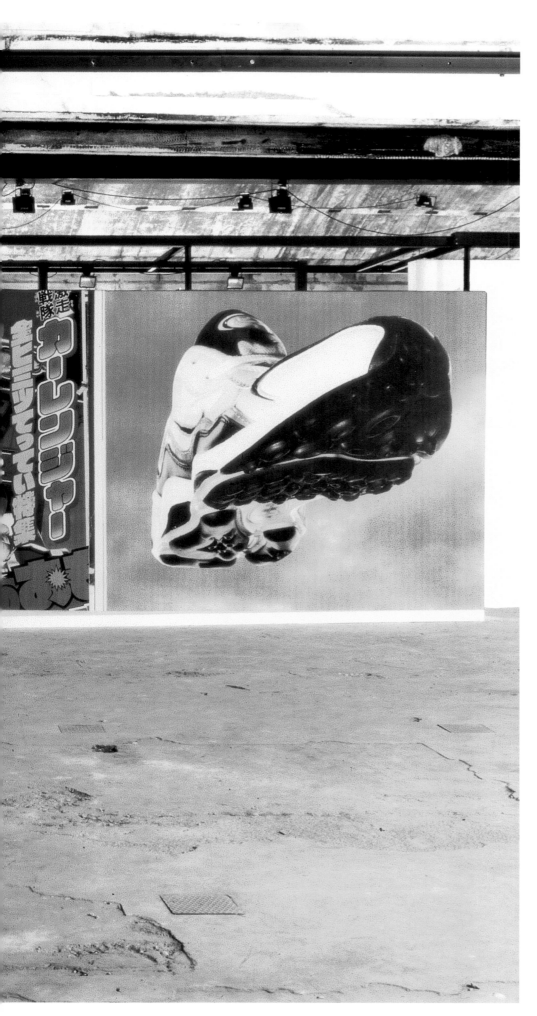

topping out
Städtische Galerie Nordhorn, 1997
Installationsansicht

dieser einzelfall an konstruktion
ist insofern ein schlüsselbild, als
er das irrationale, nämlich der
gewohnten räumlichen rationalität
widersprechende raumgefüge
der nachfolgenden abstrakten bilder
fast didaktisch ankündigt, 1997
Lack, Aluminium auf Stadur,
Digitaldruck, Rigips, Holz, Disper-
sionsfarbe; 340 × 1023 × 870 cm

topping out
Städtische Galerie Nordhorn, 1997
installation view

dieser einzelfall an konstruktion
ist insofern ein schlüsselbild, als
er das irrationale, nämlich der
gewohnten räumlichen rationalität
widersprechende raumgefüge
der nachfolgenden abstrakten bilder
fast didaktisch ankündigt, 1997
lacquer, aluminium on stadur,
digital print, sheetrock, wood,
emulsion paint; 340 × 1023 × 870 cm

Michel Majerus: *space safari*
Anders Tornberg Gallery, Lund, 1997
Installationsansichten

Michel Majerus: *space safari,*
Anders Tornberg Gallery, Lund, 1997
installation views

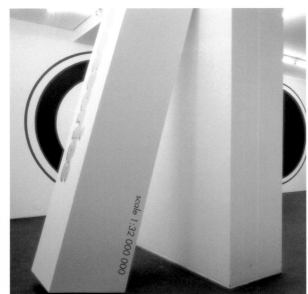
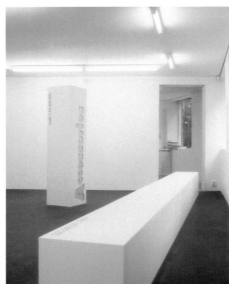

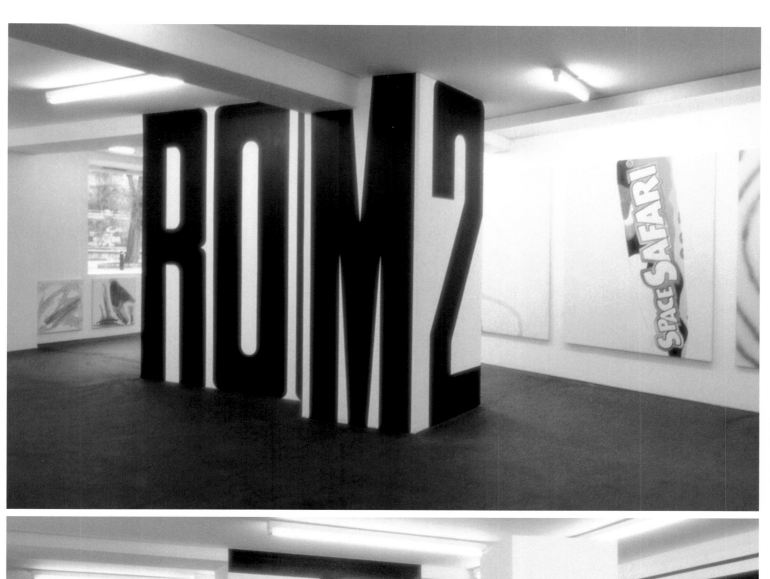

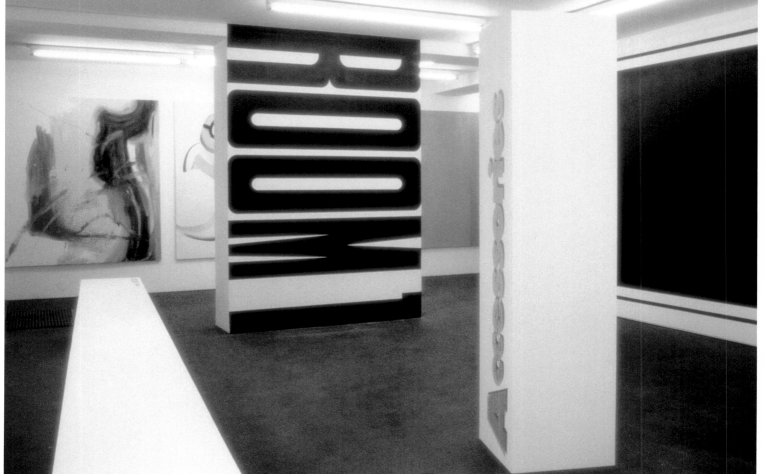

progressive aesthetics, 1998
Acryl auf Leinwand; 322 × 476 cm,
2-teilig, je 322 × 238 cm

progressive aesthetics, 1998
acrylic on canvas; 322 × 476 cm,
2 parts, each 322 × 238 cm

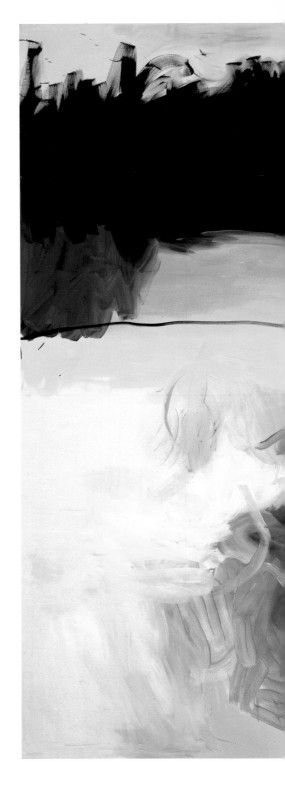

progressive aesthetics, 1998
Acryl auf Leinwand; 322 × 476 cm,
2-teilig, je 322 × 238 cm

progressive aesthetics, 1998
acrylic on canvas; 322 × 476 cm,
2 parts, each 322 × 238 cm

10 Jahre Open Art München, 1998
Hauptbahnhof München
Installationsansichten

Beschleunigung, 1998
Lack und Digitaldruck auf Aluminium;
900 × 1400 × 50 cm

10 Jahre Open Art München, 1998
central terminal Munich
installation views

Beschleunigung, 1998
lacquer, silkscreen and digital print
on aluminium; 900 × 1400 × 50 cm

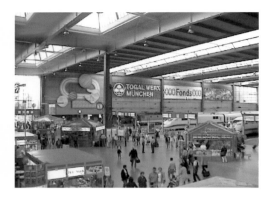

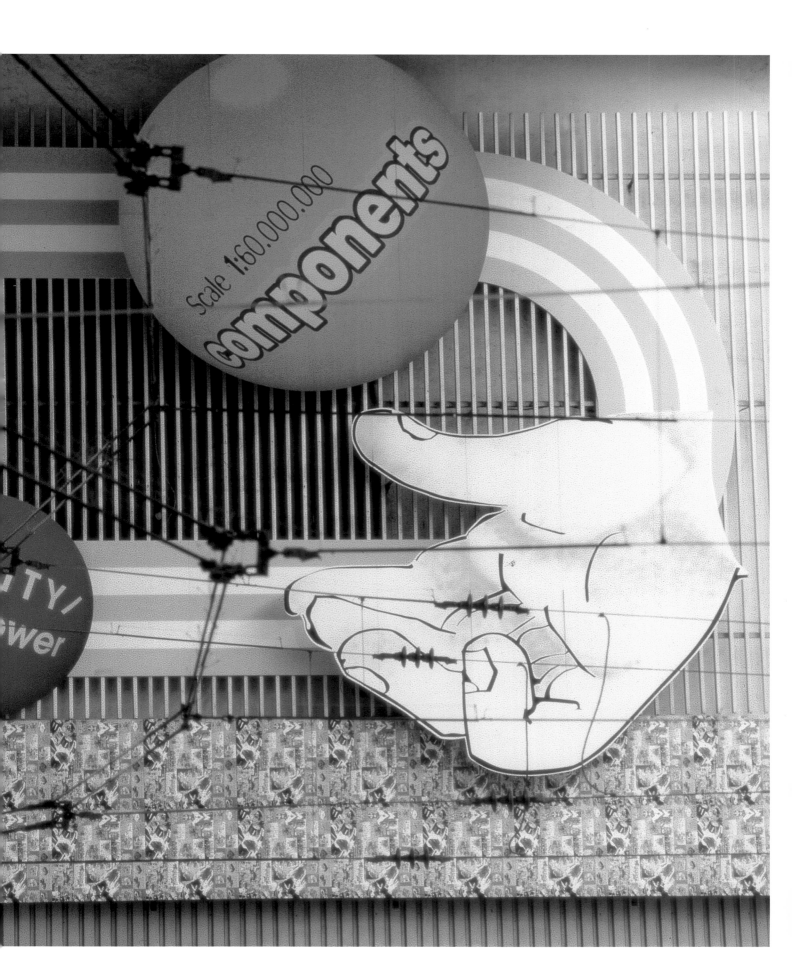

*Tell me a Story: narration
in Contemporary Painting
and Photography*
Centre National d'Art Con-
temporain de Grenoble, 1998
Installationsansicht

sinnmaschine, 1997
Acryl auf Leinwand,
industrieller Metallboden;
7 Paneele, je 450×150 cm

*Tell me a Story: narration
in Contemporary Painting
and Photography*
Centre National d'Art Con-
temporain de Grenoble, 1998
installation view

sinnmaschine, 1997
acrylic on canvas, industial
metal floor; 7 panels, each
450×150 cm

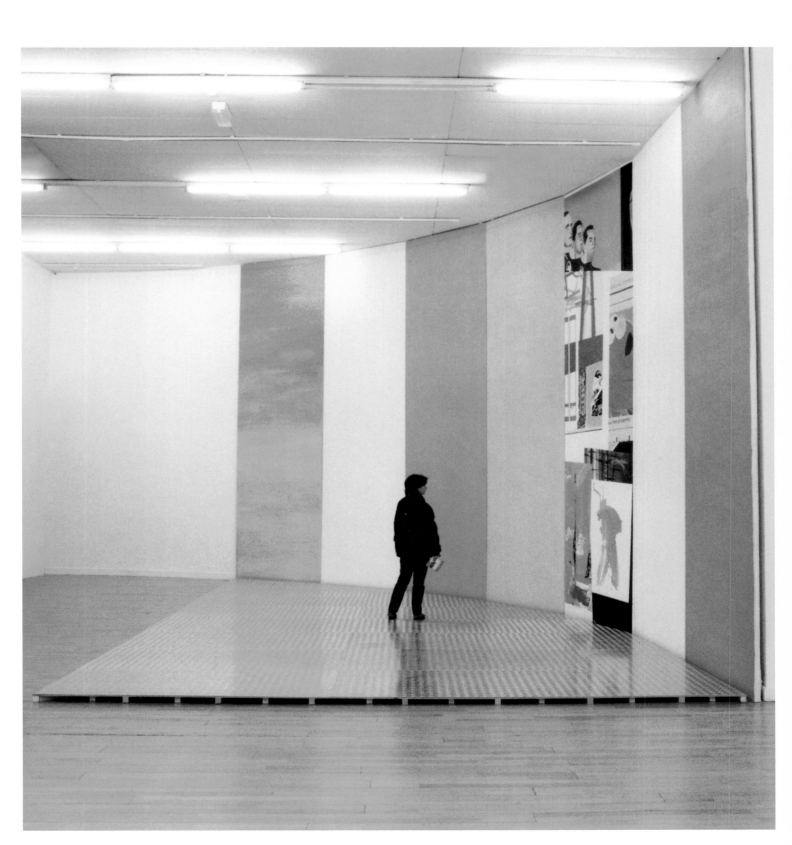

it's cool man, 1998
Lack und Siebdruck
auf Aluminium;
251 × 548 × 15,5 cm

it's cool man, 1998
lacquer and silkscreen
on aluminium;
251 × 548 × 15,5 cm

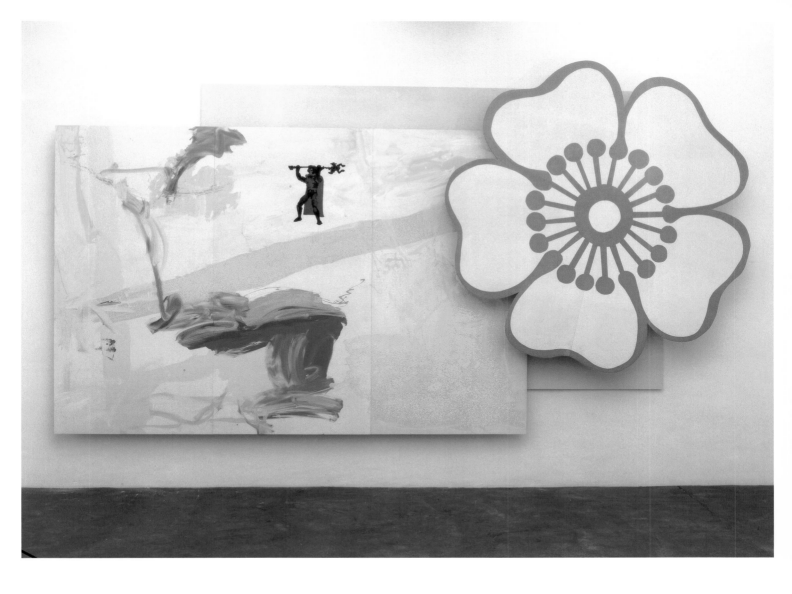

hilfe, 1998
Digitaler Entwurf für: *Das Jahrhundert
der künstlerischen Freiheit. 100 Jahre
Wiener Secession,* Wiener Secession, 1998

hilfe, 1998
digital layout for: *Das Jahrhundert
der künstlerischen Freiheit. 100 Jahre
Wiener Secession,* Wiener Secession, 1998

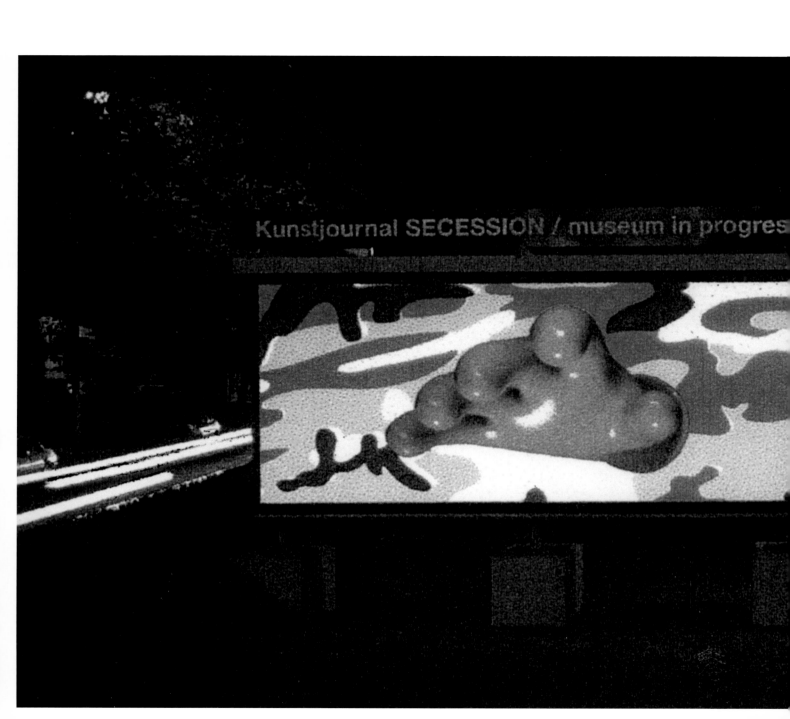

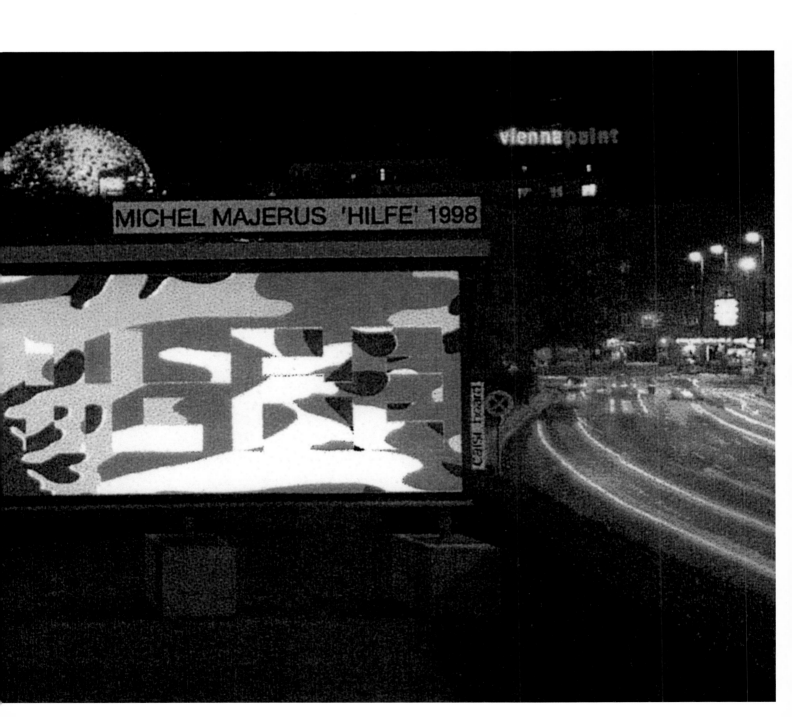

MoM Block 31, 1998
Acryl auf Leinwand;
200×180 cm

MoM Block 31, 1998
acrylic on canvas;
200×180 cm

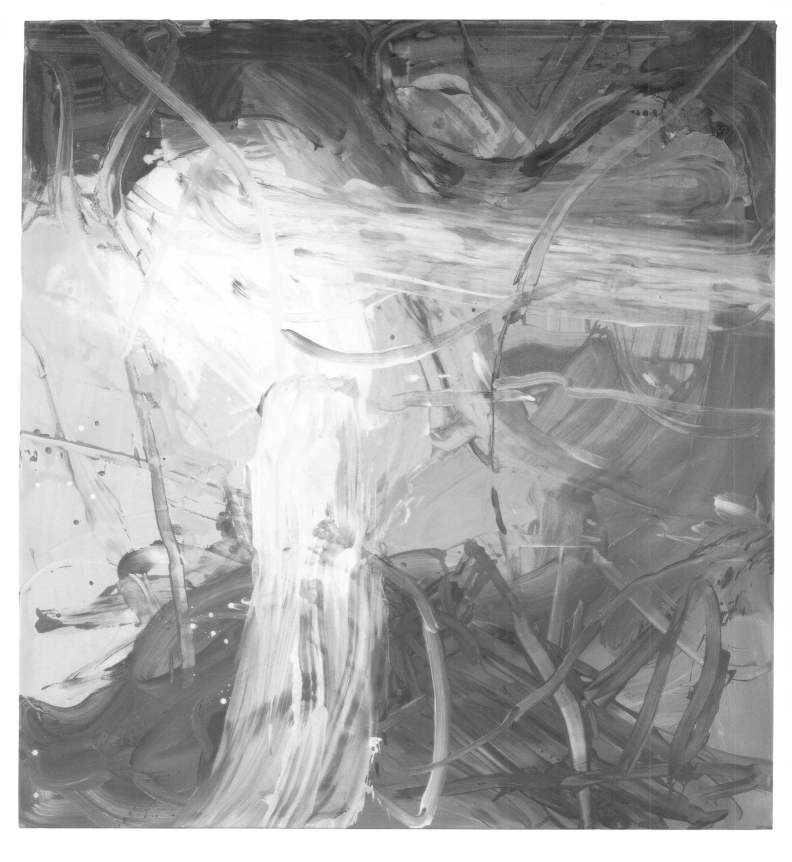

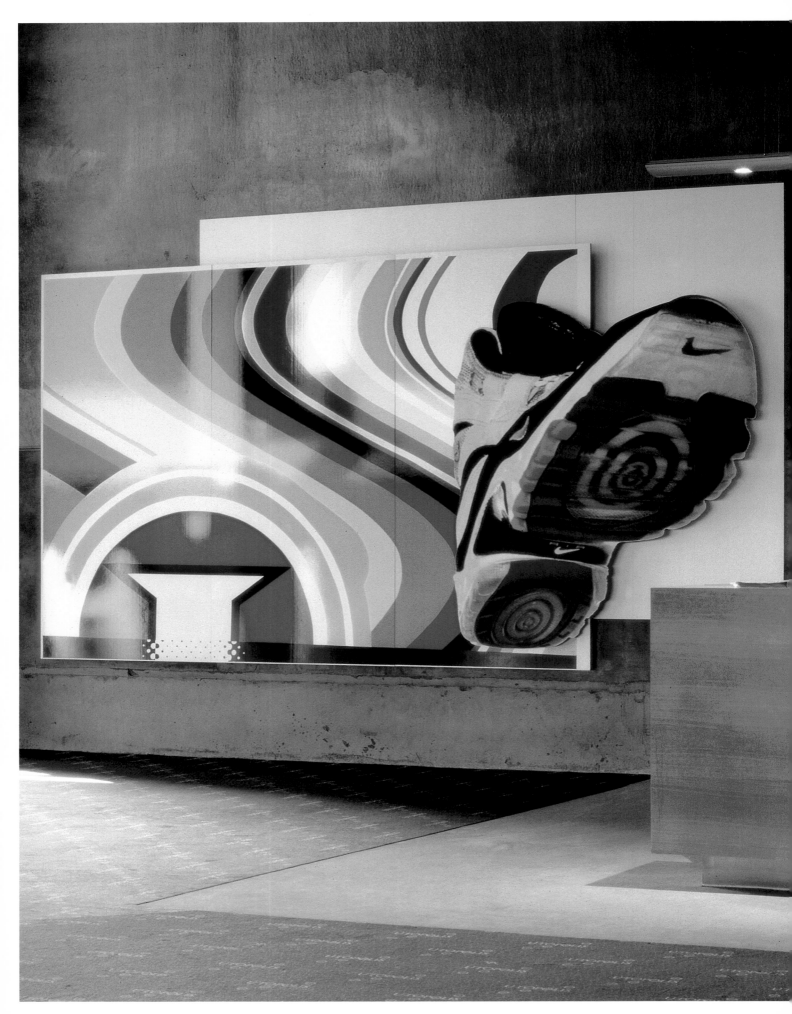

Manifesta 2, Luxemburg, 1998
Kino Utopolis
Installationsansicht

*yet sometimes what is read
successfully, stops us with its
meaning, no. II*, 1998
Lack und Digitaldruck auf
Aluminium; 278,5 × 485 × 15,5 cm

Manifesta 2, Luxembourg, 1998
Kino Utopolis
installation view

*yet sometimes what is read
successfully, stops us with its
meaning, no. II*, 1998
lacquer and digital print on
aluminium; 278,5 × 485 × 15,5 cm

it's because history has repeated itself three times in three decad

enough, 1999
Acryl auf Leinwand;
250×400 cm

enough, 1999
acrylic on canvas;
250×400 cm

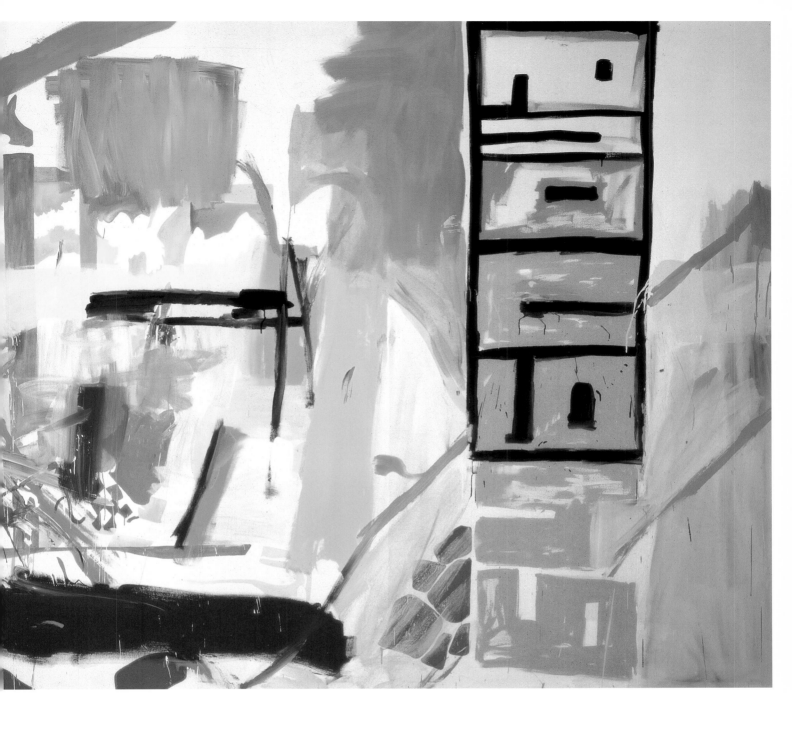

Michel Majerus
Galleria Giò Marconi, Mailand, 1998
Installationsansichten

unexpected disaster, 1998
Lack auf Aluminium;
320 × 750 × 20 cm

Michel Majerus
Galleria Giò Marconi, Milan, 1998
installation views

unexpected disaster, 1998
lacquer on aluminium;
320 × 750 × 20 cm

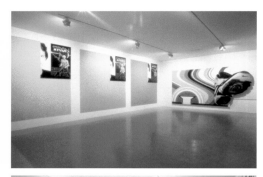

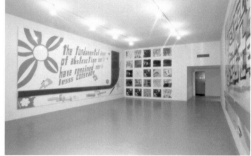

Michel Majerus
Galleria Giò Marconi, Mailand, 1998
Installationsansichten

unexpected disaster, 1998
Lack auf Aluminium;
320 × 750 × 20 cm

Michel Majerus
Galleria Giò Marconi, Milan, 1998
installation views

unexpected disaster, 1998
lacquer on aluminium;
320 × 750 × 20 cm

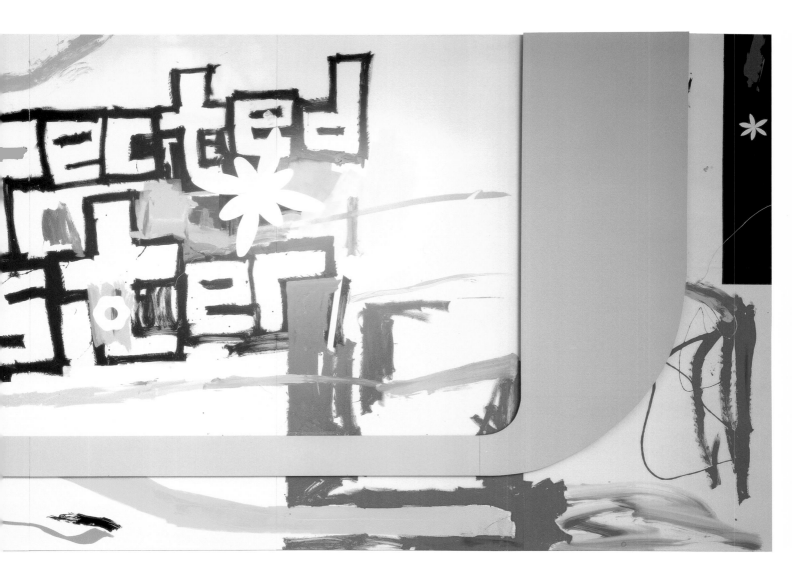

d'APERTutto, 48. Esposizione
Internazionale d'Arte, La Biennale
di Venezia, Venedig 1999
Fassade des italienischen Pavillons
Installationsansichten (S. 84–87)

sun in 10 different directions, 1999
Digitaldruck auf Forex, Polystyrol-
Spiegel, Dispersionsfarbe auf Wand;
ca. 1100×2800×320 cm

d'APERTutto, 48. Esposizione
Internazionale d'Arte, La Biennale
di Venezia, Venice 1999
Facade of the Italian pavillon
installation views (p. 84–87)

sun in 10 different directions, 1999
digital print on Forex, polystyrene
mirror, emulsion paint on wall;
approx. 1100×2800×320 cm

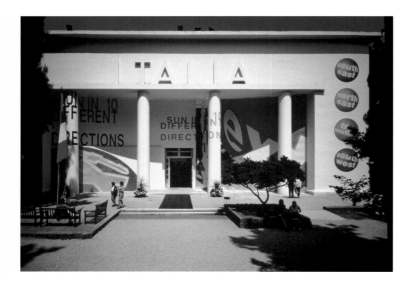

d'APERTutto, 48. Esposizione
Internazionale d'Arte, La Biennale
di Venezia, Venedig 1999
Fassade des italienischen Pavillons
Installationsansichten (S. 84–87)

d'APERTutto, 48. Esposizione
Internazionale d'Arte, La Biennale
di Venezia, Venice 1999
Facade of the Italian pavillon
installation views (p. 84–87)

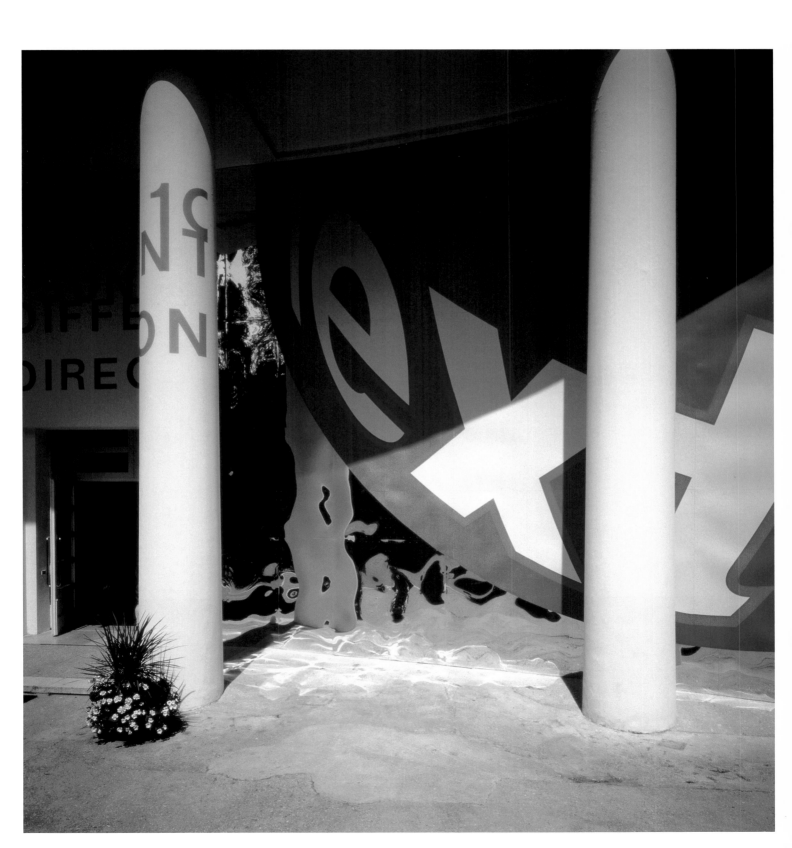

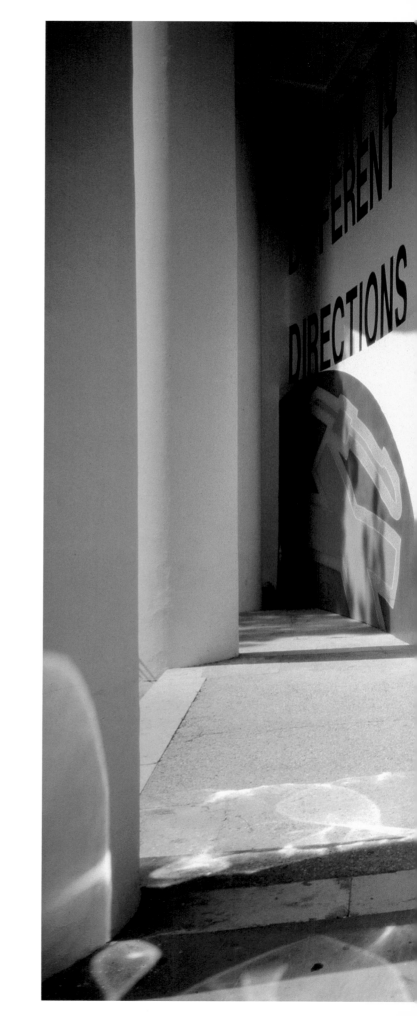

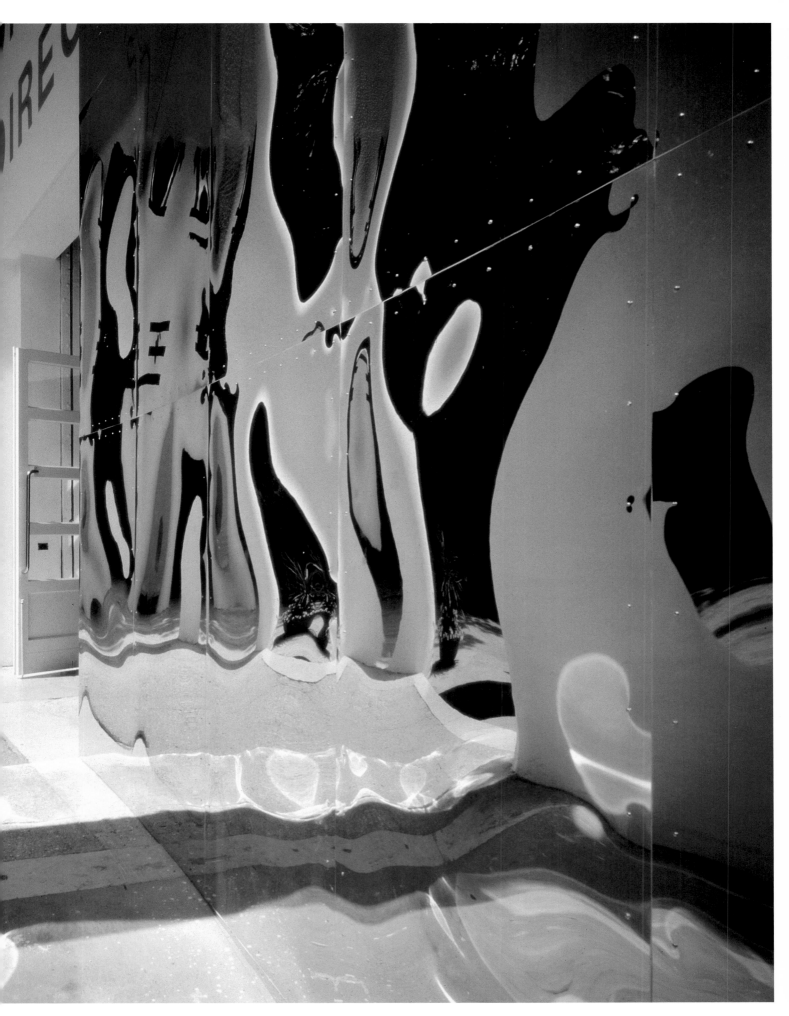

Michel Majerus
Galerie Rüdiger Schöttle,
München, 1999
Installationsansichten

Michel Majerus
Galerie Rüdiger Schöttle,
Munich, 1999
installation views

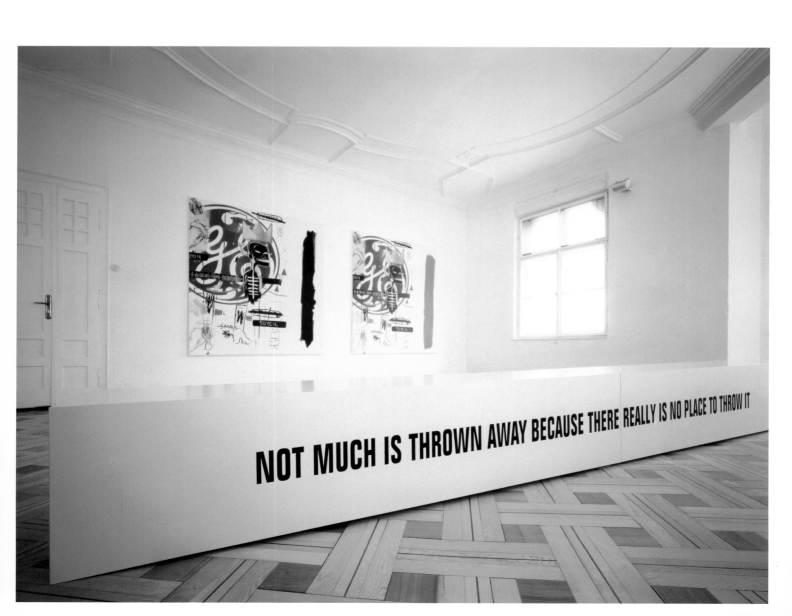

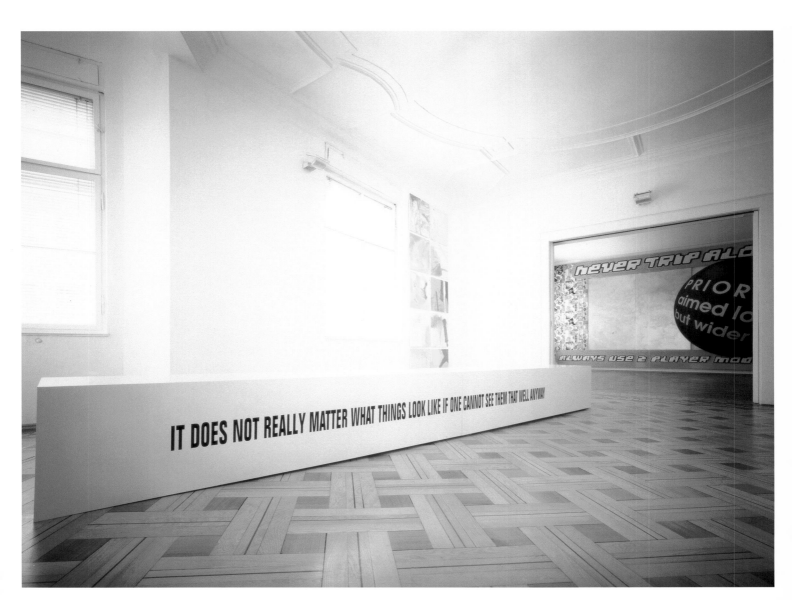

Le Capital: tableaux, dia-
gramms, bureaux d'études
Centre Regional d'Art
Contemporain, Sète, 1999
Installationsansicht

eye protection, 1999
Digitaldruck auf Aluminium,
Polystyrol-Spiegel,
Dispersionsfarbe auf Wand;
ca. 680 × 1100 × 340 cm

Le Capital: tableaux, dia-
gramms, bureaux d'études,
Centre Regional d'Art
Contemporain, Sète, 1999
Installation view

eye protection, 1999
digital print on aluminium,
polystyrene mirror,
emulsion paint on wall;
approx. 680 × 1100 × 340 cm

Le Capital: tableaux, dia-
gramms, bureaux d'études
Centre Regional d'Art
Contemporain, Sète, 1999
Installationsansicht

Le Capital: tableaux, dia-
gramms, bureaux d'études,
Centre Regional d'Art
Contemporain, Sète, 1999
Installation view

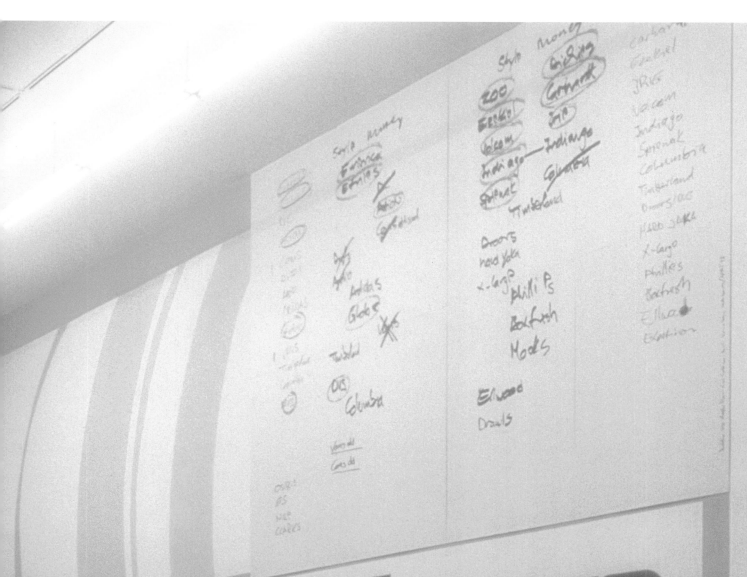

protection

a proper analysis

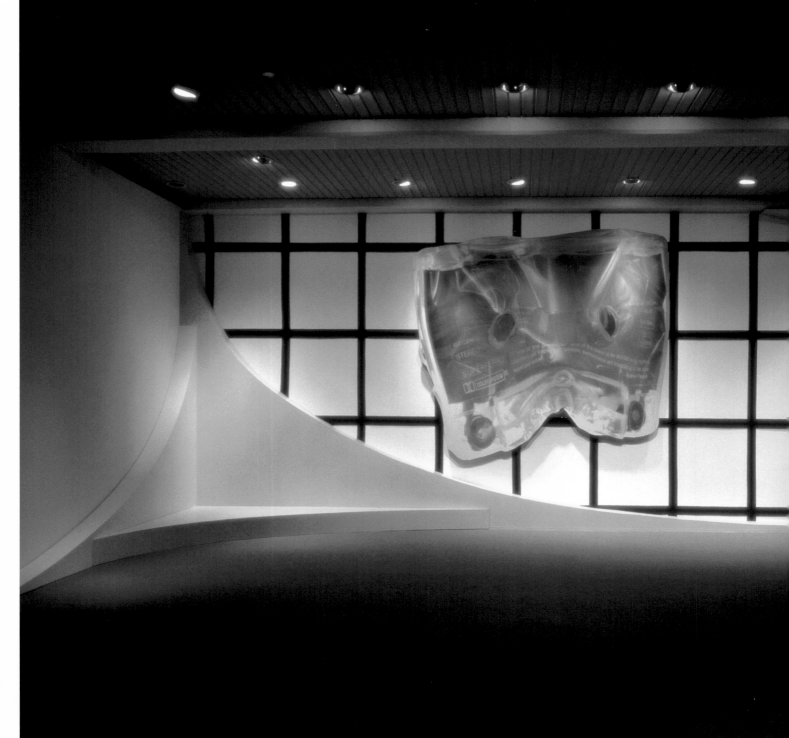

kraftwerk BERLIN
Aarhus Kunstmuseum, 1999
Installationsansicht

melt piece, 1999
Digitaldruck auf Aluminium,
Dispersionsfarbe auf Holz, Filz;
380×1000×320 cm

kraftwerk BERLIN,
Aarhus Kunstmuseum, 1999
installation view

melt piece, 1999
digital print on aluminium,
emulsion paint on wood, felt;
380×1000×320 cm

kick kick kick, 1999
Acryl auf Leinwand;
303 × 333 cm

kick kick kick, 1999
acrylic on canvas;
303 × 333 cm

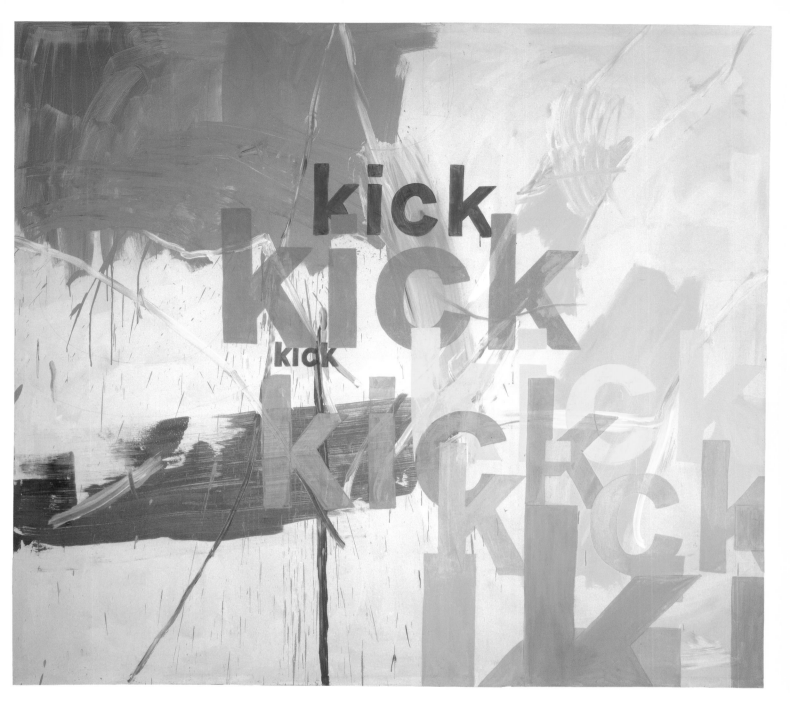

Colour Me Blind!
Städtische Ausstellungshalle am
Hawerkamp, Münster, 2000;
Dundee Contemporary Arts, 2000
Installationsansichten

aufnahme position/löschschutz position –
record position/protected position, 1999
Digitaldruck auf Spanplatte,
Dispersionsfarbe auf Wand;
Münster: 240 × 610 × 763 cm;
Dundee: 620 × 390 cm

Colour Me Blind!
Städtische Ausstellungshalle am
Hawerkamp, Münster, 2000;
Dundee Contemporary Arts, 2000
installation views

aufnahme position/löschschutz position –
record position/protected position, 1999
digital print on chipboard,
emulsion paint on wall;
Münster: 240 × 610 × 763 cm;
Dundee: 620 × 390 cm

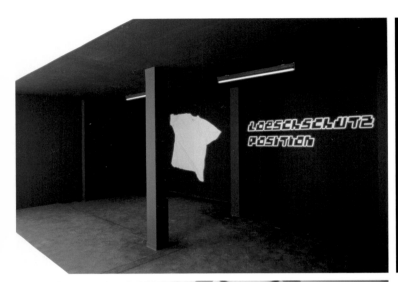

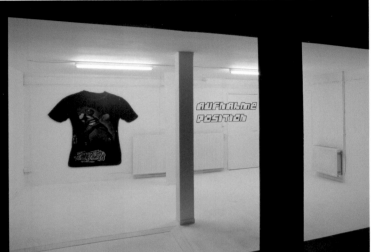

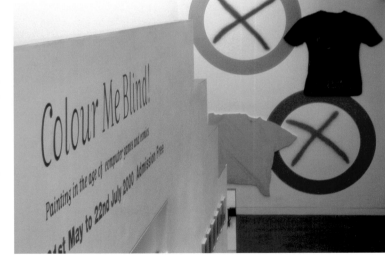

Colour Me Blind!
Württembergischer Kunstverein,
Stuttgart, 1999
Installationsansicht

aufnahme position/löschschutz position –
record position/protected position, 1999
Digitaldruck auf Spanplatte, Lack auf Holz;
450 × 1350 × 180 cm

Colour Me Blind!
Württembergischer Kunstverein,
Stuttgart, 1999
installation view

aufnahme position/löschschutz position –
record position/protected position, 1999
digital print on chipboard, lacquer on wood;
450 × 1350 × 180 cm

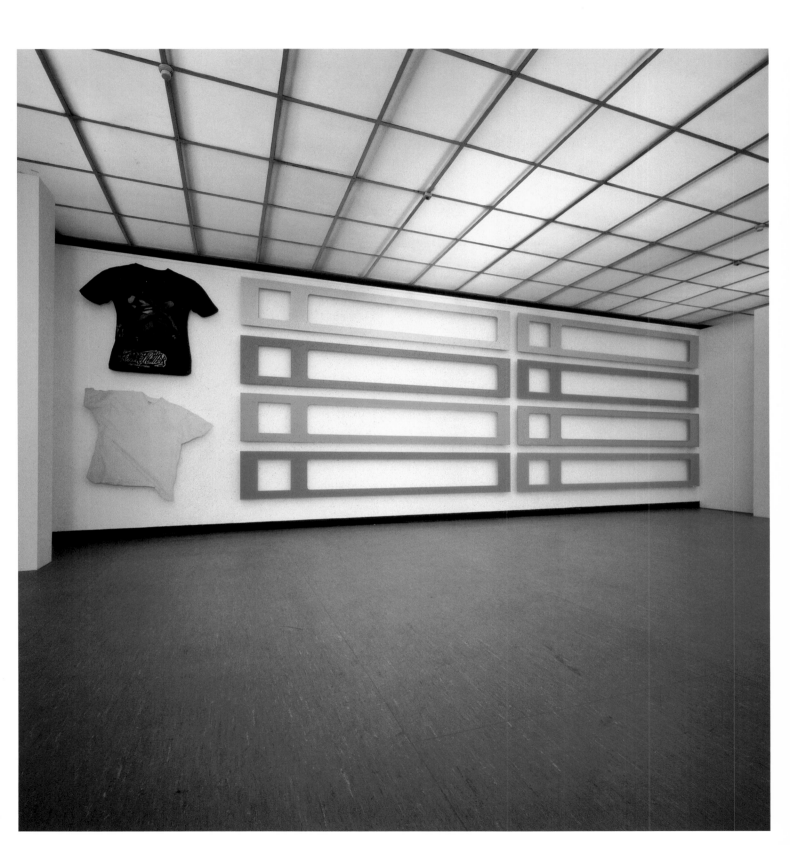

german open
Kunstmuseum Wolfsburg, 1999
Installationsansicht

*what looks good today may not
look good tomorrow,* 1999
Styropor, Holz, Dispersionsfarbe;
ca. 1200 × 4000 × 100 cm

german open
Kunstmuseum Wolfsburg, 1999
installation view

*what looks good today may not
look good tomorrow,* 1999
Styrofoam, wood, emulsion paint;
approx. 1200 × 4000 × 100 cm

german open
Kunstmuseum Wolfsburg, 1999
Installationsansicht

*what looks good today may not
look good tomorrow,* 1999
Styropor, Holz, Dispersionsfarbe;
ca. 1200 × 4000 × 100 cm

german open
Kunstmuseum Wolfsburg, 1999
installation view

*what looks good today may not
look good tomorrow,* 1999
Styrofoam, wood, emulsion paint;
approx. 1200 × 4000 × 100 cm

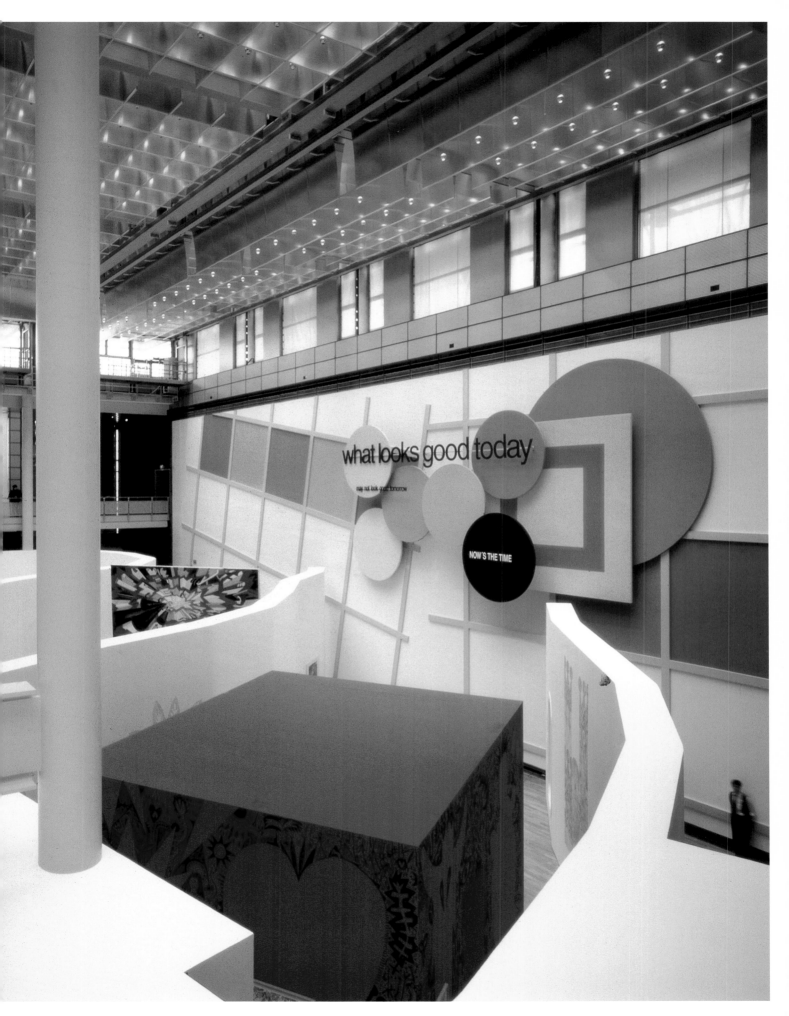

what looks good today

may not look good tomorrow

NOW'S THE TIME

Michel Majerus
neugerriemschneider, Berlin, 1999
Installationsansichten (S. 100–103)

*sein lieblingsthema war sicherheit
seine these – es gibt sie nicht,* 1999
Acryl auf Leinwand, Digitaldruck
auf Aluminium, Polystyrol-Spiegel,
Rigips, Riflex, Dispersionsfarbe;
365 × 1058 × 987 cm

Michel Majerus
neugerriemschneider, Berlin, 1999
installation views (p. 100–103)

*sein lieblingsthema war sicherheit
seine these – es gibt sie nicht,* 1999
acrylic on canvas, digital print on
aluminium, polystyrene mirror,
sheetrock, Riflex, emulsion paint;
365 × 1058 × 987 cm

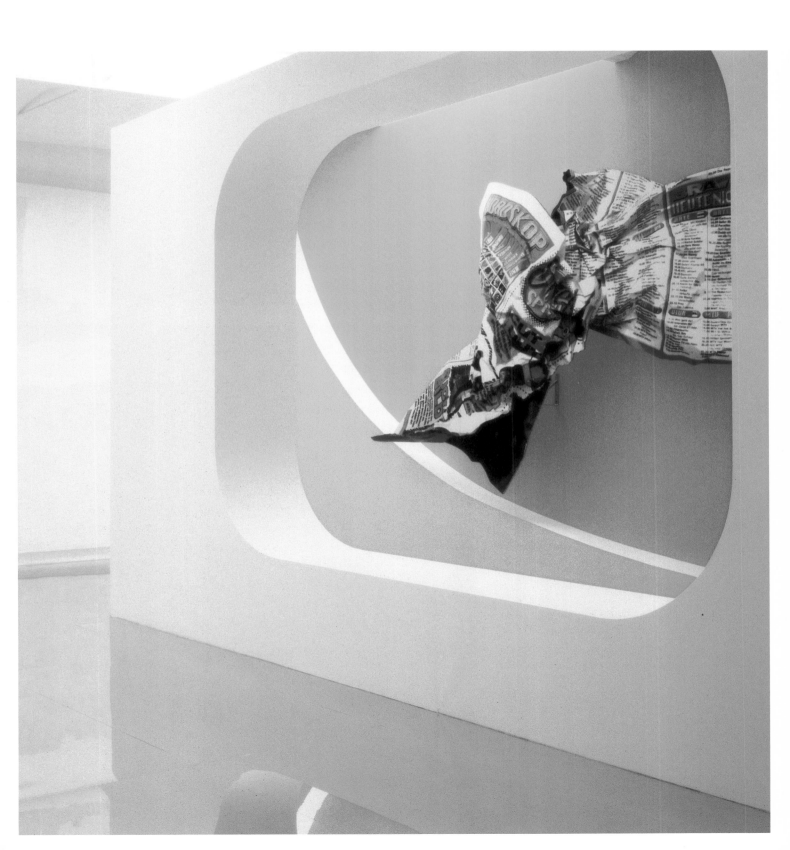

pure pragmatism deducing it ...her than its c

pure pragmatism ...ng it

pure pr...at

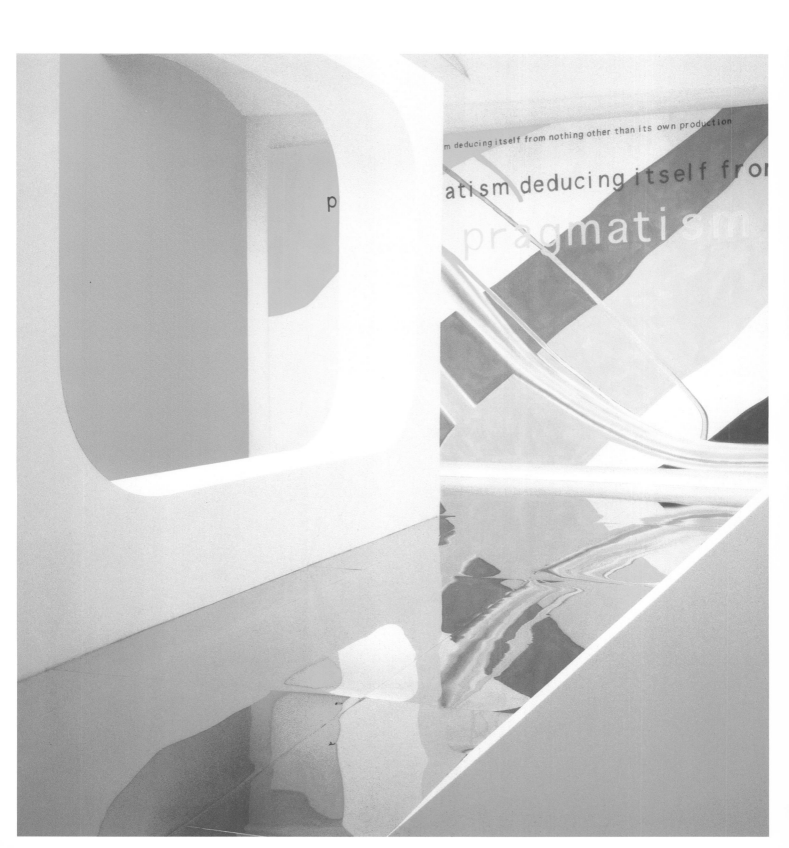

m deducing itself from nothing other than its own production

atism deducing itself fro

pragmatism

what looks good today may
not look good tomorrow, 1999
Acryl auf Leinwand; 303 × 341 cm

what looks good today may
not look good tomorrow, 1999
acrylic on canvas; 303 × 341 cm

what looks good today may
not look good tomorrow, 1999
Acryl auf Leinwand; 303 × 341 cm

what looks good today may
not look good tomorrow, 1999
acrylic on canvas; 303 × 341 cm

what looks good toda

may not bok good tomorrow

what lo

what lo

may not bok

may not bok

NOW'S THE TIME

Michel Majerus, the better
day project, Hamburg, 1999
Installationsansichten

erholung verloren, 1999
Digitaldruck auf Depafit;
320 × 500 × 300 cm

Michel Majerus, the better
day project, Hamburg, 1999
installation views

erholung verloren, 1999
digital print on depafit;
320 × 500 × 300 cm

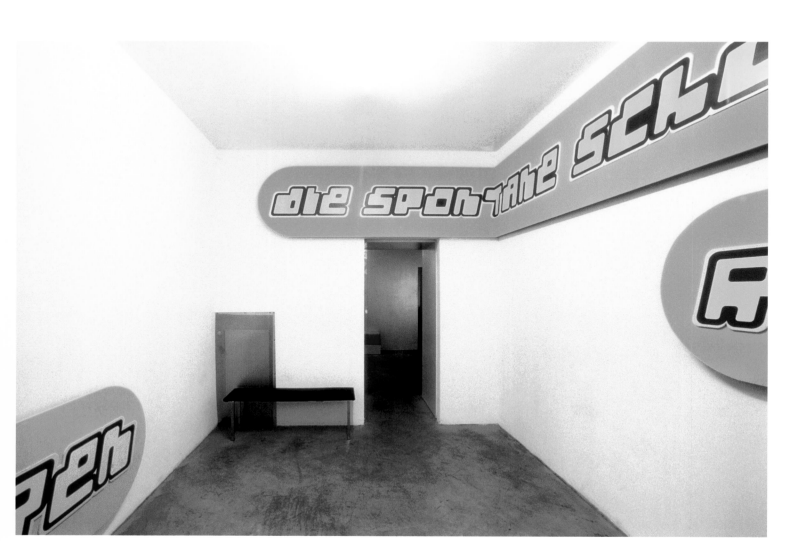

Michel Majerus, the better
day project, Hamburg, 1999
Installationsansichten

erholung verloren, 1999
Digitaldruck auf Depafit;
320 × 500 × 300 cm

Michel Majerus, the better
day project, Hamburg, 1999
installation views

erholung verloren, 1999
digital print on depafit;
320 × 500 × 300 cm

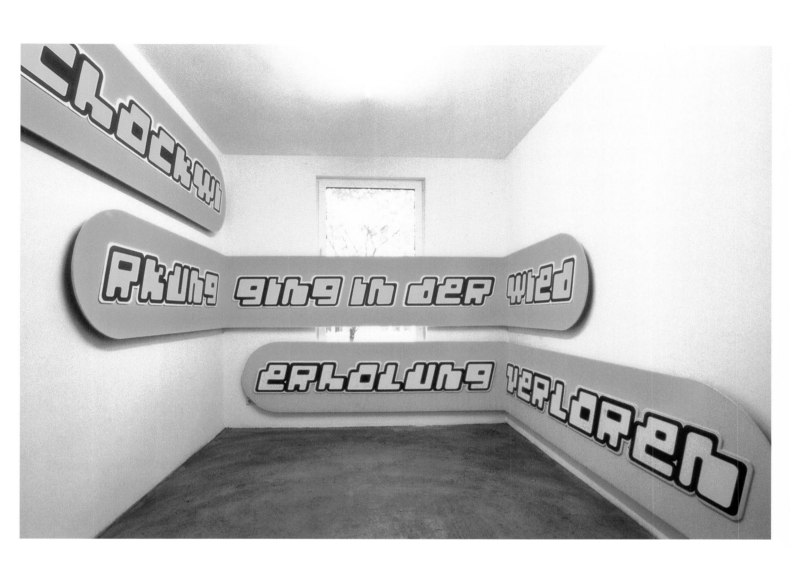

Michel Majerus/Björn Dahlem
schnitt ausstellungsraum,
Köln, 1999
Installationsansicht

*what looks good today may
not look good tomorrow,* 1999
Dispersionsfarbe auf Wand;
308×504 cm

Michel Majerus/Björn Dahlem
schnitt ausstellungsraum,
Cologne, 1999
installation view

*what looks good today may
not look good tomorrow,* 1999
emulsion paint on wall;
308×504 cm

oks good

ay not look

morrow

gold, 2000
Acryl auf Leinwand;
303×348 cm

gold, 2000
acrylic on canvas;
303×348 cm

Sammlung Falckenberg,
Phoenix Stiftung, Hamburg, 2001;
Installationsansicht

all like something, 1999
Dispersionsfarbe auf Wand; ca.
408 × 690 cm und 408 × 1210 cm

Sammlung Falckenberg,
Pump Haus, Hamburg, 1999
Installationsansicht

all like something, 1999
Dispersionsfarbe auf Wand;
keine Massangabe

Sammlung Falckenberg,
Phoenix Stiftung, Hamburg, 2001;
installation view

all like something, 1999
emulsion paint on wall; approx.
408 × 690 cm and 408 × 1210 cm

Sammlung Falckenberg,
Pump Haus, Hamburg, 1999
installation view

all like something, 1999
emulsion paint on wall;
no measurement

Sammlung Falckenberg,
Phoenix Stiftung, Hamburg, 2001;
Installationsansicht

all like something, 1999
Dispersionsfarbe auf Wand; ca.
408 × 690 cm und 408 × 1210 cm

Sammlung Falckenberg,
Pump Haus, Hamburg, 1999
Installationsansicht

all like something, 1999
Dispersionsfarbe auf Wand;
keine Massangabe

Sammlung Falckenberg,
Phoenix Stiftung, Hamburg, 2001;
installation view

all like something, 1999
emulsion paint on wall; approx.
408 × 690 cm and 408 × 1210 cm

Sammlung Falckenberg,
Pump Haus, Hamburg, 1999
installation view

all like something, 1999
emulsion paint on wall;
no measurement

Michel Majerus
Delfina, London, 2000
Installationsansichten
(S. 114–117)

the space is where you'll find it, 2000
Digitaldruck auf Vinyl, Holzunter-
konstruktion; 8 Teile installiert in
einem Raum, 310 × 1862 × 1535 cm

Michel Majerus
Delfina, London, 2000
installation views
(p.114–117)

the space is where you'll find it, 2000
digital print on vinyl, wooden
substructure; 8 parts installed in one
room, 310 × 1862 × 1535 cm

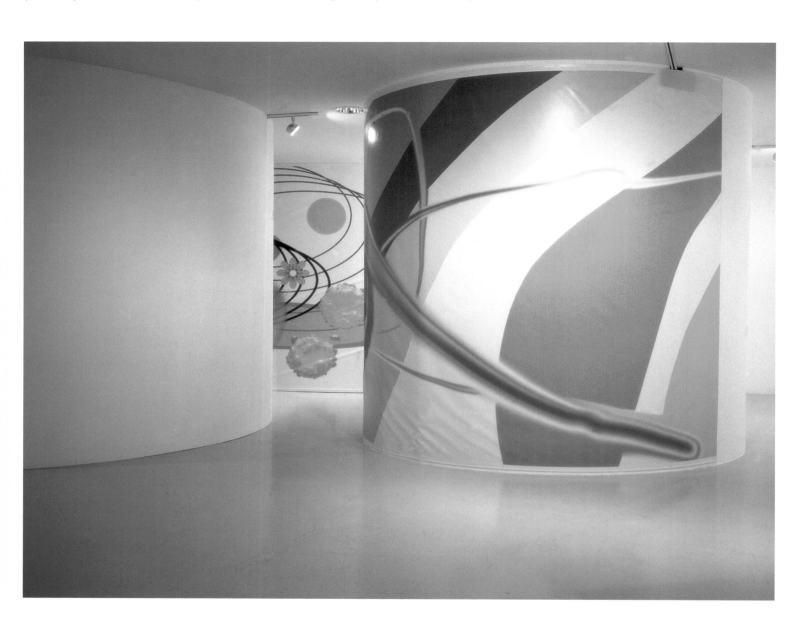

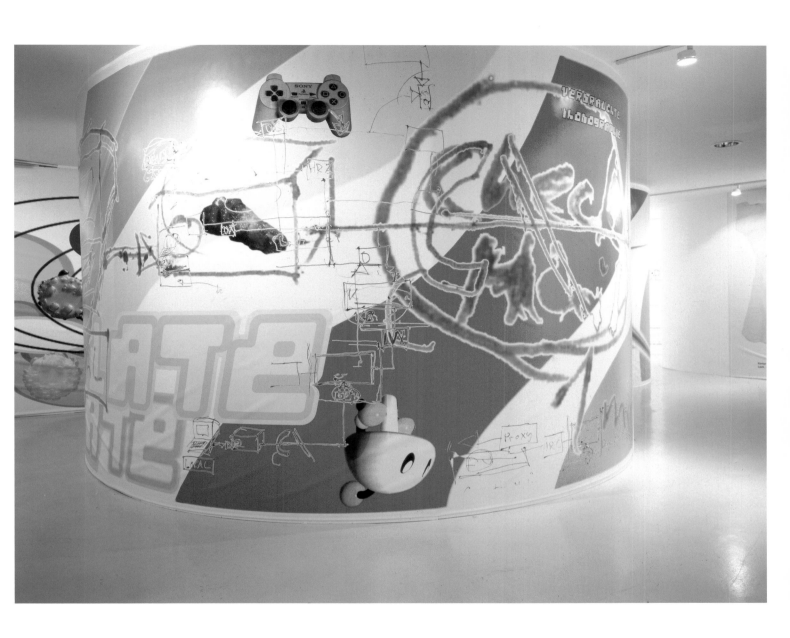

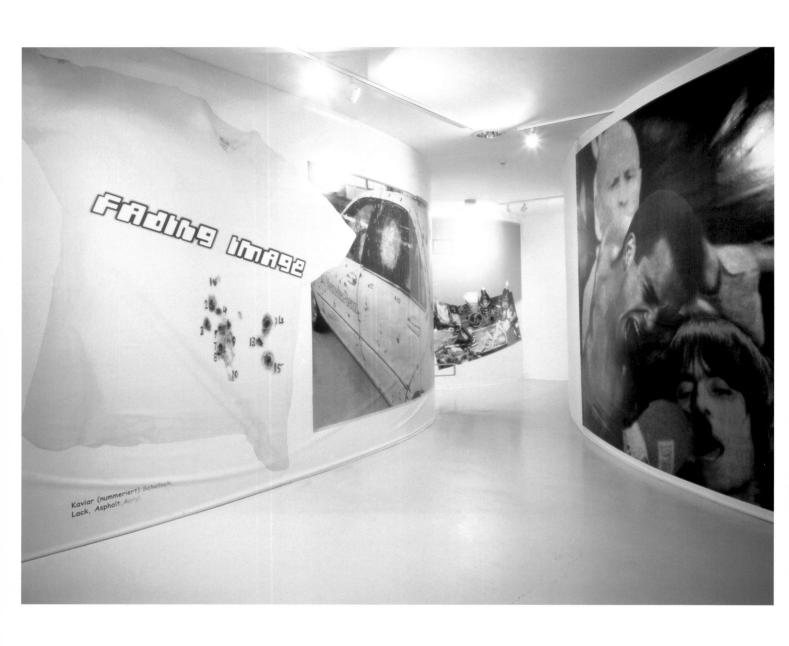

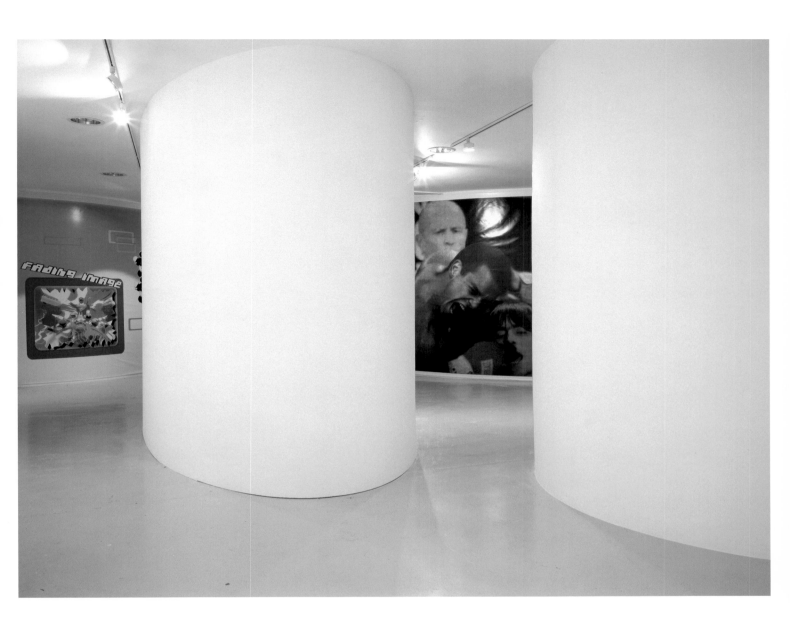

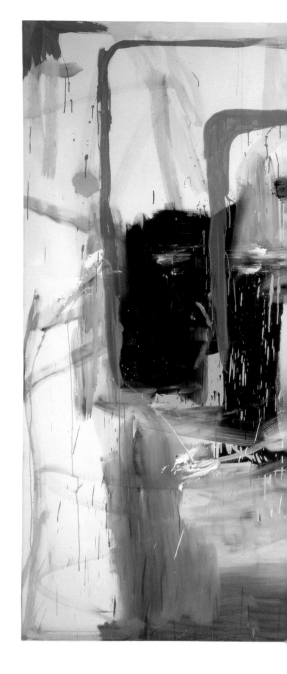

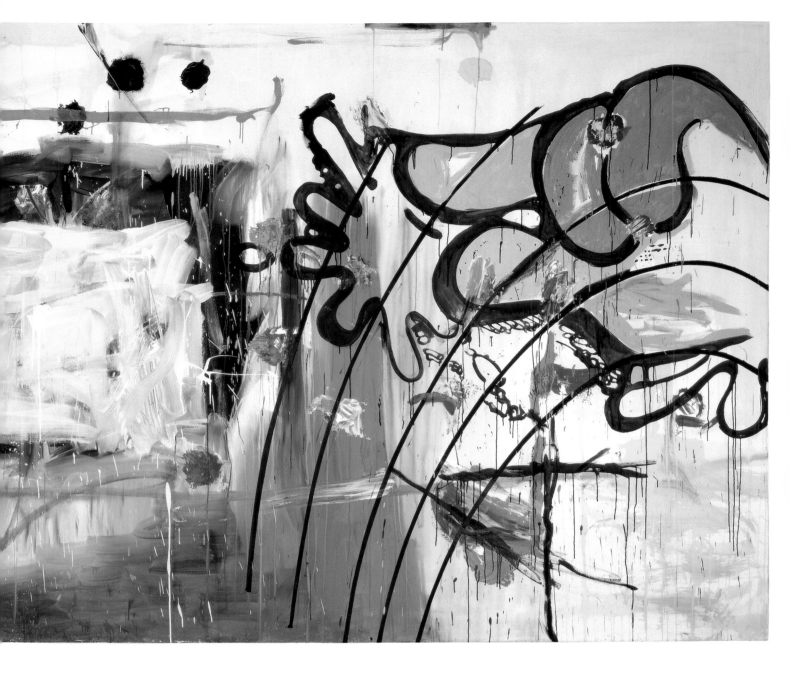

Michel Majerus: *demand the best,*
don't accept excuses
Monika Sprüth Galerie, Köln, 2000
Installationsansichten (S. 120–123)

mace the space ace, 2000
Digitaldruck und Lack auf Aluminium,
Rigips; 484 × 1443 × 971 cm

Michel Majerus: *demand the best,*
don't accept excuses
Monika Sprüth Galerie, Cologne, 2000
Installationsansichten (p. 120–123)

mace the space ace, 2000
digital print and lacquer on aluminum,
sheetrock; 484 × 1443 × 971 cm

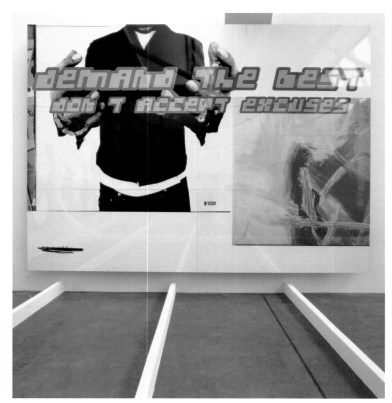

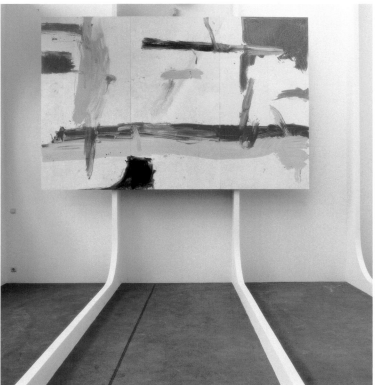

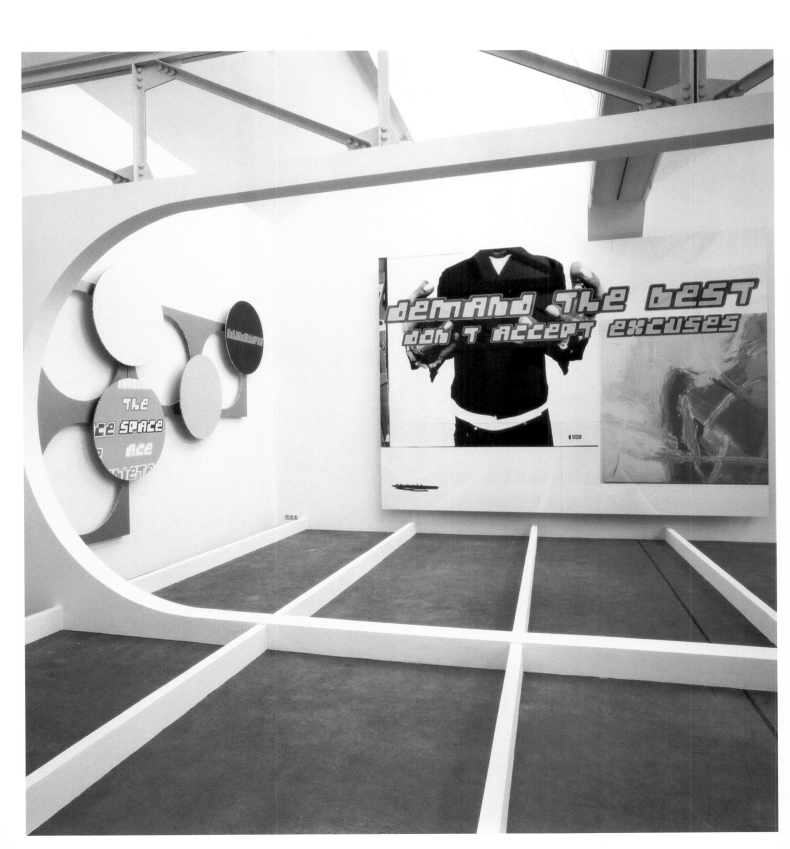

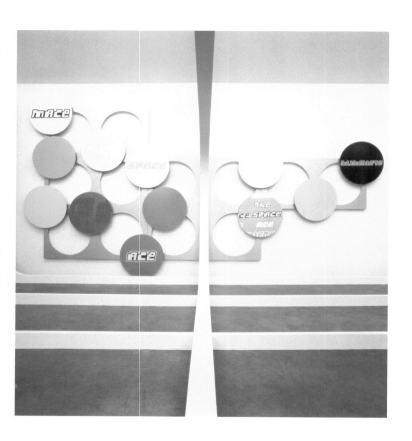

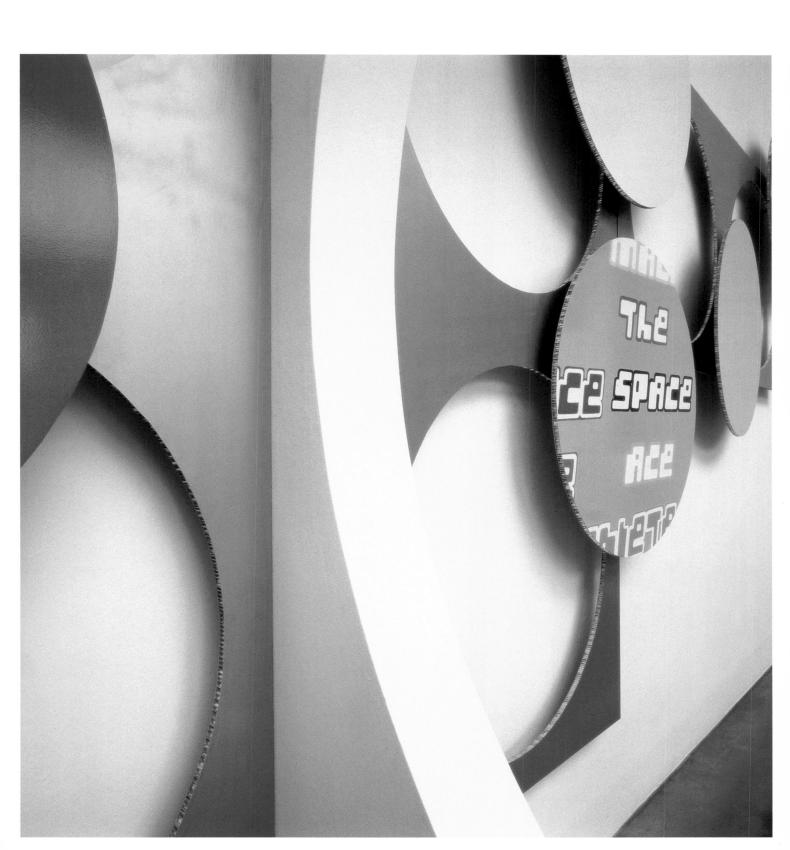

Taipeh Biennale,
Taipeh, 2000
Installationsansichten

bring the next line up, 2000
Dispersionsfarbe auf Wand,
Digitaldruck auf PVC und Forex,
Rigips; 410 × 900 × 764 cm

Taipeh Biennale,
Taipeh, 2000
installation views

bring the next line up, 2000
emulsion paint on wall, digital
print on PVC and Forex,
sheetrock; 410 × 900 × 764 cm

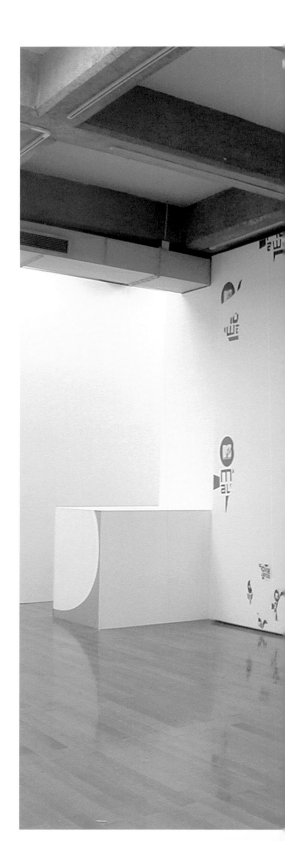

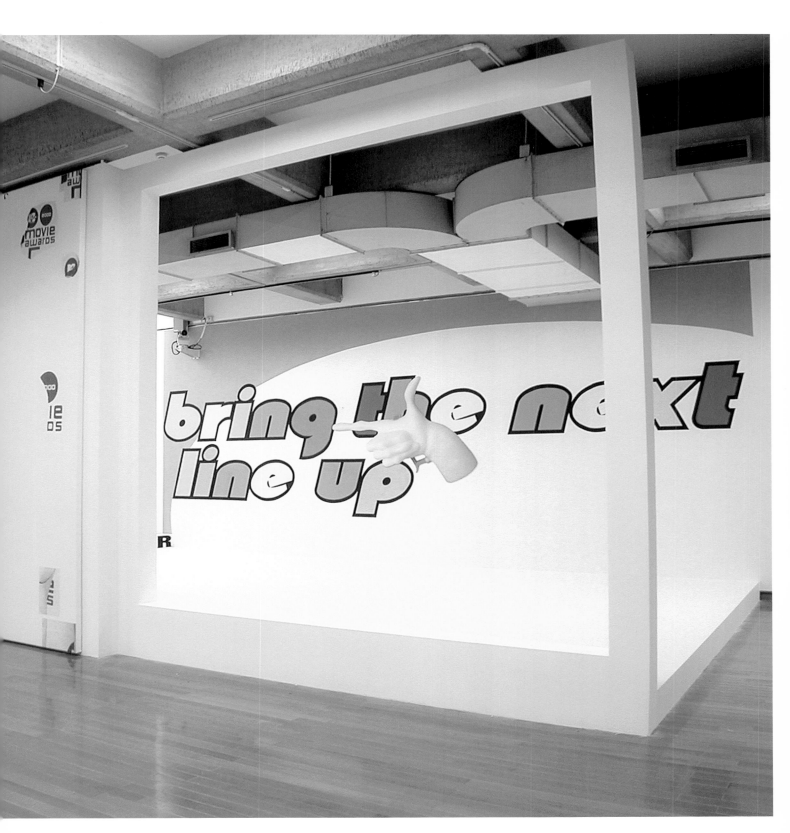

HausSchau – das Haus in der Kunst
Deichtorhallen, Hamburg, 2000
Installationsansicht

Das goldene Zimmer, 2000
zusammen mit Stephan Balkenhol
und Rüdiger Schöttle, Außenwand-
gestaltung Michel Majerus

Hausschau – das Haus in der Kunst
Deichtorhallen, Hamburg, 2000
installation view

Das goldene Zimmer, 2000
together with Stephan Balkenhol
and Rüdiger Schöttle, outwall
design Michel Majerus

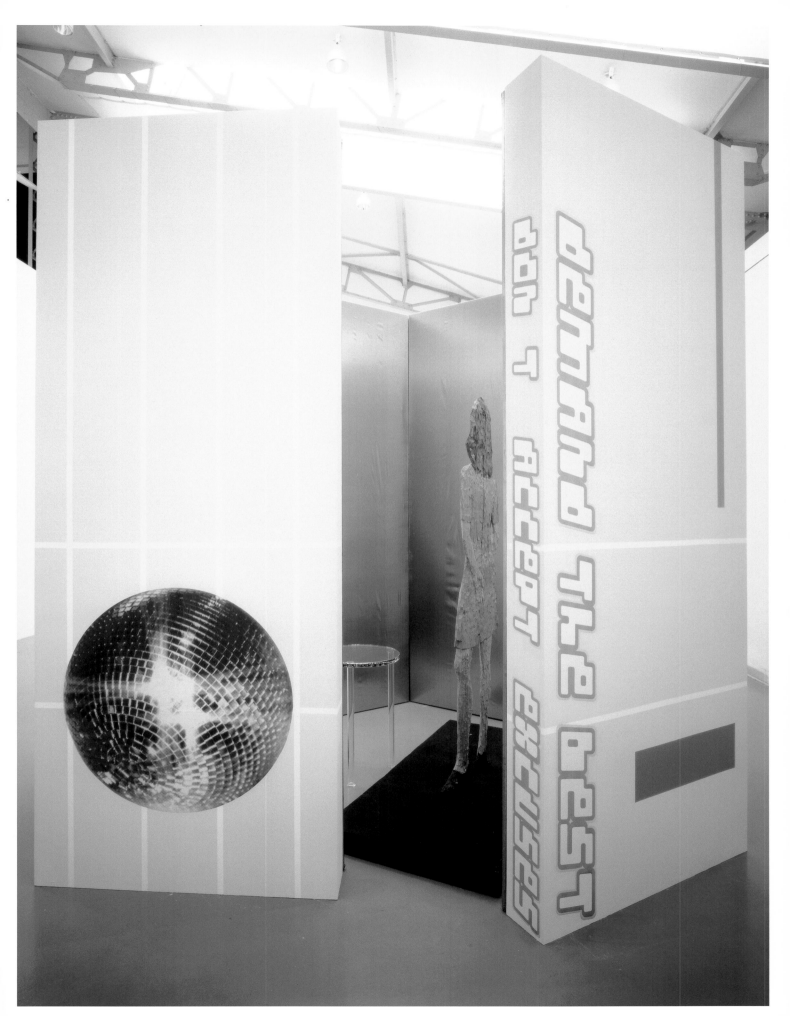

Michel Majerus,
Kölnischer Kunstverein,
Köln, 2000
Installationsansichten
(S. 128–131)

if we are dead, so it is, 2000
Holzkonstruktion, Digitaldruck,
Multiplex, Acrylfarbe, Lack;
300 × 992 × 4600 cm

Michel Majerus,
Kölnischer Kunstverein,
Cologne, 2000
installation views
(p. 128–131)

if we are dead, so it is, 2000
wood, digital print, multiplex,
acrylic, lacquer;
300 × 992 × 4600 cm

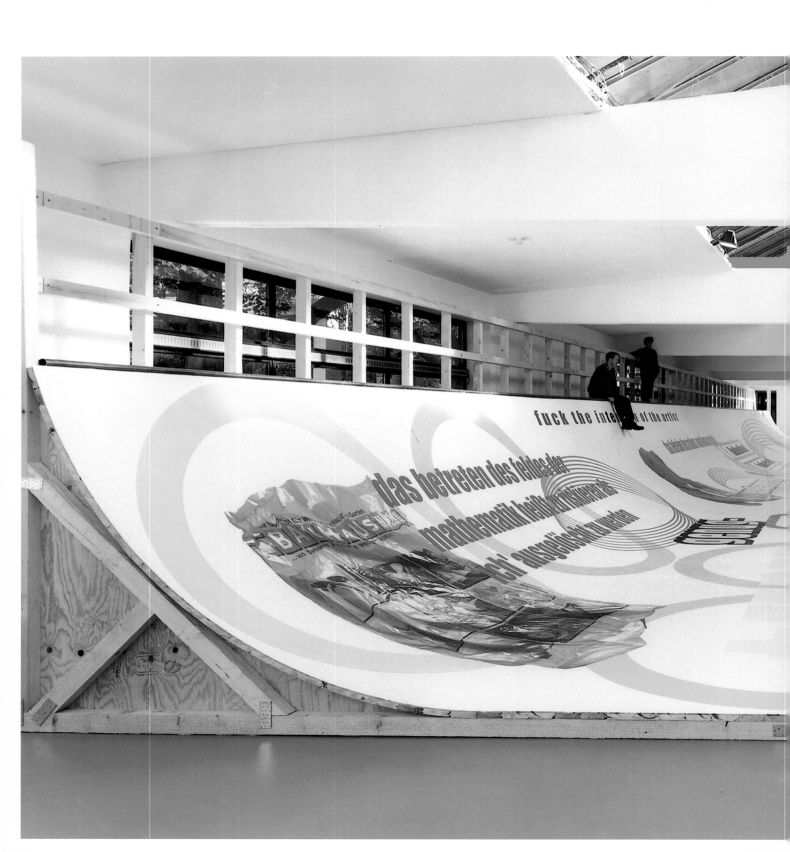

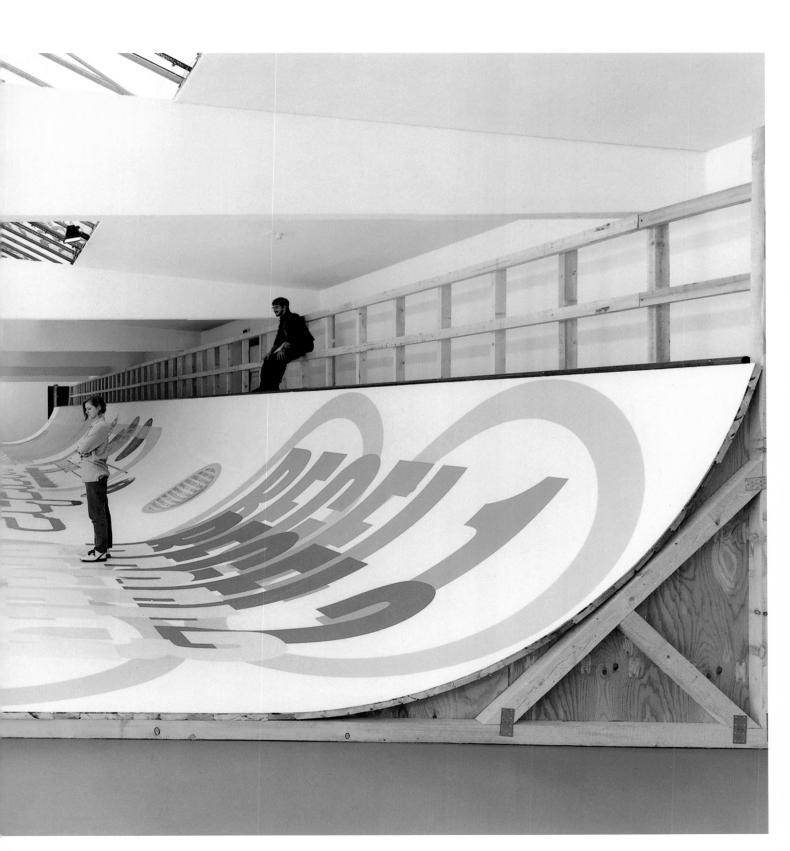

der amerikanische markt funktioniert anders.
du kannst nicht einfach so konfus mal dies
und mal das machen, das geht nicht. die sind auf
spezielle einzelwerke aus.

labe

the symbols [manly]

ALL MAKE
STEAKS

burne

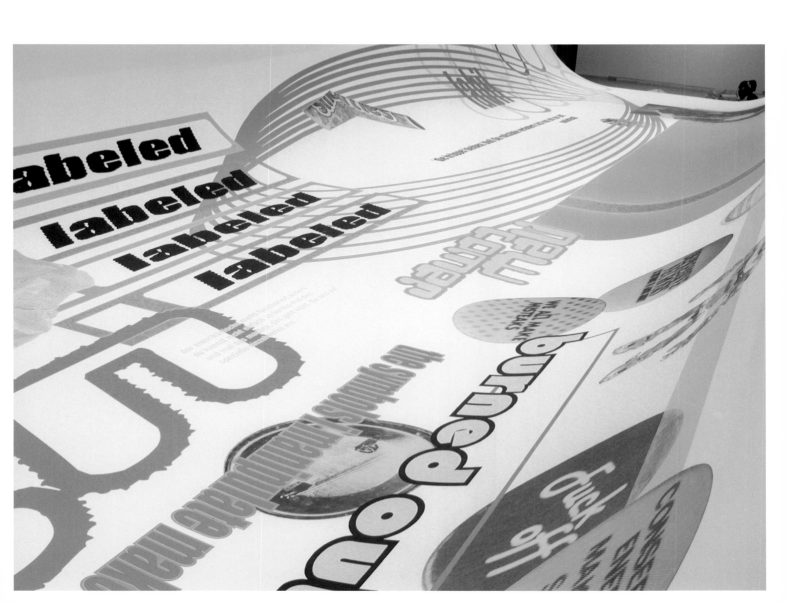

Lydmar Hotel, Stockholm
Installationsansicht

Errvolk, Everybody Sucks, 2001
Dispersionsfarbe auf Wand, Digital-
druck auf Karton; 376×1000 cm

Lydmar Hotel, Stockholm
installation view

Errvolk, Everybody Sucks, 2001
emulsion on wall, digital print
on cardboard; 376×1000 cm

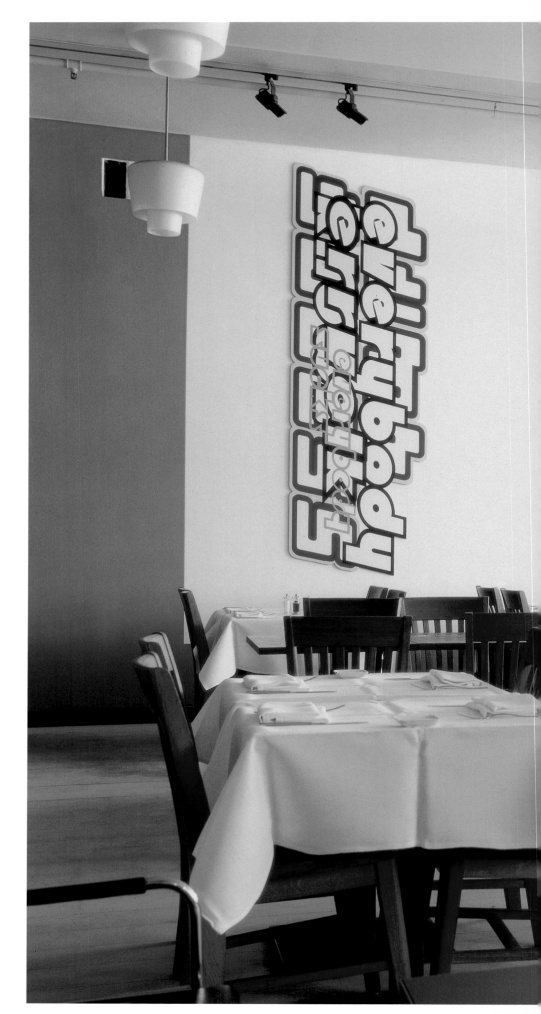

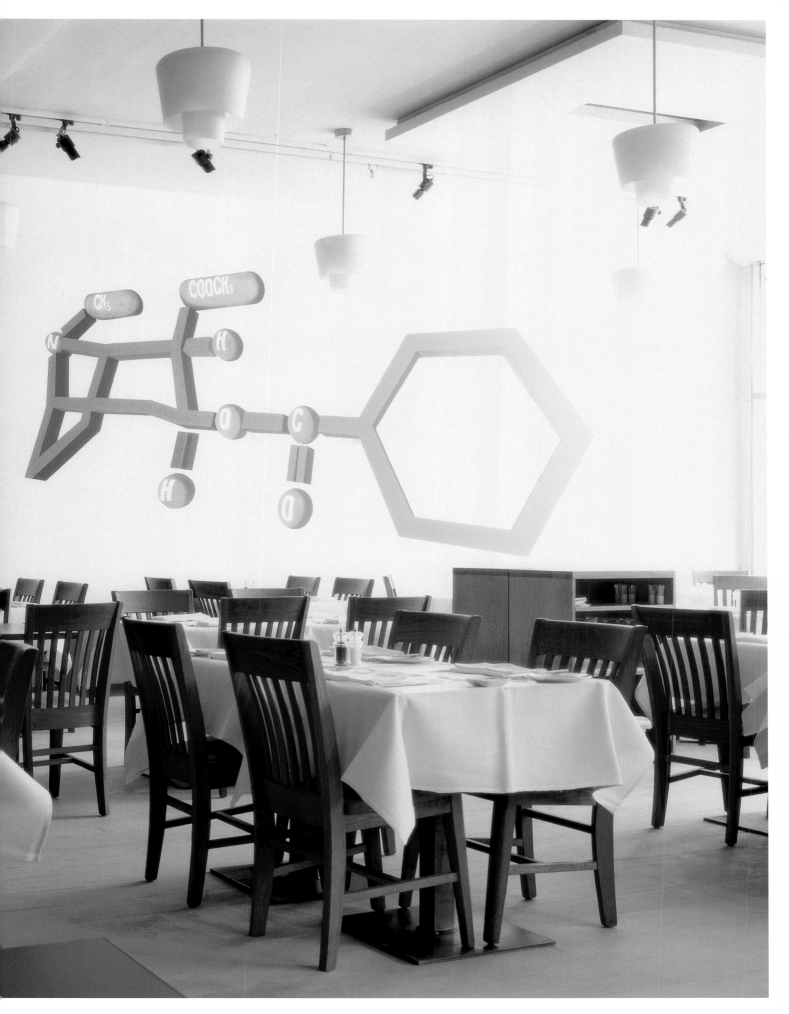

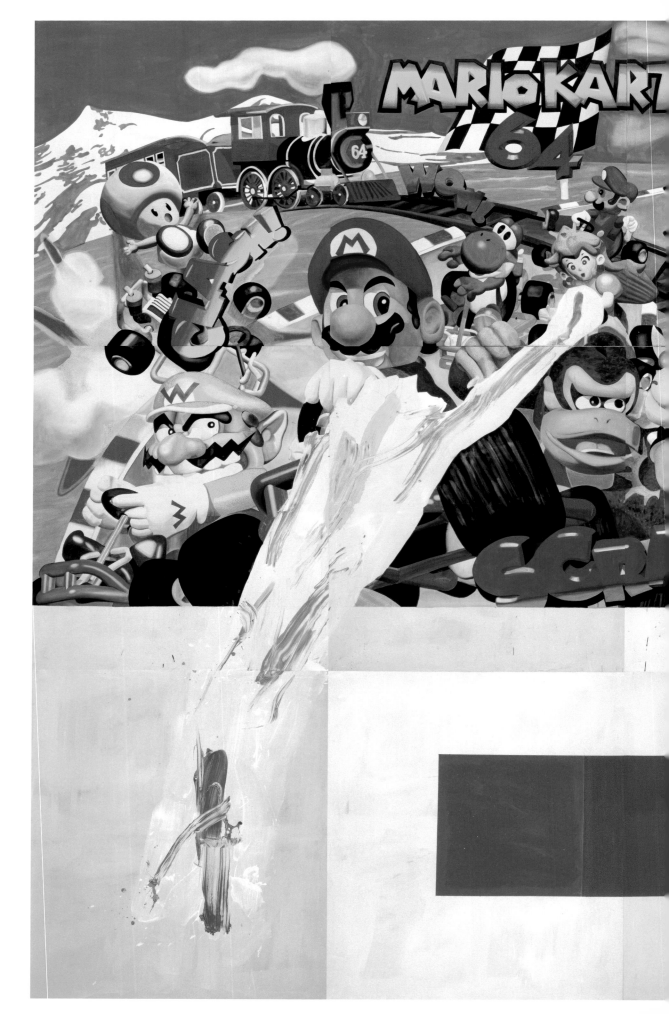

Thälmannkart, 2001
Acryl auf Leinwand;
480×700 cm, 15-teilig,
je 160×140 cm

Thälmannkart, 2001
acrylic on canvas;
480×700 cm, 15 parts,
each 160×140 cm

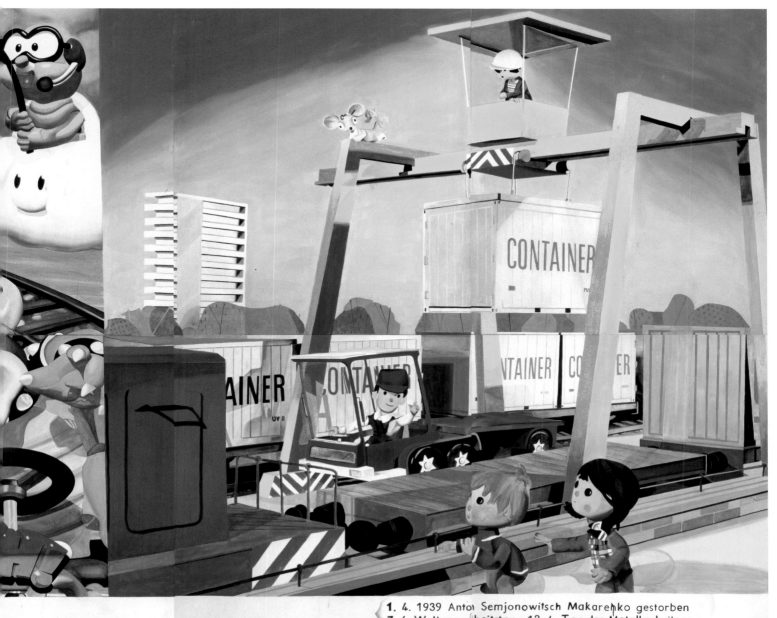

1. 4. 1939 Anton Semjonowitsch Makarenko gestorben
7. 4. Weltgesundheitstag · 12. 4. Tag des Metallarbeiters
12. 4. 1961 Erste bemannter Weltraumflug mit Juri Gaga-
rin · 16. 4. 1886 Ernst Thälmann geboren · 17. 4. Kar-
freitag · 19. 4. Ostersonntag · 21. 4. 1782 Friedrich Fröbel
geboren · 21. 4.1946 Gründung der SED auf dem Vereini-
gungsparteitag von KPD und SPD (21./22. April) · 22. 4.
1870 W. I. Lenin geboren · 24. 4. Internationaler Tag der
Jugend und Studenten gegen Kolonialismus und für die
friedliche Koexitenz

HypoVereinsbank Luxemburg
Eingangsbereich
Installationsansicht

Gradnetz, 1999–2000
Lack auf Aluminium;
1400×650×50 cm, 4-teilig,
je 250×650×50 cm

HypoVereinsbank Luxembourg
entrance area
installation view

Gradnetz, 1999–2000
lacquer on aluminium;
1400×650×50 cm, 4 parts,
each 250×650×50 cm

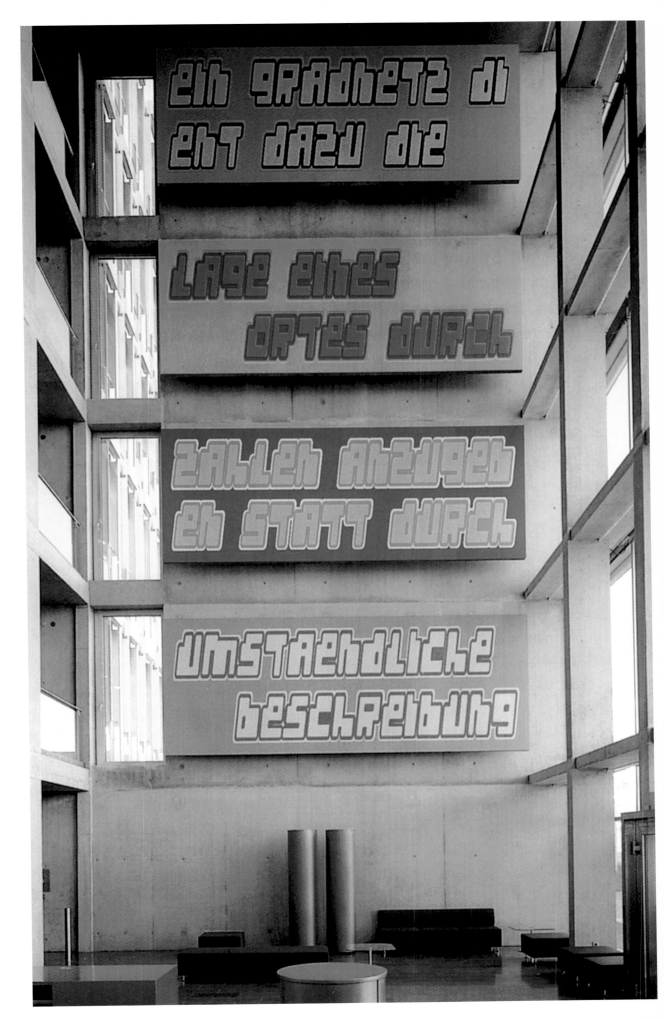

Casino 2001
SMAK Gent, 2001
Installationsansichten

*Bin Laden wohnt
in Buxtehude,* 2001
Rigips, Digitaldruck,
Polystyrol-Spiegel,
Acryl auf Leinwand;
300 × 1186 × 845 cm

Casino 2001
SMAK Gent, 2001
installation views

*Bin Laden wohnt
in Buxtehude,* 2001
sheetrock, digital print,
polystyrene mirror,
acrylic on canvas;
300 × 1186 × 845 cm

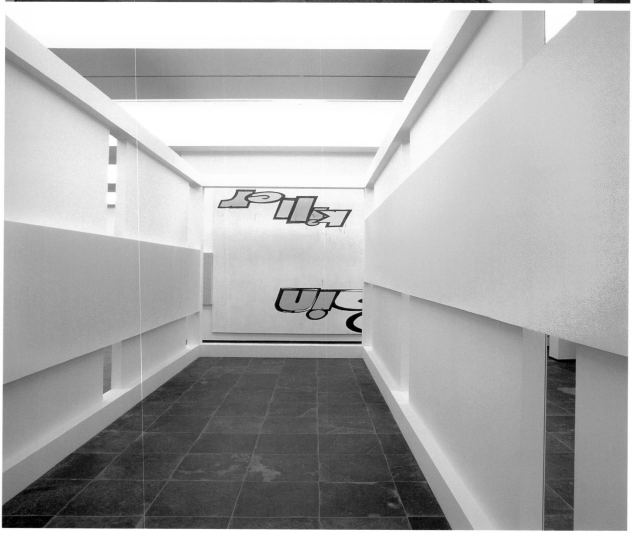

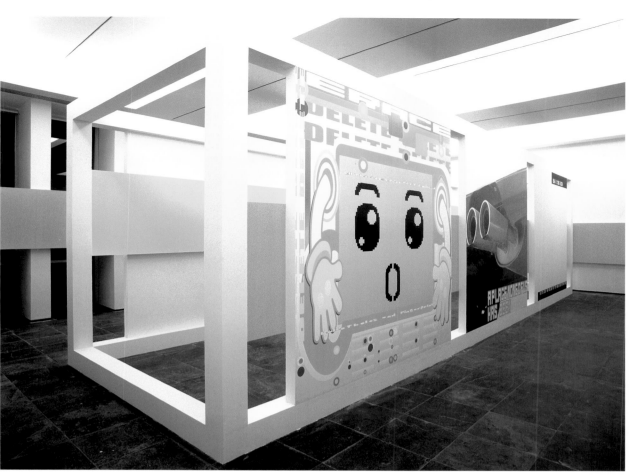

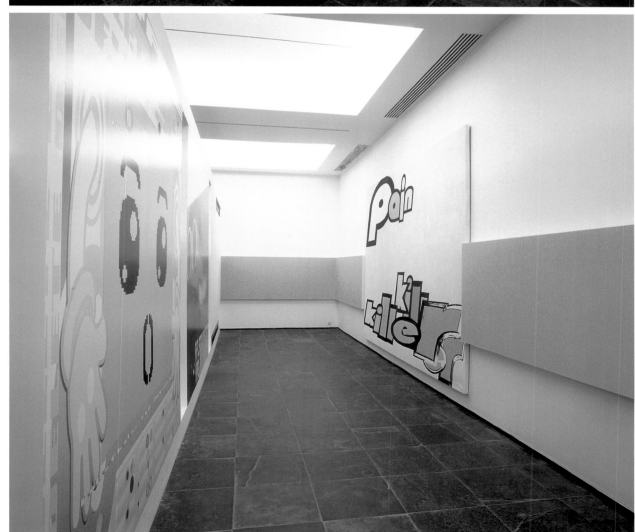

blood allover, 2001
Acryl auf Leinwand;
280×400 cm

blood allover, 2001
acrylic on canvas;
280×400 cm

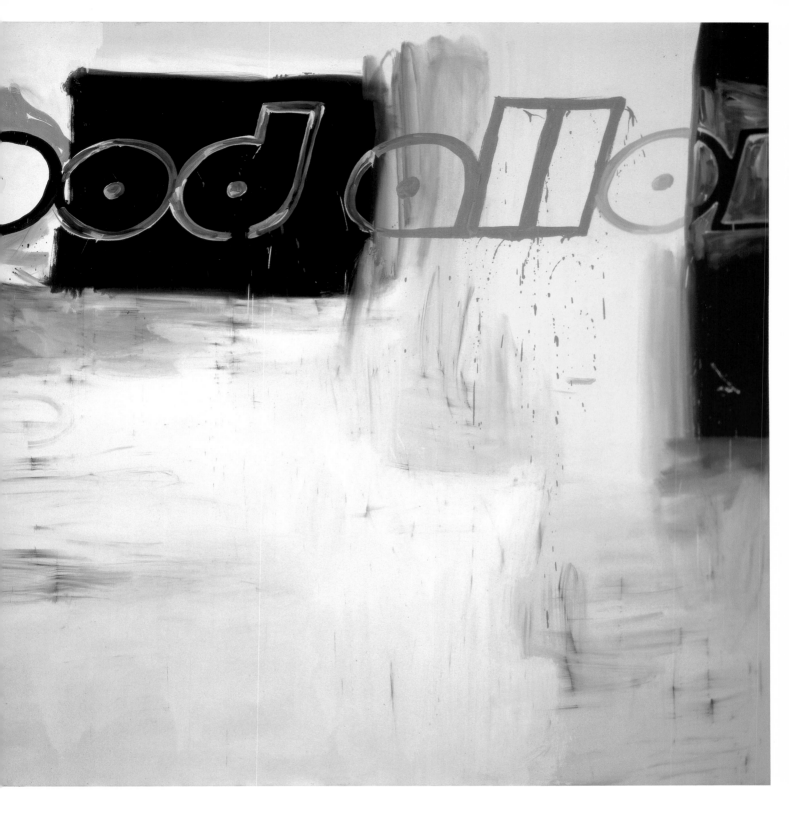

Brandenburger Tor,
Berlin, 2002
Installationsansicht

Sozialpalast, 2002
Digitaldruck auf Kunststoff;
1700×3900 cm

Brandenburg Gate,
Berlin, 2002
installation view

Sozialpalast, 2002
digital print on synthetic
fabric; 1700×3900 cm

splash bombs 3, 2002
Acryl auf Leinwand;
370 × 540 cm

splash bombs 3, 2002
acrylic on canvas;
370 × 540 cm

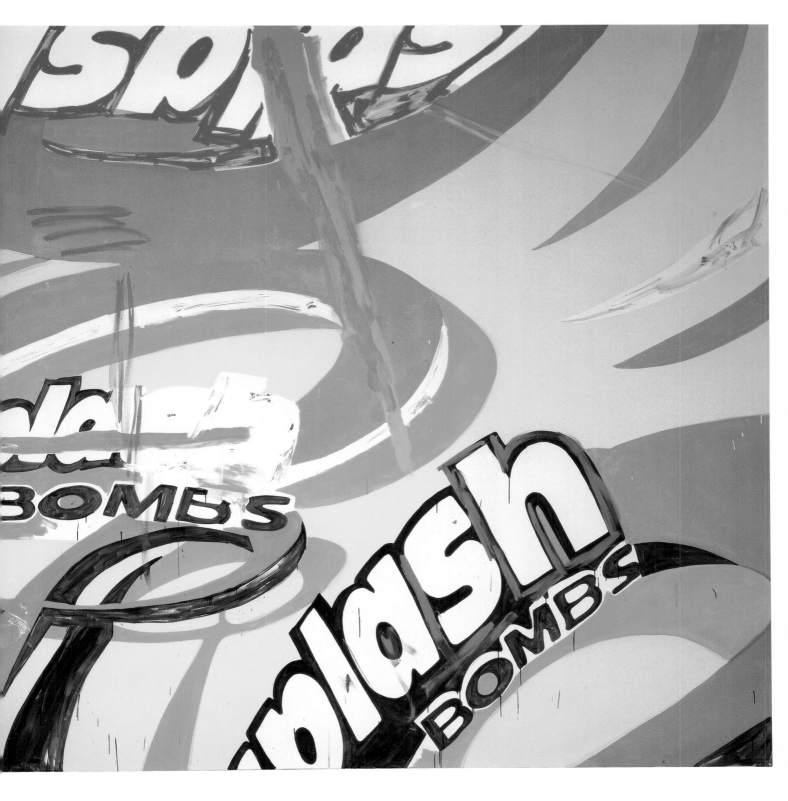

Michel Majerus
neugerriemschneider, Berlin, 2002
Installationsansichten (S.146–149)

controlling the moonlight maze, 2002
Nirosta, Lack auf Stahl, Siebdruck und Lack
auf pulverbeschichtetem Aluminium, Digital-
druck auf PVC, Acryl und Siebdruck
auf Leinwand, Dispersionsfarbe auf Wand;
365 × 1058 × 987 cm

Michel Majerus
neugerriemschneider, Berlin, 2002
installation views (p.146–149)

controlling the moonlight maze, 2002
Nirosta, lacquer on steel, silkscreen
and lacquer on powder-coated aluminium,
digital print on PVC, acrylic and silk-
screen on canvas, emulsion on wall;
365 × 1058 × 987 cm

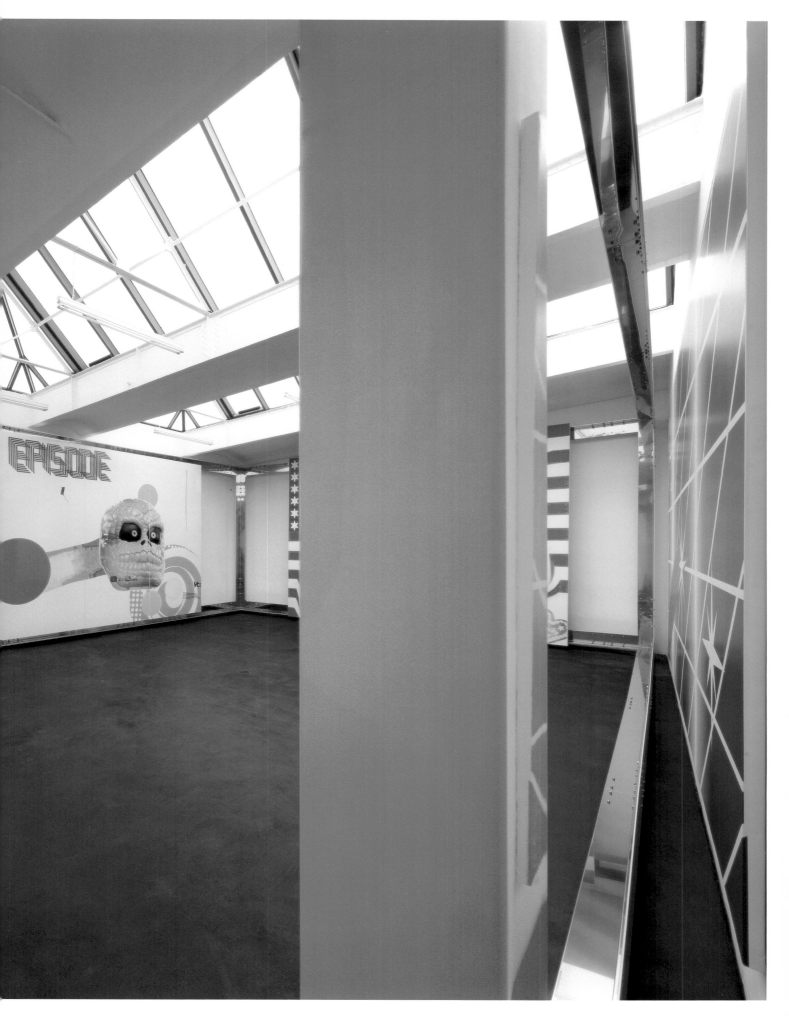

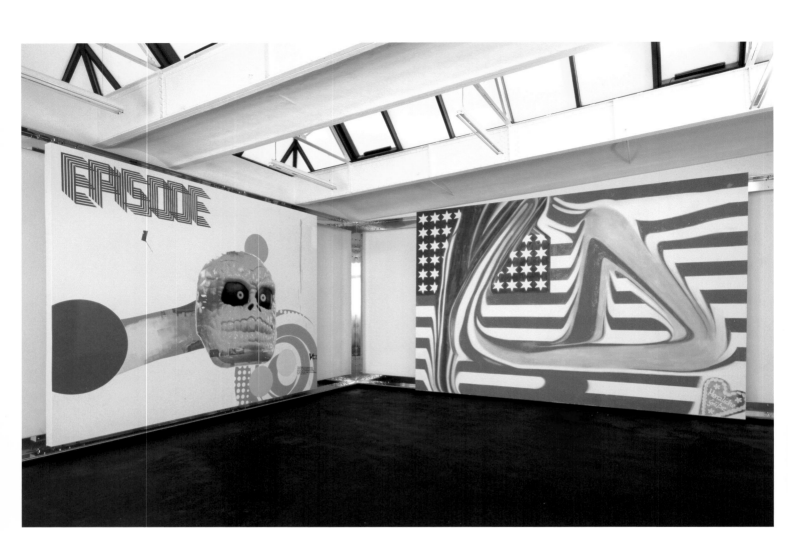

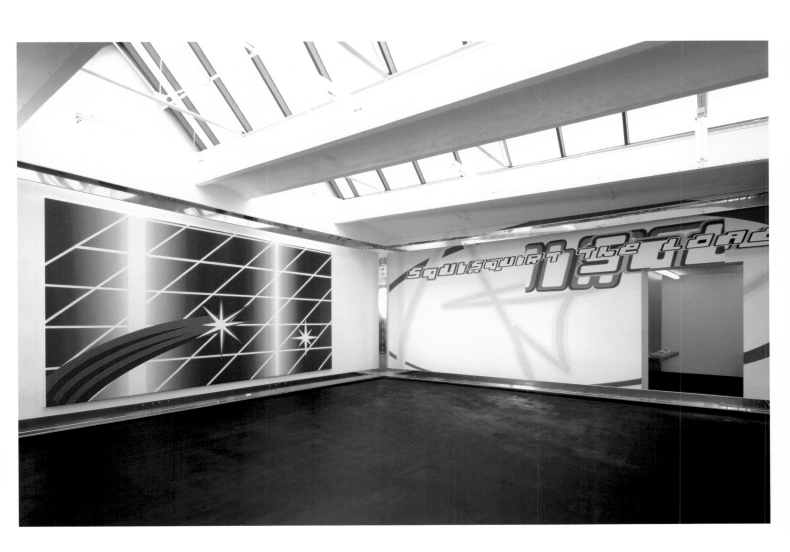

Michel Majerus/John Bock
Pinakothek der Moderne,
München, 2001
Installationsansichten

Michel Majerus/John Bock
Pinakothek der Moderne,
Munich, 2001
installation views

The starting line, 2001
Metall, Neon, Licht, Trans-
formator; 277 × 1263 × 40 cm

The starting line, 2001
metal, neon, light, trans-
former; 277 × 1263 × 40 cm

Painting on the Move
Kunsthalle und Kunstmuseum
Basel, 2002
Foyer im Stadtkino, Basel
Installationsansichten

lost forever, 2002 (2-teilig)
Dispersionsfarbe auf Wand,
368 × 627 cm; Acryl auf Leinwand,
280 × 400 cm

Painting on the Move
Kunsthalle und Kunstmuseum
Basel, 2002
Foyer of Stadtkino, Basel
installation views

lost forever, 2002 (2 parts)
emulsion paint on wall,
368 × 627 cm; acrylic on canvas,
280 × 400 cm

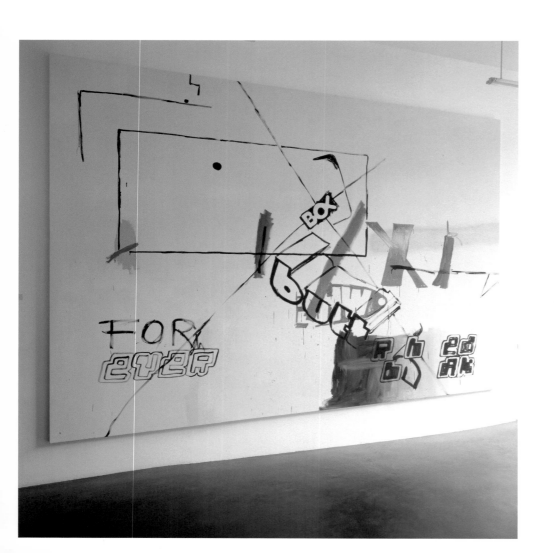

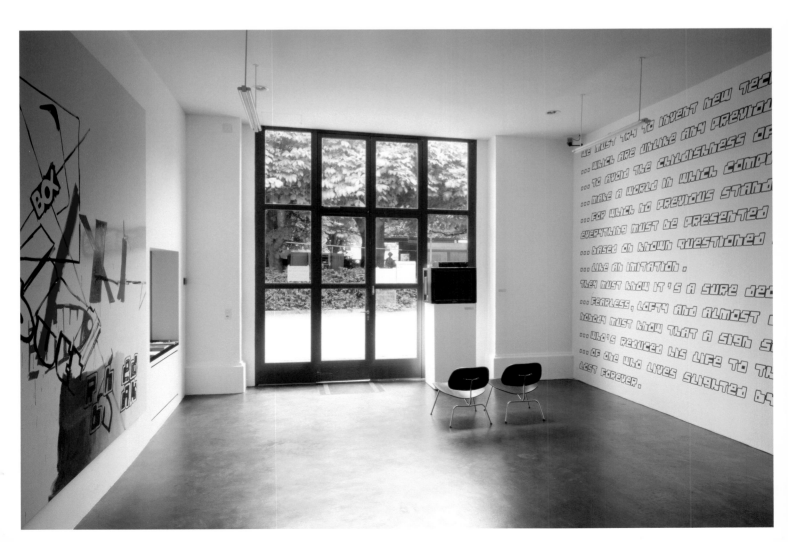

tex mex, 2002
Acryl auf Leinwand;
370×540 cm

tex mex, 2002
acrylic on canvas;
370×540 cm

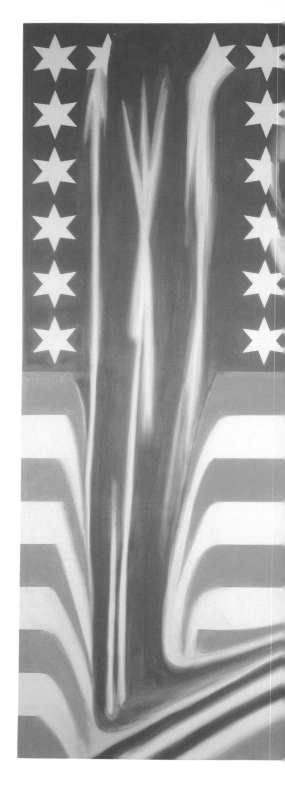

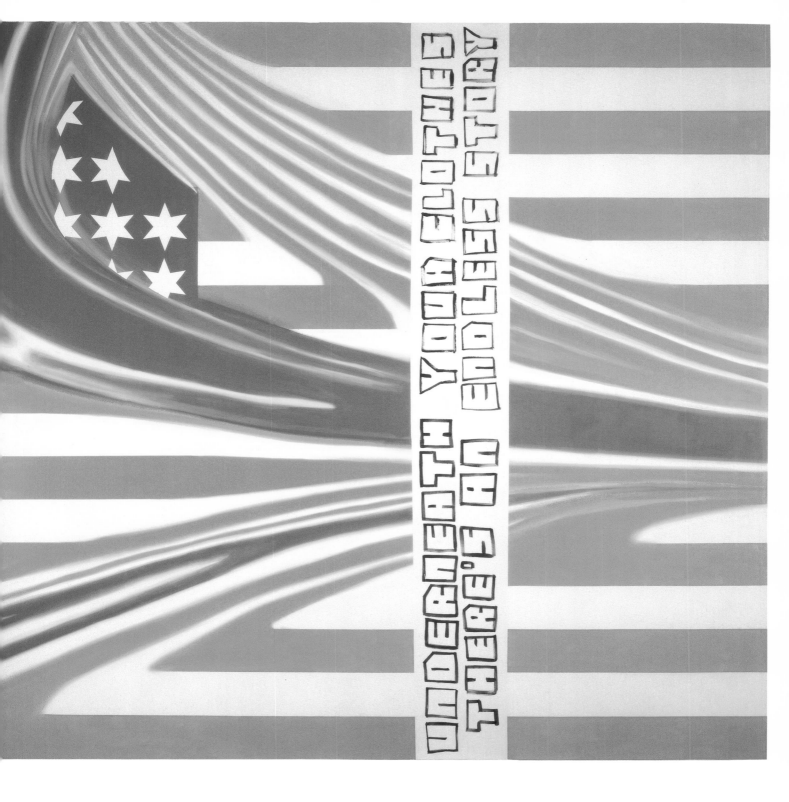

Michel Majerus: *Leuchtland*
Friedrich Petzel Gallery, 2002
Installationsansichten

Michel Majerus: *Leuchtland*,
Friedrich Petzel Gallery, 2002
installation views

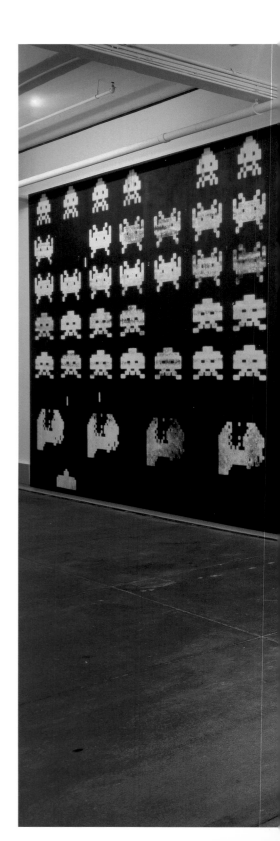

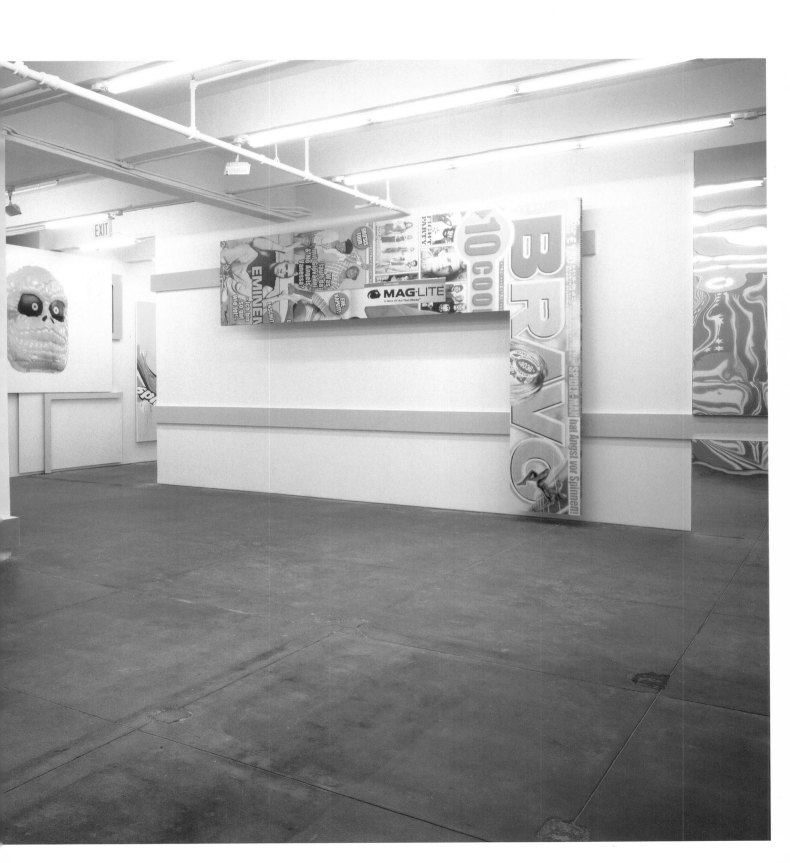

mm1, 2001
Acryl auf Leinwand;
260×300 cm

mm1, 2001
acrylic on canvas;
260×300 cm

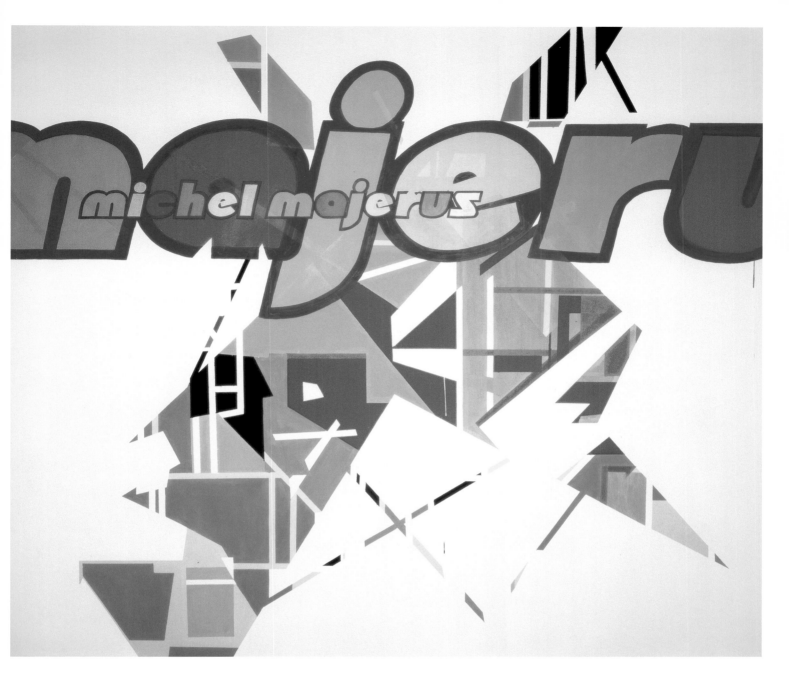

Textbeiträ
Contribut

ge

ons

Günther Holler-Schuster

Von hier aus können wir überall hingehen
Michel Majerus und die Erweiterung der Malerei
From here we can go anywhere
Michel Majerus and the Extension of Painting

Günther Holler-Schuster, geboren 1963 in Altneudörfl/AT, lebt in Graz/AT.

Studium der Kunstgeschichte und Volkskunde an der Karl-Franzens-Universität Graz. Seit 1993 Kurator der Neuen Galerie Graz am Landesmuseum Joanneum.

Als Kurator an diesem Institut verantwortlich für die Ausstellungen (Auswahl): *Adrian Schiess* (1996), *David Reed* (1997), *Cameron Jamie* (2004), *Moderne in Dunkler Zeit* (2001), *The Magic Hour – Kunst und Las Vegas* (2001), *M_ARS – Kunst und Krieg* (2003, mit Peter Weibel), *Peter Weibel – das offene Werk 1964–1979* (2004).

Verantwortlich für das Programm im Studio der Neuen Galerie für junge Positionen innerhalb der österreichischen Kunst (seit 1998). Zuständig für die Videosammlung der Neuen Galerie. Zahlreiche Textbeiträge und Essays für Kataloge und Bücher, u.a. für die Neue Galerie und andere Institutionen in Österreich und im Ausland (seit 1990). Vorträge zu verschiedenen Themenbereichen innerhalb der Kunstgeschichte im 20. bzw. 21. Jahrhundert in Österreich und im Ausland (seit 1991). Lehraufträge am Institut für Kunstgeschichte an der Karl-Franzens-Universität (1991/92, 1994). Lehrauftrag an der Fachhochschule JOANNEUM, Graz (seit Herbst 2003).

Als Künstler (Mitbegründer der Künstlergruppe G.R.A.M.) zahlreiche Ausstellungen seit 1987 in Österreich und im Ausland.

Günther Holler-Schuster, born 1963 in Altneudörfl/AT, lives in Graz/AT.

Studied art history and folklore at the Karl Franzens University in Graz. Since 1993, he has been curator of the Neue Galerie Graz at the Landesmuseum Joanneum.

Exhibitions he has been responsible for as curator at the latter include (selection): *Adrian Schiess* (1996), *David Reed* (1997), *Cameron Jamie* (2004), *Moderne in Dunkler Zeit* (2001), *The Magic Hour – Kunst und Las Vegas* (2001), *M_ARS – Kunst und Krieg* (2003, with Peter Weibel), *Peter Weibel – das offene Werk 1964–1979* (2004).

He is responsible for the programme at the Neue Galerie's Studio for New Artists within Austrian art (since 1998), and for the Neue Galerie's video collection. He has written numerous articles and essays for catalogues and books, for the Neue Galerie and other institutions in Austria and abroad (since 1990), and has lectured on various subjects having to do with the history of art in the 20th and 21st centuries in Austria and abroad (since 1991). He has had teaching duties at the Institut für Kunstgeschichte at the Karl Franzens University (1991/92, 1994) and at the Fachhochschule JOANNEUM, Graz (since autumn 2003).

As artist (co-founder of the G.R.A.M. group of artists), he has had many exhibitions in Austria and abroad since 1987.

Wenn ein Künstler nicht viel von seinem Daseinszweck einbüßen will, bleibt ihm wohl nichts übrig, als die Populärkunst zu plündern, um die Bilderwelt wiederzugewinnen, die sein rechtmäßiges Erbe ist.

Richard Hamilton

If an artist does not want to be deprived of the purpose of his existence, he has probably no choice but to plunder popular art in order to win back the world of images that is his rightful inheritance.

Richard Hamilton

„Wer gegen finstere Mächte kämpft, hat die Sympathien des Publikums auf seiner Seite. Der tapfere Einzelkämpfer mit guten Absichten gegen das übermächtige Böse: Das ist der Stoff, aus dem Mythen geschmiedet werden. Stirbt der Held plötzlich und unerwartet und kann die Hoffnungen, die stellvertretend in ihn gesetzt wurden, nicht mehr erfüllen, fragt man sich umso mehr: Warum musste das sein?"

So beginnt das Buch *TRON – Tod eines Hackers* von Burkhard Schröder, das das Leben und die mysteriösen Umstände um den Tod des jungen Informatikers Boris F. alias Tron untersucht. Nach Karl Koch alias Hagbard (*23*) ist er der zweite junge Hacker, der auf geheimnisvolle Art ums Leben kam und sofort zum Mythos wurde. Hacker sind die Desperados des Computerzeitalters. Sie reiten nicht mehr über die weiten, sandigen Steppen des amerikanischen Westens und stellen ihr Außenseitertum zur Schau, sondern sitzen bleichgesichtig in ihren Jugendzimmern vor ihren Computern und nennen die Weiten des Cyberspace ihr Betätigungsfeld. „Nichts ist wirklich sicher", war Trons Credo, und das beweisen Leute seiner Art täglich. Tron ist aber auch der Held des legendären Walt Disney-Films, der 1982 in die Kinos kam. Dem virtuellen Helden wird im Film ein realer Held (Flyn) beigestellt, der in die Welt des Computers hineingezogen wird und dort gegen das Böse kämpfen muss. In einer phantastischen bunten Cyber-Welt startet das Spiel und wird zur Realität. Erstmals wurde der virtuelle Raum eines Computer-Games Schauplatz eines Kinofilms.

Tron ist tot. Michel Majerus, der begeisterte Player und außerordentliche Künstler, auch. Er war an Bord einer Propellermaschine der Luxair, als diese im November 2002 über Luxemburg abstürzte. Auch von ihm könnte der zuvor genannte Wahlspruch stammen. Auch in der Kunst ist nichts sicher, was Majerus auch permanent unter Beweis stellte. Er war Teil eines Systems – der bildenden Kunst –, das er als sein „Game", seine Weiten, empfand. Er hatte darin Begegnungen mit Tron, Mario, Lara Croft genauso wie mit den Road-Runnern, den Teletubbies, aber auch mit Andy Warhol, Frank Stella, Willem de Kooning oder Joseph Kosuth. Immer wieder leuchteten Slogans wie „The Space is where you'll find it", „fading image" oder „fuck the intention of the artist" auf – dann erschienen sogar komplett weiße, unberührte Flächen. Alles das kommt zwar aus dem Analogen, es erschien jedoch, als sei es in diese Game-World hineingesaugt worden, und Majerus rast wie Tron durch die diversen Programme und

"Anyone who fights the forces of darkness has the sympathies of the public on his side. The brave individual with good intentions in combat with all-powerful evil – that is the stuff legends are made of. If the hero suddenly dies unexpectedly and can no longer fulfil the general hope that was invested in him, one wonders all the more why this thing had to be."

These are the opening lines of *TRON – the Death of a Hacker* by Burkhard Schröder, which investigates the life and mysterious circumstances surrounding the death of young computer hacker Boris F, alias Tron. According to Karl Koch, alias Hagbard (*23*), he is the second young hacker to lose his life in mysterious fashion and immediately become legend. Hackers are the desperadoes of the computer age. They no longer ride over the wide sandy plains of the American west flaunting the outlaw but sit wan-faced at their computers in their teenage bedrooms and call the horizons of cyberspace their patch. "Nothing is really for sure", was Tron's creed, and people of his kind prove that every day. But Tron is also the hero of a legendary Walt Disney film that hit the cinemas in 1982. The virtual hero has a real hero (Flyn) as sidekick, who is drawn into the world of computers and has to fight evil there. The game starts in a fantastic, colourful cyber world and becomes reality. For the first time, virtual space in a computer game became the setting of a feature film.

Alas, Tron is dead. And so is Michel Majerus, who was both an enthusiastic games player and extraordinary artist. He was on board a propeller aircraft of Luxair that crashed over Luxembourg in November 2002. The above watchword could as well have come from him. Nothing is for sure in art either, as Majerus was constantly proving. He was part of a system – art – that he saw as his "game", his far horizons. He had encounters in it with Tron, Mario, Lara Croft, and with Road Runner and the Teletubbies, also with more substantial figures such as Andy Warhol, Frank Stella, Willem de Kooning and Joseph Kosuth. Slogans such as "The Space is where you'll find it", "fading image" or "fuck the intention of the artist" flashed up time and again – and after that even completely white, untouched surfaces appeared. That's all analogue stuff, but it seemed to have been drawn into this world of games and, like Tron, Majerus races through

Fig. 1 Jean Arp,
Abstrakte Komposition, 1915/16

Fig. 2 László Péri,
Raumkonstruktion, 1923

Fig. 1 Jean Arp,
Abstract Composition, 1915/16

Fig. 2 László Péri,
Raumkonstruktion, 1923

Datenbanken. Von seinem Trip zeugen seine Manifestationen, die er im Medium Malerei verwirklichte. Raumgreifende Installationen aus Einzelbildern, Fragmenten, architektonischen Einbauten, Leuchtschriften, Wandmalereien, Computerprints, Videos etc. – alle ihm zur Verfügung stehenden visuellen Ausdrucksmittel waren ihm willkommen.

Die Malerei, eines der ältesten und klassischsten Medien, erschien Majerus für seine Aufzeichnungen am idealsten. Für ihn war, trotz vielfacher Meldungen, die Malerei keineswegs tot, und er wollte ihr auch nichts Böses antun. Vielmehr sah er sie als ein heterogenes Feld, das Aktivitäten weit jenseits von Leinwand oder der weißen Wand erlaubt. Er musste die Vorstellung eines virtuellen Raumgefüges im Kopf gehabt haben, wenn er an seinem Malereibegriff arbeitete. Einzelbilder sind darin genauso vorhanden und können auch als solche existieren wie aufwändige installative Anordnungen, die den gesamten zur Verfügung stehenden Raum besetzen und neu definieren. Die Erfahrung der Virtualität durch die neuen elektronischen Medien scheint Majerus mit Forderungen der klassischen Malereitheorie zu verbinden. Ein Beispiel: Konrad Fiedler schreibt 1885 in seinem Aufsatz *Wechsel von Flächenerscheinungen und deren Abstufungen in der Tiefenordnung*: „Der Künstler muss also die ihm zu Gebote stehenden Erscheinungsmittel so verwenden, dass sich aus ihnen Raumwerte ergeben. In der Natur ist die Raumerscheinung das Produkt sehr verschiedener zusammenwirkender Elemente, wie z.B. der plastische Gegenstand, seine Lokalfarbe, die Beleuchtungsquelle, der Standpunkt, den der Beschauer zum Gegenstand einnimmt; dieses Zusammenwirken verschiedener Elemente vermag der Künstler im Raumwert zum Ausdruck zu bringen." Fiedler spricht zwar von der in die Zweidimensionalität transferierten Dreidimensionalität, aber sitzt nicht der Player auch vor der zweidimensionalen Monitorfläche und somit letztlich vor einem Bild? Es ist zwar ein flexibles Bild, das er durch Interaktion sogar verändern kann, trotzdem bleibt es ein begrenzter Ausschnitt. Ähnlich wie im Kino hat man in der ersten Reihe sitzend zwar den Eindruck, sich direkt im Geschehen zu befinden, doch sind die Grenzen der Leinwand die Realität. Selbst in Barnett Newmans Großformaten, die als Ereignisse, als Farbräume konzipiert sind, stößt das Auge an Grenzen, und der Blick schweift vom Bildrand hinaus auf die Wand. Kurt Schwitters versucht, nicht durch die Erweiterung der Dimension, sondern durch die Integration von Realität (bunte Holzstücke, bedrucktes Papier etc.) der

various programmes and databases. The manifestations he effected in the medium of painting bear witness to his trip. Space-embracing installations from individual pictures, fragments, architectural inserts, neon writing, wall paintings, computer prints, videos, etc. – any kind of visual expressive medium was grist to his mill.

Painting, one of the oldest of the truly classic media, seemed to him the ideal instrument for his work. For him, despite many apocalyptic statements to the contrary, painting was by no means dead, nor did he wish it any harm. In fact, he saw it as a heterogeneous terrain that allowed activities far beyond canvas or white walls. He must have had the notion of a virtual space structure in his head when he was working at his idea of painting. Individual pictures are part of it, and can exist as such just as much as lavish installation arrangements that occupy and redefine all the space available. Majerus seems to have combined his experience of virtuality in the new electronic media with the requirements of academic notions of painting. For example, Konrad Fiedler wrote in his essay *Wechsel von Flächenerscheinungen und deren Abstufungen in der Tiefenordnung* (Alternation of Surface Phenomena and Gradations Thereof as a Function of Depth) in 1885: "The artist must therefore use the resources of the visible phenomena at his command in such a way as to produce spatial values from them. In nature, the appearance of space is the product of very diverse elements working in combination, such as the three-dimensional object itself, its local colour, the source of light and the viewpoint the viewer adopts vis-à-vis the object; the artist can bring out the combined effect of different elements in the spatial dimension." Though Fiedler talks of the three-dimensional translated into the two-dimensional, doesn't a games player also sit at a two-dimensional monitor screen and thus ultimately in front of a picture? It may be a flexible picture that can in fact undergo change as a result of interaction, but nonetheless it remains a limited part of the whole. In the same way, sitting in the first row in the cinema, you may get the impression you're directly involved in what's going on, yet the limits of the screen are still the reality. Even in Barnett Newman's large canvases, which are conceived as events, or colour spaces, the eye encounters borders, and the gaze wanders from the edge of the pic-

Malerei neue Impulse zu geben. Er schafft so eine partielle Akkumulation realer Gegenstände, die durch die rahmende Form des Rechtecks zum Bild werden. Bild, Monitor, Fenster – sie alle bleiben Ausschnitte aus verschiedenen Realitätsebenen. Man muss schon die gesamte Umgebung, den gesamten Raum zum Bild erklären, um diesem Dilemma zu entkommen. Was mit den Collagen und Assemblagen von Pablo Picasso, Kurt Schwitters, Jean Arp etc. innerhalb des Rahmens der Bildfläche begonnen hatte, stellte sich als radikale Umwälzung der Bildfläche dar und konnte nicht mehr zurückgenommen werden, sondern musste differenziert und ausgeweitet werden. Aus Merz-Bildern wurden Merz-Bauten. Aus László Péris bemalten Betonreliefs aus dem Jahre 1923 wurden in der Folge „Shaped Canvases" bei Frank Stella oder Elsworth Kelly, die in ihrer radikalsten Ausformung den gesamten Raum zum Bild werden ließen und die Bedingungen der Malerei genauso erfüllen wie die des Objektes. Das Ende der klassischen Malerei muss somit nicht das Ende der Malerei generell bedeuten. Paradoxerweise hat sich aus den zahlreichen Schlusspunkten – egal ob Kasimir Malewitschs *Weißes Quadrat auf Weiß* von 1918 oder Lawrence Weiners *Two Minutes of Spray Paint Directly upon the Floor from a Standard Aerosol Spray Can,* 1967 – immer eine neue Sicht auf das Medium Malerei ergeben. Somit haben sich aber auch neue Möglichkeiten eines „Neustarts" ergeben, von wo aus man auf veränderte Perspektiven gestoßen ist. Michel Majerus hat sich immer wieder von neuem an den Start gebracht und ist von dort aus in die nächste Ebene aufgebrochen, in schier endlose Weiten desselben Mediums. Die Geschichte der Malerei zeigt, wie sich gewisse Elemente in ihr aufgelöst haben, andere wieder isoliert wurden, gewisse haben zeitweise an Relevanz verloren oder sind überhaupt neu hinzugekommen. Vom historischen Standpunkt aus hat sich die Malerei in einigen Entwicklungsphasen fast bis zur Unkenntlichkeit verändert, aber sie ist nicht ans Ende gekommen. Dass sie das gar nicht kann, scheint Michel Majerus aufgebrochen zu sein zu beweisen. Wie kaum ein Künstler folgte Majerus dem Gefühl seiner Zeit – die ausgehenden 1980er Jahre und in der Folge die 1990er Jahre – so intensiv. Er bestimmte sie sogar mit, indem er Teil dieser Entwicklung war. Dazu gehörte für ihn nicht nur der hermetische Bereich der bildenden Kunst, sondern selbstverständlich, wie bereits angedeutet, der populärkulturelle Bereich der Jugendkultur. Er war Teil dessen, was sein Game bereicherte, in eine nächste Ebene transportierte.

ture outwards to the wall. Kurt Schwitters sought to bring new ideas into painting not by expanding dimensions but by integrating reality (bits of coloured wood, printed paper, etc.). He thus creates a partial accumulation of real objects which become a picture through the framing shape of the rectangle. Picture, monitor and window are all extracts from different levels of reality. To escape this dilemma, you need to declare the whole environment, the whole room as the picture. What began with the collages and assemblages of Picasso, Schwitters, Jean Arp, etc. within the frame of the picture surface constituted a radical change in the pictorial surface that, once effected, could not be undone. It could only be differentiated and extended. Merz pictures turned into Merz structures. László Péris painted concrete reliefs of 1923 later turned into the "shaped canvases" of Frank Stella or Elsworth Kelly, which in their most radical development turned the whole room into a picture and fulfilled the conditions of painting as much as those of objects. The end of classic painting does not therefore have to mean the end of painting in general. Paradoxically, the numerous demises of painting that have been proclaimed – whether Malevich's *White Square on White*, 1918 or Lawrence Weiner's *Two Minutes of Spray Paint Directly upon the Floor from a Standard Aerosol Spray Can,* 1967 – have always engendered a new view of painting as a medium. The result was thus an opportunity for a new start, which brought a change of perspective. Michel Majerus went back to the start time and again and from there passed on to the next level, towards the endless horizons of the same medium. The history of painting shows how certain elements have merged into it while others remained isolated, and again, some lost their relevance for a while or became transformed. From a historical point of view, painting in some phases of its development may have changed almost beyond recognition, but it did not come to an end. Majerus seems to have set out to prove that it *could* not come to an end. More than almost any other artist, he kept an intent finger on the pulse of his time – particularly the late 1980s and the following decade. He took part in defining the age by being involved its development. As far as he was concerned, it included not only the hermetic field of art but as a matter of course (as already indicated) popular youth culture. He was part of the process that enriched his game – beamed up to the next level.

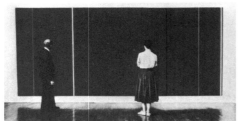
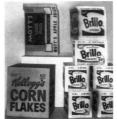

Fig. 4 Barnett Newman,
Vir heroicus sublimis, 1950/51

Fig. 5 Andy Warhol,
*Brillo, Corn Flakes, Mott's
Apple Juice Boxes,* 1962

„Just what is it what you want to do? We wanna be free,
to do what we wanna do, and we wanna get loaded, and
we wanna have a good time…"
(Primal Scream, *Screamadelica,* 1991)

Was sich hier wie ein anarchischer Schrei nach Freiheit anhört,
kann letztlich als der Geburtsschrei einer Generation gewertet
werden, die sich im Gegensatz zu Punk („Macht kaputt, was
euch kaputtmacht!") nicht mehr kämpferisch aggressiv ver-
hält, sondern eher zurückblickt auf Woodstock („Wir sind hier,
um zusammen zu sein. Von hier aus können wir überall hinge-
hen"), um sich im nächsten Moment wieder umzudrehen. Kein
„Angelus Novus" mehr, der vom Sturm, der vom Paradies her
weht, vorangetrieben wird. Das Paradies liegt in der Zukunft
und der Trümmerhaufen in der Vergangenheit. Die Love Para-
de hat ihr Vorbild gefunden, hat nach Woodstock einen neuen
Maßstab im „get together" geschaffen und ist in neue Galaxi-
en vorgedrungen. Wer hätte sich schon gedacht, dass es Ende
der 1990er Jahre mit 750 000 Ravern, aus der ganzen Welt
kommend, in Berlin bei der Love Parade zur umfangreichsten
friedlichen Demonstration in der Geschichte Deutschlands
kommen würde? Was im Juli 1989 begann, als die ersten
Freaks hinter einem Lieferwagen mit einer Tonanlage darauf
den Berliner Kurfürstendamm entlangsprangen, wurde zu
einer Touristenattraktion und zu einem Wirtschaftsfaktor („We
are one familiy") und zu einem neuen „Summer of Love", der
ein gutes Jahrzehnt anhielt. Der „Magic Bus" der Pranksters
ist endlich zum Flugobjekt mutiert, wieder unterwegs und bes-
tens ausgestattet – perfekte Versorgung an Bord.[1] Nicht nur
der „Spiral Tribe" ist Teil der bunt geschmückten Karawane
auf dem Weg nach „Higher than the Sun".[2] Das letzte Jahr-
zehnt des 20. Jahrhunderts zu überspringen, die Zeit zu be-
schleunigen, noch einmal zu resümieren, aber gleichzeitig alles
Gewesene aufzulösen scheint der unbewusste Drang der so
genannten „Technoszene" und ihrer Sympathisanten gewesen
zu sein. Wenn schon bis jetzt nicht, dann aber sofort: „We
wanna be free, to do what we wanna do…". Resümieren, das
schien auch Majerus in seiner Arbeit gewollt zu haben. Ist die
Malerei noch leistungsfähig? Hat sie zeitgemäße Möglichkei-
ten, sich künstlerisch auszudrücken? Haben die neuen Medien
sie anachronistisch gemacht, oder kann man nach dem wie-
derholten Versuch des letzten Bildes erneut starten? Wenn
man darauf Antworten weiß, kann das verdammt frei machen.

Jean Baudrillard hatte 1990 gefordert, die 1990er Jahre im
Voraus zu streichen und direkt ins Jahr 2000 zu springen.

"Just what is it what you want to do? We wanna be free,
to do what we wanna do, and we wanna get loaded, and
we wanna have a good time…"
(Primal Scream, *Screamadelica,* 1991)

What sounds there like an anarchic scream for freedom
could also be considered as the birth cries of a genera-
tion that, in contrast to smash-it-all punk ("Smash what
smashes you") with its naked all-out aggression, was
more in the vein of Woodstock ("We're here to be toge-
ther. From here we can go anywhere"), only to do
a turnabout in the following moment. Not an *angelus
novus* any more, driven by the storm blowing from para-
dise. Paradise is in the future, the heaps of rubble are
in the past. Love Parade found its model and established
a new dimension in post-Woodstock "get-togethers"
and moved on to new galaxies. Who would have anti-
cipated that in the late 1990s 750 000 ravers from all
over the world would descend on Berlin for Love Parade
to stage the most comprehensive peaceful demons-
tration in the history of Germany? What began in July
1989 when the first freaks hopped along Berlin's
Kurfürstendamm behind a truck with a sound installa-
tion on it, became a tourist attraction and an economic
factor ("We are one family") and a new "summer of love",
which lasted a decade or more. The "magic bus" of the
Merry Pranksters turned a roadtrip into another sort of
trip, perfect customer care on board.[1] The Spiral Tribe
weren't the only ones in the colourful procession on the
way to places "higher than the sun".[2] To speed up time
and leap across the last decade of the 20th century,
to sum up again but at the same time dissolve every-
thing that's been – that appears to have been the sub-
conscious urge of the "techno scene" and its fans. If not
so far, then right away. "We wanna be free, to do what
we wanna do…". Majerus also seems to have wanted
to sum things up in his work. Is painting still capable of
anything? Does it have up-to-the-minute opportunities
to express itself artistically? Have the new media made
it an anachronism or can one start over after the
repeated attempt of the last picture? If you know the
answers to that, it can make you damned free.

In 1990, Jean Baudrillard suggested skipping the 1990s
and going straight on to 2000. The end of the century
would in any case be a dreary grind generating a

Das Ende des Jahrhunderts sei ohnehin mit all seinem nekro-
kulturellen Pathos, seinen Klagen und Gedenkfeiern und Ins-
zenierungen musealer Art eine langweilige Mühle geworden,
die einen „Objekt- und Bilder- (und) Medienzwang […] erzeug-
te."**3** Für die offiziellen Einrichtungen und das Gros der Gesell-
schaft mag das zutreffen – man hätte sich tatsächlich einiges
sparen können. In subkulturellen Bereichen lebt man spezieller
und trifft sich dabei strukturell mit der als elitär verschrienen
Intelligentsia. Somit wurde Baudrillard zum Verbündeten einer
Generation, die ebenfalls rasch weiterkommen wollte. Sein
Pessimismus scheint jedoch nicht für möglich gehalten zu
haben, dass die „Technoszene" mit ihrem Anhang die 1990er
Jahre produktiv nutzte – als Trägerrakete ins virtuelle Zeitalter,
in dem es „no limits" geben sollte. Computer und die Verbrei-
tung des Internets hinauf bis in die letzte Almhütte lösten
diese Grenzen tatsächlich grundsätzlich auf. Neue Möglich-
keiten, neue Räume, neue Sinneserfahrungen entstanden
im Zuge der noch immer andauernden globalen Medienrevo-
lution. McLuhan sei Dank, wusste man ohnehin schon früh,
dass die Erweiterung oder Veränderung irgendeines Sinnes,
die Art und Weise, wie wir denken und handeln, auch die
Art und Weise, wie wir die Welt wahrnehmen, verändert – wie-
der ist der Mensch ein anderer geworden.**4** Gemeint ist ein
Mensch, der sich mutig, individuell, kreativ und innovativ der
Zukunft mit allen ihren technologischen Möglichkeiten stellt
und dazu noch Zerstörungsenergien wie Krieg, Diskriminie-
rungen, Umweltzerstörung etc. trotzt. Die Neuheit des Ansat-
zes scheint wohl proportional zum Technologiefortschritt zu
sein. Im kreativen Bereich der Kunst – in ihren High- und Low-
Ausformungen – stellte man sich den Herausforderungen des
„Medien-Overkills" und folgte der Idee eines „virtuellen Zeit-
alters", in der sich die Ordnung von Raum, Zeit und Ort vor
unseren Augen auflöst. Dabei spielte es weniger eine Rolle,
inwieweit man sich noch analoger Strukturen bediente oder
sich ausschließlich den neuen Technologien bzw. Medien wid-
mete – die Wechselwirkungen waren und sind entscheidend.
Ist die Halluzination Realität geworden und kann man in ihr
leben? An der Beantwortung dieser Frage arbeitet die Medien-
theorie seit McLuhans Zeiten intensiv. Die Bilderflut hat ein
buntes Nebeneinander von Inhalten, Stilen und Epochen be-
wirkt. „Techno", als vehementer Ausdruck einer Zeit, spiegelte
das, hielt das fest.

„Das perfekte Zusammenspiel von Licht, Musik, Stroboskop
zerlegt die tanzende Masse in gestaltlose Energie. Form und
Gestalt werden vermieden. Der individuelle Körper wird unter

"compulsion for objects and picture[s and] media", what
with all its necro-cultural pathos, breast-beating, com-
memorative celebrations and museum-type events.**3**
That may well be true of official bodies and the majority
of people – we certainly could have been spared a lot of
things. In subcultural fields, life is more special and coin-
cides structurally with what is normally dismissed as an
elitist intelligentsia. Baudrillard thus became an ally of
a generation that likewise wanted to move on quickly.
However, his pessimism seems not to have considered
it possible for the "techno scene" and its followers to use
the 1990s productively – as a launch rocket into the vir-
tual age, in which there would be no limits. Computers
and the spread of the Internet broke down barriers for
good, accessing even the most remote mountain hut.
New opportunities, new spaces and new sensory expe-
riences have arisen and are still developing as the global
media revolution progresses. Thanks to McLuhan, we
already knew early on that changing or extending any
sense faculty also changes the way the way in which we
think and act, and the way we perceive the world. Man
has become someone else.**4** "Man" means here those
who face the future and all its technological opportunities
with courage, creatively and innovatively and moreover
defy destructive energies such as war, discrimination,
environmental destruction, etc. The novelty of the ap-
proach seems indeed almost proportional to the techno-
logical progress involved. In the creative aspect of art
in both its high and low manifestations – people took up
the challenges of media overkill and pursued the idea of
the "virtual age", in which the orderliness of space, time
and place dissolved before our eyes. To what extent ana-
logue structures were still used thereby or whether only
the new technologies and media were resorted to was
not so important – the cross-fertilisation effects were
and still are critical. Has the hallucination become reality
and can one live in it? Media sages have been frantically
endeavouring to answer these questions ever since
McLuhan's day. The flood of images has brought with
it a colourful co-existence of content, styles and epochs.
As a vehement expression of an era, techno reflected
and recorded that.

"The perfect combination of light, music and strobo-
scope breaks up the crowd of dancers into shapeless
energy. Forms and figures are avoided. Individual bodies

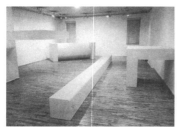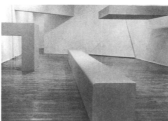

Fig. 7 Robert Morris,
Installation, 1964

dem Stroboskop zerhackt. Er ist nur noch als winkende Hände, rudernde Arme und zappelnde Beine, hüpfende Leiber zu erkennen".**5** Man glaubt, ein künstlerisches Manifest der frühen Netzhautkunst zu lesen, wenn man dieser Beschreibung einer Performance- bzw. Installationsanordnung folgt. Sieht man sich eine frühe Ausgabe des deutschsprachigen „Zentralorgans der Technokultur", *Frontpage,* an, so sieht man Derartiges in die Zweidimensionalität übertragen. Das grafische Design stieß an die Grenzen des konventionell Zumutbaren. Eine Orientierung war für das laienhafte Auge nur sehr schwer möglich. Durch ständiges Überlagern von Schrift – in verschiedensten Typografien gleichzeitig – und Bild wurde das Lesen zur Anstrengung, teilweise unmöglich. Der visuelle Charakter dieser Gestaltungsart verbreitete sich rasch und wurde in mehr oder weniger radikaler Ausformung zum Mainstream. Inhalte begannen sich mehr und mehr über Visuelles zu vermitteln. Texte, Sätze wurden sloganhaft und prägnant. Wieder andere Typografien bzw. Logos wurden inhaltlich verschoben – wurden durch „Sampling" zu neuen Bedeutungsebenen umcodiert. Auf T-Shirts ist das bis heute ein beliebtes Spiel. So wird „Adidas" zu „Adihasch" oder „Coca-Cola" zu „Kokser-Cola" und „Ritter-Sport" zu „Zitter-Sport" etc. – über Dekontextualisierung wird ein neuer Bedeutungskontext geschaffen, der den alten ironisiert oder sogar überhöht und somit zur Imagebildung beiträgt. Man fühlt sich an die Künstlergruppe „General Idea" erinnert, die aus Robert Indianas Pop-Ikone „LOVE" eine Entsprechung anderen Inhalts entwickelte – „AIDS". Inzwischen sind derartige Praktiken in den Werbeabteilungen gängig geworden. Was als „Sampling-Strategie" bei der Gestaltung von Flyern (Zettel mit Veranstaltungsankündigungen) begann, erstreckte sich bald auf die unterschiedlichsten Druckwerke (Plattencover, T-Shirts, Poster, Magazine etc.). Das Thema Copyright wurde plötzlich aktueller denn je und verursachte in der Szene erhebliche Probleme. Ein integraler Bestandteil einer sich gerade formierenden Kultur kam mit dem Gesetz in Konflikt und das nicht (nicht nur) wegen Verstößen gegen das Suchtmittelgesetz. „KLF – Kopyright Liberation Front" war der Name eines Musikproduzenten-Duos aus England zu Beginn der 1990er Jahre, das genau in diese Richtung ging. In der Musikszene war man diesbezüglich wesentlich erfahrener. Das „Sampeln", „Remixen" und „Sequencen", das letztlich aus dem „Dubbing" der Frühzeit des Reggaes (1960er Jahre) kam, ging von bestehenden Elementen bereits existierender Musikstücke aus und verarbeitete sie neu zu eigenständigen Soundstrukturen.

are fragmented under the stroboscope. They can only be identified as waving hands, flailing arms and jiggling legs, jumping bodies."**5** You would think you were reading an early "Netzhautkunst" manifesto, to read this description of a performance or installation arrangement. If you look at an early issue of *Frontpage,* the German-language "central organ of techno culture", you will see things of this kind translated into two dimensions. Its graphic design bumped up against the frontiers of what was conventionally reasonable. A lay eye would find it very difficult to orientate. The constant superimposition of script – simultaneously in a wide range of different fonts – and images made reading an effort or downright impossible. The visual nature of this form of design quickly spread and soon became mainstream, in more or less radical forms. Content was increasingly subsumed into the visual. Text and sentences were reduced to pithy slogans. Other fonts or logos were amended and recoded to new levels of meaning by "sampling", a practice still commonly seen on T-shirts. "Adidas" mutates to "Adihasch", "Coca Cola" to "Kokser Cola" and "Ritter-Sport" to "Zitter-Sport". A new context of meaning is created by decontextualisation that derides or exaggerates the old meaning and thereby contributes to image-building. One is reminded of the artist group General Idea, who used Robert Indiana's pop icon "LOVE" and developed an alternative slant ("AIDS"). Tricks of this kind have become fashionable in advertising departments as well. What began as a "sampling strategy" in designing event flyers was soon extended to printed matter of all kinds (record covers, T-shirts, posters, magazines, etc.). Copyright issues suddenly became more burning than ever and caused considerable problems for the scene. An integral component of a nascent culture came into conflict with the law, not (or not only) because of breaches of the Addictive Substances Act. "KLF – Kopyright Liberation Front" was the name of a British music producer duo in the early 1990s heading precisely in that direction. The music scene was much more experienced in this respect. Sampling, remixing and sequencing, which ultimately derived from the dubbing of early reggae music in the 1960s, used existing elements of already published music and reprocessed it into new independent sound structures.

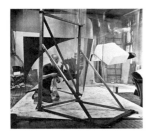

In der bildenden Kunst waren die Montage-Künstler der Fotografie wie John Heartfield, Hannah Höch bzw. die russischen Konstruktivisten in den 1920er Jahren die ersten wichtigen Vorläufer dieser Strategien. Damit entstand ein Bewusstsein von der Abhängigkeit vorhandener Bildwelten, das sich über die Pop-Art hinauf über die Appropriation Art der 1980er Jahre bis zur medienreflexiven Kunst der Gegenwart verfolgen lässt. Man musste erkennen, dass sich hinter dem letzten Bild wieder ein Bild verbirgt – das der Medien.

In der Minimal Art lässt sich eine überraschende Strukturverwandtschaft mit den zuvor erwähnten Ansätzen der Technoszene feststellen. Speziell im Grafik-Design werden diese offensichtlich. Klassische Minimal-Künstler wie Donald Judd, Frank Stella oder Robert Morris z.B. reflektieren im materiellen und kompositorischen Umgang innerhalb ihrer Werke eine auffallende Parallele zu den Praktiken des Corporate Designs. Designer und Künstler haben in dieser Zeit zwar einen deutlicher voneinander unterscheidbaren Kunstbegriff, der sich manchmal sogar wechselseitig ausschließt – was heute nicht der Fall ist –, jedoch haben sie beide einen Glauben an die Leistungsfähigkeit der Form als ein Mittel zur Umgestaltung der Gesellschaft erkennen lassen, was auch in den zuvor erwähnten Beispielen von T-Shirts und Magazinen erkennbar ist.

Walter Darby Bannard schrieb 1966 in Bezug auf die Minimal Art: „die Bedeutung einer minimalistischen Arbeit existierte außerhalb der Arbeit selbst. Es gehört zum Wesen dieser Arbeiten, dass sie Gedanken und Emotionen auslösen, die der Betrachter bereits vorher hatte".[6] Die Minimal Art nimmt weniger inhaltlich als vielmehr formal (Organisation der Bildelemente) auf diesen Bereich einer alltagskulturellen Ausformung Bezug, daher auch der eher subtile Charakter. In der Pop-Art wird die Inhaltlichkeit deutlicher spürbar, während die Lesbarkeit von abstrakten Formen zurücktritt. In der Kunst der letzten beiden Jahrzehnte nähern sich die Begriffe „Abstraktion" und „Gegenständlichkeit" einander an. Ein postmodernes Grundgefühl mag dafür mitverantwortlich sein. So kann Umberto Ecos Feststellung hier nützlich sein: „Die postmoderne Antwort auf die Moderne besteht in der Einsicht und Anerkennung, dass die Vergangenheit, nachdem sie nun einmal nicht zerstört werden kann [...] auf neue Weise ins Auge gefasst werden muss: mit Ironie, ohne Unschuld."[7]

Das Thema „Abstraktion" und „Gegenständlichkeit" scheint jedoch längere Zeit schon nicht mehr zentrales Anliegen der

In art, the montage artists of photography such as John Heartfield, Hannah Höch and the Russian Constructivists in the 1920s were the first important forerunners of these strategies. They created an awareness of the dependency on existing picture worlds, which can be traced through Pop Art up to Appropriation Art of the 1980s and to the media-based art of the present day. It had to be accepted that there was another picture behind the last picture – that of the media.

In Minimal Art, there was a surprising structural kinship to the techno scene practices mentioned above. This is particularly evident in graphic design. Classic Minimal artists such as Donald Judd, Frank Stella and Robert Morris for example, reflect striking parallels with the practices of corporate design in their handling of materials and composition in their works. Though designers and artists at this time had clearly distinct notions of art that were sometimes mutually exclusive – which is not the case today – they both showed faith in the power of form to change society, and this is visible in the examples of magazines and T-shirts mentioned earlier.

In 1966, Walter Darby Bannard wrote of Minimal Art that the importance of a Minimalist work existed outside the work itself, and it was part of the essence of these works that they gave rise to thoughts and emotions that the viewer had already had.[6] Minimal Art plugs into this aspect of an everyday cultural manifestation, less in terms of content than formally, i.e. in the organisation of pictorial elements, which tends to give it a more subtle character. In Pop Art, the influence of content is immediately visible, while the readability of abstract forms is secondary. In the art of the last ten years, the concepts of abstraction and objectivity have moved closer together. A basic post-modern feeling may be partly responsible for this. A remark by Umberto Eco is perhaps relevant here: "The post-modern response to modernism lies in appreciating and acknowledging that the past, since it can now hardly be destroyed [...] must be looked at again – with irony, without innocence."[7]

Yet the dichotomy of "abstraction" and "objectivity" has long ceased to be headline news in art. The two coexist, with equal status. Michel Majerus was well aware of this, and like many artists of his generation, treated

Fig. 9 Frank Stella, *Conway 1,* 1966

Kunst zu sein. Beides existiert gleichzeitig und gleichwertig. Michel Majerus trägt dem Rechnung und geht, wie viele KünstlerInnen seiner Generation, spielerisch damit um. Die historischen Stile der abstrakten Malerei – konstruktive oder informelle – sind zeichenhaft geworden, werden metasprachlich verstanden und auch so eingesetzt, ähnlich wie Logos. Ihr Inhalt ist die jeweilige historische Entwicklungsstufe der Malerei, z.B. der gestische Pinselstrich, das monochrome Farbfeld etc. Die Malerei kann sich im freien Spiel der malerischen Signifikanten entfalten. Dazu kommt noch der gesamte Kosmos der bestehenden Bilder, der vermittelten Bilder einer mediatisierten Visualität. Michel Majerus geht in seinen Überlegungen von kulturellen Codes aus. Die Kunstgeschichte wird, indem sie vorwiegend aus Büchern und Zeitschriften rezipiert wird, zu einer vermittelten Visualität, ähnlich wie die Bilder der Massenmedien aus Fernsehen, Zeitungen, Kino etc. Die Kunst der 1990er Jahre – und Majerus' Kunst ist im Wesentlichen Teil dieser – stellt sich bewusst dieser mediatisierten Visualität und erkennt neue Möglichkeiten in diesem Kontext der technischen Bilder. Nicht die subjektive Empfindung ist im Produktionsprozess entscheidend, sondern die Analyse der kulturellen Produktion der Artefakte. Nicht die Beziehung zur Wirklichkeit im traditionellen Sinne, sondern die Beziehung zu den vermittelnden Medien steht im Zentrum der künstlerischen Bemühungen. Der Wandel vom historischen zum gegenwärtigen Trägermedium wird dabei bewusst gemacht und in seiner Bedeutung erkannt. Gerhard Richter spricht bereits 1966 davon, dass alle Maler Fotos abmalen sollten, was er selbst praktiziert. Der amerikanische Maler David Reed bringt es auf den Punkt, wenn er sagt: „Wir sehen Gemälde jetzt wegen Film und Video anders." Maler wie Sigmar Polke oder Gerhard Richter vereinen in ihren Arbeiten gleichzeitig mehrere Individualstile, was Arthur C. Danto veranlasst festzuhalten: „Man kann jetzt am Morgen ein abstrakter Maler sein, am Nachmittag ein Photorealist, und am Abend ein minimaler Minimalist".**8** Michel Majerus eignete sich in seinen Arbeiten Motive und Stilelemente aus dem breiten Fundus der Kunstgeschichte an und kombinierte sie ohne Wertung mit populärkulturellen Zeichen wie Comic, Werbung, Game-Culture, Computergrafik etc.

Wenn sich Gerhard Richter bereits 1966 dafür ausspricht, Fotos abzumalen sei die zeitgemäßeste Form der Malerei, so darf Andy Warhol nicht fehlen. Mit der exzessiven Verwendung des Siebdruckes, eines Mediums, das man vorwiegend in der Werbung einsetzte, und des Films gab er der Malerei in den 1960er Jahren neue Impulse. Er lässt Film und Malerei in

Fig. 10 Lawrence Weiner,
*Two Minutes of Spray Paint Directly Upon the
Floor from a Standard Aerosol Spray Can,* 1967

Günther Holler-Schuster 172 173

Wechselwirkung treten, wenn er seine Bildmotive auf der Lein-
wand wiederholt und dabei wie Filmstreifen aussehen lässt. In
Filmen wie *Empire* von 1962, in dem er das Empire State Buil-
ding aus ein und derselben Einstellung acht Stunden lang auf-
nahm, erzeugte er letztlich ein Gemälde. Es handelt sich dabei
um ein nahezu starres Bild. Nur das Licht ändert sich. Würde
man ein beliebiges Bild in einem Raum an die Wand hängen,
könnte man einen vergleichbaren Effekt erzielen, obwohl der
installative Charakter eher zu Majerus führt. Die zuvor er-
wähnte vermittelte Visualität war in der Pop-Art generell ein
zentrales Thema. Nicht nur Robert Rauschenberg integrierte
Bilder aus den Massenmedien collageartig in seine Gemälde.

James Rosenquist ist an dieser Stelle unumgänglich. In einem
Interview äußert er sich 1964: „Ich bin überrascht und erregt
und fasziniert von der Art, in der uns Dinge entgegengeschleu-
dert werden, von der Art, wie diese unsichtbare Leinwand,
die vor uns, vor unserem Verstand und unseren Sinnen sich
befindet, vom Radio, vom Fernsehen und anderen visuellen
Kommunikationsmitteln angefallen wird, und durch Dinge, die
überlebensgroß sind. Und von der packenden Gewalt von Din-
gen, die uns mit einer solchen Kraft entgegengeschleudert
werden, dass das Malen und die Einstellung gegenüber Male-
rei als Kommunikation heute altmodisch erscheinen können".**9**
Rosenquist war in den 1950er Jahren als Reklamemaler tätig,
fuhr als solcher durch Amerika und malte das Werbesignet
von „Philipps 66" auf große Benzintanks, die man weithin von
den Highways sehen konnte. Für ihn waren diese Landschaften
mit den Werbetafeln und bemalten Tanks die „schönste Gale-
rie, die man sich vorstellen kann". Ungeahnte Weiten und knal-
lig bunte Zeichen – eine Supernova der Populärkultur (Malerei,
Skulptur, Kino und die Musik im Autoradio). Die überdimensio-
nalen Zeichen, die aus der Nähe gesehen zu abstrakten For-
men wurden, in denen man sich verlieren konnte, begeisterten
ihn und beeinflussten seine künstlerische Praxis nachhaltig.
In den Werken der Reklamemaler sah er einen wesentlichen
Ursprung seiner Überlegungen. Er erkannte sofort, dass ein
überdimensional gemaltes Motiv suggestiv aus dem Bild her-
ausragte. Der Gegenstand verliert durch die Dimensionierung
seine Identität und wird Form.

Majerus erzielt einen ähnlichen Effekt, wenn er einen riesigen
Nike-Turnschuh abbildet. Tom Wesselmann, dessen Groß-
formate ähnliche Ziele verfolgten, kombinierte seine kulissen-
haften Gemälde mit dreidimensionalen Elementen. In *Still
Life Nr. 19* von 1962 integrierte er einen ursprünglich zu

motifs on the canvas to make them look like film strips.
In films such as *Empire* of 1962, when he photographed
the Empire State Building for eight hours on the same
setting, he was ultimately producing a painting. It involved
a virtually static picture where only the light changed. If
you hung any picture on the wall of a room, you would
achieve much the same effect over eight hours, although
the installation nature thereof would be more like Majerus.
The transmitted visuality mentioned earlier was a central
theme in Pop Art in general. Robert Rauschenberg
was not the only one to integrate pictures from the mass
media like collages in his paintings.

A mention of James Rosenquist is inevitable at this point.
In an interview in 1964, he said: "I am surprised and
excited and fascinated by the way things are flung at us,
the way this invisible canvas in front of us, in front of our
minds and our senses, is assaulted by the radio, tele-
vision and other visual communications media, and by
things that are larger-than-life. And by the gripping vio-
lence of things that are flung at us with such force that
painting and the attitude to painting as communication
can seem old-fashioned today".**9** Rosenquist worked as a
billboard painter in the 1950s, travelling around America
in this capacity and painting the advertising icon of
"Philips 66" on large petrol tanks that could be seen a
long way from the road. For him, these landscapes with
advertising billboards and painted tanks were the "finest
gallery you can imagine". Undreamt-of horizons and
gaudily coloured signs – a supernova of popular culture
(painting, sculpture, film and music on the car radio).
The oversized signs which, close-up, looked like abstract
shapes you could get lost in, excited him and influenced
his artistic approach permanently. He traced much of his
thinking back to the works of the billboard painter and
recognised at once that larger-than-life motifs are sug-
gestive elements that stand out in the composition. The
object loses its identity by being outsize and becomes
a shape.

Majerus achieved a similar effect when he paints a giant
Nike gym shoe. Tom Wesselmann, whose large formats
pursued similar aims, combined his scenario-like paint-
ings with three-dimensional elements. In *Still Life No. 19*
of 1962, he incorporated into the painting a three-dimen-
sional loaf of bread originally produced for advertising

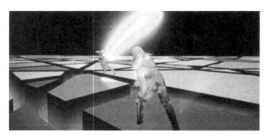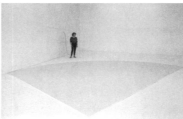

Fig. 11 *TRON*, Walt Disney Prod., 1982 (Still)

Fig. 12 Ellsworth Kelly, *Yellow Curve*, 1992

Werbezwecken hergestellten dreidimensionalen Brotlaib in das Gemälde. Dieses Element ragt in den realen Raum hinein und bringt die Schichtung von Gegenständen, die schon im Überlagern der anderen, collagierten Elemente enthalten ist, zu einem konsequenten Abschluss. In der Folge verwendet er zahlreiche derartige dreidimensionale Gegenstände, um der räumlichen Dimension in seinen Gemälden einen drängenderen Charakter zu verleihen.

Um die Verräumlichung der Bildfläche weiter voranzutreiben, begann James Rosenquist 1965 auf Plastikfolien zu arbeiten. Er malte die Motive auf die transparente Folie und installierte die Flächen im Raum, so dass man sich durch die Bildelemente bewegen konnte. Der Besucher durchwanderte einen Wald von Autoteilen, riesigen Würsten, Sägen und Tankwagen. Diese „Environmental Paintings" stellten somit eine frühe Form eines virtuellen Raumes dar. Sigmar Polke machte 1992 etwas Ähnliches, als er auf transparentem Polyestergewebe beidseitig malte. Frei im Raum schwebende Formen kamen dem Betrachter entgegen.

Das virtuelle Reich von Tron ist wesentlich ausgereifter und stellt eine vielfältigere Malerei dar. Während die Cyberspace-Szenarien der Games immer stärker Realität werden – sowohl Soldaten als auch Sportler setzen sie zum Training ein – hat Michel Majerus noch einmal versucht, sie zu analogisieren, zu decodieren, bevor er uns „lost in space" zurückließ.

purposes. This feature sticks out into real space, bringing the layering of objects contained in the overlapping of other collage elements to a logical conclusion. Subsequently Wesselmann used numerous three-dimensional objects of this kind to lend a more urgent character to the spatial dimension in his paintings.

In order to develop the spatial qualities of the picture surface further, Rosenquist began in 1965 to work on acetate sheets. He painted motifs on transparent sheets and installed them in the room so that one could move through the picture elements. Visitors wandered through a forest of car parts, huge frankfurters, saws and tankers. These "Environmental Paintings" thus constituted an early version of a virtual space. In 1992, Sigmar Polke did something similar by painting on both sides of transparent polyester material. Shapes floating freely in space greeted the viewer.

The virtual realm of Tron is much more sophisticated and constitutes a more varied kind of painting. Whereas the cyberspace scenarios of the games become increasingly real – both soldiers and athletes use them for training – Michel Majerus sought once more to make them analogue and decode them before he left us behind, lost in space.

Anmerkungen

1 Kesey und die Merry Pranksters, eine LSD-Avantgarde in wechselnder Zusammensetzung und Größe, veranstaltete 1966 entlang der kalifornischen Küste LSD-Parties. Bis zu 10 000 Leute gingen bei diesen „Acid Tests" auf psychedelische Reisen.

2 Spiral Tribe, ein Mitte der 1990er Jahre von Großbritannien kommender Zusammenschluss von Techno-Freaks, der seither durch Europa tourt und Parties veranstaltet. Die Infrastruktur wird mit einem LKW-Konvoi mitgeführt – absolute Selbstversorger.

3 Jean Baudrillard: *Das Jahr 2000 findet nicht statt.* Berlin: Merve 1990, S. 46.

4 Marshall McLuhan: *Das Medium ist Message.* Frankfurt am Main, Berlin, Wien: Ullstein 1984, S. 41.

5 Friedhelm Böpple, Ralf Knüfer: *Generation XTC – Techno und Ekstase.* Berlin: Volk und Welt 1996, S. 161.

6 Walter Darby Bannard, zitiert aus: Gregor Stemrich (Hrsg.): *Minimal Art – Eine kritische Retrospektive.* Dresden, Basel: Verlag der Kunst 1995.

7 Umberto Eco: *Nachschrift zu ‚Der Name der Rose'.* München: Hanser 1984, S. 77 f.

8 Arthur C. Danto: *Die philosophische Entmündigung der Kunst.* München: Fink 1993, S. 144.

9 James Rosenquist: *Gemälde – Räume – Graphik.* Ausst. Kat. zur gleichnamigen Ausstellung des Wallraf-Richartz Museums, Kunsthalle Köln 1972, S. 7.

Notes

1 Kesey and the Merry Pranksters, a loose grouping of the LSD avant-garde that varied in membership and size, organised LSD parties along the Californian coast in 1966. Up to 10 000 people went on psychedelic trips during these "acid tests".

2 Spiral Tribe, a grouping of British techno freaks in the 1990s that subsequently toured Europe and organised parties. They carried the infrastructure with them in a convoy of lorries – absolute self-reliance.

3 Jean Baudrillard: *Das Jahr 2000 findet nicht statt.* Berlin: Merve 1990, p. 46.

4 Marshall McLuhan: *Das Medium ist Message.* Frankfurt am Main, Berlin, Wien: Ullstein 1984, p. 41.

5 Friedhelm Böpple, Ralf Knüfer: *Generation XTC – Techno und Ekstase,* Berlin: Volk und Welt 1996, p. 161.

6 Walter Darby Bannard, quoted from: Stemrich, Gregor (ed.): *Minimal Art – Eine kritische Retrospektive,* Dresden, Basle: Verlag der Kunst 1995.

7 Umberto Eco: *Nachschrift zu 'Der Name der Rose'.* Munich: Hanser 1984, pp. 77.

8 Arthur C. Danto: *Die philosophische Entmündigung der Kunst.* München: Fink 1993, p. 144.

9 James Rosenquist: *Gemälde – Räume – Graphik,* catalogue on the exhibition of this name at the Wallraf-Richartz Museum, Kunsthalle Köln, Cologne 1972, p. 7.

Robert Fleck
Von der Malerei zur Installation und retour
From Painting to Installation and Back Again

Robert Fleck, geboren 1957 in
Wien/AT, lebt in Hamburg/DE.

Studium der Geschichte und Philosophie in Wien, Innsbruck und Paris.
1991–1993 Bundeskunstkurator
in Österreich, 2000–2003 Direktor
der Kunsthochschule von Nantes,
Frankreich, seit 2004 Direktor der
Deichtorhallen Hamburg.

Kurator der Ausstellungen (Auswahl):
*Das Jahrhundert der künstlerischen
Freiheit. 100 Jahre Wiener Secession*
(Wien 1998), *Manifesta 2* (Luxemburg
1998, mit Maria Lind und Barbara
Vanderlinden).

Zahlreiche Publikationen, zuletzt:
Yves Klein et Marie Raymond.
Angers 2004.

Robert Fleck, born 1957 in
Vienna/AT lives in Hamburg/DE.

Studied history and philosophy
in Vienna, Innsbruck and Paris.
He was previously federal curator
of art in Austria (1991–1993) and
director of the art college in Nantes,
Brittany (2000–2003). Since
2004 he has been director of the
Deichtorhallen in Hamburg.

Exhibitions he has curated include:
*Das Jahrhundert der künstlerischen
Freiheit. 100 Jahre Wiener Secession*
(Vienna 1998) and *Manifesta 2*
(Luxembourg 1998, with Maria Lind
and Barbara Vanderlinden).

He has published extensively,
most recently: *Yves Klein et Marie
Raymond.* Angers 2004.

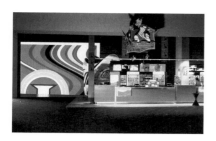

Fig.1 *yet sometimes what is read
successfully, stops us with its meaning,*
1998, Katalogseite für *Manifesta 2,*
Luxemburg, 1998

Fig.1 *yet sometimes what is read
successfully, stops us with its meaning,*
1998, Catalogue page for *Manifesta 2,*
Luxembourg, 1998

Robert Fleck 176 177

„Fax von Michel Majerus, +49-30/285-8366
an Ulrike Groos (Manifesta), +352-229/695
Berlin, den 6.3.98

Liebe Ulrike,
wie geht's dir? Ich bin jetzt zurück in Berlin und hab mir noch
mal alles genau überlegt: Ich bin doch mit Anette und Gitte im
Kino Utopolis gewesen. Da gibt es diese riesige Popcorntheke,
ich glaube, es ist die einzige im ganzen Kino. Gleich da, wo die
Theke links ansetzt, gibt es eine 5m breite Betonwand. *Genau
diese* Wand ist perfekt für die Arbeit mit dem Turnschuh und
den Farbwellen. Das dürfte doch kein Problem sein, oder was
denkst du? Es wäre perfekt. Dann sähe eine Katalogseite fol-
gendermaßen aus:
Frontalaufnahme von der gesamten Theke mit der links im Hin-
tergrund angrenzenden leeren blaugrauen Wandfläche. Meine
Arbeit wird eingescannt (die Vorlage habe ich gegebenenfalls)
und mit Photoshop an die Wand montiert. Die restlichen 3
Katalogseiten ergeben sich, sobald ich weiß, ob alles so klappt.
Anette weiß, von welcher Wand die Rede ist. Enrico hat eine
schwarz-weiß Kopie von der Arbeit + auch alle Angaben für
die Beschaffung des Aluminiums. 12 Tafeln werden benötigt.
Da ich für andere Arbeiten noch zusätzlich 12 Tafeln benötige,
ist es vielleicht vorteilhaft, gleich *24* Platten zu bestellen. (Die
12 zusätzlichen Platten betreffen nicht die Manifesta!) Da die
Anlieferung unter Umständen 2–3 Wochen benötigt, ist es
ratsam baldmöglichst das mit den Platten + mit dem Kino
zu klären. Bitte teile mir mit, ob das so funktioniert.
Liebe Grüße Michel"[1]

Michel Majerus schrieb dieses Fax im März 1998 im Zusammen-
hang mit der Biennale *Manifesta,* zu deren zweiter Ausgabe
in Luxemburg er eingeladen war, an Ulrike Groos, damals ver-
antwortlich für die Künstlerprojekte bei dieser internationalen
Großausstellung für jüngere Kunst aus allen Teilen Europas.
Das Schreiben gibt Einblick in die „Werkstatt", in das gedank-
liche Atelier eines bedeutenden Malers aus der jüngeren
Künstlergeneration der 1990er Jahre. Michel Majerus legt auf
die halböffentliche Situation des Kinos, in dem er eines seiner
beiden wandfüllenden Bilder ausstellen will, offensichtlich weit
mehr Wert als auf die Ausstellungshalle, die für seine andere
Arbeit zur Verfügung stand. Er wählte sich den ungeschützten,
„lauten" und seine Malerei scheinbar marginalisierenden Platz
in einem großen, postmodernen Kinokomplex, der sich mehr
als zwei Kilometer abseits aller anderen Ausstellungsorte der
Manifesta 2 befand, um in dieser isolierten Situation, fernab

"Fax from Michel Majerus, +49-30/285-8366
To: Ulrike Groos (Manifesta), +352-229/695
Berlin, 6.3.98

Dear Ulrike
How are you? I'm now back in Berlin and have thought
hard about it all again. The thing is, I was with Anette
and Gitte at the Utopolis Cinema. They've got this huge
popcorn bar there, I think it's the only one in the whole
cinema. Just where the bar starts on the left there's
a concrete wall five metres wide. This is *just* the wall for
the work with the gym shoe and the colour waves. There
couldn't be any problem there, d'you think? It would
be perfect. A catalogue page would then look like this:
A front view of the whole bar with the empty bluish grey
wall surface next to it in the left background. My work
will be scanned in (I have the original if necessary) and
mounted on the wall with Photoshop. The remaining
three catalogue pages will follow as soon as I know how
it all works out.
Anette knows which wall it is. Enrico has a b/w copy
of the work + all the details for getting the aluminium.
12 panels are required. As I need another 12 panels for
other works, it would probably be useful to order *24*
sheets at once. (The extra twelve sheets are not for
Manifesta!) As delivery can take two to three weeks, it's
advisable to get things with the sheets and the cinema
cleared asap. Can you let me know if it works out OK?
All the best, Michel"[1]

Michel Majerus wrote this fax to Ulrike Groos in March
1998 in connection with the second *Manifesta* Biennial
in Luxembourg, to which he had been invited. Ulrike
Groos was at the time in charge of artist projects at this
major international exhibition of recent art from all parts
of Europe. The message provides an enlightening glimpse
of the mental "studio", i.e. the thought processes of an
important painter of the 1990s generation of young art-
ists. Majerus obviously ranked the semi-public location
in the cinema, where he wanted to install one of his two
wall-size pictures, much more highly than the exhibition
hall that was available for his other work. He opted
for the unprotected, brash location (where his painting
would seemingly be marginalised) in a large post-modern
cinema complex well over a mile from all other exhibition
venues of *Manifesta 2* because in this isolated situation,

der anderen ausstellenden Künstler, eine direkte Kommunika-
tion mit dem Kinopublikum einzugehen, das wohl nie auf
die Idee gekommen wäre, die Kunstausstellung *Manifesta* zu
besuchen. Diese Kommunikation mit einem anderen, überwie-
gend jugendlichen Publikum lag Michel Majerus in Luxemburg
sehr am Herzen. Es ging dabei nicht um populistische Absich-
ten, ein breites Publikum zu erreichen, und auch nicht um einen
Jugendkult, auch wenn der Künstler in diesem Fall ganz be-
wusst sein Bild in die Umwelt jugendlicher Kinogeher platzieren
wollte. Sondern es ging Michel Majerus um den Dialog, den
sein Bild, selbst aus Signets und öffentlichen Markenzeichen
und Mustern komponiert, in der selbst mit postmodernen
Signets übersäten Kino-Atmosphäre entfalten würde, obgleich
es ohne offensichtliches Hinweisschild bescheiden einfach an
der Wand hing. Die „Arbeit mit dem Turnschuh und den Farb-
wellen" wie Majerus sich ausdrückte (*yet sometimes what is
read successfully, stops us with its meaning,* 1998), hing denn
auch ohne besonderen Hinweis auf die Ausstellung *Manifesta*
an der breiten Betonwand neben der Popcorntheke: Majerus'
bildhafte Collage aus Zeichen und Signets hing inmitten der
Zeichen und Signets der Kino-Konsumwelt kommentarlos
herum, ohne Diskurs, präsent und unübersehbar bloß durch
die monumentale Wirkung des multi-dimensionalen und multi-
direktionellen Samplings aus verschiedenen vorgefundenen
Zeichen, das das Bild ausmacht, sowie durch die Anbringung
am oberen Abschluss der zum Vorraum der Kinosäle führen-
den, überbreiten Treppe, mit der es an ein Wandbild aus den
Zeiten der Romantik beispielsweise erinnerte.

Die „Turnschuh-Arbeit" erweist sich beim näheren Hinsehen als
sowohl aggressiv wirksames als auch komplexes, besonders
vielschichtiges Bild. Es enthält drei unterschiedliche Elemente.
Der fast schockhafte Eindruck beim ersten Blick ergibt sich
durch die digital umgesetzte Fotografie eines Turnschuhs, des-
sen räumliche Stellung ein auf den Betrachter hintretendes
Bein, einen gewaltsamen Stoß beschreibt, während das Objekt
zugleich als rein ästhetisches Phänomen neutralisiert ist. Der
buchstäblich aus den Fugen des Bildes tretende Schuh desta-
bilisiert die im Übrigen flache Bildkomposition, sie reißt einen
stürzenden Raum auf und führt zugleich eine physische Kraft
ein, mit der das Bild trotz seines ruhigen, ausgewogenen Auf-
baus frappiert. Ein zweites Element des Bildes scheint dem dia-
metral entgegengesetzt. Es handelt sich um ein Piktogramm,
also ein per se zweidimensionales Signet ohne jene räumliche
Dimension, das gemeinhin ein Zeichen für Lautsprecher bzw.
für die Lautstärke-Einstellung in einem Computer oder digitalen

a long way from all the other exhibiting artists, he could
enter into direct communication with the cinema-going
public, people who would never dream of going to an art
exhibition like *Manifesta*. This communication with a dif-
ferent, preponderantly young public was very important
to Majerus' in Luxembourg. It was not that his intentions
were populist, aiming at a broad public, nor was it a cult
of youth, even if in this case the artist wanted to place
his picture in the environment of young cinema-goers.
The key element for Majerus was the dialogue that his
picture, which itself was made up of icons and patterns,
would trigger off in a cinema context also replete with
post-modern symbols, even though it would simply
hang modestly on the wall without a visible notice.
At Manifesta, therefore, the "work with the gym shoes
and the colour waves" as Majerus puts it (*yet sometimes
what is read successfully, stops us with its meaning,*
1998), hung without any particular reference to the
Manifesta exhibition, on the wide concrete wall alongside
the popcorn bar. Majerus' pictorial collage made of signs
and icons hung there in the middle of the signs and
icons of the cinema consumer world without commen-
tary or debate, present and inescapable only by virtue
of the monumental effect of the multi-dimensional and
multi-directional samples of various pre-existent signs
that make up the picture, and of its location at the upper
end of a wide staircase leading to the lobby outside the
auditoria, where it was reminiscent of a wall picture from
the Romantic period.

On closer inspection, the "gymshoe work" turns out to
be both aggressively effective and a complex, multi-
layered picture. It contains three different elements. The
almost shocking initial impression comes from the digit-
ally produced photo of a gym shoe, whose position
in the room describes a violent kick, a leg walking on the
viewer, while the object is at the same time neutralised
as a purely aesthetic phenomenon. Literally stepping out
of the picture's framework, the shoe destabilises what is
otherwise a flat composition; it opens up a plunging void
and at the same time introduces an astonishing physical
force despite the calm, balanced structure of the picture.
A second element in the picture seems diametrically
opposed to the foregoing. It involves a pictogram, i.e. a
per se two-dimensional sign without any spatial dimen-
sion that generally indicates "loudspeaker" or the volume-

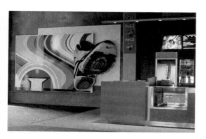

Fig. 3 *yet sometimes what is read success-fully, stops us with its meaning, no. II,* 1998, Installationsansicht
Manifesta 2, Luxemburg, 1998

Fig. 3 *yet sometimes what is read success-fully, stops us with its meaning, no. II,* 1998, Installation view
Manifesta 2, Luxembourg, 1998

Robert Fleck 178 179

Abspielgerät anzeigt. Dieses Signet ist gleichsam beiläufig an die untere Bildkante gesetzt, scheint aus dem Bildraum herauszukippen, hält sich aber mitbestimmend im Bild, ähnlich wie auf der Befehlsleiste auf einem Computer oder dem Bildschirm eines digitalen Abspielgeräts. Zwischen beiden Zeichen besteht kein narrativer Zusammenhang, sodass das Lautstärke-Signet als abstrakte Form, ruhig und statisch zur Geltung kommt. Das Bild als solches ist aus verschiedenen Signets „zusammengedacht", aber das Lautstärke-Signet gibt ihm seinen eigentlichen Halt.

Das dritte Element des Bildes nannte Michel Majerus die „Farbwellen". Auch hier wieder handelt es sich – für den Künstler sehr kennzeichnend – um vorhandene Signets und keinesfalls um abstraktes, dekoratives Füllmaterial. Diese bunten Linienflächen füllen nicht einen Leerraum aus, sondern sie sind selbst auch wieder vorgefundene, allbekannte Zeichen, die durch das lückenlose Sampling mit den anders gearteten Zeichen in eine Spannung versetzt werden. „Sampling" oder „Collage" sind in diesem Zusammenhang wohl missverständliche Ausdrücke, denn sie könnten suggerieren, dass das Bild von Michel Majerus aus verschiedenen, mehr oder weniger beliebigen Teilen „zusammengestellt" oder „arrangiert" sei. Genau das Gegenteil ist der Fall, und deshalb besitzt das Gemälde auch diese Spannung, die noch sieben Jahre später und in einem ganz anderen Ausstellungszusammenhang ungebrochen ist. Die Bilder von Michel Majerus sind, um einen anderen, metaphorischen Ausdruck zu verwenden, mathematisch präzise Setzungen aus unterschiedlichen, scheinbar unvereinbaren Teilen, die alle in unterschiedlicher Weise gemeinsam haben, aus öffentlichen Signets verschiedenen Typus zusammengesetzt zu sein. „Mathematisch präzise" meint in diesem Fall nicht, die Bilder seien mit dem Rechenstift erarbeitet worden. Michel Majerus hat seine Bilder rein visuell, durch langes Ansehen und Verschieben der Teile in verschiedenen Ausformungen in seinem Atelier geschaffen. „Mathematisch präzise" meint eher den Satz: „Ich habe das lange versucht – es geht genau *so* auf den Millimeter, anders geht es nicht." Nichts ist ausgefüllt an den Bildern, sondern drei Arten von Signets sind zueinander in eine dynamische Konstruktion des Bildraums gebracht, die keine Handbreit an Zwischenräumen zulässt. Das Vorgehen entspricht demjenigen abstrakter Maler bei geometrischen, aber visuell komponierten Bildern, nur dass Michel Majerus mit der Macht neutralisierter Signets arbeitet, die im Tafelbild und in präzisen, unbekannten Zusammenführungen eine neue, zugleich schockartige und kontemplative Macht entfalten.

control on a computer or digital player. This pictogram is placed almost as an afterthought on the lower edge of the picture, appearing to tilt out of the picture but nonetheless forming part of it, rather like a command bar on a computer or the screen of a digital player. There is no narrative connection between the two signs, so that the volume icon is an abstract shape, exerting calmness and static force. The picture as such is dreamed up from various icons, but the volume icon provides the actual terra firma.

The third element was called "colour waves" by Majerus. Here too – and characteristically for the artist – pre-existing icons were involved instead of abstract, decorative space-filling material. These colourful linear surfaces do not fill up an empty space but are again pre-existing, generally familiar signs that create a field of tension through seamless sampling with other kinds of signs. In this context, "sampling" and "collage" are probably misleading terms since they might suggest that the picture by Majerus is arranged or "stuck together" more or less randomly from discrete parts. Quite the opposite is the case, which is why the painting still retains this high-voltage character seven years on and in quite a different exhibition context. To use a different metaphorical expression, Majerus' pictures are mathematically precise settings of assorted, seemingly incompatible parts that in different ways all have one thing in common: they are made up of different types of public icons. "Mathematically precise" does not mean here that the pictures were worked out on a drawing board. Majerus worked at his pictures in his studio purely visually, gazing at the parts for ages and pushing them around in various trial arrangements. Mathematically precise means something along the lines of "I've spent hours looking for that – that's *it*, to the last millimetre, that's how it has to be." There is no "filling out" in the picture. Three kinds of icon are juxtaposed in a dynamic structuring of the picture field that leaves no hand's width free. The procedure is the same used by abstract painters producing geometrical but visually composed pictures, except that Majerus works with the power of neutralised icons which unfurl a new, at once shocking and yet contemplative force in the picture, in precise, unfamiliar juxtapositions. That is why the "work with the gym shoe and colour waves" achieved such supreme

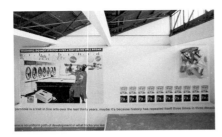

Fig. 4 *reminder,* 1998
Installationsansicht
Manifesta 2, Luxemburg, 1998

Fig. 4 *reminder,* 1998
Installation view
Manifesta 2, Luxembourg, 1998

Deshalb erzielte die „Arbeit mit dem Turnschuh und den Farb-
wellen" in dem Kinopalast in Luxemburg auch eine souveräne
Intensität, ohne von der lauten, für Kunst scheinbar ungeeig-
neten Atmosphäre abhängig zu sein.

Die zweite Arbeit (*reminder,* 1998) für die Biennale *Manifesta 2*
war in einem der drei zentralen Gebäude der Ausstellung an-
gesiedelt und bespielte in kontemplativerer Weise eine weiße
Wand von rund 15 Metern Länge. Dieses Bilderensemble ist
weniger offensiv und – im Gegensatz zu den meisten Werken
von Michel Majerus – nicht in einer Farbigkeit gestaltet, die an
die Erfahrungen von Neonschildern, Großplakaten und Leucht-
flächen der städtischen Umwelt gemahnt, auch wenn sie deren
Kolorismus nicht imitiert. In dieser zweiten Arbeit konzentrierte
er sich auf eine „kunstimmanente" Farbigkeit, und sie war denn
auch als ein Statement seiner Generation zur neueren Malerei-
tradition angelegt. Auf Augenhöhe der Betrachter entfaltete
sich ein serielles Ensemble aus zweimal zehn gleichförmig be-
druckten, quadratischen Leinwänden über die gesamte Länge
der Ausstellungswand, ein sanftes Ensemble abstrakter Kunst
mit strenger minimalistischer Ausrichtung in der Raumauffas-
sung ergebend. Schräg rechts darüber hing ein monumentales
Bildrelief von Frank Stella (*o. T.,* 1998) in Originalgröße, wobei
Michel Majerus das Werk von Frank Stella aus dessen barocker
Periode der 1980er Jahre präzise, aber nicht täuschend ähnlich
nachgebaut hatte. Beide Elemente zusammen ergaben auf
der großen, weiß bemalten Betonwand ein fast melancholisches
Statement zu den Möglichkeiten der Malerei in der Gegenwart,
mit besten Beispielen für gelungene Kunst und für weiterhin
tragfähige Fundamente malerischer Arbeit ausgestattet und
als solches eine schöne Museumswand bildend, zugleich aber
bewusst etwas „verstaubt" ausgeführt, wie utopistische Desig-
nermöbel der 1970er Jahre als heutige Flohmarktware.

Beide Arbeiten für *Manifesta 2* stellten die Spannweite von
Michel Majerus dar. Da war einmal das aggressiv auftretende,
in sich aber trotz seiner Collagiertechnik aus öffentlichen Sig-
nets ausgewogen komponierte Bild mit dem Turnschuh, das
sich auch in der rauen Atmosphäre des Kinos zu bewahren ver-
mochte. Dem stand ein wandumspannendes, aber in Farbig-
keit und Zeichensprache eigentümlich verhaltenes Ensemble
gegenüber, das von Malerei anhand der zwei Ausgangspunkte
von Michel Majerus' Werk handelt, der minimalistischen Form
der Bildtafeln, die sein Lehrer an der Stuttgarter Akademie,
der amerikanische Konzeptkunst-Pionier Joseph Kosuth, in den
späten 1960er Jahren entwickelt hatte, sowie dem barocken,

intensity in the cinema in Luxembourg without being
dependent on the noisy atmosphere seemingly unsuited
to art.

The second work for *Manifesta 2* (*reminder,* 1998) was
located in one of the three central buildings, and occu-
pied a contemplative position on a white wall about
15 metres long. Unlike most works by Majerus, this
ensemble of pictures is less offensive and not designed
in a coloration that evokes (without actually copying the
colour of) neon signs, billboards and illuminated surfaces
in urban environments. In this second work, he focused
on inherently artistic colour, and this was also set out
as a statement by his generation on the recent tradition
of painting. Placed at a comfortable viewing height, it
consisted of a series of ten similarly printed square can-
vases occupying the whole length of the exhibition wall,
producing in the room context a placid ensemble of ab-
stract art with rigorous Minimalist orientation. Diagonally
above it on the right hung a full-scale monumental relief
of a Frank Stella picture (*o. T.,* 1998), Majerus having
reconstructed the work from Stella's baroque period of
the 1980s, accurately but not to the point of its being
interchangeable with the original. Read together, the two
elements on the white-painted concrete wall constituted
an almost melancholic comment on the opportunities
for painting nowadays, equipped with the best examples
of successful art and firm foundations for painters to
work on and as such forming a nice museum wall, but
at the same time deliberately executed in rather fuddy-
duddy fashion, like Utopian designer furniture of the
1970s now featuring as junkshop goods.

The two works for *Manifesta 2* represented Majerus'
range as a painter. On the one hand there was the
aggressive-looking but – despite the collage technique
using public icons – nonetheless balanced picture with
the gym shoe that proved capable of holding its own
even in the raw atmosphere of a cinema. On the other
hand, there was another wall-filling ensemble oddly
subdued in coloration and sign language that was
about painting seen through two aspects of Majerus'
work – the Minimalist form of panel pictures devel-
oped in the late 1960s by his teacher at the Stuttgart
Academy, the pioneering American conceptual artist
Joseph Kosuth, and the baroque, post-Minimalist

post-minimalistischen Ausbruch von Formen, die Frank Stella ausgehend vom Prinzip der „shaped canvas", der vom inneren Motiv und seiner Eigendynamik bestimmten äußeren Form der Leinwand, gleichfalls ab den späten 1960er Jahren ausprägte. Michel Majerus hatte sich für die Ausstellungshalle von *Manifesta 2* zu einer Hommage an diese beiden geistigen „Väter" entschlossen, hielt das Ensemble jedoch – vor allem durch die Farbe und den bewussten Kopie-Charakter der einzelnen Bilder – in einer verhaltenen Traurigkeit, die mehr als einen Besucher befremdete. Wer das Glück hatte, dem Künstler bei der Konzeption und dem Aufbau dieser zweiten Arbeit stundenlang zusehen zu können, bewunderte in der Folge gerade diesen Mut zur Gebrochenheit in einem manifestartigen Statement zur neueren Malerei. Die Fachwelt reagierte überwiegend vergleichsweise enttäuscht gegenüber dieser zweiten Arbeit, während das Turnschuh-Bild im Kino spontan überzeugte. Dabei hatte Michel Majerus gerade im museumsähnlichen Ausstellungsraum die virtuose, aufrüttelnde Bildsprache 2 seines übrigen Werkes zurückgenommen und im melancholischen Verhältnis zur malerischen Tradition der letzten 30 Jahre viel von sich selbst preisgegeben.

„Subject: Schoenberg
Date: 26/08/2001 01:10:55 Heure d'été Paris Madrid
From: michelmajerus@hotmail.com (Michel Majerus)
To: FleckRob@aol.com

Lieber Robert,
mit 15 habe ich Schoenberg für mich als einen der wenigen Komponisten durchgehen lassen, wegen dem Atonalen. Das hat mir gut gefallen. Ich konnte darin ganz gut eine Struktur erkennen, mit der ich mich selbst identifizieren konnte und ich hatte so das Gefühl, der will, dass das die Leute verstehen sollen, oder dürfen, die sich mit Tonalität unwohl fühlen.
Das fand ich eine gute Grundlage, etwas Eigenes herzustellen. Neulich habe ich mich hier in LA mit jemandem unterhalten, der meinte, er liebt Beuys dermaßen, weil er für alle unbequem war. Da dachte ich mir, wenn man es von dieser Seite her sieht ist alles ja ganz schön blöd. Ich finde es immer besser man macht etwas für die, die sich damit identifizieren können und die anderen ziehen später sowieso nach und das interessiert mich dann nur am Rande, weil ich mir denke, das ist mir zu pädagogisch so rum zu denken, ich wünsche es niemandem, sich unbequem zu fühlen.
Dann hat Heike mir neulich erst diese lustige Geschichte von Schoenberg in LA erzählt, wo er sich in Hollywood vorstellen

outbreak of forms that Frank Stella had developed likewise from the late 1960s, starting from the principle of the "shaped canvas", the external shape of the canvas being determined by the inner subject matter and its innate dynamic. Majerus opted to present a work in the exhibition hall of *Manifesta 2* as an homage to these two spiritual fathers, but the end result – particularly because of the colour and the deliberate replica nature of the individual pictures – was imbued with a muted tristesse that disconcerted more than one visitor. Anyone who had the good fortune to be able to watch the artist at work for hours on the conception and development of this second work was later able to admire the courage of this "broken spirit" in what emerged as a manifesto-like statement on recent painting. The reaction of the art world was mainly one of relative disappointment at this second work, whereas the gym shoe in the cinema was spontaneously successful. Yet it was exactly in the museum-like exhibition room that Majerus had reined in the rousing, masterly pictorial language 2 of his other work and revealed much of himself in his melancholic reflection on the painting tradition of the last 30 years.

"Subject: Schoenberg
Date: 26/08/2001 01:10:55 Heure d'été Paris Madrid
From: michelmajerus@hotmail.com (Michel Majerus)
To: FleckRob@aol.com

Dear Robert
At 15, I went along with Schoenberg as one of the few composers for me, because of the atonal thing. I liked it a lot. I could easily recognise a structure in it that I could identify myself with, so I had the feeling this man wants people who don't feel comfortable with tonality to understand, or be able to do so. I found that a good basis for producing something of my own. I recently talked to someone here in LA who thought he loves Beuys so much because he makes everyone uncomfortable. Then I thought to myself, if you look at from that side, it makes absolutely everything stupid. I think it is always better to do something for people who can identify with it and the others will catch up later anyway, and that will then interest me only marginally. Because my view is, taking this and that into account all the time is far too pedagogic for me, I don't want anyone to feel uncomfortable. Anyway, Heike only recently told me this funny story

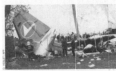

Crash d'un avion à Luxembourg

Fig. 5 Ausriss der Tageszeitung *20 minutes* über den Flugzeugabsturz, bei dem Majerus ums Leben kam; Paris, 7.11.2002

Fig. 5 Newspaper cutting from the daily *20 minutes* about the plane crash in which Majerus died; Paris, 7.11.2002

wollte und er dann darum gebeten wurde: ‚Can you whistle a tone?' – und er sich dann geweigert hat. Seine Malerei nahm ich immer ein bisschen so wahr wie B-Seiten auf Schallplatten, was ich gerade deshalb auch interessant fand.
Vielleicht fällt mir ja noch etwas dazu ein. Eigentlich sehr passend mit der Schoenbergbiographie, mit dem Unterschied, dass ich immer hin und herpendeln kann.
Danke auch für deine Einladung nach Nantes. Ich werde mal schauen, wann ein guter Zeitpunkt ist dort zu sein. Entschuldige auch bitte meine verzögerten Mails.
Es gefällt mir übrigens sehr gut hier in LA. Ich werde ab November wieder in Berlin sein, aber ich ziehe auch nicht von LA weg. Ich mag es gerne, dass ich hier andere Sachen unternehmen kann als in Berlin. Des Weiteren glaube ich aber weniger daran, dass es meine Arbeitsweise in irgendeiner Hinsicht verändert hat, da es ja nicht so ist, dass ich von dieser Stadt davor nichts wusste.
Bis bald und liebe Grüße, Michel"**3**

Anlass für dieses E-Mail, das drei Jahre nach dem eingangs zitierten Fax entstand, war eine Umfrage unter Künstlern für einen Textbeitrag im Katalog zur Ausstellung der Malerei Arnold Schönbergs in der Schirn Kunsthalle in Frankfurt am Main. Michel Majerus hielt sich zu diesem Zeitpunkt in Los Angeles auf. Ähnlich wie bei den Atelierbesuchen in Berlin erweist er sich in dem Schreiben als äußerst bescheiden und zurückhaltend, zugleich aber visionär, von einer tief sitzenden Überzeugung um die Notwendigkeit neuer Bildwelten und Raumauffassungen in der Malerei und um seine eigene Rolle und Position in diesem Rahmen erfüllt. Michel Majerus war das Gegenteil eines überheblichen Künstlers, wusste aber genau, was er wollte und warum das notwendig war. Dies war nicht aus einer theoretischen Überlegung entstanden, sondern aus visuellem Umgang, aus Beobachtung und beständigem Umgang mit malerischen Elementen auf der Leinwand – kein „Kopf-Künstler" also, aber ein überaus kultivierter Künstler, dessen Werk aus dem malerischen Duktus kam, zugleich aber wohl die wichtige Gegenposition zum Revival der expressionistischen Bildsprachen in der Malerei des frühen 21. Jahrhunderts darstellt.

Majerus' spontane Reaktion auf die an sich anekdotische Frage nach seinem Verhältnis zu Arnold Schönberg ist in zweifacher Weise interessant. Zunächst mag überraschen, wie der Jugendliche sich für Schönbergs atonale Periode interessierte und daran in gewisser Weise seine eigene Haltung zur Kunst ablas:

about Schoenberg in LA, where he wanted to introduce himself in Hollywood and then he was asked: 'Can you whistle a tone?' – which he refused to do. I always looked on his painting as a bit like the B side of a record, which I found interesting just for that reason.
Perhaps something else will occur to me on this point. Actually it fits in well with the Schoenberg biography, with the difference that I can always travel back and forth.
Also, thanks for your invitation to Nantes. I'll check out when's a good time to be there. My apologies for the delay in my e-mails.
Otherwise I like it a lot here in LA. I'll be back in Berlin from November, but I'm not moving away from LA. What I like here is that I can do different things than in Berlin. But I also don't really think it's changed my way of working in any respect, because after all it's not as if I didn't know anything about this city before.
More later and all the best, Michel"**3**

The occasion for this e-mail, sent three years after the fax mentioned above, was a survey among artists for a text contribution to be published in the exhibition catalogue of Arnold Schoenberg's paintings at the Schirn Kunsthalle in Frankfurt. At the time, Majerus was in Los Angeles. Like the studio visits in Berlin, the e-mail shows him to be a very modest, reticent person but at the same time visionary, filled with a deeply rooted conviction of the need for new pictorial horizons and concepts of space in painting and of his own role and status within this framework. Michel Majerus was quite the opposite of the arrogant artist, but knew exactly what he wanted and why it was necessary. This arose not from theoretical considerations but from his visual experiences, observations and constantly handling the elements of painting on canvas. He was thus not a cerebral artist but a very cultivated one, whose work sprang from the act of painting. Nonetheless he probably constitutes the leading counter-position to the revival of expressionist styles in early 21st-century painting.

Majerus' spontaneous reaction to the per se anecdotal question as to his relationship with Schoenberg is interesting for two reasons. First, it may come as a surprise to find a 15-year-old being interested in Schoenberg's atonal period and seeing it as a reflection of his own

„der will, dass das die Leute verstehen sollen, oder dürfen, die sich mit Tonalität unwohl fühlen." Genau an einer solchen Schwelle oder Bruchstelle ist auch 90 Jahre später die Malerei von Michel Majerus angesiedelt. Auch sie richtet sich an Leute, die sich mit dem „Tonsystem" der Malerei der letzten 40 Jahre und dem Verhältnis von gemaltem Bild und Alltagswelt unwohl fühlen, ohne dass die neue Ästhetik schon vollständig ausgebildet und sichtbar wäre. Genau diese Schwelle oder Bruchstelle thematisiert das Werk von Michel Majerus, und es bezieht daraus auch seine Intensität und Wirkung. Dabei tritt es unprätentiös, aber mit großer Selbstverständlichkeit auf – „ich wünsche es niemandem, sich unbequem zu fühlen" –, denn das Werk wendet sich an diejenigen, die die Schwelle oder Bruchstelle in der Malerei und der Alltagsästhetik ebenso intensiv empfinden.

Der Satz „Seine [Schönbergs] Malerei nahm ich immer ein bisschen so wahr wie B-Seiten auf Schallplatten, was ich gerade deshalb auch interessant fand" ist zum einen eine hervorragende Charakterisierung der Ölbilder und Zeichnungen von Arnold Schönberg, die dieser zeitlebens als gleichwertig zu seinem musikalischen Schaffen betrachtete. Zum anderen aber enthält der schöne Satz auch einen interessanten Gesichtspunkt für Majerus' eigenes Werk, denn seine Malereien und Installationen treten gleichfalls wie „B-Seiten" auf, unterspielend, zumindest auf den ersten Blick ohne bedeutungsschwere Gesten, gleichsam beiläufig „heruntergeklopft" wie die Rückseiten von Hit-Singles, bei denen der eigentliche „Hit" dann locker und gelöst noch mal variiert und vorgetragen wird. Das war bei Michel Majerus' malerischer Geste eine durchgehende Methode, mit der er präziser als in der herkömmlichen Konfrontation mit der Leinwand an die visuellen Brüche der Gegenwart herankam, die ihn derart interessierten. Zugleich steht der Satz von den „B-Seiten" auch stellvertretend für die visuelle und musikalische Kultur dieser Künstlergeneration, in der Erfahrungen aller Stilrichtungen, Medien und ästhetischen Höhenlagen in besonders freier und hierarchieloser Weise nebeneinander stehen.

Diese Dokumente zeigen auch die ruhige Art von Michel Majerus, der nichts von einer Getriebenheit an sich hatte und dessen Lebensgeschichte man daher keinesfalls mit dem gehetzten „Zu-Ende-bringen-Wollen" vergleichen kann, das bei anderen früh verstorbenen Ausnahmetalenten der zeitgenössischen Kunst wie Yves Klein oder Piero Manzoni feststellbar war. Der Tod von Michel Majerus am 6.11.2002 war bloß ein idiotischer Unfall ohne wie immer gearteten Sinn, der einen

attitude to art: "he wants people who don't feel comfortable with tonality to understand, or be able to do so." It is just this threshold or brink that Majerus' painting occupies 90 years later. It is similarly directed at people who "don't feel comfortable" with the "tonal system" of painting in the last 40 years and the relationship between painted pictures and the everyday world, without the new aesthetic being completely developed and visible. It is precisely this threshold or brink that is the subject matter of Majerus' work, and it acquires its intensity and effect therefrom. It is an unpretentious art, but full of self-assurance – "I don't want anyone to feel uncomfortable" – because the work is directed at those who experience the threshold or brink in painting and everyday aesthetics just as intensely.

The sentence "I always looked on his [Schönberg's] painting as a bit like the B side of a record, which I found interesting just for that reason," is in itself an excellent description of Schoenberg's oil paintings and drawings. Schoenberg himself thought they were as good as his musical creations. But Majerus' dictum is also an interesting comment on his own work, because his paintings and installations also appear like "B sides", underplayed and at the first glance lacking in gestures of any import, knocked off casually like the second side of hit singles, where the actual hit is varied and re-recorded in a loose, relaxed version. That was a consistent thread in Majerus' gestus, a method by which he approached the visual fractures of the present day that particularly interested him more accurately than in the traditional confrontation with the canvas. The sentence about the B side is also representative of the visual and musical culture of this generation of artists, in which the experiences of all stylistic trends, media and aesthetic heights stand in a notably free and unhierarchical manner.

These documents also show the peaceable nature of Michel Majerus, who had nothing of the demonic urge about him and whose life story is in no way comparable with the agitated "let's end it all" of other prematurely deceased outstanding talents of contemporary art such as Yves Klein or Piero Manzoni. The death of Michel Majerus on 6 November 2002 was merely a stupid accident without any kind of meaning, that carried off a key artist of this generation at the height of his creative

zentralen Künstler dieser Generation mitten aus der Arbeit riss. Das Werk von Michel Majerus ist buchstäblich abgerissen, erscheint aber rückblickend als eines der wichtigsten und persönlichsten Statements zur Malerei an der Schwelle des Jahrhunderts. Michel Majerus war zum einen ein exemplarischer Künstler für die dichte kreative Situation im Berlin der zweiten Hälfte der 1990er Jahre. Er befand sich zu diesem Zeitpunkt in Berlin in einem ständigen Dialog mit einem guten Dutzend anderer großer Talente aus seiner Generation, die alle – ähnlich wie in den 1960er Jahren in Düsseldorf – einige Jahre zuvor den Weg nach Berlin aus den verschiedensten Himmelsrichtungen gefunden hatten. Damit bildete Berlin ab der Mitte der 1990er Jahre eine in Europa einzigartige Situation, ohne die dieses Werk nicht denkbar ist.

Zum anderen zeigt das Werk von Michel Majerus die Produktivität der luxemburgischen Situation im Bildungswesen, die die Studenten dazu zwingt, im Ausland zu studieren. In Stuttgart empfing Majerus entscheidende Anregungen bei Joseph Kosuth, dem Pionier und Vordenker der Concept Art, mit dessen Bildtafeln Majerus' Konzeption des zweidimensionalen Bildes enge Verbindungen aufweist, auch wenn letztere, insbesondere in den Installationen, in neue Definitionen des malerischen Raumes vorstößt. Aus seiner Herkunft aus einem Kleinstaat mit marginalisierten Sprachverhältnissen [4] bewahrte er sich zugleich die Verbindung von bescheidener Grundehrlichkeit mit einer visionären Grundhaltung.

Überblickt man sein Gesamtwerk, so faszinierte ihn vor allem die Macht des zweidimensionalen, statischen Bildes, das keinen Rahmen mehr hat und über die Vergrößerungsmöglichkeiten der Projektions- und Digitaltechnik zu einer zweiten Haut für Raumteile werden kann. Die Macht dieses zweidimensionalen Bildes ist sowohl in den malerischen Arbeiten als auch in den Installationen von Michel Majerus stark über Affekte ausgerichtet. Aus abstrakten oder öffentlichen Signets neue Affekte auszubauen, war sein eigentliches Thema. Über Affekte in der Malerei aber kann man nicht reden. So bleibt in der Sprache nur das untertreibende Statement, wie in seinem Textkommentar im Ausstellungskatalog von *Manifesta 2:* „Die Voraussetzungen von meiner Seite sind insofern neu, als das Thema inzwischen ja im wesentlichen schon Geschichte ist. Das gibt Raum für Neubewertungen."

powers. Majerus' work has been literally broken off, but in retrospect appears to be one of the most important and personal statements on painting on the threshold of the new century. Majerus was an excellent representative of the crowded, creative scene in Berlin in the second half of the 1990s. At the time in Berlin, he was in constant dialogue with at least a dozen other great talents from his generation, who all – similarly to the 1960s generation in Düsseldorf – had come together in Berlin from all points of the compass some years earlier. The result was that from the mid-1990s, the situation in Berlin was unique in Europe, without which this work is not conceivable.

However, Michel Majerus' oeuvre is also revealing of the productivity resulting from Luxembourg's education situation, which forces students to study abroad. In Stuttgart, Majerus was decisively influenced by Joseph Kosuth, the pioneer and father of Conceptual Art, and his concept of the two-dimensional picture shows close parallels with Kosuth's own works, even though they venture into new definitions of space in painting, particularly in the installations. From his origins in a small country with a marginalised language situation [4] he retained the combination of modest, fundamental honesty and a visionary attitude.

If we look at his work as a whole, what is most fascinating is the power of the two-dimensional, static image that no longer has a frame and thanks to the enlargement technology of projectors and digitalisation can become a second skin for parts of rooms. The power of this two-dimensional image, both in the painted works and the installations, is forcefully channelled through emotion. His actual idea was to construct new emotions from abstract or public icons. But one cannot talk of emotions in painting. In language therefore what remains is only the understated comment, as in his statement in the exhibition catalogue for *Manifesta 2:* "The assumptions on my side are new inasmuch as the subject has in fact basically become history. That leaves room for new evaluations."

Anmerkungen

1 Fax von Michel Majerus an Ulrike Groos, Projektleiterin (mit Enrico Lunghi) bei *Manifesta 2,* Berlin, 6.3.1998, Archiv Robert Fleck, Lannion.

2 Diese sehr persönliche, neue Bildsprache beherrschte er perfekt, wie sich drei Monate vorher in der brillanten Außenarbeit für die Ausstellung *Das Jahrhundert der künstlerischen Freiheit. 100 Jahre Secession* in Kooperation mit dem museum in progress in Wien gezeigt hatte.

3 E-Mail von Michel Majerus an den Autor, Los Angeles, 26.8.2001, Archiv Robert Fleck, Lannion.

4 Deutsch und Französisch sind in Luxemburg zugleich Alltags- und Fremd-sprachen gegenüber der luxemburgischen Muttersprache, die nur von 200000 Menschen gesprochen wird.

Notes

1 Fax from Michel Majerus to Ulrike Groos, project leader (with Enrico Lunghi) at *Manifesta 2,* Berlin, 6.3.1998, Robert Fleck Archive, Lannion.

2 He had total mastery of this very personal new visual idiom, as had been evident three months earlier in the brilliant exterior work for the *Jahrhundert der künstlerischen Freiheit. 100 Jahre Secession* exhibition in Vienna, in co-operation with the museum in progress in Vienna.

3 E-mail from Michel Majerus to the present author, Los Angeles, 26.8.2001, Robert Fleck Archive, Lannion.

4 In Luxembourg, German and French are both everyday languages and foreign languages vis-à-vis the Luxembourg mother tongue, which is only spoken by 200000.

Veit Loers
Splash Bombs
Zur Malerei von Michel Majerus
Splash Bombs
On the Painting of Michel Majerus

Veit Loers, Studium der Kunstgeschichte und Philosophie in München/DE und Wien/AT.

Ab 1981 Leiter der Städtischen Galerie Regensburg, ab 1987 Künstlerischer Direktor des Museum Fridericianum Kassel, 1995–2003 Direktor Museum Abteiberg Mönchengladbach; 2000–2002 Bundeskurator für die Sammlung zeitgenössische Kunst.

Zahlreiche Ausstellungen von moderner und Gegenwartskunst, u.a. *Schlaf der Vernunft,* 1988, Joseph Beuys, documenta-Arbeit 1993, Martin Kippenberger, 1997, *actionbutton,* 2003.

Veit Loers, studied the history of art and philosophy in Munich/DE and Vienna/AT.

He has been variously head of the Städtische Galerie in Regensburg (from 1987), art director of the Fridericianum Museum in Kassel (from 1987), director of the Abteiberg Museum in Mönchengladbach (1995–2003), and federal curator for the Contemporary Art Collection (2000–2002).

He has curated numerous exhibitions of modern and contemporary art, including *Schlaf der Vernunft,* 1988, Joseph Beuys, documenta work 1993, Martin Kippenberger, 1997 and *actionbutton,* 2003.

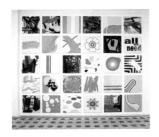

Fig. 1 Installationsansicht
fertiggestellt zur zufriedenheit aller,
die bedenken haben,
neugerriemschneider, Berlin 1996

Fig. 1 Installation view
fertiggestellt zur zufriedenheit aller,
die bedenken haben,
neugerriemschneider, Berlin 1996

Für eine kunsthistorische Würdigung der Malerei des früh verstorbenen Michel Majerus mag es noch zu früh sein. Weder wissen wir, welche Rolle man der Malerei der 1990er Jahre zuweisen kann, noch wissen wir, wer ihre wichtigsten Repräsentanten sein werden. Aber langsam lichtet sich das hermeneutische Dunkel, das entsteht, wenn die künstlerischen Events verblassen.

Das Erbe von Martin Kippenberger konnte er nicht antreten. Michel Majerus war anders: poetischer und wesentlich verliebter in die Malerei, auch wenn er gleichzeitig immer nach Möglichkeiten suchte, sie im Sinne der Factory Warhols zu objektivieren und sich von ihr kritisch und ironisch zu distanzieren. Anders als Kippenberger benutzte er die technischen Mittel der Reklamemalerei, um sich in der Perfektion der Kunstproduktion einzunisten und nicht, um wie dieser Meister des Dilettantentums zu werden. Die Ironie von Majerus war verspielter, aber gleichzeitig distanzierter. Den Faktor Comic setzte er zum Beispiel nicht ein, um eine Aussage zu treffen, sondern um mit dessen Sprache der künstlerischen Abstraktion ein Äquivalent an die Seite zu setzen, das sich ebenfalls an der Oberfläche des Bildträgers abspielte, sowohl gedanklich als auch faktisch. Und es fragt sich, ob die mosaikhaften Anordnungen von 60 × 60 cm Formaten mit ihrer universalistischen Bilderzählung einer verflossenen Avantgarde – a link to the past[1] – nicht darauf abzielten, jedes Bildmuster und jeden Inhalt zu egalisieren, um festzustellen, dass in diesem immerwährenden Pop ein Sampler nicht von Kunst, sondern von Bildern überhaupt geschaffen werden konnte. Mit seinen Galeriefreunden Tobias Rehberger, Franz Ackermann und Jorge Pardo hatte er einiges gemeinsam. Mit Rehberger die Vorliebe für Flächen und Versatzstücke als Design-Metapher, mit Ackermann die Wandmalerei und den Auftritt der Inszenierungen, mit Pardo die manipulative Verwendung des PC-Photoshops. Der Malereibegriff von Majerus war von allem Anfang an offen für Wall Painting, für farbige Objekte und für Schriften. Aber er geizte nicht mit Bildern, malte in seinen kleinen Ateliers die Einzelteile seiner großen Paneele, die er nur außen oder im Ausstellungsraum zum Gesamtbild zusammensetzen konnte. Die junge wiedererstarkte Malerei der 1980er Jahre war in der zweiten Hälfte des Jahrzehnts zu einem dünnen akademischen Konstrukt erstarrt, das sich Neo-Geo nannte. Ungeachtet dessen wurde an den Akademien immer noch oder auch wieder figurativ gemalt. Mit einem kleinen Unterschied. Kräftiger Pinselstrich und/oder monochromer Farbauftrag wichen gegenständ-

It is probably too soon for an art-historical evaluation of Michel Majerus who recently died at an early age. We know neither how the painting of the 1990s will be viewed nor do we know who its most important representatives will be. But light is slowly penetrating the hermeneutic gloom that inevitably arises as the artistic events fade from life.

Majerus could not pick up where Martin Kippenberger left off. He was of a different mould – more poetic and altogether more in love with painting, even if he was at the same time always looking for opportunities to objectivise it like Warhol's Factory and take a critical, ironically distanced view of it. Unlike Kippenberger, he made use of the technical resources of advertising art in order to ensconce himself in the perfection of art production rather than to become a master of dilettantism like the older artist. Majerus' use of irony was more playful but at the same time more aloof. He did not, for example, use the comic-strip element to get the message across but used its idiom of abstraction to put the equivalent on the page, where it all happened in both a factual and intellectual sense. One may wonder whether the mosaic-like layouts of 60 × 60 cm formats with their universalist picture narratives of a bygone avant-garde – a link to the past[1] – were not in fact intended to level out every pictorial precedent and every type of subject matter in order to establish that evergreen Pop could act as a sampler not just of art but of any picture you like. Some things Majerus had in common with his gallery associates Tobias Rehberger, Franz Ackermann and Jorge Pardo. With Rehberger he shared a fondness for surfaces and set pieces as a design metaphor. With Ackermann, it was a liking for wall paintings and backdrops, while with Pardo it was a predilection for Photoshop manipulations on the PC. Majerus' notion of painting was from the first overtly about wall painting, coloured objects and writing. But he did not stint with the pictures. He painted the individual parts of his large panels in his tiny studio, but could only put them together as a whole outside or in the exhibition room. By the second half of the decade, the newly revived fashion for painting in the 1980s had ossified into a thin, academic construct called Neo-Geo. Regardless thereof, academic institutions went on or resumed painting figuratively – with one small exception. Bold brushstrokes and/or the monochrome application of paint gave way to more object-based pictures

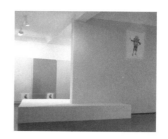

lichen Bildern, die das Bild und nicht den malerischen Ausdruck meinten. Diese Bilder konnten Teil eines Kontext-Concepts sein, wie es in den frühen 1990er Jahren gängig wurde. An der Stuttgarter Akademie arbeiteten Michel Majerus und seine Malerfreunde Stephan Jung und Wawa Tokarski an solchen Konzepten. Das erklärt auch die Einbeziehung der Schrift in Form von Worten und Texten in Installationen und Bilder in der Tradition von Lawrence Weiner, Ed Ruscha, John Baldessari, Joseph Kosuth (einem der Lehrer von Majerus) und jüngeren Künstlern wie Jenny Holzer, Barbara Kruger oder Kay Rosen. In wandfüllenden Bildern hatte Majerus erstmals um 1995/96 sein bildnerisches Programm repräsentativ ausgebreitet, nachdem er zunächst mit Asphalt über dem Galerieboden und Tuschezeichnungen am Laufmeter bei neugerriemschneider in Berlin reüssiert hatte. Erst den Auftritt proben, dann die Bilder malen. So groß und so schnell wie Michel Majerus schaffte dies kaum jemand. Natürlich nicht in Öl, sondern Acryl. In seiner ersten großen Einzelausstellung in der Kunsthalle Basel (1996) ist das schnell gemalte Bild Anlass für eine ikonologische Inszenierung, in der nicht nur im Sinne von Folk das figurative Bild als Comic auftritt und das abstrakte als eine Art Wanddekoration, sondern, wo Streifen und Images die wechselvolle Geschichte von High und Low Culture aneinander reihen, von Avantgarde und Mottentod. Majerus spricht im Hinblick darauf von Codes, die er in seine Bilder einbaut, „um sie im gleichen Moment wieder zu unterlaufen oder wie ein Hacker zu entschlüsseln".[2] Der ehrwürdige große Saal des Basler Kunstvereins wird zur Multikultihalle, in der auch der Parkettboden durch Metallroste verdeckt und damit synchronisiert wird, eine All-Over-Inszenierung, die Majerus in anderer Weise auch noch später einsetzen wird. „Ich glaube nicht an eine bestimmte Form von Unmittelbarkeit", bemerkte der Künstler.[3] Man sprach damals noch vom Zitat, vom Iterativismus und dem Ready-Made-Effekt der Malerei. Heute ist mit dem Begriff der Referenz das ganze Kapitel abgedeckt, von Daniel Richter bis zu Cerith Wyn Evans.

In seiner Ausstellung in der Galerie Monika Sprüth in Köln 1996/97 waren Teile von Comics mit Kaskadierungen aus dem Photoshop geklont sowie mit gestischen Farbverschlingungen und abstrakten Farbflächen kombiniert – und das alles auf einem wandfüllenden Riesenformat (*MoM-Block I,* 1996). Dazu zeigte er in der Größe von Apple-Verpackungen eine Neuversion von Warhols *Brillo-Boxen* mit Comics sowie Logos der Techno-DJ's Jeff Mills und Richie Hawtin.[4] Im gleichen Jahr

that were about images and not painterly expression. Such pictures could be part of a context-concept such as became popular in the early 1990s. Michel Majerus and his painter friends Stephan Jung and Wawa Tokarski worked at concepts of this kind at the academy in Stuttgart. That explains the introduction of writing in the form of words and texts in installations and pictures in the tradition of Lawrence Weiner, Ed Ruscha, John Baldessari, Joseph Kosuth (one of Majerus' teachers) and younger artists such as Jenny Holzer, Barbara Kruger or Kay Rosen. Majerus first set out his artistic stall to the public around 1995/96, after previously doing a trial run at the neugerriemschneider gallery in Berlin with asphalt on the floor and drawings per running meters. First try out the presentation, then paint the pictures. Michel Majerus did this on a scale and with a facility second to none. Not in oils, of course, but in acrylics. In his first large solo exhibition at the Kunsthalle Basle (1996), the hastily painted picture was the occasion for an iconological show in which figurative art featured as a comic strip and abstraction as a kind of wall decoration not only in a folk sense but – with strips and images stringing together the changing histories of high and low culture, of avant-garde und defunct past. Referring to this, Majerus spoke of codes that he built into his pictures "while simultaneously undermining them or decoding them like a hacker".[2] The venerable hall of the Basler Kunstverein became a multi-culti venue, with even the parquet flooring being covered with metal grates and thereby synchronised into an all-over setting that Majerus would later use in other ways. "I don't believe in any particular form of directness," he once remarked.[3] At the time, one spoke of quotations, "iterativism" and the ready-made effect of painting. These days the whole field from Daniel Richter to Cerith Wyn Evans is encompassed in the term "reference".

In his exhibition at the Gallery Monika Sprüth in Cologne in 1996/97 there were parts of comics cloned with cascadings from Photoshop and combined with tangles of gestural paint and abstract colour surfaces – again, all in a huge wall-filling format (*MoM-Block I,* 1996). He also showed a new version of Warhol's *Brillo Boxes* in the size of Apple packaging, with comics and logos of the techno DJs Jeff Mills and Richie Hawtin.[4] In the same year, room dividers in the Grazer Kunstverein became monochrome pictures and monochrome pictures became painted wall

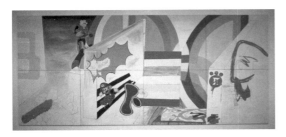

werden im Grazer Kunstverein Raumteiler zu monochromen Bildern und monochrome Bilder zu farbigen Wandabdeckungen, freilich mit aufgedruckten Comics. Bodenteile erinnern vage an die Morris-Inszenierungen der 1960er Jahre und die Bilder selbst, etwa der große *MoM-Block II,* 1996 (benannt nach dem Modezentrum Mitte, das sich vor ihm in seinem Atelier befand) thematisiert zum Teil noch nicht bemalte Ausstellungswände. Super Mario betritt vorsichtigen Schritts ein Level mit Streifen, um vor den Streifen Frank Stellas nicht zu kapitulieren. Die sophistische Kombinatorik des zeitweise leidenschaftlichen Nintendo-Spielers Majerus bleibt ein Laboratorium der Postavantgarde, obwohl bereits viele Register seiner Auftritte in den Jahren danach gezogen sind. Zu diesen gehören die Raumgliederungen der Ausstellung *Space Safari* in der Tornberg Gallery in Lund, Schweden (1997). Jetzt wird die Galerie selbst mit Wandmalerei und Pfeilern miteinbezogen, denen man die Schriften ROOM1, 2 und Accessoires entnimmt, während auf den Gemälden an der Wand die üblichen minimalistischen und informellen Muster zu sehen sind. Man sieht also Malerei räumlich auseinander gefächert und determiniert durch Anordnung: An den Wänden hängen Bilder, die ein vages Gefühl von Moderne verbreiten, unterkühlt und in Relation zu den Raumelementen. In der Ausstellung *German Open* (1999) im Kunstmuseum Wolfsburg hat Majerus seinen Mammutauftritt – entsprechend den Gegebenheiten der dortigen monströsen Museumsarchitektur. Den Entwurf seiner farbigen Wandinstallation entnimmt er, zumindest in der Anlage, dem Cover des Ausstellungskatalogs *Die Schule von Athen,* zu dem ich ihn kurz zuvor beauftragt hatte.[5] Die dort auftretende eckige Schrift, von der Majerus nur wenige Buchstaben auf einem Plakat sah, während er den Rest dazu erfand, sollte dann später bei den Los-Angeles-Bildern eine große Rolle spielen. Das Image der Wolfsburger Ausstellung mit ihrer Design-Haltung war trotz der Teilnahme wichtiger junger Künstlerinnen und Künstler der Höhepunkt von Ausstellungsinszenierungen im Easy-Stil, die Majerus mit seinem Installations-Slogan im Nachhinein richtig gesehen hatte: „what looks good today may not look good tomorrow". Für die Malerei des Künstlers wurden in der Folge die auf Bilder oder die Wand geschriebenen Slogans immer wichtiger, da sie – wie zuvor die Bildcodes – sich gegenseitig verstärken oder aber aufheben. Seit 1998 entwickelte er aus Buttons wie in Werbespots sich drehende Kugeln mit Umschriften. Eine riesige Wandinstallation im Münchner Hauptbahnhof mit solchen Kugeln vor einer Carrera-Bahn hieß *Beschleunigung.* In Interviews wurde Michel Majerus hinsichtlich seiner Produk-

coverings, with of course comic printed on. Parts of the floor were vaguely reminiscent of Morris scenarios of the 1960s and the pictures themselves – for example the large *MoM Block II,* 1996 (named after the Modezentrum Mitte outside his studio) – adopted the still partly unpainted exhibition walls as subject matter. Super Mario made a cautious entry on the comic strip level so as not to capitulate to Frank Stella's strips. The sophistic, mixed rhetoric used by Majerus, who was at one point a passionate Nintendo player, was a laboratory of the post-avant-garde, although many elements used in his later presentations were already well known. These include the spatial arrangements of the *Space Safari* exhibition at Tornberg Gallery in Lund, Sweden (1997). Here the gallery itself was involved in the form of wall painting and piers, their labels ROOM1, 2 and accessories being removed, while the paintings on the walls showed the usual minimalist and informal works. Painting was thus spatially fanned out and divided by arrangement. The pictures on the walls disseminated a vague feeling of modernism, subdued and in relation to the room elements. Majerus had his grand presentation at the *German Open* exhibition (1999) at the Kunstmuseum Wolfsburg, quite in keeping with the characteristics of the monstrous museum architecture there. He took the design of his coloured wall installation, at least in general layout, from the cover of the *School of Athens* catalogue I had commissioned from him shortly before.[5] The angular script there, which Majerus saw only a few letters of on a poster and invented the rest himself, would later feature prominently in the Los Angeles pictures. The image of the Wolfsburg exhibition with its designer attitude was, despite the participation of important young artists, the peak of easy-style exhibition settings, as Majerus rightly appreciated in retrospect with his installation slogan "what looks good today may not look good tomorrow". In his subsequent paintings, the slogans written on pictures or on the wall became more and more important as, like the pictorial codes, they mutually reinforced or cancelled each other out. From 1998, he used buttons to create revolving spheres with inscriptions like those in advertising spots. A huge wall installation at Munich's central station showing such spheres in front of a Carrera toy racetrack was called *Beschleunigung.* In interviews, Majerus was constantly asked about the concept of speed in relation to his productions – the term had oddly come into vogue in

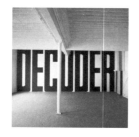

Fig. 5 *decoder,* 1996
Installationsansicht *produce-reduce-reuse,*
Galerie Karl Heinz Meyer, Karlsruhe, 1996

Fig. 5 *decoder,* 1996
Installation view *produce-reduce-reuse,*
Galerie Karl Heinz Meyer, Karlsruhe, 1996

tionen immer wieder zum Begriff der Schnelligkeit befragt, der in den 1990er Jahren durch Paul Virilio eine eigene Popularität erhalten hatte. Er selbst argumentierte lieber mit Begriffen wie Verfallszeit, der „Chemie" eines Werkblocks, den „Andock-möglichkeiten" oder der „Ökonomie der Produktion". Dem ehrfurchtsvollen Verneigen vor der Minimal Art setzte er das entgegen, was von ihr geblieben war: Entweder ihre völlige Durchmischung mit einem minimalistischen Design oder die Verarbeitung von Erinnerung wie ein Chip.

„Aus dem Grund tendiere ich gerne dazu, Ausgangsmaterial zu wählen, das eine solche Leere bereits ausgefüllt hat, allgemein als Überfüllung gelesen wird, im Eigentlichen aber die gleiche Leere meint". Derart semantisch ambivalent dozierte Michel Majerus in einem Interview mit Raimar Stange **6**. Wie in einem *Leuchtland* (Titel der Ausstellung in der Friedrich-Petzel-Gallery, New York, 2002) imaginierte er damit die Ästhetik Andy Warhols, der natürlich so etwas nie gesagt hätte. Dass Majerus es sagte, kennzeichnete ihn als deutschen oder besser europäischen Diskurs-Romantiker, der in der Tradition Hegelscher Dialektik die im Zusammenhang stehenden Teile erst ausdifferenzierte, um sie dann umzukehren und in der Negation/Position zu belassen als Message im Sinne McLuhans. Aber nicht nur das Umpolen der Vorlagen und Inhalte, sondern das Verändern ihrer Wertigkeit im Gesamtgefüge strebte Majerus an. Damit begab er sich in die konzeptuelle Nähe von Künstlern wie Lawrence Weiner. Sein Drahtseilakt war, eine Malerei der Fülle mit Leere zu durchsetzen und ihr sowohl im „Display" als auch im Displacement einen Ort zuzuweisen, der im Spiel zwischen Realität und Fiktion virtuell blieb wie das Programm seines Notebooks. Der Poet und Fabulierer Michel Majerus blieb immer sein eigener, beinahe zynischer Skeptiker, nicht festlegbar auf seine Strategien, gleichzeitig einer, der an der Einheitlichkeit der Oberfläche und der Oberflächlichkeit festhalten wollte. Ein Unentschlossener aus Einsicht sozusagen.

Um so merkwürdiger wirkt eine Gruppe von großen Bildern, die im Jahre 2000 entstanden. Sie ist ziemlich pastos gemalt und setzt im Gegensatz zu früheren Gemälden und dem späteren Los-Angeles-Block auf malerische Konsistenz. Es ist weniger die erwähnte Dialektik von cooler Designer-Oberfläche und artifizieller Geste als eine durchgängige depressive Schwere, die auf ihnen lastet. So liest man auch auf einem großen Button DEPRESSIVE NEUROSIS. Ein weißes Bild mit schwarzen Chiffren offeriert neben Totenkopf und schreiendem

the 1990s thanks to Jacques Derrida. He himself preferred to argue using terms such as "best-before", the "chemistry" of a block of work, "docking opportunities" or "economy of production". He countered the awed approach to Minimal Art with what was left of it – either completely mixed up with a Minimalist design or processed memory like a chip.

"Basically, I tend to choose raw material that has already filled a vacuum of that kind and is generally seen as too much, but actually means the same vacuum." Majerus held forth in an opaque vein like this in an interview with Raimar Stange **6**. As in a *Leuchtland* (the title of a Majerus installation at the Friedrich Petzel Gallery, New York, 2002) he imagined he was conjuring up Andy Warhol's aesthetic, though Warhol had of course never said any such thing. That Majerus said it stamped him as a proponent of German (or European) romantic discourse, who in the tradition of Hegelian dialectics first distinguished the parts connected with each other, only to turn them round and leave them in negation/ position as a message in the sense of Marshall McLuhan. But Majerus was also striving not just to reverse the polarity of sources and content but also to change their importance in the total structure. That is why he ventured into the conceptual proximity of artists such as Lawrence Weiner. His high-wire act was to achieve a style of richness with a vacuum, allocating to it both in the "display" and the displacement a location that, in the interplay of reality and fiction, remained virtual like the programme in his notebook. As poet and storyteller, Michel Majerus always remained his own person, an almost cynical sceptic who could not be pinned down as to his strategies but at the same time was someone minded to capture the homogeneity of surface and superficiality. One might call him "undecided" through insight.

A group of pictures dating from 2000 is therefore all the more remarkable. They are painted in a rather pasty way, and in contrast to earlier pictures and the later Los Angeles set they display scrupulous painterly consistency. This is not so much the dialectic of cool designer surface and artificial gesture mentioned earlier as a pervading oppressive heaviness weighing upon them. One button says for example DEPRESSIVE NEUROSIS. Along with a skull and screaming comic posturing, a white picture with black characters serves up gloomy prognoses of the future such as "fuck", "out" and "(g)enug".

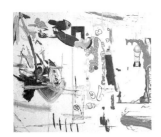

Comic-Gehabe düstere Prognosen eines No Future wie „fuck", „out" und „(g)enug". Auch das in brandigen Farben gemalte *another flowershop,* 2001 – die von einem DDR-Tassendekor übernommene Blume kennt man schon von früheren Bildern – beunruhigt durch zwei Kreise, die als Augen aus dem informellen Malkontext herausstechen. Am speziellsten aber ist das *hell copter,* 2000, betitelte Bild, das Folklore-Elemente mit destruktiven Tattoo- oder Graffiti-Fragmenten auf weißem Grund verbindet. Neben dem Titellogo fährt eine Rakete (Bombe) nach unten. Es gibt ein weniger bekanntes Computer-Spiel mit identischem Titel und ähnlichen Images. Schließlich enthält eine von Herzen umgebene Kartusche das Wort „(c)ollection". Neben einem Papagei erkennt man eine makabre Fratze im Stil Asger Jorns oder der mit ihm in Verbindung stehenden Gruppe SPUR. Die Überleitung zur Los-Angeles-Serie des nächsten Jahres stellt eine Gruppe von sieben miteinander verwandten Bilder dar, deren horizontal und vertikal frei gemalte Streifen sich durch ihre nihilistischen Schriften aufeinander beziehen: *all force no thought – all thought no control,* 2002. Ein ironischer Kommentar auf die gestisch-abstrakte Malerei, der er sich selbst verschreibt, um sie dann – eben mit der Schrift – wie in einem Paradigmenwechsel zu durchbrechen, jedoch in der Sprache der Malerei zu bleiben. Doch ist es bedeutsam, dass Majerus in Los Angeles diesen Typus von Malerei nur noch marginal fortsetzte, etwa im Bild *slayer,* 2001. Eine neue konzeptuelle Transparenz wird die Malerei des Jahres 2001 definieren.

In LA, wohin er ein daad-Stipendium erhalten hatte, entstanden im Jahr vor seinem jähen Tod 2002 27 großformatige Bilder **7**, alle im Format 280 × 400 cm, die er gerollt nach Berlin zurückschickte, nicht nur um Transportkosten zu sparen, sondern weil er sie sonst nie und nimmer in sein Kreuzberger Atelier bekommen hätte. In diesen Bildern ist so manches, was er zuvor in Wandmalerei oder Rauminstallation verwirklicht hatte, in die Bilder selbst gepackt, die Auseinandersetzung mit Schrift, Bedeutung und Farbe, mit Determiniertheit und Fake. Das Bild sozusagen als Laboratorium und Projektion des Innenlebens im White Cube, in dem die Begriffe von Leben und Tod nur gefiltert herein kommen und am Ende zu Gebrauchsanordnungen für die eigene Malerei werden.

Aber lassen wir die Bilder selbst sprechen. Das erste Gemälde war ein überdimensionales aus vier Teilen zusammengesetztes Bild im Format 560 × 800 cm mit dem Titel: *you know, you've got a bad habit, you breathe,* 2001.**8** Das Riesenformat mit

Another flowershop, 2001, is painted in flaming colours – the pattern is taken from East German painted tea-cups and is familiar from earlier Majerus pictures – and disturbs because of two circles that stand out as eyes in the informal painting context. The most singular picture in the group is however the one called *hell copter,* 2000, which links folklore elements with destructive fragments of tattoos or graffiti on a white background. Alongside the title logo a rocket (bomb) plunges earthwards. There is an obscure computer game with the identical title and similar images. Finally, a cartouche surrounded by hearts contains the word "(c)ollection". Beside a parrot we can make out a macabre face in the style of Asger Jorn or the SPUR Group associated with him. A group of seven closely related pictures constitutes the transition to the Los Angeles series, their horizontal and vertical freehand stripes being related to each other by nihilistic inscriptions (*all force no thought – all thought no control,* 2002) – an ironic commentary on the same gestural abstract painting which he prescribes himself, only to break through it with the writing, as in a change of paradigms, while still remaining in the idiom of painting. Yet it is significant that, in Los Angeles, Majerus continued this type of painting only marginally, for example in *slayer,* 2001. A new conceptual transparency would define the painting of 2001.

In the year before his sudden death, working in LA, where he went on a DAAD scholarship, he did 27 large-format pictures (all 280 × 400 cm) **7**, which he sent back to Berlin rolled up not just to save transport costs but be-cause otherwise he would never have gotten them into his studio in Kreuzberg. These pictures pack in so much that he had previously put into effect in wall paintings or room installations – the focus on writing, meaning and colour, the interest in the pre-determined and the fake. The picture is as it were a laboratory and projection of the inner life of the white cube, into which the concepts of life and death enter only in filtered form and ultimately become user instructions for his own painting.

But the pictures can speak for themselves. The first painting was an outsize picture in four parts measuring 560 × 800 cm called *you know, you've got a bad habit, you breathe,* 2001.**8** This huge format with its cynical title consists of colour strips in the basic colours of modernism, the primary colours red, yellow and blue, on a white

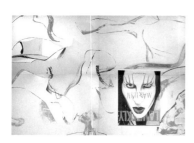

Fig. 7 *you know, you've got a bad habit, you breath,* 2001

dem zynischen Titel besteht aus Farbschleifen in den Grund-farben der Moderne, den Primaries Rot – Gelb – Blau vor wei-ßem Grund. Im rechten unteren Teil sieht man das Cover der Zeitschrift *LA Weekly,* auf dem ein diabolisches Porträt des Sängers Marilyn Manson zu sehen ist. Auch die Malerei unter-scheidet sich: einerseits die Pinselschlieren und die gestische abstrakte Malerei, die jedoch zum Teil abgeklebt ist, dann das realistisch gemalte weiße Gesicht des geschminkten Stars, das beinahe wie ein Alter Ego von Majerus selbst aussieht. Zwei total gegensätzliche Bilder, die sich tatsächlich zu so etwas wie einer Transvestiten-Moderne aufladen, während die Bilder, die in der Folge entstanden, das Genre der düster-schrägen Los-Angeles-Kunsttradition nur in den gemalten Worten und ihren Bedeutungen wiedergeben. Die Malerei bleibt eine Fortsetzung dessen, was Majerus zuvor in Angriff genommen hatte: eine farbige poetische Bildwelt, deren Motto im Bild *popsicle,* 2001, zum Ausdruck kommt. In Tom-Wesselmann-Ambiente ist der Sticker des Ice-Lolly als räum-liches Schild ins Bild gesetzt, während weiße Pinselstriche und -kleckse wie nachträgliche Flusen herumfliegen und nicht nur dem Pop-Motto Historizität verleihen, sondern auch der Bildidee von Majerus selbst, gestische Malerei mit fotorealis-tischer zu verbinden. In *popsicle,* 2001, wird nicht nur „Pop for ever" verkündet, sondern auch die perspektivische Compu-teranimation der Fernseh-Werbung übernommen. Tatsächlich schieben sich nun die Schriften als die Leitmotive der Bilder analog wie Animationen ins „Bild" oder sie erscheinen wie in einem elektronischen Schriftband. In einem zweiten „pop-sicle"-Bild mit dem Titel *load,* 2001, ist das Motiv in die Ecke gerückt und mit den Wörtern „load" und „allover" verbunden. *Blood allover,* 2001, heißt ein anderes Bild der Serie, das sich als Antithese ins Bild schleicht, während die Bedeutung des Allover-Painting durch *load,* 2001, virtuell angedacht ist: denn die rechte untere Hälfte ist nicht ausgemalt. Freie Pinsel-striche, die über dem „popsicle" lagern, sind an dieser Stelle noch Malerei in statu nascendi. Das Bild wird an dieser Stelle noch wie das Attachment einer Mail aufgeladen. Wie im eingangs angeführten Zitat des Künstlers begegnet sich die Leere innerhalb der Fülle mit der tatsächlichen Leere.

Insgesamt fällt auf, dass die LA-Bilder von Michel Majerus nicht zu viele Saiten anschlagen, sondern sich bis auf wenige Ausnahmen auf Themen und Slogans beschränken, die sich gegenseitig durchdringen. Neben dem „popsicle" und „allover" sind dies Begriffe und deren gestalterische Artikulation wie z.B. „splash bombs", „slayer", „die-cast", „painkiller" oder „your

background. In the right hand lower part the cover of *LA Weekly* magazine can be seen, showing a diabolical portrait of the singer Marilyn Manson. The painting is also differentiated – on the one hand the streaks of brushwork and the gestural abstract painting (though in fact partly masked off), on the other hand the realistically painted, heavily made-up white face of the star, which almost looks like an alter ego of Majerus himself – two totally contrasting images, that in fact are charged with a kind of transvestite modernism, whereas the subsequent pictures reflect the LA sombre/weird art genre only in the painted words and their meanings. The painting style remains a continuation of what Majerus had embarked on earlier – a colourful, poetic pictorial world, whose motto is expressed in the picture *popsicle,* 2001. In a Tom Wesselmann setting, the sticker of the ice lolly is placed in the picture as a spatial sign, whereas white brushstrokes and blobs fly around like so much added fluff, not only lending the pop motto historicity but also tying in with Majerus' own pictorial idea of combining gestural painting and photorealism. *popsicle,* 2001, not only proclaims "Pop forever" but has also taken over the computer animation perspective of TV advertising. In fact, the inscriptions now come up as leitmotifs of the pictures analogous to ani-mations, or they appear like an electronic news strip. In a second "popsicle" picture called *load,* 2001 the motif has moved to the corner and become combined with the words "load" and "allover". Another picture in the series is called *blood allover,* 2001, creeping into the frame as an antithesis, while the *load,* 2001, gives the allover painting a virtual meaning, because the lower right half is not painted in. Freehand brushstrokes overlaying the *popsicle* are in effect painting *in statu nascendi* at this point. Here, the picture is still being loaded like the attachment to an e-mail. As in the quotation from the artist earlier on, emp-tiness within the fullness encounters the actual emptiness.

Overall, it is noticeable that Majerus' LA pictures do not strike many strings. For the most part, they are limited to themes and slogans that mutually interlock. Along with "popsicle" and "allover", they are concepts articulated in terms of design, such as "splash bombs", "slayer", "die-cast", "painkiller" or "your ideas get you killed", as if the artist had run out of subject matter or hidden himself away in his studio in this huge city.

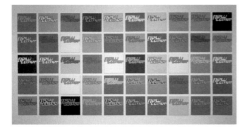

Fig. 8 *newcomer,* 2001

Veit Loers 192 193

ideas get you killed". So, als wäre dem Künstler der Stoff ausgegangen oder als hätte er sich in dieser riesigen Stadt ins Atelier verkrochen.

Michel Majerus fehlte es jedoch in Los Angeles nicht an äußeren Eindrücken. Zunächst war er genervt, sich nur mit der Organisation seines Aufenthalts beschäftigen zu müssen: Atelier, Autokauf, Versicherungen, Aufenthaltsgenehmigung etc. Dann musste er den Kontakt mit seinem Assistenten in Berlin, Bastian Krondorfer, via Mail herstellen, wobei es längere Zeit dauerte, bis die Attachments mit präzise erarbeiteten Computer-Bildern wie *newcomer,* 2001, auch ankamen, da die verschiedenen Programme nicht kompatibel waren.[9] Aber aus den ersten enttäuschten Prognosen „ich weiss nicht ob mich LA jemals interessieren wird"[10] bis zu den Beschreibungen kurz vor der Heimreise – schon unter dem Eindruck des 11. Septembers – „it's like a movie, it's very scenic" oder „it's like walking through the Universal Studios"[11] – lag eine erlebnisreiche Zeit, in der er nicht nur der Beobachter einer für ihn faszinierenden und gleichzeitig grotesken Welt war, sondern selbst eine Rolle darin übernahm. Eine Rolle, die er stets von innen und außen reflektierte. In einem Mail an Heike Föll schreibt er:

„Gestern lag ich im Atelier auf dem Boden auf einem schönen warmen Styroporklotz und hab auf meinem Laptop ‚fallen angels' von Wong Kar Wei angeschaut, und währenddessen ist der Tag dunkel geworden, und ich habe auf dem Boden ein bisschen gedöst. Ich habe ab und zu mal ein Telefon klingeln hören […] Die Stimmung im Film kam dem sehr nahe, wie ich mich hier liegend von aussen beobachten könnte, alleine und diese ausufernde Stadt um mich rum. Die richtigen Filme im richtigen Moment sind einfach das Beste."[12]

Michel Majerus bewegte sich während seines LA-Aufenthalts lautlos, aber zielsicher. Er hatte vor allem den engen Kontakt zu seinem Galerie-Freund Jorge Pardo, der in Los Angeles sein Haus als Art Piece erbaut hatte, und er frischte andere Kontakte auf. Vom 40. Geburtstag Benedikt Taschens listet er Namen wie Helmut Newton, Jeff Koons und Mike Kelley auf und berichtet, dass ihn die New Yorker Galeristin Barbara Gladstone mit einer bekannten Kuratorin besuchen kam, während in seinem Berliner Atelier amerikanische und deutsche Sammler Bilder sehen wollten. Dass Michel Majerus während seiner Absenz in Berlin seine Ausstellungen in Europa einhalten will und auch einhält, ist der professionelle Plan

Not that Majerus was short of external stimuli in Los Angeles. At first he was irritated at having to deal with organising his stay – getting a studio, buying a car, arranging insurance and a residence permit, etc. Then he had to get things set up with his assistant in Berlin, Bastian Krondorfer, by e-mail – it took some time for the attachments with the meticulously processed computer images such as *newcomer,* 2001, to finally arrive, as the various programmes were not compatible.[9] But LA proved an eventful experience, from the first disappointed reactions ("I don't know if LA will ever interest me"[10]) to the descriptions shortly before he left for home, with 9/11 already history ("it's like a movie, it's very scenic" or "it's like walking through Universal Studios"[11]). He was not just an observer in what was for him a fascinating and at the same time grotesque world, but had his own part to play in it. It was a part he mulled over internally and depicted outwardly. In an e-mail to Heike Föll, he wrote:

"Yesterday I lay on the floor in the studio, on a nice warm piece of polystyrene and watched fallen angels by Wong Kar Wei on my laptop, and as I lay there it got dark and I dozed off there on the floor. From time to time I heard the phone ringing […] The atmosphere in the film was very much like what I was observing externally there on the floor, alone in this overspilling city around me. The right films at the right time are simply the best."[12]

During his stay in LA, Majerus moved around silently but surefootedly. He was in close contact mainly with his gallery friend Jorge Pardo, who had built his house in Los Angeles as an art piece, and he renewed other contacts. On publisher Benedikt Taschen's 40th birthday he lists names such as Helmut Newton, Jeff Koons and Mike Kelley, and reports that New York gallery owner Barbara Gladstone came on a visit with a well-known curator, while American and German collectors wanted to see pictures in his Berlin studio. That during his absence from Berlin, Majerus wanted to and did indeed keep his exhibition arrangements in Europe owes to the professional level of his career planning as an artist, a plot with his co-conspirator and assistant Bastian, who was not from an art background. Meanwhile Bastian had to paint and frame pictures to instruction and with electronically transmitted colour swatches, organise transport and dun

Fig. 9 *painkiller 1,* 2001

Fig. 10 *painkiller 2,* 2001

seiner Künstlerkarriere, ein Komplott mit seinem Mitverschwo-
renem, dem Assistenten Bastian, der nicht aus dem Kunst-
kontext kommt. Der muss in der Zwischenzeit Bilder nach
Anweisung und elektronisch übermitteltem Farbfächer malen,
rahmen, Transporte organisieren und nicht zahlungswillige
Käufer abmahnen. Dass Majerus nach einer langen Anlaufzeit
am Ende selbst viel Zeit im Atelier verbringt, beweisen die
fertig gestellten Bilder und die nach Berlin gemailten Com-
puter-Bilder. Trotzdem plant er als geheimen Coup, dass eine
„supercoole" Kritikerin, die auch für das *Artforum* schreibt,
Bilder für ihn malen solle. Milena, eine mexikanische Künst-
lerin und Sängerin, bringt ihm die Inspirationen für „painkiller",
und Krondorfer malt nach seinen Entwürfen die Bilder. Nach
dem ehemaligen Mafia-Boss Solo Morreno, einem der legen-
dären Gegner von Superman, der durch chemische Reaktionen
nach einer Atomexplosion unsterblich wurde und als Schlamm-
monster Autos in New York zertrampelt, soll eine neue Serie
benannt werden **13**, und für neuere neokonservative Entwick-
lungen in Deutschland, den Aufstieg von Neo Rauch und
Daniel Richter („Trichter") hat er nur Spott übrig, die sollten
doch mal zusammen mit Willi Sitte ausstellen. Am Beach
macht er Bodybuilding und surft, färbt sich, wie er nach Berlin
berichtet, die Haare schwarz, und kleidet sich mit einem rosa
T-Shirt, blauen Shorts und einer orangenen Baseballkappe ein.
Bei der Hochzeit von Jorge Pardo in Long Island im Juli 2001
sehe ich ihn mit einer grotesken Kniehose aus Vollsynthetik
auf einem Leihfahrrad herumfahren, weil er entweder zu geizig
war, sich ein Auto zu leihen oder weil er sportlich erscheinen
wollte. Das neue Berliner Atelier, das er plant, wenn er zurück-
kommt, sieht in seiner Phantasie wie eine Majerus-Installation
aus: zwei Stockwerke übereinander, transparentes Plexiglas
als Bodenplatten, „die Raumteiler würden auch immer umge-
baut werden können, so dass es ein ständig mutierender
supercleaner Arbeitskomplex ist" „und jede Woche eine Party,
damit wieder neuer Wind durchbläst."

Als programmatisch innerhalb der LA Serie dürfen *deutsch-
amerikanische freundschaft,* 2001, und *actionbutton,* 2001,
gelten. Beim ersten wird abstrahierend ein orangefarbener
Vorhang geöffnet. Vor weißem Grund sieht man den Schrift-
zug „California" verwoben mit einer – im Pazifik? – unter-
gehenden Sonne, die zugleich ein Abendrot sein könnte, um
das Vögel flattern. Vor diesem Welcome mit Touristatmos-
phäre sieht man den Kopf des „Blauen Klaus", einer besonders
lächerlichen Comicfigur von Loriot aus den 1960er Jahren,
die Majerus als Kind möglicherweise von Luxemburg aus im

reluctant customers. The fact that Majerus himself even-
tually spent a lot of time in the studio after a long run-in
time is proved by the completed works and the computer
pictures mailed to Berlin. Despite this, he planned that a
"supercool" critic who also wrote for *Artforum* should paint
pictures for him as a secret co-operative job. Mexican
artist and singer Milena furnished him with inspiration for
"painkiller", and Krondorfer painted the pictures according
to his designs. A new series would be named after former
Mafia boss Solo Morreno, a legendary opponent of Super-
man, who became immortal as a result of chemical
reactions following an atomic explosion and trampled on
cars in New York as a mud monster.**13** More recent neo-
conservative developments in Germany, the rise of Neo
Rauch and Daniel Richter ("Trichter") were now the butt
of his mockery – why didn't they go and exhibit with Willi
Sitte, haha. He did body-building workouts on the beach
and surfed, and, as he told people in Berlin, dyed his hair
black, dressed in a pink T-shirt and blue shorts and topped
it with an orange baseball cap. I saw him at Jorge Pardo's
wedding on Long Island in July 2001 riding around on
a borrowed bicycle wearing grotesque knee-length shorts
made of 100% synthetics either because he was too
stingy to hire a car or because he wanted to look sporty.
The new studio he planned in Berlin when he returned
looked in his imagination like a Majerus installation –
two superimposed storeys, transparent Plexiglass floor
panels, "infinitely adjustable room partitions so that it
would be a constantly changing, superclean work complex,"
with a "party every week so that new wind would blow
through it."

A programmatic element within the LA series was con-
tained in *deutsch-amerikanische freundschaft,* 2001,
and *actionbutton,* 2001. In the first, an orange curtain is
opened as a quasi-abstract element. The inscription
"California" is woven in on a white background with a set-
ting sun (in the Pacific?) that might also be a sunset with
birds fluttering round it. Against this big welcome in
a touristy vein we see the head of "Blue Klaus", a rather
pathetic comic figure of Loriot's from the 1960s whom
Majerus may have seen in Luxembourg on Saarland
Television, which broadcast it.**14** "Blue Klaus" wears a red
woolly hat with a white bobble, the red of the hat glowing
itself like a setting sun. His proboscis-like nose seems to
be pressing against an invisible plate of glass. As a repre-

Saarländischen Fernsehen sah, wo sie lief.**14** Der „Blaue Klaus"
trägt eine rote Pudelmütze mit Bommel, der selbst wie eine
untergehende Sonne erstrahlt. Mit der rüsselartigen Nase
scheint er gegen eine unsichtbare Glasplatte zu stoßen. Er,
als Repräsentant Deutschlands und möglicherweise als Persi-
flage seiner selbst, ist also eine Repoussoirfigur, sozusagen
auf dem Proszenium befindlich, um auf das Paradies California
aufmerksam zu machen: et in Arcadia ego. „actionbutton"
ist quer vor das gleichnamige Bild platziert. Der Startknopf für
einen Spielautomaten oder ein Computerspiel in haptischen
Blocklettern geschrieben für ein Bild, in dem es auch tat-
sächlich rumst. Die sternartige Chiffre für Explosion aus dem
Comicgenre bildet in mehreren Farben das zurückliegende
Zentrum des Bildes, während sich vorne rechts eines dieser
Teile wie aus Holz ausgesägt und grün bemalt verselbständigt
hat und wegschwebt. Vorne links sieht man in blauem Grund
einen weißen Fleck, der locker gemalt Diskontinuität prokla-
miert, als wolle er sagen, es ginge um Malerei und nicht um
Action. Die Aktion verpufft, sie wird nur simuliert, um anzu-
kündigen, dass es um Malerei geht; das Vorhaben gerinnt so-
zusagen im Bild und seinen Sujets.

Los Angeles lässt Majerus immer mehr zur Gewissheit kom-
men, dass er auf den Spuren von Warhols Factory wandeln
müsse. „Ich male grad viel und ich will es immer schneller
und beiläufiger machen. Funktioniert auch gut und sieht sogar
besser aus, als wenn ich stundenlang davor sitzen würde und
mir einen runtermale."**15** So entstehen zwischen den großen
Acrylbildern immer wieder Siebdrucke und Prints. Eine Sieb-
druckserie 60 × 60 cm in Schwarz-Weiß drückt das LA-Gefühl
besonders gut aus: futuristische Farbschlieren, ein ballernder
Robot, dem nicht von ungefähr der Begriff „simplicity" unter-
legt ist, „Wheel World", sowie das Klo am Beach von St. Monica,
das eher wie eine Fixer-Kabine aussieht. Zum Abbremsen hat
er ein uraltes Raketencomic beigefügt. Eine Art Straßen- oder
Brückengeländer wurde im Nachhinein durch das Porträt der
schönen Milena ersetzt. Ein anderer großer Computerprint
280 × 400 cm zeigt einen Carcrash bei einem Stock-Race. Der
kryptische Bildtitel *3mmT* erklärt sich durch die Aufschriften
der drei beteiligten Fahrzeuge. Die Vorlage ist ein Zeitungsfoto
der *Los Angeles Times* vom 19. 2. 2001.**16** mm, das sind natür-
lich auch die Initialen des Künstlers selbst. Er ist mit dabei,
wenn es kracht. *Crash Test* ist der Bildtitel eines Schriftbildes
von 2000. Schon in Berlin spielt er gerne Car-Racing am
Computer gegen seine Galeristen. Der Print dient dann auch
noch als Vorlage für ein gänzlich in Weiß gemaltes Bild, dessen

sentative of Germany and possibly persiflage of himself,
he is a kind of repoussoir figure, on the proscenium, as
it were, in order to draw attention to the paradise of
California – et in Arcadia ego. The "actionbutton" is placed
across the front of the picture of the same name – the
start button for a one-armed bandit or a computer game
in haptic block letters written for a picture that indeed
really rumbles. The retracted centre of the picture is
formed by the star-like shorthand for explosion in comics
painted in several colours, while in front on the right, one
of these parts – apparently made of wood – has broken
loose and is making off on its own. In the left foreground
we see a white spot on a blue ground that proclaims
loosely painted discontinuity, as if to say this was all about
painting, not one of those "action" things. The "action"
falls flat, being only simulated, is if to announce that this
here is painting. The intention congeals, as it were, in the
picture and its subjects.

Los Angeles convinced Majerus with ever-growing certainty
that he must change, and follow in the tracks of Warhol's
Factory. "I happen to paint a lot, and I want to speed it
up and just run it off. That way works well and looks even
better than when I sit in front of it for hours and bang
away at it."**15** The result was an increasing number of silk-
screens and prints alternating with the large acrylic pic-
tures. A series of 60 × 60 cm black and white silk-screen
prints expresses the LA feeling particularly well – futurist
streaks of colour, a robot chucking things around that
is not by chance a model of "simplicity", Wheel World and
the loo on the beach at Santa Monica, which looks more
like a junkie cabin. To slow it down he adds an ancient
rocket comic. Later on a kind of street or bridge backdrop
was replaced by a portrait of the lovely Milena. Another
large computer print measuring 280 × 400 cm shows a
crash in a stock car race. The cryptic title *3mmT,* is ex-
plained by the letters on the three vehicles taking part.
The source was a press photo from the *Los Angeles
Times* dated 19.2.2001,**16** while mm are of course the art-
ist's own initials. He is bound to be involved when there's
a clash. *Crash Test* is the title of an inscription picture
dated 2000. Back in Berlin he had loved competing with
his gallery owners in car races on the computer. The print
then also serves as a model title for a picture painted
entirely in white, whose top left corner is occupied by a
rectangular fragment of the print in blue. Majerus may

Fig. 13 *3mmT1,* 2001
Fig. 14 *3mmT2,* 2001

obere linke Ecke rechteckig von einem Fragment des Prints in Blau besetzt ist. Majerus mag an Polke gedacht haben: …*obere linke Ecke schwarz malen.* An seine Galeristen neugerriemschneider mailt er: „Letzte Woche hab ich einen Idiotentest bestanden. Ich stand an einer Strassenkreuzung, links von mir gab es ein leeres grosses billboard und rechts von mir eine riesige aufgeblasene Ente von Van Nuys Car Sales. Die Ampel wurde gleich grün und ich konnte allerhöchstens ein Foto machen. Ich weiss nicht warum, aber ich habe das weisse billboard fotografiert. Ich Idiot, und dabei könnte ich mit Photoshop jedes blöde Plakat weiss machen, aber das mach ich natürlich nicht, das überlasse ich den anderen Leuten. Jedenfalls habe ich die Ente nicht fotografiert und somit den Deppentest bestanden."**17** Der Übergang von der Malerei zum Print kann auch wieder umgekehrt verlaufen. Die früher mit Overhead-Projektoren auf die aufgespannte Leinwand projizierte Bildvorlage oder Skizze wurde in den späten 1990er Jahren durch den Laptop und den Beamer ersetzt, mit denen man die im Photoshop erarbeiteten Bilder direkt projizieren konnte. Bei zwei der LA-Bilder ließ Michel Majerus, wie er mir später im Kreuzberger Atelier demonstrierte, die Maus des Paint-Programms von alleine marschieren, bis sie an den Rand kam und wie eine Billardkugel an der Bande ihre Richtung änderte. Das ganz pinkfarbene *smudge tool,* 2001, auf weißem Grund gehört ebenso dazu wie *degenerated,* 2001. Dabei lässt er wie in einem Wettrennen verschiedene horizontale Bahnen durch die primärfarbenen Farbstreifen laufen. Einer schiebt sich durch ein grünes Farbfeld links und durchquert nochmals das ganze Bild, indem er das Grün nach rechts transportiert. Der automatische Entstehungsprozess gibt den rasch ausgeführten Bildern eine coole und delikate Note. Von der Kamm-Malerei des Bauernschranks über die informellen Schlieren Sonderborgs bis zu den Hybriden von Majerus gibt es eine inhaltliche Steigerung und Pervertierung. Im riesigen Bild *tex mex,* das er 2002 nach seinem LA-Aufenthalt gemalt hat, lässt er das Sternenbanner wie Tortenguss verlaufen, wobei die mexikanischen Nationalfarben Grün-Orange im Verbund mit der Aufschrift „underneath your clothes there's an endless story" den subversiven Aspekt des „Unterwanderns" besonders deutlich werden lassen.

Flecken, verlaufende Farben und gestische Malerei setzte Majerus ganz bewusst ein, um die Ebene der abgeklebten Designmalerei zu durchbrechen. Zum einen lässt er in *slayer* (Name einer Metal-Band) neben der Schrift des Bildtitels pastos gemalte horizontale und vertikale Streifen aufeinander

have thought of Polke: …*paint top left corner black.* He e-mailed his neugerriemschneider gallery owner: "Last week I qualified as an idiot. I was standing at a street corner, on my left was a large empty billboard, on my right a huge blown-up duck from Van Nuys Car Sales. The traffic lights were about to turn green and I only had enough time to take one photo. I don't know why, but idiot that I am, I photographed the white billboard, although I could make any stupid poster white with Photoshop, but of course I won't do that, I'll leave that to other people. In any case, I didn't photograph the duck and so I passed the Idiot Test."**17** The transition from painting to print can also go the other way round. Whereas previously the source image or sketch had been projected onto the taut canvas with overhead projectors, in the late 1990s he used laptop and beamer so he could work on them with Photoshop and project them directly. As he later showed me in the studio in Kreuzberg, in two of the LA pictures Majerus let the mouse of the paint programme move by itself until it reached the edge, where it changed direction like a billiard ball. The very pink *smudge tool,* 2001, on a white background is another such picture, as is *degenerated,* 2001. In these, various horizontal bands seem to race across the primary coloured stripes. One runs through a green patch on the left and then traverses the whole picture again, transporting the green to the right. The automated genesis of these rapidly executed pictures produces a cool, delicate note. The development from the comb painting of rustic furniture through Sonderborg's informal streaks to Majerus' hybrids represents a process of enhancing and perverting the content. In the huge *tex mex* picture painted in 2002 after he returned from LA, he lets the Star Spangled Banner run like a glaze, with the Mexican national colours of green and orange combined with the inscription "underneath your clothes there's an endless story" making the subversive aspect of "infiltration" particularly clear.

Majerus used spots, runny colours and gestural painting quite deliberately to break through the level of masking-taped designer painting. In one case, *slayer* (the name of a thrash metal band), he has pasty horizontal and vertical stripes colliding and overlayering each other beside the inscription of the title, while in another case he has paint spotting the white background as in a watercolour or gouache. Thus he simulates gesturally painted grids and abstract

Fig. 15 *XXX,* 2001 Veit Loers 196 197

prallen und überlagern, zum andern zieht er die Farbe flecken-artig über den weißen Bildgrund wie auf Aquarellen oder Gouachen. Er simuliert also gestisch gemalte Gitter und abstrakte Malstrukturen wie bei Rauschenberg oder Förg. Kurz vor seinem Tod zeigte er dann in den „Kollaborationen" mit Hans Jörg Mayer, dass er mit diesem expressiven Pinselstrich durchaus umzugehen wusste, dass aber die Kombination von cool und hot ihn am Ende mehr interessierte. In der Reihe der LA-Bilder sind zwei merkwürdige Arbeiten, in denen das malerische Element eine spezielle Rolle spielt. *Splash,* 2001, besteht im Wesentlichen aus einem schwarzen und dichten, eher absorbierenden Untergrund, auf der den Titelbegriff in der Art eines Werbeslogans in verdickten blaugrauen Konturen mit weißer Höhung gesetzt ist, so aber perspektivisch eingesetzt, dass er räumliche Assoziationen bewirkt. „Splash", das wie andere Begriffe auch noch eine Hard-Rock-Band meint, schwimmt wie Quecksilber vor dunkler gummiartiger Masse. Ohne Zweifel hat hier Majerus dem normalen Schema seiner Schriften eine neue Qualität verliehen. Ähnlich bei dem Bild *ohne Titel,* 2001, mit den ungewöhnlichen Maßen 183 × 548,5 cm, wo ein ähnlicher, aber hellblauer Grund zahlreiche rostrote Flecken trägt, die mit Rändern wie Rotwein in Stoff eingedrungen sind. Tatsächlich war der Ausgangspunkt das mit Rotwein versaute Hemd von Jorge Pardo.**18**

Die Malerei von Michel Majerus hatte in Los Angeles insgesamt eine Verbreiterung und Differenzierung erfahren, die es vorher nicht gab. Zwar waren die Stilmittel – Designer-Schrift in Verbindung mit gestischer Malerei und twombly-hafter Skizzenhaftigkeit mit weißen Tipp-Ex-Löschungen zuvor entwickelt. Ihre Souveränität und Kombinatorik wird jedoch in Los Angeles auf eine neue Stufe gehoben. Die Coolness der Motive und Ausführungen hält eine eigene Dialektik in jedem Bild bereit. Sie beruht auf These und Antithese, entwickelt sich aber manchmal über drei Stufen. Etwa in *gib auf,* 2001, von „start" über „sit" zu „gib auf". Selten gibt es noch lapidarere Pop-Bilder wie das Bild mit der Videokassette *XXX,* 2001, wo jedoch der Hinweis auf Porno weitere Denk-Dimensionen bereithält.

Michel Majerus' Umgang mit der Malerei wurde in dieser Zeit subtiler und rhetorischer. Wer in allen Stilen malen kann, malen lässt und printet, gibt seinen Arbeiten eine artifizielle Haltung, die Malerei rein aussagemäßig in eine Posteriori-Qualität schiebt. Michel Majerus konnte den Déjà-vu-Effekt mit dem Casting seiner Bilder unterlaufen. Er selbst spielte

painting structures as in works by Rauschenberg or Förg. Shortly before his death, he showed in his "collaborations" with Hans Jörg Mayer that he was thoroughly master of the expressive brushstroke, but ultimately the combination of cool and hot interested him more. There are two remarkable works in the series of LA pictures in which the painterly aspect played a special part. *Splash,* 2001, consists basically of a dense black, rather absorbent ground on which the title name is placed in thick blue-green outlines with white highlights, in the manner of an advertising slogan, but rendered in perspective such that it generates spatial associations. "Splash", which like other terms also means a hard rock band, swims like quicksilver against a dark, rubbery mass. Here, Majerus has undoubtedly given the normal arrangement of his inscriptions a new twist. The same applies to *ohne Titel,* 2001, unusual in the imperial dimensions (183 × 548.5 cm), where a similar but light blue background is spotted with numerous rust-red flecks, which have edges like red wine soaked into fabric. The idea did indeed come from a shirt of Jorge Pardo's stained with red wine.**18**

In sum, Majerus' painting went through a process of expansion and differentiation in Los Angeles, producing qualities that had previously not been there. Though the stylistic resources – designer script in combination with gestural painting and Twombly-style sketchiness with white Tipp-Ex deletions – dated from an earlier period, in Los Angeles they were enhanced to a new level of mastery and deployment. The coolness of the motifs and xecution already contain a dialectic of their own in every picture. It is based on thesis and antithesis, but sometimes evolves over three levels, e.g. in *gib auf,* 2001, from "start" through "sit" to "gib auf". Rarely have there been more succinct Pop pictures than *XXX,* 2001, with the video cassette, where the reference to porno indicates further intellectual dimensions in reserve.

During this period, Majerus' handling of painting became more subtle and rhetorical. Anyone who can paint in all styles – and does indeed get things painted and printed – adds an artificial tone to his works that shifts the painting message into a posteriori category. Majerus managed to undermine the déjà vu effect with the casting of his pictures. He himself always had a part to play in this that generally emphasised the marginality of art. Even in the

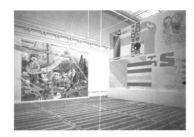

Fig. 16 Installationsansicht
Kunsthalle Basel, 1996

Fig. 16 Installation view
Kunsthalle Basel, 1996

darin stets auch eine Rolle, die meist auf die Marginalität des Künstlertums abhob. Schon in der Skaterrampe des Kölnischen Kunstvereins (2000) hatte er, Beuys verballhornend, in einem Slogan festgestellt: „Die Absichten des Künstlers werden überbewertet".[19] In einer Mail an Heike Föll aus Los Angeles bemerkt er: „Ich […] bin überzeugt davon, dass man die Kontrolle über die kurze Zeit, in der man gute Sachen macht, selbst nicht hat. Man weiss vermutlich auch nie, wann es sich um diese Zeit handelt. Wahrscheinlich passiert es in der Zeit, in der niemand etwas von einem erwartet und man auch von sich selber nichts erwartet."[20] Die fatalistische, zugleich fast prophetische Bemerkung lässt erkennen, dass sich der Künstler bei aller Ironie und der unbeschwerten Lust am Malen ständig in einem reflexiven Diskurs über Kunst befand, der diese nicht nur egalisierte und auf eine Schiene mit der Alltagskultur senkte, sondern auch zu einem kollektiven Akt werden ließ, der von vornherein außerhalb der Kontrolle des Künstlers stand. Am Ende hatte Majerus seine Sprache gefunden, die sich von anderen ähnlichen Versuchen dadurch abhob, dass sie mit Schriften und Titeln, mit Stilen und Gestaltmerkmalen ein konzeptuelles Klima erzeugte, das mit einer plakativen Farbigkeit eine unerhörte Präsenz heraufbeschwor. Die Verspieltheit der Bilder wurde ironisch verzerrt oder einfach als vorübergehender Zustand determiniert. Die vordergründige Ähnlichkeit mit den Affichistes, die durch die verblichenen Werbefarben und die Collagierungseffekte entsteht, am ähnlichsten vielleicht mit dem Werk von Mimmo Rotella, mag eher Zufall sein. Majerus gelang es zunehmend, mit seiner Malerei ein Klima zu schaffen, in dem die Banalität zu höheren Zwecken eingesetzt wurde, zu artifiziellen Konstrukten der Beiläufigkeit, in denen er den Ort der Malerei und die Ikonen selbst jedes Mal aufs Neue versammelte. Diese Banalität, verbunden mit der Lebensfreude eines Pop immortel funktioniert jedoch nur, weil er ihr eine dunkle Seite beimischt, die zumeist aus Symbolen, Logos, Worten und Stickern besteht. Wie Sprengsätze sind sie in das Bild eingebaut, ein Memento Mori oder eine Warnung an sich selbst, den Lebenscode seiner Bilder auch im Tod zu verankern. Wie Andy Warhol in seinem Spätwerk mit Sculls und dem auslöschenden Camouflage-Effekt eine Aussage negiert, sozusagen mit dem Tod überdeckt, so konterkariert Majerus schon früh seine humorvollen Bildwelten mit dieser Schattenseite. „Globol tötet Motten und Mottenbrut", das große Bild von Basel ist eine ambivalente Devise dieser Art. Die Mumie auf der großen Installation der *Manifesta* in Luxemburg droht mit einem Besen: „Warning: Do not stretch over…" Sogar

skating rink of the Kölnischer Kunstverein (2000), he had proclaimed – in a parody of Beuys – "the artist's intentions are over-rated".[19] In an e-mail to Heike Föll from Los Angeles, he comments: "I […] am convinced that we ourselves have no control over the brief period in which we do good things. Presumably we never know when we're actually in this period. It probably happens at a time when noone expects anything of us and we also expect nothing of ourselves."[20] This fatalistic but at the same time almost prophetic remark highlights that, for all the mockery and carefree delight in painting, the artist was always in a state of reflective discourse about art that not only evened it out and reduced it to a par with everyday culture but also turned it into a collective act that was a priori beyond the artist's control. Ultimately Majerus found his individual voice, which was distinct from other similar voices in conjuring up a conceptual climate using script and titles, styles and designer features to create an incredible sense of presence with striking colouration. The playfulness of the pictures was distorted by mockery or simply stated as a temporary condition. The superficial similarity to the affichistes arising from the faded advertising colours and collage effects, closest perhaps to the work of Mimmo Rotella, is possibly purely accidental. Majerus increasingly managed to create a climate with his painting where banality was deployed for higher ends, for artificial constructs of triviality where he himself brought together the place of painting and the icons afresh every time. This banality, combined with the zest of immortal Pop, only functioned because he mixed into it a dash of the dark side, mainly in the form of symbols, logos, words and stickers. These are built into the picture like explosive devices, a memento mori or warning to himself to anchor the vital code of his pictures in death as well. Just as Andy Warhol negates messages with sculls and obliterating camouflage effects in his late work, as if covering it with death, so Majerus contradicted the humorous world of his pictures with this shadow side even in his early days. "Globol kills moths and moth larvae", the large picture of Basle days, is an ambivalent motto of this nature. The mummy on the large installation of the *Manifesta* in Luxembourg sports a threatening broom: "Warning – do not stretch over…" Even the Athens catalogue cover mentioned earlier features mysterious bomber aircraft within the number 20 in the lower part. This digit refers to the number of artists taking part in the exhibtion.

Fig. 17 *space invaders 3, 2002*

Veit Loers 198 199

das erwähnte Katalogcover des Athener Katalogs zeigt im unteren Teil mysteriöse Bombenflugzeuge innerhalb der Ziffer 20. Diese Ziffer bedeutet die Anzahl der an der Ausstellung teilnehmenden Künstler. Vom düsteren Arsenal der Bilderserie des Jahres 2000 war schon die Rede. Das Rotwein-Flecken-bild der LA Serie kann in seiner unbeschwerten Klecksologie auch mit der Schrift eines anderen Bildes gelesen werden: „blood allover" oder sich auch eine andere Bildschrift der LA-Serie zu eigen machen: „your ideas get you killed".

In einem der letzten Gemälde, *space invaders,* 2002, einem asketischen Acrylbild mit Siebdruck in Schwarz und Weiß, lässt er kriegerische Kopffüßler wie eine Armee aufmarschie-ren, fast eine bedrohliche aztekische Maskenfassade als Abwehrzauber. Dann denkt man, der Künstler könne sie aus einem frühen Computerspiel herauskopiert haben. Irrtum. Gerade eben habe ich entdeckt, dass ich das archaische Video-game – um 90 Grad gedreht – auf meinem Handy habe. Unter der Rubrik „Spiele" kann ich es auswählen. Titel: „Space Invaders".

The sombre arsenal of the 2000 series of pictures was already in the making. The casual daubs in the picture with the red wine stains can also be interpreted with the in-scription of another picture – "blood allover" – or adopt the message of another item in the LA series: "your ideas get you killed".

In one of the last paintings, *space invaders,* 2002, an ascetic acrylic picture with silk-screening in black and white, martial cephalods march up like an army, almost a threat-ening façade of Aztec masks as defensive magic. Then we remember that the artist might have copied them from an early computer game. Wrong. I have just discovered I have the archaic video game – turned through 90 degrees – on my mobile. It's one of the options under the heading "Games". The title? "Space Invaders".

Anmerkungen

1 Schriftbild von M.M. aus einer 60×60cm Serie (1996) der Kunstsammlung der LBBW. Vgl. dazu den Text zu Majerus von Raimar Stange, in: *ZOOM. Ansichten zur deutschen Gegenwartskunst,* Sammlung Landesbank Baden-Württemberg, Stuttgart. Ostfildern-Ruit: Hatje Cantz 1999, S.374f.

2 Zitiert nach Susanne Küper: *Michel Majerus, MoM Block.* In: *Nach-Bilder.* Ausst.Kat., Kunsthalle Basel 1999, S.60.

3 Zitiert nach Raimar Stange: *M.M.* In: *Artist Kunstmagazin* (2/1997), H.31, S.18.

4 Ibid.

5 *Deutsche Kunst heute.* Hrsg. von Hellenic Art Galleries Association, Athen 1999.

6 Raimar Stange: *Interview mit M.M.* In: R.S.: *Sur.Faces, Interviews 2001/02.* Hrsg. von Christoph Keller. Frankfurt a.M.: Revolver 2002, S.18.

7 *Michel Majerus: Los Angeles.* Hrsg. von Joachim Jäger. Köln: König 2004.

8 Abb.; *Michel Majerus: Los Angeles,* Umschlag.

9 Bastian Krondorfer möchte ich an dieser Stelle für die selbstlose Überlassung seiner E-Mails mit Michel Majerus in dieser Zeit herzlich danken.

10 22.11.2000.

11 13.09.2001.

12 10.04.2001, E-Mail an neugerriemschneider, zitiert nach Cover, *Michel Majerus: Los Angeles.*

13 26./27.01.2001.

14 Persönliche Mitteilung von M.M. an den Autor.

15 14.05.2001.

16 Freundliche Mitteilung von Christiane Rekade und Philipp Muras, neugerriemschneider, Berlin.

17 07.02.2001. E-Mail an neugeriemschneider, zitiert nach Cover, *Michel Majerus: Los Angeles.*

18 Freundliche Mitteilung von Burkhard Riemschneider.

19 Siehe dazu die Rezension von Noemi Smolik: *Die Absichten des Künstlers werden überbewertet.* In: *FAZ,* 3.11.2000, S.49.

20 27.01.2001. Zitiert nach Cover, *Michel Majerus: Los Angeles.*

Notes

1 Inscription picture by M.M. from a 60×60cm series (1996) in the LBBW art collection. Cf. Raimar Stange's article about Majerus in: *ZOOM, Ansichten zur deutschen Gegenwartskunst,* Sammlung Landesbank Baden-Württemberg, Stuttgart. Ostfildern-Ruit: Hatje Cantz 1999, pp.374/375.

2 Quoted from Susanne Küper, *Michel Majerus, MoM Block,* in: exhibition catalogue *Nach-Bilder,* Kunsthalle Basle 1999, p.60.

3 Quoted from Raimar Stange, *M.M., Artist Kunstmagazin* (2/1997), issue 31, p.18.

4 Ibid.

5 *Deutsche Kunst heute,* ed. by Hellenic Art Galleries Association, Athens 1999.

6 Raimar Stange: *Interview with M.M.* In: R.S.: *Sur.Faces, Interviews 2001/02.* Ed. by Christoph Keller. Frankfurt a.M.: Revolver 2002, p.18.

7 *Michel Majerus: Los Angeles.* Ed. by Joachim Jäger. Cologne: König 2004.

8 Ibid, Ill., cover.

9 I should like to record here my profound gratitude to Bastian Krondorfer for generously giving me access to his e-mail correspondence with Michel Majerus from this period.

10 22.11.2000.

11 13.09.2001.

12 10.04.2001. e-mail to neugerriemschneider, quoted from cover, *Michel Majerus: Los Angeles.*

13 26./27.01.2001.

14 Told to the author personally by M.M.

15 14.05.2001.

16 Kindly communicated by Christiane Rekade und Philipp Muras, neugerriemschneider, Berlin.

17 07.02.2001. Quoted from Cover, *Michel Majerus: Los Angeles.*

18 Kindly communicated by Burkhard Riemschneider.

19 See also the review by Noemi Smolik: *Die Absichten des Künstlers werden überbewertet.* in: *FAZ,* 3.11.2000, p.49.

20 27.01.2001. Quoted from the Cover, *Michel Majerus: Los Angeles.*

Raimar Stange
DisPLAYer auf Zeit
Zu den (Raum-)Installationen von Michel Majerus
Temporary DisPLAYer
Michel Majerus' (Room)Installations

Raimar Stange, geboren 1960,
lebt in Berlin/DE.

Studium der Literaturwissenschaften,
Philosophie und Geschichte.
Lebt und arbeitet als Kunstpublizist
und freier Kurator in Berlin.
Korrespondent für das *Kunst-Bulletin,*
Zürich.

Mitherausgeber des Berliner
Artfanzines *Neue Review.*

Bassist im *Art Critics Orchestra.*

Buchpublikationen (Auswahl):
Sur.Faces. Frankfurt 2002.
Zurück in die Kunst. Hamburg 2003.
Insight Inside. Köln 2005.

Raimar Stange, born 1960,
lives in Berlin/DE.

Studied literature, philosophy
and history.
Lives and works in Berlin as an
art journalist and freelance curator.
Correspondent of *Kunst-Bulletin,*
Zurich.

Co-editor of the Berlin-based
art fanzine *Neue Review.*

Bassist in the *Art Critics Orchestra.*

Selected book publications:
Sur.Faces, Frankfurt 2002.
Zurück in die Kunst, Hamburg 2003.
Insight Inside, Cologne 2005.

*Ich mag Sachen, die sich erstmal
in einem Moment befinden,
in dem sie auf etwas warten.* **1**
Michel Majerus

*I like things that only find them-
selves the moment they
are waiting for something.* **1**
Michel Majerus

0.

Michel Majerus' Stärke war das Warten sicher nicht: Dynamische Bewegung und produktive Aktion waren ihm stets wichtiger als geruhsame (Inter-)Passivität. In seiner Malerei z.B. ist diese auf Geschwindigkeit – sowohl die Produktion wie auch die Rezeption betreffend – abzielende Energie deutlich ablesbar. **2** Und im Kino oder vor dem TV-Apparat fiel Michel bei vergleichsweise „langweiligen" Szenen flugs in einen erholsamen Kurzschlaf und genoss den Film als Ganzen dann umso mehr. **3**

Kunsträume nun sind „erstmal" leer und „warten" darauf, gefüllt zu werden, sie schreien quasi nach (ausstellender) Aktivität. Der moderne White Cube, so meinte schon Brian O'Doherty, zeichnet sich zudem durch seine puritanische und reduzierte Kahlheit aus, die ihn fast zu einer abwartenden, immer wieder scheinbar jungfräulichen „Klosterzelle" werden lässt. **4**

Nicht verwunderlich also ist, dass diese beiden Gegensätze **5** sich anzogen und in beinahe schon dialektischer Spannung bemerkenswerte ästhetische Resultate erzielten – nämlich die hier vorzustellenden (Raum-)Installationen von Majerus, die der Künstler bei nahezu jeder wichtigen Präsentation seiner ästhetischen Arbeit inszenierte.

Bei diesen Installationen fällt auf den ersten Blick auf – dies wird später von mir zu präzisieren sein –, dass der Raum nicht als notwendiges Übel nur vom Künstler akzeptiert wird, sondern dass vielmehr dessen unterschiedliche Qualitäten unterstrichen bzw. erst hergestellt werden, damit dann der/die Betrachter/in sich mittendrin im Kunstraum/werk der Marke Majerus befinden kann. Auch dieses Moment des Mittendrin war eben typisch für Michel: Bei schon erwähnten Kinobesuchen saß er stets in den vordersten Reihen, suchte er doch statt kritischer Distanz immer lustvoll und neugierig das Zentrum des – und dies trotz aller Medialität der (ästhetischen) Ereignisse – möglichst direkten Involviertseins. Vor allem aber betonen – auch dazu später selbstverständlich mehr – die Installationen meist das zeitliche, mehr oder weniger dynamische Moment ihrer Wahrnehmung.

0.

Waiting was certainly not one of Michel Majerus' strong points: dynamic movement and productive action were always more important to him than quiet (inter)passivity. This speed-oriented energy – in terms both of production and reception – is clearly visible in his painting, for example. **2** And during relatively "boring" scenes in the cinema or on television, Michel instantly fell into a refreshing sleep and thus enjoyed the film as a whole all the more. **3**

Art spaces are "first" empty, "waiting" to be filled; they almost cry out for (exhibition) activity. What is more, as Brian O'Doherty once claimed, the modern "white cube" is characterised by a puritanical and reduced bareness, which almost turns it into a waiting, seemingly virginal "monastery cell". **4**

It is not surprising, therefore, that these two opposites **5** attract and, in an almost dialectical tension, bring about remarkably aesthetic results – namely, the kind of (room-) installations presented here, which the artist Majerus mounted for almost every important exhibition of his aesthetic work.

What is striking about these installations at first sight, and will be discussed more precisely further on, is the fact that the artist accepts the room as more than just a necessary evil. Instead he underscores or even creates its different qualities, so that the viewers are then able to find themselves in the middle of an art space/work with the brand name Majerus. This aspect of being in the middle of things was also typical of Michel: during the above mentioned visits to the cinema, he always sat in the front row, curiously and pleasurably seeking not a critical distance, but the most direct involvement possible, despite the fact that the (aesthetic) event was mediated. Above all, the installations mostly emphasise the temporal, more or less dynamic moment of their perception, about which I will of course also say more later.

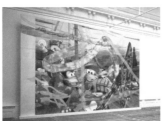

Fig. 1 Baumstrunk mit Jahresringen

Fig. 2 *Einschiffung,* 1996

Fig. 1 Treestump with annual rings

Fig. 2 *Einschiffung,* 1996

1.

Basel, anno 1996: In der traditionsreichen Kunsthalle Basel hat Majerus für seine erste große Einzelausstellung einen schwingenden Stahlgitterboden im zentralen Oberlichtsaal verlegt. Das Parkett darunter blieb zwar sichtbar, doch statt des dezenten Knarrens war jetzt bei jedem Schritt das vergleichsweise laute Klappern der Schuhsohlen und -absätze auf dem Stahl zu hören – das Gehen wurde so gleichsam akustisch erfahrbar, die Wahrnehmung der Kunst, die ja immer auch etwas mit dem Annähern und Entfernen von der Arbeit zu tun hat, „verschwieg" ihre körperliche Dimension nicht (mehr). Zudem noch: Die Gerüstbohlen, handelsübliche, eigentlich für den Bau gedachte Konstruktionen, erzeugten in dem historischen Raum einen Charakter des Offenen, Transitorischen, denn in dem so auratischen wie altehrwürdigen Saal war plötzlich ein „eigener" und „neuer" Raum entstanden, der im selben Moment aber den „alten" Raum einsehbar beließ und so seine Eingebettetheit in diesen betonte. Diese wohlkalkulierte Strategie, sich reflektierend (und wartend) in der (Kunst-)Geschichte zu befinden – das Bild von Jahresringen in Baumstämmen passt hier nicht schlecht –, um dabei deren Fluss selbstbewusst mitbestimmen zu können, ist typisch für die künstlerische Arbeit von Majerus überhaupt, wie ich gleich anhand von einigen damals in der Kunsthalle Basel vorgestellten Bildern und später angesichts weiterer Installationen zeigen werde.

Die in diesem Raum gezeigten Gemälde – vier großformatige Leinwände waren auf Podesten vor der Wand bzw. im Raum frei stehend platziert, die übrigen Bilder hingen an den Wänden – verweisen mit ihrem Display ebenfalls auf die Dialektik von Wechsel und Dauer: Einerseits nutzte Majerus mobile und temporäre Möglichkeiten, wie die aneinandergefügten Bildwände, andererseits setzte er auf „klassisch-stabile" Hängeflächen wie die Saalwände.

Last, but not least fand sich das Thema der Zeitlichkeit auch motivisch auf den Bildern wieder. Etwa auf dem in Basel gezeigten *Trophäen, die auf Verhandlungsgeschick deuten, II,* 1995: ein zu einem abstrakten Bild morphierter „Skull" von Andy Warhol ist da in Acryl auf der Leinwand zu sehen. Das Motiv des legendären Pop-Artisten – wir haben es alle in unserem „imaginären Museum" (André Malraux) noch abgespeichert – ist verfremdet und mit dem malerischen Stil eines de Kooning aufgeladen. Copyright oder Originalität wird hier

1.

Basle, 1996: For his first large solo exhibition at the time-honored Kunsthalle Basle Majerus had a vibrating steel grid floor laid in the main exhibition hall. The parquet floor beneath it was still visible, but at each step, instead of a discreet creaking, one could hear the comparatively loud clacking of shoe soles and heels on the steel – with the result that the act of walking became acoustically perceptible, so to speak. The perception of art, which always has something to do, among other things, with approaching and distancing oneself from a work, no longer "kept quiet" about its physical dimension. What is more, these grids, industrially-manufactured commercial items actually intended for construction work, added something open, transitory, to this historical space. Suddenly, in the so atmospheric and time-honoured room of the Kunsthalle, a "particular", "new" space emerged which at the same time, however, left the "old" space visible, thus emphasising that it was embedded in it. This well-calculated strategy of finding oneself reflecting (and waiting) in (art)history – the image of annual rings in tree trunks is quite fitting here – in order to be able to self-confidently co-determine its flow, is altogether typical of Majerus' artistic work, as I will now show with reference to some of the paintings exhibited at the time in the Kunsthalle Basle, and later with reference to other installations.

Because of the way they are displayed, the paintings shown in this room – four large canvases on free standing pedestals in front of the walls or in the middle of the room, the others hung on the fixed walls – also refer to the dialectics of change and duration: On the one hand, Majerus availed himself of the mobile and temporary possibilities like, for example joining together canavases, on the other, he relied on the "classically stable" hanging area provided by the museum walls.

Last but not least, the theme of temporality was also to be found in the motifs of his paintings. For example in his *Trophäen, die auf Verhandlungsgeschick deuten, II,* 1995, on exhibition in Basle, showing a "skull" by Andy Warhol morphed into an abstract image in acrylic on canvas. The motif of the legendary Pop artist – we all still have it stored in our "imaginary museum" (André Malraux) – is alienated and charged in the painterly style of a

aufgegeben zu Gunsten sensibler ästhetischer Verknüpfungen, die längst Geschichte gewordene Formulierungen quasi aktualisieren und so vor dem Vergessen bewahren. Zudem wurde hier Kunst der 1960er Jahre verarbeitet, im Wissen der technischen Möglichkeiten der 1990er Jahre; so treffen sich hier wiederum zwei Zeitstellen. Wie ein Grafikdesigner an seinem Computer speist Majerus nämlich Motivik und Stil der vorherigen Bildgeneration ein in sein eigenes aktuelles Bildprogramm und „sampelt" es dann malerisch.

Auch wenn der Stahlgitterboden ein wenig an Dancefloors aus manch Techno-Club erinnerte und auch wenn in einigen der in Basel gezeigten Bilder Signets aus der Welt des grenzenlosen Tanzvergnügens auftauchten, so liegt die Affinität von Majerus zu Techno doch vor allem in diesem gerade aufgezeigten nonlinearen Zeitbewusstsein: Für die sich stunden-, ja tagelang ohne klaren Ziel- und Höhepunkt in z.B. nicht enden wollenden Loops mehr entfaltende, denn wirklich entwickelnde Techno-Musik gilt wie für Majerus' Ästhetik: Der Glaube an klar definierte Anfänge bzw. Enden ist längst aufgegeben und durch ein Gefühl für Dauer ersetzt, das die Zeit zwar als vergänglich und geschwinde begreift, aber auch als eine Dauer [6], deren Geschwindigkeit gespeichert, (ab-)gewendet und somit erlebnisreich genossen werden kann. [7]

Das Entscheidende nun ist, dass dieses doppeldeutige Zeitbewusstsein – und nicht ein vordergründiges Crossover von Pop und Kunst sowie von High and Low, wie manch Kritiker/in vorschnell annimmt – Majerus' ästhetische Auseinandersetzung mit der Konzeption des White Cube begründet. So schrieb Brian O'Doherty, dieser Raum sei zuweilen „ein Protomuseum, das den Zustand der Zeitlosigkeit vorbereitet" [8]. Gegen genau diese naive Vorstellung von Zeitlosigkeit arbeitete Majerus' Installation – ohne dabei allerdings, wir haben es gerade gesehen, der Idee einer zeitlich linear voranschreitenden Avantgarde (wortwörtlich: „Vorhut"), die der „klassischewigen" Zeitlosigkeit vorausgeht, das Wort zu reden. [9] Auch diese stromlinienförmige Idee ist bekanntlich trotz aller postmodernen Absichten nicht untypisch für die Konzeption des White Cube.

2.

Vier Jahre später, Köln: Majerus stellte eine eigentlich funktionstüchtige Halfpipe mit dem Titel *if we are dead, so it is,* 2000, mitten in den Kölnischen Kunstverein. Mit diesem

de Kooning. Here copyright and originality are abandoned in favour of sensitive aesthetic links which update, so to speak, long since historical formulae, thus preventing them from being forgotten. Moreover, the art of the 1960s has been processed here with the knowledge of the technical possibilities of the 1990s, so that again two timepoints meet. Like a graphic designer at his computer, Majerus feeds the motifs and styles of the previous image generation into his own current image programme and then does some painterly "sampling".

Even if the steel grid floor is slightly reminiscent of dance floors in techno-clubs, and even if signets from the world of infinite dancing delights turn up in some of the paintings shown in Basle, the main affinity between Majerus and techno lies in the previously mentioned non-linear time consciousness: what applies to techno music – which for hours or days on end unfolds rather than actually develops, with no clear aim or climax in, for example, never-ending loops – also applies to Majerus' aesthetic: all faith in clearly defined beginnings or ends has long been abandoned and replaced by a feeling for duration which understands time as transient and fleeting, but also as a duration [6], the speed of which can be stored, tempered and thus made a thoroughly enjoyable experience. [7]

Decisive, however, is that this ambiguous consciousness of time – and not some superficial crossover of pop and art, or high and low, as many critics all too hastily assume – is the basis of Majerus' aesthetic engagement with the concept of the "white cube". Brian O'Doherty describes that space as sometimes being "a protomuseum" preparing a state of "timelessness" [8]. Majerus' installation worked against this naive notion of timelessness, but, as we have just seen, without coming out in favour of the idea of a chronologically linear progressive avant-garde, or advance guard, that precedes the "classically eternal" timelessness. [9] Despite all its postmodern intentions, this streamlined idea is, as we know, not untypical of the concept of the white cube.

2.

Four years later, Cologne: In the middle of the Kölnischer Kunstverein exhibition hall Majerus exhibited a functioning half pipe entitled *if we are dead, so it is,* 2000. With this

Fig. 4 Skizze zu *if we are dead, so it is,*
Kölnischer Kunstverein, 2000

Fig. 4 Sketch of *if we are dead, so it is,*
Kölnischer Kunstverein, 2000

„Bewegungsdisplay" betont der Künstler den Aspekt von „Wahrnehmung, Zeit und (geschwinder) Bewegung" noch stärker als in der Kunsthalle Basel. Auf der u.a. mit textlichen und bildlichen Zitaten aus der Werbe-, Techno- und Kunstwelt bemalten „Bild-Skulptur" – von „vielen, vielen bunten Smarties" über die Rock-Ikone Motörhead bis hin zu dem Statement „das befreien des malens vom thema ausdruck" reicht das Spektrum – konnten die Besucher der Ausstellung skaten und so das für das Skaten typische Zeitgefühl des rhythmischen Dahingleitens buchstäblich erfahren. Der Architekturtheoretiker und Skatespezialist Iain Borden beschreibt dieses Zeitgefühl, das durchaus Parallelen zu dem eben beschriebenen von Majerus' Arbeit und Techno besitzt, folgendermaßen: „Während die Zeit im Kapitalismus in immer stärkerem Maße von der von Uhren und ökonomischen Grundprinzipien gemessenen Zeit dominiert wird, erstreckt sich die Zeit beim Skateboarden über die Dauer der Session […] und das rhythmische Muster von ‚move-transfer-move-transfer', während der Skater zwischen den Walls hin- und herpendelt".**10**

Andererseits wurden die Skater zum sich hin- und herbewegenden Bestandteil der Installation. Wenn man so will: „Der Besucher wird gleichzeitig zum Betrachter und zum Akteur."**11** In der heutigen Skatekultur – auch darum hat Majerus das Objekt Halfpipe für seine Ausstellung ausgesucht – ist genau diese Durchmischung von Akteur und (Vor-)Bild typisch. Die Skater lernen ihre „moves" nach Bildern (aus Fachmagazinen und Videos), suchen selbst zu (lebenden) Bildern zu werden und tauchen dann als solche in Fanzines oder neuen Videos auf. Über diesen Prozess schreibt Iain Borden: „Die gelebte Darstellung von Skateboardbildern findet statt, wenn Skater die Moves selbst ausführen und somit Fotografien, Videomaterial und Movie-Clips aus dem Internet kraft ihres Körpers nachvollziehen und wieder erleben."**12** Genau dieses Moment der Parallelschaltung von Bild, dessen Hersteller und dem Betrachter scheint die Trennung von Produzent und Rezipient endlich emanzipativ aufzuheben. In *if we are dead, so it is,* 2000, gelingt dies jedoch nur gleichsam „Spezialisten", nämlich den vor allem jungen Menschen, die in der Lage sind, die Halfpipe mit dem Skateboard zu befahren. Und dies ist, ich habe es versucht, ein recht schwieriges Unterfangen. So definiert Majerus bewusst „sein" Publikum um, stellen Skater doch nicht unbedingt den normalen Kunstvereinsbesucher dar.

"display of movement" the artist gave even more prominence to the aspect of "perception, time and (swift) movement" than in the Kunsthalle Basle. Using this "pictorial sculpture", painted among other things with textual and image citations from the worlds of advertising, techno and art – ranging from "lots and lots of colourful smarties" to rock icon Motorhead to the statement "das befreien des malens vom thema ausdruck" (liberating painting from the theme of expression) – visitors to the exhibition could actually skateboard and thus experience the feeling of time conjured up by the typical rhythmic gliding involved. This feeling of time, which has certain parallels to the one described with reference both to Majerus' work and to techno, is described by architecture theorist and skateboard specialist Iain Borden as follows: "Whereas time in capitalism is increasingly dominated by the measured time of clocks and economic rationales, time in skateboarding ranges from the duration of the session […] and the rhythmic pattern of move-transfer-move-transfer as the skater oscillates between walls".**10** In the curve of the half pipe, therefore, duration takes place in the form of a "move-transfer-move-transfer" loop.

On the other hand, the skateboarders themselves became an oscillating element of the installation. Meaning, if you will, that "the visitor becomes both an observer and an actor."**11** This very mixture of actor and (model)image is typical of skateboarding today, which is yet another reason why Majerus selected the half pipe for his exhibition. Skateboarders learn their "moves" from images (in special magazines and videos), try to become (living) images themselves, and then turn up as such in magafanzines or new videos. Iain Borden comments on this process: "The lived representation of skateboard images occurs when skaters undertake the moves themselves, reliving and re-producing photographs, video footage and internet movie clips through the agency of their body."**12** This emancipatory moment, when the image, its producer and the observer are parallel, seems to finally eliminate the separation between producer and recipient. In *if we are dead, so it is,* 2000, only "specialists" succeed in this, that is to say, the mainly young people who are able to ride the half pipe on their skateboards. Which is quite a difficult undertaking. I know, I've tried it. Given that skateboarders are not necessarily your normal Kunstverein visitors, Majerus thus deliberately re-defines his audience.

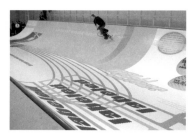

Doch Vorsicht und Widerspruch: Wird der Skater denn wirklich zum Produzent in diesem künstlerischen Spektakel?**13** Produziert dieser wirklich Bilder oder ist er nicht nur ein bloßes „youth culture"-taugliches Ornament zu den von Majerus vorab dargebotenen visuellen Äußerungen? Außerdem: Die von mir nur kurz – ein Bild sagt mehr als 1000 Worte – beschriebene Halfpipe ist schlichtweg zu groß für den Kölner Kunstraum, erlaubt den Skatern zu wenig Kopffreiheit, da sie fast bis an die Decke der Ausstellungshalle reicht. Dadurch ist die eigentlich funktionstüchtige Halfpipe, die, wie mir Michel Anfang 2000 auf der Rückseite eines Briefes flugs skizzierte, zunächst als Tunnel, als „Pipe", geplant, dann doch nicht tatsächlich zu befahren.

Insgesamt hat Majerus so mit *if we are dead, so it is,* 2000, bewusst eine konkrete Metapher für den Verlust geschaffen, den das „richtige Leben" im Kunstraum stets erfährt: Es wird mehr oder weniger zum bloß ansehbaren Bild, die Differenz von Alltag und Ästhetik soll zwar möglichst gering bleiben, ist aber wohl immer noch unüberbrückbar. In genau diesem Sinne schrieb schon Peter Bürger, dass die „Überführung der Kunst in Lebenspraxis [...] nicht stattgefunden hat und [...] wohl innerhalb der bürgerlichen Gesellschaft nicht stattfinden"**14** kann. Dann fragt er – und diese Wendung ist überaus interessant –, ob diese Aufhebung überhaupt wünschenswert ist, oder „ob nicht vielmehr die Distanz der Kunst zur Lebenspraxis allererst den Freiraum garantiert, innerhalb dessen Alternativen zum Bestehenden denkbar werden"?**15**

(Anlässlich der Biennale in Sevilla wurde 2004 posthum die Halfpipe ein zweites Mal aufgestellt, und zwar im Innenhof eines Klosters. Nun, open air installiert, war sie optimal befahrbar.)

3.

Berlin, 2002: Mit seiner letzten Installation *controlling the moonlight maze,* 2002, in der Berliner Galerie neugerriemschneider geht Majerus einen Schritt weg von „außerkünstlerischen" Raumzitaten hin zu einer dezidierten Reflexion einer künstlerischen Raumsituation. Die Installation besteht aus fünf oder, wenn man so will, sechs Teilen: Da ist zunächst das spiegelnd polierte, hinterrücks gelb pulverbeschichtete Edelstahlgerüst *keine zeit,* das mit fast schon „minimalistischer" Kühle vor jeder der vier Wände des Ausstellungsraumes einen nahezu raumgroßen Rahmen platziert und ihn sogleich ordnet. Vier Bilder

But careful; objection: Does the skateboarder really become a producer in this artistic spectacle?**13** Does the latter really produce images, or is he merely an appropriate "youth culture" ornament for the visual statements presented in advance by Majerus? Moreover, the half pipe which I have only briefly described – a picture says more than a thousand words – is simply too large for the Cologne art space and leaves the skateboarders too little headroom, reaching as it does almost up to the ceiling of the exhibition hall. So the functioning half pipe which, as Michel sketched for me on the back of a letter in early 2000, was initially planned as a tunnel or pipe, cannot actually be skated on.

As a whole, with *if we are dead, so it is,* 2000, Majerus deliberately created a concrete metaphor for the loss which "real life" always undergoes in the space of art: becoming more or less just a visible image. Although the gap between everyday life and art is intended to be as minor as possible, it obviously still cannot be bridged. Peter Bürger thus wrote that the "transfer of art into life practice [...] has not taken place and cannot take place within bourgeois society"**14**. He then asks what is an altogether interesting question, namely, whether this elimination is desirable at all, or "whether it is the distance between art and life practice that actually guarantees free space in the first place, that scope within which alternatives are conceivable to what already exists"?**15**

(The half pipe was posthumously installed a second time, in 2004 at the biennial in Seville, in the inner courtyard of a monastery. There, in the open air, it could be optimally used for skateboarding.)

3.

Berlin 2002: With his last installation *controlling the moonlight maze,* 2002, at the Galerie neugerriemschneider in Berlin, Majerus moved away from "extra-artistic" space citations towards a definite reflection on the artistic spatial situation. The installation consists of five, or if you like, six parts: first the shiny mirroring stainless steel scaffold powder-coated yellow on the back and called *keine zeit* which, with quasi "minimalist" cool, constitutes an almost room-high frame in front of each of the four walls of the exhibition space to put it immediately in order.

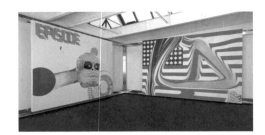

Fig. 6 Installationsansicht
controlling the moonlight maze,
neugerriemschneider, Berlin, 2002

Fig. 6 Installationsansicht
controlling the moonlight maze,
neugerriemschneider, Berlin, 2002

werden dann von diesen vier Rahmen umspielt: Die Wandmalerei *squirt the load,* Siebdruck und Lack auf einem Aluminiumkasten *(episode),* der Inkjet-Druck auf PVC *grid* sowie, Acryl auf Leinwand, das Gemälde *the modern age ‚abstract‘.* Dazu kommt als wohl sechster Teil der Galerieraum. Die vier Bilder sind hinter dem Rahmen *keine zeit* auf der Wand, zwischen Wand und Rahmen, im Rahmen und vor dem Rahmen installiert. Mit diesen ästhetischen und konkreten „Rahmenhandlungen" führt der Künstler, genau wie er hier unterschiedlichste Arten der Bildproduktion präsentiert, unterschiedliche Formen künstlerischer Displays vor. Dabei werden die Arbeiten quasi verschoben: gleichsam „fallen sie aus dem Rahmen" – mal nach vorne, mal nach hinten –, ein anderes zeigt sich als klassisch gerahmtes Tafelbild, dann wieder wird die Tradition des Wandbildes zitiert, die das Werk in situ verankert und als eigentlich nicht transportierbar formuliert. Vor allem aber bedenkt Majerus mit dieser intelligenten Installation das Problem, das schon Brian O'Doherty interessierte: die Rahmenbindungen von Galerie und Kunst. Die Galerie trennt die Kunst vom alltäglichen Leben und „schirmt das Werk von allem ab, was seiner Selbstbestimmung hinderlich in den Weg tritt"[16], und dadurch wird die Galerie letztlich zu einem so dominanten Kontext, dass dieser zum Inhalt zu werden droht und so „in einer seltsamen Umkehrung das Kunstwerk in der Galerie die Galerie und ihre Gesetze rahmt"[17]. Majerus spielt diese beiden Prozesse in allen möglichen Variationen durch: So gibt die Galerie[18] etwa die Größe und auch die Platzierung für *controlling the moonlight maze,* 2002, vor. Und viele der Motive der vier Bilder, etwa das werbemäßige Glitzern einer Sternschnuppe in *grid,* werden (hehre) „Kunst", nicht zuletzt durch den Kontext, in dem sie gezeigt werden, die Galerie bestimmt also den „Inhalt", das Bild ist ein Stück weit der (wartende) Rahmen im Rahmen.

Der Künstler versucht mit dieser vielschichtigen Installation selbstverständlich nicht den Ausbruch aus dem White Cube – dieser eben ist nicht mehr intendiert, ganz im Gegenteil[19] – und gerade weil Majerus mit *keine zeit*[20] und mit der die Arbeit begrenzenden und gleichzeitig konstituierenden Galerie sich den Rahmen selbst vorgibt, in dem er sich bewegen kann (und als Künstler letztlich wohl muss), gelingt es ihm, sich in seinem nun eigenen Betriebssystem mit größtmöglicher Freiheit zu bewegen. „Grenzen setzen heißt, diese überschreiten", hat der idealistische Staatsphilosoph Georg W. F. Hegel diese Dialektik einmal beschrieben. Diesen entgrenzten „Freiraum", wie es Peter Bürger nannte, nutzt Majerus auf seinen Bildern

Four paintings interact with these four frames: the wall painting *squirt the load,* silk-screen and varnish print on aluminium *episode,* the inkjet print on PVC *grid,* and the painting *the modern age 'abstract',* in acrylic on canvas. Part six would then be the gallery room. The four paintings are located behind the frame *keine zeit* either on the wall, between wall and frame, in the frame, or in front of the frame. By means of these aesthetic and concrete "framework actions" the artist presents different forms of artistic display, just as he also presents the most varied kinds of image production. In doing so, he actually shifts the works: they "fall out of the frame" (the German phase means to be out of the ordinary) – now to the front, now to the back; another one acts as a classically framed panel-painting; then the tradition of the mural is cited, anchoring the work on site. With this intelligent installation Majerus focuses above all on a problem that already interested Brian O'Doherty: the framework conditions of the gallery and of art. The gallery separates art from everyday life and "shields it from anything that might be an obstacle to its self-determination"[16]. Ultimately, the gallery-as-context is so dominant that it threatens to become content and "in a strange reversal, frame the artwork in the gallery, the gallery and its laws"[17]. Majerus plays with these two processes in all their possible variations: thus the gallery[18] determines, for example, the size and also the position of *controlling the moonlight maze,* 2002. And many of the motifs in the four paintings, for example, the advertisement-like glitter of a falling star in *grid,* become (sublime) "art" not least due to the context in which they are shown. So the gallery determines the "content"; to an extent, the painting is the (waiting) frame within the frame.

Needless to say, the artist is not using this multi-layered installation as an attempt to break out of the "white cube" – which is not his goal, on the contrary[19]. And because in *keine zeit*[20] and in the gallery that both restricts and constitutes the work, Majerus himself determines the framework in which he can move (and, as an artist, must ultimately move), he succeeds in moving with the greatest possible freedom within his own operating system. "Setting limits means breaking them" is how the idealist philosopher Georg W. F. Hegel once described this dialectic. Majerus thus uses this unrestricted free space (Freiraum) as Peter Bürger calls it, in his paintings, for

Fig. 7 *Sozialpalast,*
Brandenburger Tor,
Berlin, 2002

Fig. 7 *Sozialpalast,*
Brandenburg Gate,
Berlin, 2002

Fig. 8 *Sozialpalast*
in den Nachrichten

Fig. 8 *Sozialpalast*
in the TV news

Raimar Stange 208 209

u.a. damit, dass er, wie z.B. in *episode,* unterschiedliche Form-elemente wie Text, Grafik, die bildliche Darstellung einer kindlichen Horrormaske und eine malerische de Kooning-Para-phrase auf nur einem Bildgrund vereint.

4.

Abspann: Um der Versuchung einer nur chronoLOGISCHen Interpretation des leider allzu jung gebliebenen Werkes von Michel zu widerstehen, möchte ich zum Abschluss meines Textes kurz eine Installation vorstellen, die wieder hinausgeht aus dem White Cube und sich voll auf „Außerkünstlerisches" konzentriert, nämlich die Installation *Sozialpalast,* 2002. Für diese Arbeit hat Majerus das Brandenburger Tor, also eines der symbolträchtigen Displays in Deutschland für Erinnerungs-arbeit und Tourismusschwärmerei, mit dem „lebensgroßen" Abbild des Sozialpalasts behängt. So sah man statt des welt-bekannten Tores in Berlin-Mitte plötzlich an gleicher Stelle irritierenderweise das zumindest in Berlin als sozial prekär verschriene Gebäude aus der Pallasstraße in Schöneberg.**21** Zwei Images spielt der Künstler so gegeneinander aus: das des „sehenswürdigen" Brandenburger Tores und das des ver-meintlich urbanen „Schandflecks" Sozialpalast. Dabei ereignet sich eine so oberflächliche wie tiefgründige Dekontextualisie-rung, eine visuelle Verschiebung, die die Frage stellt, welche Bilder in unserem „imaginären Museum" abgespeichert wer-den und präsent sind, welche aber nicht. Dass diese Frage nicht zuletzt etwas mit Macht und Ökonomie zu tun hat, dies liegt auf der Hand.

Berlin, im Dezember 2004

example *episode,* in order to unite different formal elements such as text, graphics, the depiction of a children's horror mask and a painterly de Kooning-paraphrase on a single pictorial ground.

4.

Final credits: To resist the temptation of a merely chrono-LOGICAL interpretation of Michel's unfortunately all too young work, I would like to conclude my text by briefly presenting an installation that abandons the "white cube" so as to concentrate completely on something "extra-artistic", namely, the installation *Sozialpalast,* 2002. For this work, Majerus covered the Brandenburg Gate, one of the highly symbolic display areas for remembrance work and tourist enthusiasm in Germany, with a life-size image of the same "Sozialpalast". So in Berlin-Mitte, instead of the world famous Gate, one was suddenly irritated by the sight of a building from Pallasstrasse in Schöneberg, a district reputed, at least in Berlin, to be socially precari-ous.**21** The artist was playing off two images against one another: that of the "worthwhile" Brandenburg Gate and that of the Sozialpalast, a supposedly urban eyesore. A decontextualisation that is as superficial as it is pro-found, causing a visual shift that raises the question of which images are stored at the ready in our "imaginary museum", and which are not. Obviously, this question has to do, not least, with power and economics.

Berlin, December 2004

Anmerkungen

1 In: Raimar Stange: *Sur.Faces – Interviews 2001/2002.* Frankfurt am Main: Revolver 2002, S. 18.

2 So schreibt Robert Fleck etwa: „Majerus versucht die malerische Konsequenz aus dem Umstand zu ziehen, dass nach Pollock, de Kooning und Warhol eine kontemplative Haltung nicht mehr möglich sei." Und: „Es geht Majerus um visuell schnell erfahrbare Bilder." (beides in: *German Open,* Ausst. Kat., Kunstmuseum Wolfsburg, 1999, o. S.)

3 Klar: Auch ich habe im Studium gelernt, dass vom Leben nicht auf das Werk eines Künstlers zu schließen sei. Doch trotz dieser akademischen Rigidität: Als Start- und Kontrollmoment für einen Text taugt der „Kurzschluss" von Person und Arbeit allemal.

4 Selbstverständlich in: Brian O'Doherty: *In der weißen Zelle/Inside the White Cube.* Berlin: Merve 1996, S. 68.

5 (Sich vereinende) Gegensätze prägen auch das Werk des Künstlers Majerus über weite Strecken, etwa die von Abstraktion und Gegenständlichkeit, von High and Low, von Pop- und Minimal Art, von planer Zweidimensionalität und voluminöser Dreidimensionalität, von Schnelligkeit und deren Abbremsung sowie von laut und leise. Und zum Champagner hat Michel gerne Chips gegessen.

6 Majerus' Arbeit unter dem Blickwinkel von Henri Bergsons Begriff der „Dauer" zu untersuchen, wäre sicherlich ein spannendes Unterfangen, sprengt aber leider den Rahmen dieses Aufsatzes.

7 Mehr zu den Themen „Malerei" bzw. „Techno" im Essay von Veit Loers auf S. 38 ff. in diesem Katalog.

8 O'Doherty: *In der weißen Zelle,* S. 90.

9 *What looks good today may not look good tomorrow,* betitelte Majerus in diesem Sinne seine Installation in der Ausstellung *German Open,* Kunstmuseum Wolfsburg, 1999.

10 Iain Borden: *Skateboarding, Space and the City.* Oxford, New York: Berg 2001, S. 111.

11 Noemi Smolik: *Die Absichten des Künstlers werden überbewertet.* In: *Frankfurter Allgemeine Zeitung,* 3. November 2000, S. 49.

12 Borden, *Skateboarding,* S. 270.

13 Prompt betont der damalige Leiter des Kölnischen Kunstvereins, Udo Kittelmann, dass die Ausstellung „ein viel größeres Publikum reizt" (zitiert nach: *Kunsthistorische Arbeitsblätter,* 4/2001; vgl. http://www.kabonline.de).

14 Peter Bürger: *Theorie der Avantgarde.* Frankfurt am Main: Suhrkamp 1972, S. 72.

15 Ibid, S. 73.

16 O'Doherty, *In der weißen Zelle,* S. 9.

17 Ibid, S. 10.

18 Die Installation wurde ein Jahr später in der Ausstellung *Painting Pictures – Malerei und Medien im digitalen Zeitalter* im Kunstmuseum Wolfsburg gezeigt. Damals wurde in die große Ausstellungshalle ein künstlicher Raum gebaut, dessen Maße denen der Galerie neugerriemschneider entsprachen.

19 „Welche Kunst, wenn sie Kunst sein wollte, ist jemals woanders gelandet als in der Institution? Wo soll Kunst schließlich sonst landen?", hat Majerus es selbst formuliert (in: Raimar Stange: *Zurück in die Kunst.* Hamburg: Rogner und Bernhard bei Zweitausendeins 2003, S. 166).

Notes

1 In: *Sur.Faces – Interviews 2001/2002,* Raimar Stange. Frankfurt am Main 2002, p. 18.

2 For example, Robert Fleck writes: "Majerus tries to draw a painterly conclusion from the fact that after Pollock, de Kooning and Warhol it is no longer possible to take a contemplative stance." And: "Majerus is interested in images that can be visually processed quickly" (both quotations from: exh. cat. *German Open,* Kunstmuseum Wolfsburg 1999, no page numbers given).

3 Of course: and during my studies I too learnt that conclusions about the work of an artist cannot be drawn from his life. But despite this academic rigour, "cross circuiting" the person and the work can certainly give an initial impulse and act as a monitor for a text.

4 Needless to say in: Brian O'Doherty: *Inside the White Cube.* Berlin: Merve 1996, p. 68.

5 To a large extent (mutually attractive) opposites also characterise the artistic work of Majerus, for examples, those of abstraction and figuration, high and low, Pop- and Minimal Art, planar two-dimensionality and voluminous three-dimensionality, speed and its braking, and loud and soft. And Michel liked to eat crisps with champagne.

6 An examination of Majerus' work with Henri Bergson's concept of 'duration' in mind would surely be an exciting undertaking, but it would exceed the bounds of this essay.

7 More on the themes of "painting" or "techno" in the essay by Veit Loers on pp. 38 in this catalogue.

8 O'Doherty: *Inside the White Cube,* p. 90.

9 *What looks good today may not look good tomorrow* is what Majerus called his installation for the exhibition *German Open,* Kunstmuseum Wolfsburg, 1999.

10 Iain Borden: *Skateboarding, Space and the City.* Oxford, New York: Berg 2001, p. 111

11 Noemi Smolik: *Die Absichten des Künstlers werden überbewertet.* In: *Frankfurter Allgemeine Zeitung,* November 3, 2000, p. 49.

12 Borden, *Skateboarding,* p. 270.

13 The then director of the Kölnischer Kunstverein, Udo Kittelmann, quickly emphasised that the exhibition "attracted a much larger public" (quoted from: *Kunsthistorische Arbeitsblätter,* 4/2001; see http://www.kabonline.de).

14 Peter Bürger: *Theorie der Avantgarde.* Frankfurt am Main: Suhrkamp 1972, p. 72.

15 Ibid, p. 73.

16 O'Doherty, *Inside the White Cube,* p. 9.

17 Ibid, p. 10.

18 The installation was shown a year later in the exhibition *Painting Pictures – Malerei und Medien im digitalen Zeitalter* at the Kunstmuseum Wolfsburg. For this occasion, an artificial room was built in the large exhibition hall, the measurements of which corresponded to those of the Galerie neugerriemschneider.

20 Auch der Titel ist dialektischer Natur: „keine zeit" bedeutet ebenso „in Eile sein" wie die Dauer der zeitlosen Ewigkeit.

21 Da das Brandenburger Tor in vielen TV-Nachrichtensendungen als Live-Bild aus der deutschen Hauptstadt eingespielt wird, fand diese Irritation nicht nur in Berlin, sondern überall dort statt, wo diese Sendungen gesehen wurden.

19 "What art, if it was intended to be art, has ever ended up anywhere else than in the institution? Where, after all, is art supposed to end up?" Majerus asked himself (in: Raimar Stange: *Zurück in die Kunst*. Hamburg: Rogner und Bernhard bei Zweitausendeins 2003, p. 166).

20 The title is also dialectical: "keine zeit" means both to be in a hurry and the duration of a timeless eternity.

21 Given that the Brandenburg Gate appears in numerous TV news broadcasts as a live image from the German capital, this irritation was not just experienced in Berlin, but everywhere these news programmes were watched.

Ralf Christofori
No Logo (No Style No Points)
Einige Stationen im Leben und Werk von Michel Majerus
No Logo (No Style No Points)
A few Stages in the Life and Work of Michel Majerus

Ralf Christofori, geboren 1967 in Traunstein/DE, lebt in Stuttgart/DE.

Studium der Kunstgeschichte und Philosophie in Heidelberg, Promotion 2003 mit einer Arbeit über „Repräsentationsmodelle in der zeitgenössischen Fotografie".

Von 1998 bis 2000 wissenschaftlicher Assistent im Württembergischen Kunstverein Stuttgart, Kurator der Ausstellungen (Auswahl): *Colour me blind! Malerei in Zeiten von Computergame und Comic* (1999), *Night on Earth* (2001). Seit 2001 als Kunstkritiker tätig, u.a. für die *Frankfurter Allgemeine Zeitung,* den *Tagesspiegel,* Berlin, sowie für die Kunstzeitschriften *frieze, Kunst-Bulletin, Kunstforum International* und *Monopol.* Verfasser zahlreicher Katalogbeiträge und Essays zur zeitgenössischen Kunst und Kultur.

Ralf Christofori, born 1967 in Traunstein/DE in 1967, lives in Stuttgart/DE.

Studied the history of art and philosophy in Heidelberg, and gained a PhD in 2003 with a thesis called "Repräsentationsmodelle in der zeitgenössischen Fotografie" (Representational Models In Contemporary Photography).

From 1998 to 2000 he was academic assistant at the Württembergischer Kunstverein in Stuttgart and curated exhibitions including: *Colour me blind! Painting in times of computergames and comics* (1999), and *Night on Earth* (2001). Since 2001 he has written on art for newspapers such as the *Frankfurter Allgemeine Zeitung* and *Tagesspiegel* (Berlin) and art periodicals such as *frieze, Kunst-Bulletin, Kunstforum International* and *Monopol.* He has written numerous catalogue articles and essays on contemporary art and culture.

Im Dezember 2004 sitze ich in Berlin und versuche, mir ein Bild vom Leben und Werk Michel Majerus' zu machen. Vor gut zwei Jahren ist er bei einem Flugzeugunglück in Luxemburg ums Leben gekommen. Er war damals genauso alt wie ich – und das ist nur ein Grund, warum es ungemein schwer fällt, sich diese viel zu kurze Lebenszeit ganz ohne Anteilnahme zu vergegenwärtigen. Vor meinem geistigen Auge tauchen Werke von Majerus auf, Ausstellungen, Begegnungen mit ihm: ein wirres Gefüge, das sich, wie in einigen seiner Arbeiten, erst nach und nach lichtet – wenn überhaupt.

So sitze ich also mit dem Kunstkritiker Raimar Stange in einem Berliner Café und höre vor allem zu. Die Zeit, behauptet er, sei einer der zentralen Aspekte im Werk von Michel Majerus gewesen. Und vielleicht hat er ja recht. Als wäre es eine Selbstverständlichkeit synchronisierte der 1967 in Luxemburg geborene Künstler vergangene und zeitgemäße Bildfindungen, während er umgekehrt die vermeintliche Gleichzeitigkeit eines visuellen Zeitgeists ebenso treffsicher zergliederte. Wenn man im Hinblick auf sein Werk von Zeit sprechen kann, dann in einem weder linearen noch chronoLOGISCHen Sinne. Und dasselbe könnte man von Michel Majerus' Lebenszeit behaupten – oder von dem, was man gemeinhin als künstlerische Biografie bezeichnet.

Natürlich ist es nicht angemessen, vom Werk eines Künstlers auf dessen Leben zu schließen – und umgekehrt. Zumal, wenn man sich dazu verführen lässt, vieles, was dieses Werk zu Lebzeiten ausmachte, vor dem Hintergrund eines zu frühen Todes auszudeuten; wenn man etwa den Titel zweier in Los Angeles entstandener Arbeiten liest: *your ideas get you killed*, 2001; wenn man die gemeinsam mit Hans Jörg Mayer entstandenen Bilder seiner Ausstellung *letzte tage*, 2002, gesehen hat; oder wenn man, wie der Freund, Galerist und Sammler Charles Asprey, über dem Horizont einer Fotografie, die Michel Majerus am Strand von Los Angeles zeigt, ein Flugzeug erkennen will.

Diese Lesart ist nahe liegend, aber sie erscheint zu einfach, zu sehr dem Mythos verpflichtet. Ebenso unangemessen wäre es, das Leben des Künstlers gewissermaßen in retrospektiver Vorausschau auf eine einzige durchgehende Lebenslinie herunterzudampfen, die so etwas wie Umleitungen, Sackgassen oder rote Ampeln nicht kannte. Zweifelsohne war Majerus ein Künstler, der ganz genau wusste, was er wollte, und ebenso rasch begriff, wie er am schnellsten ans Ziel kommt. Und trotzdem war er als Person wie als Künstler zu wenig greifbar, zu widersprüchlich und auch zu selbstkritisch. Er arbeitete

It's December and I'm sitting in Berlin trying to form an image of the life and work of Michel Majerus. He died about two years ago in an airplane accident in Luxembourg. At the time, he was the same age as I – which is just one reason why it's very difficult to envisage that all too short life without emotion. In my mind's eye I see Majerus' works, his exhibitions, meetings with him: an intricate mesh which, like some of his works, can only be untangled gradually – if at all.

So I'm sitting in this Berlin café with the art critic Raimar Stange, mainly listening. Time, he claims, is one of the major themes in Michel Majerus' work. And maybe he's right. The artist, born in Luxembourg in 1967, synchronized past and present pictorial solutions as if that were something altogether self-evident, while on the other hand, he just as accurately dissected the supposed simultaneity of a visual *zeitgeist*. If one can talk about time at all with reference to his work, then in a sense that is neither linear nor chronoLOGICAL. And the same could be said of Michel Majerus' life – or of what is customarily called the artist's biography.

Of course it's not appropriate to draw conclusions about an artist's life from his work, and vice versa. Especially if you succumb to the temptation of interpreting much of what constituted that work in his lifetime against the backdrop of his early death; if you read, for example, the title of two works he produced in Los Angeles: *your ideas get you killed,* 2001; if you have seen the paintings, done jointly with Hans-Jörg Mayer, in his exhibition *letzte tage* (last days), 2002; or if, like his friend, the gallerist and collector Charles Asprey, you are intent on seeing an airplane above the horizon on a photograph showing Michel Majerus on the beach in Los Angeles.

Such a reading is understandable, but it seems too simple, too indebted to the myth. It would be just as inappropriate to reduce the artist's life, in a kind of retrospective forecast, to a single, constant life-line that included nothing like diversions, dead-ends or traffic-lights. There can be no doubt that Majerus was an artist who knew exactly what he wanted and just as swiftly recognized the quickest way to achieve his goal. Nevertheless, both as a person and as an artist, he was elusive, very contradictory and also very self-critical.

unglaublich schnell – und war sich der „Verfallszeit" seiner Arbeiten stets bewusst. Er bediente alle Klischees, die man von zeitgenössischer Malerei erwartet – und sah darin eines der größten Missverständnisse seiner Arbeit. Wenn er „Pop" sagte, schien er doch etwas ganz anderes zu meinen. Und wenn er sich zu seiner Arbeit äußerte, mündete das nicht selten in ebenso unsichere wie schlagfertige Aphorismen: „Ist ‚neu' immer ‚neu' und ‚alt' immer ‚alt'? Gut ist, wenn ‚neu' es schafft, ‚alt' zu werden."**1**

Michel Majerus' Werk hatte gar nicht die Gelegenheit, „alt" zu werden. Zumindest ist es in meiner Erinnerung immer „neu" geblieben. Zum ersten Mal begegnete ich diesem Werk vor etwa neun Jahren. Das war im Frühjahr 1996 in der Kunsthalle Basel. Ein Konglomerat von Logos und Streifenornamenten, von „Tags" und abstrakten Malspuren brüllte da von monumentalen Bildern; daneben eine Schiffslandung (*Einschiffung*, 1995) nach klassischem Vorbild, bevölkert von den Helden und Antihelden des Computerspiels „Donkey Kong" und durchzogen von riesigen Pinselhieben; dann wiederum satte Comicszenen auf sage und schreibe 70 Quadratmetern Malfläche – Szenen, die in einer weiteren Arbeit von einer weißen Grundierung genauso schnell vernichtet wurden, wie sie zuvor e ntstanden sein mochten; über die zweiteilige Arbeit *Massnahmen…*, 1994, lief der Schriftzug: „Massnahmen gegen Konvention, Establishment und Buerokratie, verschuettet und sinngeebnet, damit die Bevoelkerung sich nicht erinnert, wiederaufdecken und von da aus weitermachen."

Was dort auf der Leinwand wie ein gesellschaftlicher Aufruf klang, musste man im Zusammenhang der Ausstellung fast zwangsläufig als eine Art malerische Zivilcourage verstehen: als eine sinnfällige Maßnahme gegen malerische Konventionen, geboren aus dem Geist einer Erinnerung, die Majerus im begleitenden Ausstellungskatalog ebenso treffend wie vage benannte – kein Katalogtext, kein Künstlerstatement, sondern lediglich Versatzstücke von Bildern und Zitaten.**2** Runge und Disney, de Kooning und Mengs, Böcklin und Stella. Habe die Ehre.

Keine Frage: Diese Ausstellung war ein Ereignis. Ein Fanal. Und, was ich erst später begreifen sollte, eine zweifache Inauguration, von der zuvor keineswegs absehbar war, ob sie erfolgreich sein würde. Zum einen war es die erste Ausstellung in der Kunsthalle Basel unter der Direktion von Peter Pakesch; das heißt: Niemand außer der Findungskommission, die den ehemaligen Galeristen kurz zuvor berufen hatte, wusste, was

He worked incredibly fast – and was always aware of the "best by" date of his works. He used all the clichés expected of contemporary painting – and saw this as one of the reasons why his work was often gravely misunderstood. When he said "pop", he seemed to mean something else altogether. And when he spoke about his work, he often resorted to apprehensive yet quick-witted aphorisms: "Is 'new' always 'new' and 'old' always 'old'? It's good when 'new' manages to become 'old'."**1**

Michel Majerus' work didn't have a chance to get "old". In my mind at least, it remains "new". I first encountered that work about nine years ago. In spring 1996 at the Kunsthalle Basle. An agglomeration of logos and ornamental stripes, tags and abstract traces of paint screamed out at me from monumental paintings; beside that a ship's landing (*Einschiffung*, 1995) in the classical style, populated with heroes and anti-heroes from the computer game "Donkey Kong" and rendered with huge brush strokes; then jam-packed comic scenes on a painted area of no less than seventy square metres – scenes that in another work are destroyed by a white primer just as quickly as they may have been first produced; across the work *Massnahmen…*, 1994, ran the words: "Measures against convention, the establishment and bureaucracy, buried and levelled so that the people do not remember, uncover again and continue from there." (Orig. in German)

What sounded on the canvas like a social plea, had, almost necessarily, to be understood in the context of the exhibition as a kind of artistic courage: as an obvious measure against painterly conventions born of the spirit of a remembrance to which Majerus referred, both aptly and vaguely, in the accompanying exhibition catalogue – no catalogue text, no artist's statement, just fragments from paintings and citations.**2** Runge and Disney, de Kooning and Mengs, Böcklin and Stella. My pleasure entirely.

No question about it: that exhibition was an event, a signal, and, as I was only to realize later, a double inauguration, the success of which was in no way foreseeable. To begin with, it was the first exhibition at the Kunsthalle Basle under the direction of Peter Pakesch; meaning that no one, apart from the finding commission

Fig. 2 Michel Majerus, 1996

Ralf Christofori 214 215

von ihm eigentlich zu erwarten war. Zum anderen war es die erste große Einzelpräsentation eines in Berlin lebenden Malers, von dem kaum jemand zuvor Notiz genommen hatte; und das hieß wiederum: ein Maler, der in seinem winzigen Atelier vielteilige Leinwände erdachte und produzierte, die erst im Oberlichtsaal der Kunsthalle Basel zu monumentalen „Schinken" zusammengesetzt werden sollten.

Was Peter Pakesch an Michel Majerus so faszinierte und was ihn zu einer so frühen Einzelausstellung in dem renommierten Haus veranlasste, beschreibt er rückblickend so: „Michels Arbeit war immer unwahrscheinlich präzise und schnörkellos. Und doch verblüffend in Unerwartetem. No Nonsense."**3** Diese Einschätzung entspricht genau dem, was diese Ausstellung für mich war, wenngleich man äußerst sorgfältig auseinanderdividieren musste, wie und wo diese Prädikate am Werk waren. Schnörkellos erschien mir diese Malerei überhaupt nicht, aber sie war es doch in der Art und Weise, wie Majerus verschiedenste visuelle Codes im großen Format fast spielerisch durcharbeitete. Präzise war diese Malerei in ihrem absolut verantwortungsvollen Rekurs auf Vorbilder der jüngeren Malereigeschichte. Und verblüffend war vor allem der souveräne Umgang mit dem historischen Oberlichtsaal der Kunsthalle Basel, den der junge Künstler komplett beherrschte, indem er seine monumentalen Bilder vor die Wand oder mitten in den Raum stellte und den Boden komplett mit Metallplanken auslegte.

„Die Kombination von Malerei und Installation"**4**, die Peter Pakesch im Kopf hatte, war Michel Majerus auf höchst unerwartbare Weise gelungen. Aber sie war weder aus dem Nichts entstanden noch hatte sie den Anschein eines bloßen One-Hit-Wonders. Denn tatsächlich war sie das Resultat einer bereits über Jahre andauernden Infragestellung der Malerei, die schon während der Akademiezeit des Künstlers begonnen hatte. Von 1986 bis 1992 studierte Michel Majerus an der Staatlichen Akademie der Bildenden Künste Stuttgart. Wie außerordentlich begabt er war, muss nicht weiter betont werden, denn im Grunde war ihm diese Begabung nur Mittel, nicht aber Zweck an sich. So reichte auch seine Auseinandersetzung mit der Malerei stets über die Grenzen des eigenen Mediums hinaus. Das war in der Klasse von KRH Sonderborg der Fall, bei dem Majerus nach Abschluss der Grundklassen studierte, weit mehr noch wurden diese Grenzen deutlich, als Joseph Kosuth die Klasse 1991 übernahm. Während Sonderborg als Künstler und Lehrer das offene Feld der

that had recently appointed the former gallerist Pakesch, knew what to expect of him. Then, it was the first large solo exhibition of works by an artist who lived in Berlin of whom scarcely anyone had taken any notice until then; which in turn meant an artist who, in his tiny studio, conceived and produced multipart canvases which were not put together until they reached the "Oberlichtsaal" (exhibition hall) of the Kunsthalle Basle where these monumental "whoppers" were then displayed.

In retrospect Peter Pakesch describes what it was that so fascinated him about Michel Majerus and inspired him to mount this early solo exhibition at that famous Basle venue: "Michel's work was always so incredibly precise and unadorned. And yet had something surprisingly unexpected about it. No nonsense."**3** This assessment corresponds exactly to my impression of the exhibition, although how and where these predicates occur in the work must be differentiated with extreme care. To me, this painting did not appear to be unadorned at all, and yet it was, as a result of the way Majerus worked through the various visual codes, almost playfully and in large format. This painting was precise in its altogether responsible recourse to models from the recent history of painting. And astonishing was above all the autonomous handling of the historical "Oberlichtsaal" at the Kunsthalle Basle, which the young artist totally dominated by placing his monumental paintings in front of the walls or in the middle of the room and completely covering the floor in sheets of metal.

"This combination of painting and installation"**4** which Peter Pakesch had in mind was something Michel Majerus succeeded in producing in a highly unexpected way. It neither emerged out of nowhere, nor did it seem like one of those one-hit-wonders. It was actually the result of a questioning of painting which the artist had already begun during his art studies and which endured for years. From 1986 to 1992 Michel Majerus studied at the Staatliche Akademie der Bildenden Künste Stuttgart. I need not point out just how unusually gifted he was, yet for him this gift was basically only a means, not an end in itself. His engagement with painting extended beyond the bounds of his own medium. That was the case in the class given by KRH Sonderborg, under whom Majerus studied after completing the basic course. These bounds

Malerei als eine Art innere Herausforderung begriff, schien Kosuth seine Schüler zuallererst mit der strengen Hermetik der Konzeptkunst konfrontieren zu wollen. Die ganze Riege von Malern, erinnert sich Stephan Jung, „bekam erst einmal Wittgenstein auf den Tisch geknallt – und zwar auf Englisch"**5**. Alles Weitere sollte sich daraus ableiten: das Denken, die Sprache und möglichst auch die Kunst.

Die Maler der Klasse reagierten gelassen – auch dann noch, wenn es um das vermeintliche Selbstverständnis ihrer Zunft gehen sollte. Ob die konzeptuelle Haltung Joseph Kosuths dennoch ihre Wirkung zeigte, ist aus heutiger Sicht schwer zu sagen. Für Michel Majerus gipfelte sie höchstens darin, dem Lehrer und dessen Kunstbegriff eine warholsche Narrenkappe aufzusetzen: 1992 produzierte er bedruckte Kopfkissen, von denen Kosuth angeblich sogar einige Exemplare käuflich erwarb; im Juni desselben Jahres verteilte er auf der *documenta 9* handelsübliche Hundeköpfe aus Plastik, mit denen die Besucher durch die Installation Joseph Kosuths im Museum Fridericianum laufen sollten **6**; wenig später wiederum bestritt Majerus mit diesen Hundeköpfen seine erste Galerieausstellung in der Zellermayer Galerie, Berlin.

Diese kurzen, konzeptuell angehauchten Episoden wären nicht weiter erwähnenswert, würden sie nicht umgekehrt darauf hinweisen, wie gefestigt und selbstbewusst das eigentliche künstlerische Umfeld Michel Majerus' damals war. Zu diesem Umfeld gehörten neben Thomas Eifler und Les Schliesser vor allem die Mitglieder einer Künstlergruppe, die sich mit immerhin zwei Ausstellungen und sogar einer Publikation fast zwei Jahre lang am Leben erhielt: 3K-NH, das waren Kugel, Käse, Kartoffel, Nasenbär und Hase – oder mit bürgerlichen Namen: Susa Reinhardt, Michel Majerus, Wawrzyniec (Wawa) Tokarski, Nader und Stephan Jung. Allesamt waren sie Studenten der Stuttgarter Akademie, und als veritable Künstlergruppe hatte man tatsächlich so etwas wie ein Manifest: „3K-NH illustriert die Beziehung menschlicher Wesen als eine den Naturgesetzen unterworfene, welche die Funktion hat, den Entropieprozess so lange wie möglich abzubremsen. 3K-NH enthüllt die Nutzlosigkeit der Kommunikation im Allgemeinen, insbesondere in Werbung und Kunst. 3K-NH verkörpert die Bedrohung, der ein Durchschnittsmensch nicht ausgesetzt ist, die er aber als Grundlage seiner Existenz benötigt."**7**

became even clearer when Joseph Kosuth took on the class in 1991. While Sonderborg, both as an artist and a teacher, saw the open field of painting as a kind of inner challenge, Kosuth seemed to want to confront his students first of all with the hermetic strictness of Concept Art. As Stephan Jung recalls, the whole squad of artists "first had Wittgenstein thrown at them – in English what is more"**5**. Everything else was to be deduced from him: thinking, language, and if possible also art.

The artists in the class were unperturbed – even when it came to the supposed self-understanding of their guild. Whether Joseph Kosuth's conceptual approach really had an impact is difficult to say today. In the case of Michel Majerus, it culminated in his making Warhol-ish fun of his teacher and his concept of art: in 1992 he produced printed pillows, of which Kosuth is said to have even bought a couple; at *documenta 9* in June of that year he distributed commercially available plastic dogs' heads with which the visitors were supposed to walk through the installation by Joseph Kosuth at the Museum Fridericianum**6**; a little later, Majerus used those dogs' heads in his first gallery exhibition at Zellermayer Gallery in Berlin.

These brief conceptual episodes are only worth mentioning because they indicate just how stable and self-confident Michel Majerus' artistic milieu was at the time. His circle included not only Thomas Eifler and Les Schliesser, but above all members of an artists' group that managed to exist for almost two years, producing two exhibitions and a publication: 3K-NH. The letters stood for Kugel, Käse, Kartoffel, Nasenbär and Hase – otherwise known as Susa Reinhardt, Michel Majerus, Wawrzyniec (Wawa) Tokarski, Nader and Stephan Jung. They were all students at the Stuttgart academy and as veritable artists' group, they even had something like a manifesto: "3K-NH illustrates the relationship between human beings as one that is subject to natural laws and has the function of slowing down the process of entropy for as long as possible. 3K-NH exposes the uselessness of communication in general, and of advertising and art in particular. 3K-NH embodies the threat which the average person is not exposed to, but which he requires as the basis of his existence."**7**

Die erste Ausstellung der Künstlergruppe 3K-NH fand Ende September des Jahres 1992 in einem Ausstellungsraum statt, den Joseph Kosuth seinen Studenten an der Stuttgarter Akademie eingerichtet hatte. Auf pinkfarbenen Wänden präsentierte die Gruppe einen schillernden Kosmos aus aquarellierten „Fahrschuledias" (Tokarski), pornografischen Grotesken (Nader) und zwei überlebensgroßen Comicfiguren (Reinhardt). Auf der einen Stirnwand leuchtete Stephan Jungs Schriftzug „ich irrte nie", während Majerus einen Fries von 50 kleinformatigen Portraits auf dem Boden abstellte: ebenso absurde wie phantasievolle Etüden über die Welt der „Simpsons". Acht Monate später, im Mai 1993, sollte die zweite und zugleich letzte Ausstellung von 3K-NH in der Linienstraße 146 in Berlin-Mitte realisiert werden, diesmal als eine Ausstellung in drei Teilen über einen Zeitraum von nicht einmal zwei Wochen. Majerus' Beitrag bestand in einer Art Petersburger Bildergalerie mit dem Titel *Maria, Pornos, Märchen, Geld,* einem Gemeinschaftsbild mit Wawa Tokarski, sowie einer Wandmalerei, in der zum ersten Mal die Nintendo-Figur „Mario" auftauchte.

Die „Nutzlosigkeit der Kommunikation" in Werbung, Kunst und anderen Bereichen der visuellen Kultur, aus der die Künstlergruppe schöpfte, schien sich in den beiden Ausstellungen unmittelbar niederzuschlagen: in Malereien, für die die Malerei nicht der eigentliche Vorwand zu sein schien, und in Installationen, die sich der Malerei ohne jegliche Vorbehalte bedienten. Dabei ist durchaus bemerkenswert, dass Michel Majerus diese ersten Ausstellungssituationen mit einer genau ausbalancierten Mischung von Aufwand und Ertrag, von Sinnstiftung und -entleerung, von Reflexion und Intuition bestritt. Das gilt für die Auftritte von 3K-NH, aber ebenso für die Ausstellungsreihe *Kunst kaufen,* die Stephan Jung bereits 1992 in Berlin-Mitte organisiert hatte.8 Der Ort war damals das besetzte Vorderhaus in der Invalidenstraße 31, der Ausstellungsraum eine ehemalige Metzgerei, in der die Kunst (oder Ware) zwischen Fleischerhaken und Waschbecken auf gekachelten Wänden präsentiert wurde. „Kunst kaufen", das hieß im Falle von Michel Majerus: die bereits erwähnten Kopfkissen, eine breite Produktpalette kleiner Acrylbilder sowie eine feine „Oblatenschachtel" mit bedruckten Oblaten, auf der das verätzte Dürerbild der „Maria als Schmerzensmutter" reproduziert war.9

In diesen frühen 1990er Jahren hatte die künstlerische Biografie von Michel Majerus nach wie vor ihre Wurzeln in dem Stuttgarter Umfeld, sie sollte sich jedoch mehr und mehr nach Berlin verlagern. Ganz direkt führte Majerus' Weg nach Berlin,

The first exhibition of works by the artists' group 3K-NH in late September 1992 took place in an exhibition space which Joseph Kosuth had organised for his students at the Stuttgart academy. On walls painted pink the group presented a shimmering cosmos of watercoloured driving school slides, (Tokarski), pornographic grotesques (Nader) and two larger-than-life-size comic figures (Reinhardt). On one of the end walls glowed Stephan Jung's words "ich irrte nie" (I was never wrong), while Majerus laid a frieze of fifty small portraits on the floor: absurd but inventive studies of the world of the "Simpsons". Eight months later, in May 1993, the second and last 3K-NH exhibition took place on Linienstrasse 146 in Berlin-Mitte, this time in three parts and over a brief period of not even two weeks. Majerus' contribution consisted of a kind of St. Petersburg Picture Gallery entitled *Maria, Pornos, Märchen, Geld,* another work he produced jointly with Wawa Tokarski, and a mural in which the Nintendo figure "Mario" turned up for the first time.

The two exhibitions seemed to give direct expression to the "uselessness of communication" in advertising, art and other realms of visual culture from which the artists group drew their inspiration: in paintings for which painting did not seem to be the real pretext, and in installations which used painting without the slightest reservation. What is quite remarkable is the fact that Michel Majerus handled these first two exhibition situations with a precisely balanced mixture of investment and return, meaningfulness and meaninglessness, reflection and intuition. This applies both to the appearances of 3K-NH, and to the exhibition series *Kunst kaufen* (Buying Art) which Stephan Jung had already organised in Berlin-Mitte in 1992.8 The venue at that time was the occupied house No. 31 looking onto Invalidenstraße; the exhibition room was a former butcher's shop in which the art (or wares) was presented on tiled walls between meat hooks and wash basins. In Michel Majerus' case, buying art meant the above mentioned pillows, a wide range of small acrylic paintings and a fine packet of consecrated wafers embossed with Dürer's *Mater Dolorosa.*9

In the early 1990s Michel Majerus still had his artistic roots in the Stuttgart milieu, but they were to be gradually redirected to Berlin. His own personal route to Berlin was quite direct: in 1993 he moved into a flat on

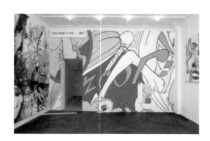

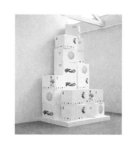

Fig. 4 Installationsansicht,
neugerriemschneider,
Berlin, 1994

Fig. 4 Installation view,
neugerriemschneider,
Berlin, 1994

Fig. 5 *A 1–7, T 1–7, H 1–7, M 1–7,* 1996
Installationsansicht, Galerie Monika
Sprüth, Köln, 1996

Fig. 5 *A 1–7, T 1–7, H 1–7, M 1–7,* 1996
Installation view, Galerie Monika
Sprüth, Köln, 1996

wo er 1993 in der Linienstraße mit Stephan Jung und Nader
eine Wohnung bezog. Auf Umwegen hingegen gelangte eine
Präsentationsmappe, die Majerus an den Kölner Galeristen
Max Hetzler schickte, zu dessen Mitarbeiter Tim Neuger.
Neuger arbeitete damals als „Scout" für Hetzler in New York
und wurde besonders aufmerksam, als er „einigen Originalen,
die in Majerus' Mappe abgebildet waren, bereits im Büro von
Colin de Land begegnete"[10]. Majerus hatte den New Yorker
Galeristen im Sommer 1992 während einer Veranstaltung im
Künstlerhaus Stuttgart kennen gelernt und ihm offensichtlich
bei seiner ersten New-York-Reise einige Arbeiten überlassen.[11]

Schon kurz nach seinem Studium erwies sich also Majerus als
cleverer Stratege, dessen Frechheit und Penetranz zum einen
von untrüglicher Begeisterung, zum anderen von einer fast
schon naiven Leichtigkeit angetrieben zu sein schien. „Diese
Leichtigkeit", erinnert sich Johannes Wohnseifer, „war bei ihm
gepaart mit einem großen Optimismus und Selbstbewusstsein.
Er schien sich schon sehr früh ziemlich sicher zu sein, was er
in der nächsten Zeit machen wollte, und wartete nur auf die
Gelegenheiten dies zu zeigen. Ich habe Michel damals zum
Beispiel sehr bewundert, weil er in seiner ersten Einzelaus-
stellung bei neugerriemschneider, trotz einiger Widerstände,
diesen Asphaltstraßenbelag verlegen ließ."[12]

Das war 1994. Und es war eine der ersten Ausstellungen der
beiden Berliner Junggaleristen Tim Neuger und Burkhard
Riemschneider. Den kleinen Raum in der Goethestraße nahm
Majerus komplett in Beschlag: von besagtem Asphaltboden,
der den Raum mitsamt Fahrbahnmarkierungen durchkreuzte,
über ein wandfüllendes Comic-Blow-Up bis hin zu einer riesigen
Leinwand, auf der sich abstrakte Gesten nach der kassettier-
ten Galeriedecke streckten; man konnte Zeichnungen erwer-
ben, die der Künstler auf laufendem Meter produzierte. Ganz
im Gegensatz zum einstigen Manifest der Künstlergruppe
3K-NH sah sich der kunstinteressierte „Durchschnittsmensch"
hier tatsächlich einer Art visuellen „Bedrohung" ausgesetzt,
die einem, wäre da nicht der Asphalt gewesen, durchaus den
Boden unter den Füßen weggezogen hätte. Gleichzeitig nahm
die Ausstellung lediglich das vorweg, was Majerus zwei Jahre
später im großen Maßstab und genauso selbstbewusst in der
Kunsthalle Basel zelebrierte.

Im Herbst 1996 wurde Majerus' zweite Einzelausstellung bei
neugerriemschneider eröffnet: *fertiggestellt zur zufriedenheit
aller, die bedenken haben*. Die Bedenken der Galeristen, dass

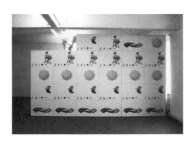

Fig.6 *A 1–7, T 1–7, H 1–7, M 1–7,* 1996
Installationsansicht *produce-reduce-reuse,*
Galerie Karl Heinz Meyer Karlsruhe, 1997

Fig.6 *A 1–7, T 1–7, H 1–7, M 1–7,* 1996
Installation view *produce-reduce-reuse,*
Galerie Karl Heinz Meyer Karlsruhe, 1997

Ralf Christofori 218 219

ihr Künstler sich wieder einmal an Boden, Wand oder Decke des Galerieraums zu schaffen machen könnte, wurden zerstreut. Stattdessen präsentierte Majerus eine schier endlose Rabatte kleinformatiger quadratischer Leinwände, auf denen er alle erdenklichen Malstile, Comichelden und Logos durchdeklinierte. Format und serielle Hängung der Bilder erinnerten an Andy Warhol, Majerus' Ikonen aber hießen nicht Marilyn oder Jackie, sondern de Kooning, Newman oder Richter, sie stammten aus „Toy Story" oder „Donkey Kong", und vor allem: Sie ließen sich allesamt prächtig verkaufen.**13**

So verlief Majerus' Ausstellung zur Zufriedenheit aller Beteiligten, aber sie war alles andere als eine Verkaufsausstellung. Vielmehr ging ihre Strategie vor allem darin auf, wieder einmal das Unerwartete ermöglicht zu haben. Von Warhol schien Majerus nicht nur ein grundlegend unhierarchisches Bildverständnis übernommen zu haben, sondern auch die Einsicht, dass das Unerwartete sich nicht zwangsläufig auf die Seite von Kritik oder Affirmation schlagen muss. Denn im Kern ging es Majerus letztlich um eine Malerei, die sich nicht länger auf die überlieferte Essenz ihres eigenen Mediums zurückziehen konnte – und um eine Kunst, die Systemgrenzen per se nicht akzeptieren wollte. „Man kann keine Kunst mehr machen, die ausschließlich Kunst ist", konstatierte Majerus**14** – und die Kunst, die er in Berlin und Basel gezeigt hatte, schien erst der Anfang zu sein.

Noch im selben Jahr produzierte er für eine Ausstellung im Grazer Kunstverein eine Serie von Aluminiumbildern, auf denen die Figur des Mario nicht mehr gemalt war, sondern per Siebdruck aufgetragen wurde. Bei Monika Sprüth in Köln konfrontierte er seine endlose und unbetitelte Serie von Acrylbildern mit gestapelten Kisten, die wiederum mit Figuren aus „Toy Story" bedruckt waren. Anfang 1997 tauchten diese Kisten in der Karlsruher Galerie Karlheinz Meyer wieder auf, diesmal umgeben von Majerus' „MoM-Block"-Bildern sowie dem Schriftzug „DECODER", dessen „O" man auch als „U" lesen konnte. Die Referenzen, die wie Pfeile durch diese Ausstellungen flitzten, bezogen sich nur noch vordergründig auf die Malerei: der offensichtliche Verweis auf Warhols *Brillo-Boxes*, ein Schriftzug, der in umgekehrter Lesart an eine Arbeit von Lawrence Weiner erinnerte (*REDUCED*), nicht zuletzt der Titel der Karlsruher Ausstellung, der ein Zitat Elaine Sturtevants paraphrasierte: *produce-reduce-reuse*.**15**

of the gallerists – that their artist would again create a problem for the floor, walls or ceiling of the gallery space – were soon dispelled. Instead Majerus presented sheer endless rows of small square canvases on which he processed all imaginable painting styles, comic heroes and logos. The format and the hanging of the paintings in series were reminiscent of Andy Warhol, but Majerus' icons were not called Marilyn or Jackie, but de Kooning, Newman or Richter, they came from "Toy Story" or "Donkey Kong", and above all, they could all be readily sold.**13**

Majerus' exhibition was thus to everyone's satisfaction, yet it was far from being just a sales exhibition. Instead it once again fully realised the strategy of facilitating the unexpected. Majerus seemed to have adopted from Warhol not only a thoroughly non-hierarchical understanding of the painting, but also the view that the unexpected need not necessarily side with criticism or affirmation. Ultimately Majerus was preoccupied with a painting that could no longer fall back on the traditional essence of its own medium, and with an art that did not want to accept borders per se. As Majerus put it, "It is not possible anymore to produce art that is exclusively art."**14** And the art he had shown in Berlin and Basle seemed to be just the beginning.

For an exhibition in the Grazer Kunstverein that same year, he produced a series of aluminium paintings in which the figure of Mario was no longer painted, but applied using the silk-screen printing method. At the Monika Sprüth gallery in Cologne he confronted his endless untitled series of acrylic paintings with stacks of boxes which, in turn, had figures from "Toy Story" printed on them. In early 1997 the boxes turned up again at the Karlheinz Meyer gallery in Karlsruhe, this time surrounded by Majerus' "MoM-Block" paintings and the word "DECODER", the "O" of which could also be read as a "U". The allusions, flitting about this exhibitions like arrows, were only superficially to painting: the obvious reference to Warhol's *Brillo Boxes,* the word which when read backwards recalled a work by Lawrence Weiner (*REDUCED*), and, not least, the title of the Karlsruhe exhibition, which paraphrased the words of Elaine Sturtevant: *produce-reduce-reuse*.**15**

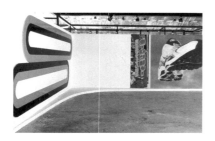

Fig. 7 *dieser einzelfall an konstruktion ist insofern ein schlüsselbild, als er das irrationale, nämlich der gewohnten räumlichen rationalität widersprechende raumgefüge der nachfolgenden abstrakten bilder fast didaktisch ankündigt,* 1997 Installationsansicht *topping out,* Städische Galerie Nordhorn, 1997

Fig. 7 *dieser einzelfall an konstruktion ist insofern ein schlüsselbild, als er das irrationale, nämlich der gewohnten räumlichen rationalität widersprechende raumgefüge der nachfolgenden abstrakten bilder fast didaktisch ankündigt,* 1997 Installation view *topping out,* Städische Galerie Nordhorn, 1997

In den Jahren 1996 und 1997 begann Michel Majerus, mit den unterschiedlichsten Mitteln zu produzieren („produce"), und diese Mittel erwiesen sich auch als geeigneter Weg, um möglichst effizient zu arbeiten. Die Möglichkeit einer bloßen Übersetzung in Malerei erschien dem Maler nicht mehr adäquat und zu angestrengt. „Computerausdrucke, die wie Werbung aussehen, weil diese ganz einfach die Mittel der Werbung sind, sind für mich meine Medien: Es geht darum, Zeit zu sparen, Arbeit zu sparen, es geht um eine möglichst ökonomisch effektive Produktion", so Majerus in einem Interview mit Kathrin Luz.**16** Unter dieser Prämisse entstanden für eine Ausstellung in der Mailänder Galerie Gió Marconi Wand- und Bodenelemente, die der Idee des Corporate Design entsprungen zu sein schienen, während in Majerus' *Space Safari* bei Anders Tornberg (Lund) Malerei und Kommunikationsdesign eine gelungene Liaison eingingen. Was die Verwendung von Computerausdrucken anbelangt, so gehört der Nike-Sneaker, den Majerus 1997 für die Gruppenausstellung *Topping Out* in der Städtischen Galerie Nordhorn konzipierte, sicher zu den frühesten und wohl auch prägendsten Beispielen.

Seine Art des Wiederverwendens („reuse") von bekannten Codes wiederum verleugnete nicht die Affinität zu den Kontexten, aus denen sie stammten. Gleichzeitig aber konnte er damit Kontexte schaffen, die das scheinbar Bekannte einer neuen Sichtweise überantworteten. So erlaubte sich Majerus auch einzelne Motive seiner Arbeiten in anderen wieder zu verwenden. Wichtig waren ihm die jeweiligen Quellen und potentielle „Andockmöglichkeiten".**17** Einen Nike-Sneaker etwa integrierte Majerus mit derselben Selbstverständlichkeit sowohl bei „topping out" in Nordhorn wie auch in seinem Beitrag für die Luxemburger *Manifesta 2* (1998), wie er eine Hommage an Frank Stella aus der Basler Ausstellung darin noch einmal wiederkehren ließ.

Der Aspekt des Reduzierens („reduce") schließlich war für Majerus doppelt ambivalent: zum einen hinsichtlich eines reduktionistischen Zugangs zu potentiellen Vorbildern, den Majerus unter allen Umständen vermeiden wollte, zum anderen, was die missverständliche Rezeption seines eigenen Werkes betraf: „Michel beklagte sich oft", erinnert sich Johannes Wohnseifer, „dass er immer wieder als ‚Malerschwein' bezeichnet und verkauft wurde. Ich weiß nicht mehr, wer den Begriff geprägt hatte, und er war in Zusammenhang mit Michels Arbeiten auch gar nicht abwertend verwendet worden, aber Michel sah sich dadurch immer reduziert."**18**

In 1996 and 1997 Michel Majerus began working with the most varied of means, which also proved to be a suitable way of producing ("produce") as efficiently as possible. The artist no longer regarded the mere translation into painting as sufficient; it was too forced. "Computer print-outs that look like advertising simply because they are the means of advertising, are my media: it's a matter of saving time, of saving effort, of the most economically-effective mode of production," so Majerus in an interview with Kathrin Luz.**16** For an exhibition at the Milan gallery Gio Marconi, and based on this premise, he produced wall and floor elements that seemed to have sprung from the idea of corporate design. In Majerus' *Space Safari* at Anders Tornberg's gallery (Lund), painting and communication design enter into a successful liaison. As for the use of computer print-outs, Nike-Sneaker, which Majerus conceived in 1997 for the group exhibition *Topping Out* at the Städtische Galerie Nordhorn, is surely one of the earliest and most telling examples.

Majerus' way of reusing ("reuse") known codes did not, on the other hand, deny their affinity to their original contexts. At the same time, however, they enabled him to create contexts which cast a new light on the apparently familiar. Thus he also allowed himself to reuse individual motifs from his own works. What was important to him were the respective sources and potential "docking on possibilities"**17**. For example, he integrated the Nike-Sneaker as well in Nordhorn into his contribution to the Luxembourg *Manifesta 2* (1998) with the same matter of factness as he reused an homage to Frank Stella from the Basle exhibition.

For Majerus, after all, the aspect of reduction ("reduce") was doubly ambivalent, on the one hand, in terms of a reductionist approach to potential models which Majerus wanted to avoid at all costs, and on the other, in terms of the misleading reception of his own work. According to Johannes Wohnseifer, "Michel often lamented that he was repeatedly designated and sold as an 'painter pig'. I no longer remember who coined the phrase, and it was also not used disparagingly in connection with Michel's works, but Michel always saw himself as reduced by it."**18**

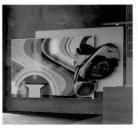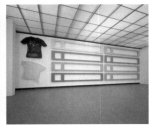

Fig. 8 *yet sometimes what is read success-fully, stops us with its meaning, no.II*, 1998
Installationsansicht *Manifesta 2,*
Luxemburg, 1998

Fig. 8 *yet sometimes what is read success-fully, stops us with its meaning, no.II*, 1998
Installation view *Manifesta 2,*
Luxembourg, 1998

Fig. 9 *aufnahme position/löschschutz-position*, 1999
Installationsansicht *Colour me blind*, Württem-bergischer Kunstverein, Stuttgart, 1999

Fig. 9 *aufnahme position/löschschutz-position*, 1999
Installation view *Colour me blind*, Württem-bergischer Kunstverein, Stuttgart, 1999

Was auch immer man unter einem solchen „Malerschwein" verstehen mag – darauf ließ sich Michel Majerus nun wirklich nicht reduzieren. Wie gesagt, der Selbstzweck malerischer Mittel und Ausdrucksqualitäten langweilte ihn von Beginn an, und so war es nur konsequent, dass er die Mittel, mit denen Computerspiele, Werbung und Design arbeiteten nahtlos in sein Werk integrierte. Der Begriff der „Bilderaufbereitungsmaschine", den Raimar Stange in Bezug auf Majerus verwendete [19], traf demgemäß weit eher zu – aber auch dann nur in dem Sinne, dass man nie vorher ahnen konnte, was diese Maschine am Ende hervorbrachte. Und damit sind nicht nur die Werke des Künstlers gemeint.

So erinnert sich Udo Kittelmann an einen Vortrag, den Majerus im September 1997 im Rahmen der großen Polke-Retrospek-tive hielt: „Ich habe selten einen intelligenteren Künstlervortrag erlebt als den in der Bundeskunsthalle Bonn. Michel, der nicht sonderlich eloquent war, besaß die Frechheit, Super-Mario-Demovideos über die halbtransparenten Lackbilder laufen zu lassen, die Polke Ende der 1980er, Anfang der 1990er Jahre gemalt hatte. Auf diese Weise und mit spärlichen Kommenta-ren untertitelt, schuf Majerus ein ebenso sinnfälliges wie über-raschendes Gefüge, das nicht nur seine Arbeit, sondern mehr noch die Sigmar Polkes in ein völlig neues Licht tauchte." [20] Schwer zu sagen, ob Michel Majerus an jenem denkwürdigen Abend wirklich vorher ahnte, was er am Ende hervorgebracht haben würde. Gut möglich, dass er es nicht wusste und damit insgeheim den Worten Willem de Koonings folgte, den er zeit seines Lebens bewunderte: „Was mich fasziniert, ist, etwas zu machen, ohne sicher zu sein, was es wird und von dem das auch sonst keiner mit Sicherheit sagen kann. Ich werde es nie wissen, und auch sonst wird es niemand wissen, so erlebe ich Kunst." [21]

Dass sich weder Künstler noch Betrachter, weder Kritiker noch Kuratoren bei Michel Majerus sicher sein konnten, habe ich am eigenen Leib erfahren. Im November 1999 kuratierte ich im Württembergischen Kunstverein Stuttgart die Aus-stellung *Colour me blind!,* die sich mit den Einflüssen von Comics und Computergames auf die zeitgenössische Malerei auseinander setzen sollte. Ich hatte einige Ausstellungen und Arbeiten von Majerus gesehen und ihn daraufhin eingeladen, eine neue Arbeit für die Ausstellung zu produzieren. Das Ergebnis war ernüchternd, wenn nicht gar enttäuschend: Es bestand aus in RAL-Farben lackierten Elementen, deren Form an die Blanko-Etiketten von Video-Cassetten erinnerten; diese

Whatever is to be understood by "painter pig" – Michel Majerus cannot seriously be reduced to that. As already mentioned, he had always been bored by the use of painterly means and expressive qualities for their own sake, so it was only consistent that he smoothly inte-grated the means used by computer games, advertising and design into his work. As such the term "image pro-cessing machine" which Raimar Stange used in connec-tion with Majerus [19] was more appropriate – but only in the sense that it was not possible to anticipate what this machine would produce in the end. And this not only applies to the artist's works.

Udo Kittelmann recalls a lecture given by Majerus in September 1997 within the framework of a large Polke retrospective exhibition: "I have seldom attended a more intelligent artist's lecture than the one given at the Bundeskunsthalle in Bonn. Michel, who was not parti-cularly eloquent, had the cheek to run 'Super Mario' demo-videos across the semi-transparent paintings which Polke produced in the late 1980s and early 1990s. By doing this, and with the help of sparse commentary-subtitles, Majerus created a construct that was as mean-ingful as it was surprising, shedding a whole new light not only on his work, but even more so on that of Sigmar Polke." [20] It is difficult to say if Michel Majerus really knew in advance what he would ultimately produce on that auspicious occasion. It's quite possible that he didn't know, and was thus secretly adhering to the words of Willem de Kooning, whom he had always admired: "I am fascinated by doing something without being sure what it will become, something that no one else can say for sure either what it will become. I will never know, and neither will anyone else; that is how I experience art." [21]

That neither artist nor spectator, critic nor curator could be quite sure with Michel Majerus is something I myself have personally experienced. In November 1999 I curated the exhibition *Colour me blind!* at the Württembergische Kunstverein Stuttgart, which aimed at investigating the influence of comics and computer-games on contempo-rary painting. I had already seen some exhibitions and works by Majerus and so invited him to produce a new work for the exhibition. The result was sobering, if not to say disappointing: It consisted of elements painted in RAL colours, reminiscent in their form of the blank labels

Fig. 10 Michel Majerus und
Bastian Krondorfer, Taipeh, 2001

Fig. 10 Michel Majerus and
Bastian Krondorfer, Taipeh, 2001

wiederum wurden an beiden Seiten flankiert von den
Computerausdrucken zweier überlebensgroßer T-Shirts.

Keine Malerei, nirgends. Und dabei hatte ich mir vorgestellt,
er würde sich als waschechter „Comicmaler" mächtig ins Zeug
legen. Majerus hatte sich indes als renitent genug erwiesen,
dieser kuratorischen Vorstellung gerade nicht zu entsprechen.
Im Grunde war diese seine Entscheidung, sich nicht als „Co-
micmaler" vereinnahmen zu lassen, absolut nachvollziehbar.
Aber darauf kam ich erst hinterher. Einen ähnlichen Eindruck
vermittelte für mich die Arbeit, die Majerus 1998 für die Aus-
stellung *Tell Me a Story: Narration in Contemporary Painting
and Photography* im Magasin, Grenoble, realisierte. Jedenfalls
findet man im Werk von Michel Majerus kaum eine Arbeit, die
weniger erzählerisch wäre, als diese es war. In beiden Fällen
hatte sich Majerus wieder einmal erfolgreich einer Reduzierung
auf Erwartbares entzogen. Zwar benutzte er Malstile und
Motive wie „Trademarks", er selbst weigerte sich indes stand-
haft, nur als „Trademark" im internationalen Kunstgeschehen
zu reüssieren. Dabei kam ihm – wie Jochen Volz bemerkt –
sicher jene „unverfrorene Selbstverständlichkeit" zugute, „mit
der Majerus Bilder, Symbole, Techniken und Ausdrucksformen
benutzte"[22] – und, so könnte man fortführen, die er ebenso
ökonomisch zu verwerten wusste. So ökonomisch diese „Bild-
aufarbeitung" aber auch gewesen sein mag, seine visuelle Auf-
nahmekapazität ließ sich in ökonomischen Begriffen gar nicht
erfassen: weder bei MTV und Nintendo noch in Museen, in
Freizeitparks oder im ganz normalen Alltag von Großstädten
wie Berlin und London.

„Michel Majerus", so erzählt Charles Asprey, „genoss seine
Zeit in London ungeheuer, hatte bei uns 1999 eine Einzel-
ausstellung, ‚Thai-Ming', und danach 2000 eine Residency in
den Delfina-Ateliers. London stillte seinen Hunger nach Kunst
aus allen Epochen. Als er nach London kam, zum Beispiel,
bestand ein typischer Tag vor der Installation seiner Ausstellung
aus einem Besuch der National Gallery, gefolgt von einem Aus-
flug in die Tate Gallery und danach einem Besuch der ‚Sega
World' auf dem Piccadilly Circus. Und es ist schwer zu sagen,
wo er glücklicher war! In der ‚Sega World' ließen wir uns in
diesen beschissenen japanischen Kabinen Seite an Seite mit
Zeichentrick-Action-Helden fotografieren und machten dann
Tintenstempel aus dem Foto, die Michel dann vor Ort überall
aufstempelte. Diese Form von ‚Trash-Kultur' des zwanzigsten
Jahrhunderts machte ihm, glaube ich, genauso viel Freude
wie die Uccellos in der National Gallery."[23]

that come with video cassettes; these in turn were
flanked on both sides by computer print-outs of two
larger-than-life-size T-shirts.

No painting, nowhere. And I had expected that as a gen-
uine "comic painter" he would really do his stuff. Majerus
turned out to be obstinate enough not to comply with
this curatorial idea. Basically, his decision not to be
monopolized as a "comic painter" was completely under-
standable, as I only realized afterwards. I got a similar
impression from the work Majerus produced in 1998 for
the exhibition *Tell Me a Story: Narration in Contemporary
Painting and Photography* at Magasin in Grenoble. At any
rate, scarcely any other work by Michel Majerus has
been less narrative than that one. In both cases Majerus
had successfully evaded being reduced to something
that could be anticipated. Although he used painting
styles and motifs like trademarks, he himself steadfastly
refused to succeed in the international art world as a
mere trademark. He was certainly helped in this, as
Jochen Volz remarks, by that "brazenness with which
Majerus availed himself of images, symbols, techniques
and expressive form"[22], which, one could add, he was
also well able to use economically. Yet however economic
this "image processing" may have been, his capacity
for visual reception could not be described in economic
terms: neither with MTV or Nintendo, nor in museums,
leisure parks or in normal everyday life in large cities
like Berlin and London.

As Charles Asprey tells us, Michel Majerus "enjoyed his
time in London enormously, having a solo show with
us in 1999, 'Thai-Ming', and a later residency at Delfina
Studios in 2000. London satisfied his appetite for the
Arts of all ages. For example, when he came to London
a typical day prior to installing his show would be a visit
to the National Gallery, followed by a trip to the Tate, fol-
lowed by a visit to 'Sega World' in Piccadilly Circus, and
it is hard to say where he was happier! In 'Sega World'
we would have photos of ourselves taken alongside ani-
mated action heroes using those crappy Japanese booths
and then make ink stamps from the photo which Michel
would stamp all over the place. This 20th Century 'trash'
culture gave him as much pleasure I think as the Uccellos
at the National Gallery."[23]

Diese unterschiedlichen Lebenswelten, die Majerus im Gedächtnis und auf seiner Computerfestplatte speicherte, um sie bei nächster Gelegenheit in Malereien, Computerausdrucke und Installationen überführen zu können, waren wesentlicher Bestandteil seines bildnerischen Denkens. Dass dieses Denken für Außenstehende kaum nachvollziehbar war, daraus resultierte umgekehrt und in nicht geringem Maße jene „Unsicherheit", die der Künstler zwar intendierte, die sein Publikum aber ebenso polarisierte. Über seine riesige und aufwändige Arbeit für die *German Open* im Kunstmuseum Wolfsburg konnte man ebenso geteilter Meinung sein wie über die Halfpipe, die er 2000 für den Kölnischen Kunstverein konzipierte. Denn angesichts der immer weiter ausgreifenden Bezugssysteme, die Michel Majerus im Laufe der Jahre in seine Arbeit aufnahm, lag ein Problem auf der Hand, das die von ihm angestrebte „Unsicherheit" fast zwangsläufig mit sich bringen musste: Wie konnte er so sicher sein, dass der ungeheure Fundus an visuellem „Material", aus dem er schöpfte, sich nicht in Wahllosigkeit erschöpfte? Und: Wie konnte er es bewerkstelligen, dass dieser Fundus in seinen Bildfindungen eine neue, tatsächlich unerwartete Relevanz bekam?

Von November 2000 bis November 2001 lebte und unterrichtete Majerus in Los Angeles, also an einem Ort, an dem sich wahrscheinlich mehr als irgendwo sonst diese Fragen stellten. So schreibt er von dort aus in einer E-Mail an seine langjährige Lebensgefährtin Heike Föll: „Ich fühle mich, wie von einem Sabotageprogramm irregeleitet, auf einem Trip, auf dem ich nur noch Eindrücke wahrnehme in der Form, wie ich sie auch selbst in meiner Arbeit produzieren kann."**24** Das „Material", aus dem er sonst schöpfte, schien dort bereits zu seinen eigenen Arbeiten verarbeitet – vor allem in riesigen Billboards an den Häuserfassaden und Freeways der Stadt. Ein Weg, diesem „irregeleiteten Sabotageprogramm" zu entkommen, bestand darin, all jene Bilder, die in LA entstanden, in jenem Billboard-Format anzulegen, das die Stadt so sehr beherrschte.**25**

Eine andere Strategie, dieser scheinbar ausgelieferten Aufmerksamkeit zu entgehen, beschreibt Majerus in einer weiteren E-Mail an die Galerie neugerriemschneider so: „Letzte Woche hab ich einen Idiotentest bestanden. Ich stand an einer Strassenkreuzung, links von mir gab es ein leeres grosses billboard und rechts von mir eine riesige aufgeblasene Ente von Van Nuys Car Sales. Die Ampel wurde gleich grün und ich konnte allerhöchstens ein Foto machen. Ich weiss nicht warum, aber ich habe das weisse billboard fotografiert. Ich Idiot, und dabei

These different lifeworlds which Majerus stored in his memory and on his hard disc so as to be able to use them at the next opportunity in paintings, computer print-outs and installations were an essential component of his creative thinking. That this way of thinking was scarcely understandable for outsiders is largely responsible for that "uncertainty" which was intended by the artist, but which polarized his audience. It was as possible to be of divided opinion about his huge complex work for the *German Open* at the Kunstmuseum Wolfsburg, as it was about the half-pipe which he conceived for the Kölnische Kunstverein in 2000. For in view of the ever more expansive reference systems which Michel Majerus integrated into his work over the years, the problem which the "uncertainty" he strove for would almost necessarily bring with it was obvious: How could he be sure that the enormous stocks of visual "material" from which he drew would not become random? And how could he ensure that his pictorial solutions would imbue these stocks with a new, really unexpected relevance?

Majerus lived and taught from November 2000 to November 2001 in Los Angeles, a place where these questions are more likely to arise than anywhere else. In an email from there to his long-term partner Heike Föll he wrote: "As if misguided by a sabotage programme, I feel as if I'm on a trip during which I only perceive impressions in a form in which I can produce them myself in my work."**24** In LA, the "material" from which he otherwise drew seemed to have already processed itself to works – above all, in the city's huge billboards on house facades and freeways. One way of escaping from this "misguided sabotage programme" was to realize all the images that he produced in LA in the billboard format that so dominated the city.**25**

In another e-mail to the neugerriemschneider gallery Majerus describes a different strategy for avoiding the apparent attacks on his attention: "Last week I qualified as an idiot. I was standing at a street corner, on my left was a large empty billboard, on my right a huge blown-up duck from Van Nuys Car Sales. The traffic lights were about to turn green and I only had enough time to take one photo. I don't know why, but idiot that I am, I photographed the white billboard, although I could make any stupid poster white with Photoshop, but of course I won't

könnte ich mit Photoshop jedes blöde Plakat weiss machen, aber das mach ich natürlich nicht, das überlasse ich den anderen Leuten. Jedenfalls habe ich die Ente nicht fotografiert und somit den Deppentest bestanden."[26] Als im Sommer 2002 bei Friedrich Petzel in New York Michel Majerus' erste Einzelausstellung in den USA eröffnet wurde, schrieb Cary Levine in *Art in America:* „Das könnte die zentrale Metapher für Majerus' Kulturverständnis sein: Der Ansturm ist nicht zu stoppen, also kannst du nur hineintauchen."[27] Aber genau das schien Majerus in dieser Ausstellung nicht zu tun. Jedenfalls suchte man vergeblich nach den frischen Eindrücken von der US-amerikanischen Westküste, in die er getaucht sein könnte. Stattdessen besann sich sein *Leuchtland* eher auf die alten Tage von „Bravo" und „Space Invaders" zurück.

Ein dritter Weg, der Michel Majerus bereits seit Mitte der 1990er Jahre immer wieder eröffnet wurde, bestand darin, seine Kunst gewissermaßen der Lebenswelt des öffentlichen und halböffentlichen Raums wieder zurückzugeben. Das geschah erstmals 1996 in der Arbeit *Aquarell,* einer mehrteiligen Leinwand von zehn mal zehn Metern Fläche, die Majerus hinter der Glasfassade des Kunstvereins in Hamburg errichtete. Zwei Jahre später füllte er eine Plakatwand in der Wiener Innenstadt, ein Projekt im öffentlichen Raum, das anlässlich der Ausstellung *Das Jahrhundert der künstlerischen Freiheit: 100 Jahre Wiener Secession* realisiert wurde. Wie nahtlos sich Michel Majerus' Bildfindungen in den öffentlichen Raum einfügen konnten, zeigte wiederum die Arbeit *Beschleunigung,* die er im selben Jahr für die Halle des Münchner Hauptbahnhofes konzipierte. Als Teilnehmer der *48. Biennale di Venezia* schließlich erdachte Majerus 1999 eine ebenso treffende wie ausgeklügelte Paraphrase: die klassizistische Fassade des Italienischen Pavillons verwandelte er in eine riesige Spielkonsole, von der aus man sich in alle möglichen Himmelsrichtungen durch das ständig rotierende Sonnensystem der zeitgenössischen Kunst navigieren konnte.

Ob sich bis zuletzt Majerus' Kunst der Lebenswelt immer mehr annäherte oder nicht, lässt sich angesichts der Werke, Ausstellungen und Projekte kaum eindeutig ermessen. Oder vielleicht ist es in diesem Zusammenhang auch so, wie es in einer seiner Arbeiten heißt: „just when i nearly had the answer i forgot the question"[28]. Dass Majerus' Antworten teilweise gigantische Ausmaße annahmen, war keine Attitüde, die man sich als „großer Künstler" allzu gerne zulegt. Vielmehr waren sie das Ergebnis ganz konkreter Fragestellungen, die nicht

do that, I'll leave that to other people. In any case, I didn't photograph the duck and so I passed the Idiot Test."[26] When Michel Majerus' first solo exhibition in the USA was opened at Friedrich Petzel in New York in summer 2002, Gary Levine wrote in *Art in America:* "This may be the central metaphor for Majerus' conception of culture: there's no way to stop its assault, so you may as well just dive in."[27] But that is exactly what Majerus does not seem to have done in this exhibition. At any rate, you sought in vain for fresh impressions of the US American West Coast into which he might have dived. Instead his *Leuchtland* reflected back on the old days of "Bravo" and "Space Invaders".

A third path that repeatedly presented itself to Michel Majerus as of the mid-1990s was to return his art, so to speak, to the lifeworld of public and semi-public spaces. This he did for the first time in 1996 in the work *Aquarell,* a multipart canvas measuring 10 × 10 metres which he installed behind the glass facade of the Kunstverein in Hamburg. Two years later, he covered a whole billboard wall in the centre of Vienna – a project in the public domain realised on the occasion of the exhibition *Das Jahrhundert der künstlerischen Freiheit: 100 Jahre Wiener Secession.* Just how readily Michel Majerus' pictorial solutions fitted into public space was evident in the work *Beschleunigung* (Acceleration) which he produced that same year for the main hall of Munich's central railway station. As a participant in the *48th Biennale di Venezia* in 1999, Majerus came up with a very apt and ingenious paraphrase: he turned the classicist facade of the Italian pavilion into a huge games console from which you could navigate in all directions through the constantly rotating solar system of contemporary art.

Whether or not in the end Majerus' art ever came closer to the lifeworld cannot be clearly assessed with a view to the works, exhibitions and projects. Perhaps what one of his works says also applies in this context: "just when i nearly had the answer i forgot the question."[28]. That Majerus' answers were sometimes gigantic in size did not reflect the kind of attitude all too readily adopted by "great artists". Rather they were the result of altogether concrete questions which were frequently overtaken on the fast lane by Majerus' answers. "The image of the artist as the all-knowing creator was alien to Michel

selten von Majerus' Antworten rechts überholt wurden. „Das Künstlerbild des allwissenden kreativen Schöpfers war Michel Majerus fremd", so schreibt Katrin Wittneven in ihrem Nachruf, „dennoch bestand er darauf, schon vorher genau zu wissen, wie das Bild aussehen würde."[29]

Das trifft vor allem für zwei Großprojekte zu, die mich persönlich mit am meisten beeindruckt haben. Das eine wurde 2002, wenige Wochen vor Michel Majerus' Tod für drei Wochen der Öffentlichkeit übergeben. „Eines frühen Morgens Mitte September", erinnert sich Daniel Birnbaum, der das Projekt gemeinsam mit Jochen Volz initiiert und begleitet hat, „läutete das Telefon und ich erwachte zu dem Klang von Michel Majerus' triumphierendem Lachen. Der in Berlin ansässige Künstler stand gerade vor dem Brandenburger Tor, dem Nationalsymbol par excellence, das während seiner zweijährigen Restaurierung zumeist mit Werbeplakaten für die Deutsche Telekom bedeckt gewesen ist. Majerus' riesiges Bild des Sozialpalastes Schöneberg, einem mit Graffitis und Sat-Schüsseln übersäten Wohnblock aus den frühen Siebzigern, war gerade zuvor über das Berliner Wahrzeichen gestülpt worden, das es in den letzten paar Wochen vor seiner Wiedereröffnung verhüllen sollte. […] Wir hatten das Projekt monatelang per Telefon geplant, und letztendlich war es da – ‚das Monster', wie er es nannte."[30]

Die Fassade eines der umstrittensten Sozialblocks der Bundeshauptstadt, der in den 1970er Jahren auf dem Grund des geschichtsträchtigen „Sportpalastes" errichtet wurde, stand also plötzlich an prominentester Stelle – und das auch noch zu einem Zeitpunkt, als zig Kamerateams vom Ausgang der Bundestagswahl berichteten. So klingelte am 22. September wieder das Telefon bei Daniel Birnbaum, und Majerus forderte ihn auf, den amerikanischen Fernsehsender CNN anzuschalten. „Der Fernsehsender hatte ein Zimmer im luxuriösen Hotel Adlon gemietet […] um, mit dem Brandenburger Tor im Hintergrund, direkt aus Berlin berichten zu können. Was der Zuschauer aber sah, war natürlich das Bild des Sozialpalastes, auf dessen Dach die vier Pferde der Quadriga geheimnisvoll herausragten."[31]

Das zweite Großprojekt von Michel Majerus, das mich gerade im Zusammenhang von Kunst und Lebenswelt besonders fasziniert hat, liegt bereits mehr als zwei Jahre zurück. Es war seine Ausstellung im Kölnischen Kunstverein, die eigentlich gar keine Ausstellung war. Bereits im Vorfeld hatte Majerus dem damaligen Kunstvereinsleiter, Udo Kittelmann, seine Idee von einer „begehbaren Malerei" unterbreitet. Ausgangspunkt war

Majerus," writes Katrin Wittneven in her obituary, "yet he insisted on knowing beforehand exactly what the picture would look like."[29]

This mainly applies to two large projects which impressed me personally the most. One of them was presented to the public for three weeks in 2002, just a few weeks before Majerus' death. "Early one morning in mid-September," recalls Daniel Birnbaum, who had initiated and supervised the project along with Jochen Volz, "the phone rang and I woke to the sound of Michel Majerus laughing triumphantly. The Berlin-based artist was standing in front of the city's Brandenburg Gate, the national symbol *par excellence,* which during its two-year restoration period had mostly been covered with advertisements for Deutsche Telecom. Majerus' huge image of the Schöneberg Sozialpalast, an early 1970s housing block covered in graffiti and pockmarked with satellite dishes, had just been draped over the Berlin landmark, which it was to veil during the last few weeks before its reopening. […] We had been planning the project for months over the phone, and finally there it was – 'the monster', as he called it."[30]

Suddenly, the facade of one of the most controversial blocks of council flats in the federal capital, built in the 1970s on the site of the historical "Sportpalast", was visible at this most prominent site – what is more, at a point in time when countless camera teams were reporting on the results of the Bundestag elections. On 22 September Daniel Birnbaum's telephone rang again and Majerus told him to turn on the American television station CNN. "The network had rented a room in the luxurious Adlon Hotel […] in order to be able to report directly from Berlin with the Brandenburg Gate as a backdrop. But of course what the viewer saw was the image of the Sozialpalast, with the four horses of the Quadriga statue sticking out mysteriously on top."[31]

The second large project by Michel Majerus which particularly fascinated me as regards art and the lifeworld was more than two years ago. It was his exhibition at the Kölnischer Kunstverein, which was not really an exhibition. In the run up to it, Majerus had already told the then director of the Kunstverein Udo Kittelmann about his idea of a "walk-in painting". The point of departure

Fig.13 Studio, Berlin, 2002

eine Röhre, die quer durch den längsrechteckigen Raum des Kölnischen Kunstvereins führen sollte. Die niedrige Deckenhöhe hätte jedoch nur einen relativ kleinen Durchmesser von etwas mehr als drei Metern erlaubt, weshalb die Röhre einen ovalen Querschnitt haben sollte. So entstand schließlich die Idee der Halfpipe über die gesamte Breite des Raumes. „Michel war begeistert", so Kittelmann, „seine begehbare Malerei, vor allem die motivischen Bezüge, die er darin herstellte, wieder in einen Funktionskontext einbetten zu können, aus dem er diese Motive ja letztlich hatte."**32**

Die Arbeit war großartig, und in ihr schien sich für mich ein Kreis zu schließen, der weit mehr beschrieb als nur das Recycling von Lebenswelt in Kunst und umgekehrt. Aber sollte es darin nach wie vor um Malerei gehen? Gilt tatsächlich, was Joachim Jäger in seinem Essay zu Majerus' Los-Angeles-Bildern suggeriert: „Was am Ende bleibt, ist Malerei als Malerei"**33**? *If we are dead, so it is,* 2000, lautete der Titel der Kölner Ausstellung – im Nachhinein eine weitere Ironie jenes Schicksals, das Michel Majerus zwei Jahre später einholen sollte. Womit wir wieder beim Mythos angelangt wären. Tatsächlich aber meinte der Titel die Spielarten der Malerei. Wenn sie für tot erklärt würden, dann sollte es eben so sein. Für Majerus hatte dies keine Relevanz, denn seine Malerei hatte längst die totgesagten Gefilde des Mediums verlassen.

was a pipe that was to run right through the long rectangular space of the Cologne Kunstverein building. The low ceiling, however, would only have allowed a relatively small diameter of not much more than three metres, for which reason the pipe was to have an oval section. This is how the idea emerged for the half-pipe covering the full width of the room. According to Kittelmann, "Michel was enthusiastic about being able to re-insert his walk-in painting, especially the motifs he had included in it, into a functional context from which he had taken the motifs in the first place."**32**

It was a marvellous work, and for me it seemed to complete a circle that described a lot more than just the recycling of the lifeworld in art, and vice versa. But was it still supposed to be about painting? Is what Joachim Jäger suggests in his essay on Majerus' Los Angeles paintings actually true?: "What remains in the end is painting as painting."**33** The exhibition in Cologne was entitled *if we are dead, so it is,* 2000 – in retrospect, another irony, given the fate that was to catch up with Michel Majerus two years later. By which we have arrived back at the myth again. In fact the title referred to types of painting; if they were to be declared dead, then so be it. For Majerus this was of no relevance, as his painting had long since left the pastures of that supposedly dead medium.

Anmerkungen

1 Michel Majerus in einem Fax-Interview mit Kathrin Luz, in: *Noëma* (Jan.–März 1999), Nr. 50, S. 80.

2 Vgl. *Michel Majerus.* Ausst. Kat. Kunsthalle Basel. Basel: Schwabe 1996.

3 Peter Pakesch in einer E-Mail vom 14. Dezember 2004 an den Autor.

4 Ibid.

5 Stephan Jung in einem Gespräch mit dem Autor am 13. Dezember 2004.

6 Majerus' Aktion bei der *documenta 9* fand am 11. Juni 1992 statt und sie dauerte nur eine Stunde.

7 *3K-NH,* Berlin 1993, S. 6.

8 Vgl. *Kunst kaufen in der Invalidenstraße 31.* In: *1992 – ein dokumentarischer Beitrag.* Hrsg. v. Stephan Jung. Berlin 1993, o. S.

9 Ob Michel Majerus' Arbeiten tatsächlich gekauft wurden, lässt sich nicht mehr zurückverfolgen. Nur soviel: Ein riesiges „Affenbild" auf braunem Bettlaken, das in kleinem Format bereits auf den Kacheln der Metzgerei in der Invalidenstraße ausgestellt war, hängt heute in der Berliner Wohnung Albrecht Kasteins. Er war einer der ersten Sammler von Michel Majerus' Arbeiten.

10 Tim Neuger in einem Gespräch mit dem Autor am 11. Dezember 2004. Colin de Land führte die New Yorker Galerie American Fine Arts und galt als ausgesprochener Kenner der jungen internationalen Kunstszene.

11 Mit derselben Chuzpe – wenn auch weniger erfolgreich – versuchte er in New York die großen Kollegen Julian Schnabel und Francesco Clemente in ihren Ateliers zu besuchen. Schnabels Telefonnummer hatte er aus den örtlichen Telefonbüchern. Als Majerus schließlich in dessen Atelier stand, zeigte sich der New Yorker Maler – wie Heike Föll meint – „komplett uninteressiert".

12 Johannes Wohnseifer in einer E-Mail vom 16. Dezember 2004 an den Autor.

13 Die Qual der Wahl schien nicht nur die des Malers zu sein, sondern mehr noch die des Betrachters. Friedrich Meschede berichtet in einem Gespräch mit dem Autor am 11. Dezember 2004: Als interessierter Käufer sei er das Problem umgangen, indem er einfach „das letzte Bild, das übrig bleiben sollte", reservierte – und schließlich erwarb.

14 Zitiert nach Raimar Stange: *Never Trip Alone: Die ,Bilderaufbereitungsmaschine' Michel Majerus.* In: *Kunstbulletin* (November 1999), Nr. 11, S. 13.

15 Das Originalzitat Elaine Sturtevants lautet: „Remake, reuse, reassemble, recombine – that's the way to go." Zitiert nach Daniel Birnbaum: *Sampling the Globe.* In: *Artforum* (Oct. 2004), S. 241.

16 Michel Majerus in einem Fax-Interview mit Kathrin Luz, in: *Noëma* (Jan.–März 1999), Nr. 50, S. 81. Ausgesprochen ökonomisch dachte Majerus nicht nur im Hinblick auf die Produktion seiner Arbeiten. So schreibt der Sammler und Freund Christian Boros in einer E-Mail vom 22. Dezember 2004 an den Autor: „Michel war ungemein schnell und genau. Und er war präzise. Manchmal für einen Sammler zu präzise. Bei einem Tauschgeschäft empfand ich seine pedantische Art als Geiz. Großzügigkeit war eher im Malduktus vorhanden. Na ja, aber er lächelte so wunderbar beim Feilschen."

17 Michel Majerus in einem Fax-Interview mit Kathrin Luz, in: *Noëma* (Jan.–März 1999), Nr. 50, S. 80.

18 Siehe Anm. 12.

19 Siehe Anm. 14.

20 Udo Kittelmann in einem Gespräch mit dem Autor am 15. Dezember 2004.

Notes

1 Michel Majerus in a fax interview with Kathrin Luz, in: *Noëma,* Jan.–March 1999, no. 50, p. 80.

2 Cf. *Michel Majerus* (exh. cat.), Kunsthalle Basel. Basle: Schwabe Verlag 1996.

3 Peter Pakesch in an e-mail to the author dated 14 December 2004.

4 Ibid.

5 Stephan Jung in a conversation with the author on 13 December 2004.

6 Majerus' action at *documenta 9* took place on 11 June 1992 and lasted only an hour.

7 *3K-NH,* Berlin 1993, p. 6.

8 Cf. *Kunst kaufen in der Invalidenstraße 31,* in: *1992 – ein dokumentarischer Beitrag* (ed. by Stephan Jung), Berlin 1993, no page numbers.

9 Whether Michel Majerus' works were actually sold is difficult to establish. However, a huge "Monkey" on a brown bed sheet which was already exhibited in a small format on the tiles of the butcher's shop on Invalidenstraße is today hanging in the Berlin apartment of Albrecht Kastein. He was one of the first collectors of Michel Majerus' works.

10 Tim Neuger in conversation with the author on 11 December 2004. Colin de Land directed the New York gallery, American Fine Arts, and was regarded as a real connoisseur of the young international art scene.

11 With the same chutzpah – though less successfully – he tried to visit the great colleagues Julian Schnabel and Francesco Clemente in their studios in New York. He got Schnabel's telephone number from the local telephone book. When Majerus finally arrived in his studio, the New York artist – according to Heike Föll – was "totally uninterested".

12 Johannes Wohnseifer in an e-mail to the author dated 16 December 2004.

13 Not only the artist seemed spoiled for choice, the spectator even more so. In a conversation with the author on 11 December 2004 Friedrich Meschede reported that, as an interested buyer, he avoided the problem by simply having "the last painting that is left over" reserved – which he finally purchased.

14 Michel Majerus, cited from Raimar Stange, *Never Trip Alone: Die ,Bilderaufbereitungsmaschine' Michel Majerus,* in: *Kunstbulletin,* No. 11/November 1999, p. 13.

15 Elaine Sturtevant's original words are: "Remake, reuse, reassemble, recombine – that's the way to go." Cited from Daniel Birnbaum, *Sampling the Globe,* in: *Artforum,* Oct. 2004, p. 241.

16 Michel Majerus in a fax interview with Kathrin Luz, in: *Noëma,* Jan.–March 1999, No. 50, p. 81. Majerus had a markedly economic way of thinking, not only with regard to the production of his work. In an e-mail to the author dated 22 December 2004, the collector and friend Christian Boros writes: "Michel was exceedingly fast and exact. And he was precise. For a collector, sometimes too precise. During an exchange deal, I found his pedantic manner miserly. He kept his generosity more for his painting. However, he had a wonderful way of smiling when haggling."

17 Michel Majerus in a fax interview with Kathrin Luz, in: *Noëma,* Jan.–March 1999, p. 80.

18 Cf. note 12.

21 Willem de Kooning, zitiert nach: *Michel Majerus*. Ausst.Kat. Kunsthalle Basel. Basel: Schwabe 1996, o.S. Vielleicht muss man in diesem Sinne auch den Titel verstehen, den Michel Majerus 1999 seiner dritten Ausstellung bei neugerriemschneider gab: *sein lieblingsthema war sicherheit, seine these, es gibt sie nicht.*

22 Jochen Volz in einer E-Mail vom 16.Dezember 2004 an den Autor. Volz war von Januar 1997 bis Februar 2001 Galerieassistent bei neugerriemschneider. Heute ist er Kurator am Portikus, Frankfurt am Main.

23 Charles Asprey in einer E-Mail vom 15.Dezember 2004 an den Autor.

24 Michel Majerus in einer E-Mail vom 10.April 2001 an Heike Föll.

25 Unter den Ausstellungstitel *pop reloaded* wurden 40 dieser in Los Angeles entstandenen Arbeiten Ende 2003 und Anfang 2004 im Hamburger Bahnhof, Museum für Gegenwart, Berlin, sowie im Project Space der Tate Liverpool gezeigt. Vgl. *Michel Majerus: Los Angeles*. Ausst.Kat. Hamburger Bahnhof, Museum für Gegenwart, Berlin/Tate Liverpool. Köln: König 2004.

26 Michel Majerus in einer E-Mail vom 7.Februar 2001 an neugerriemschneider, zitiert nach Cover, *Michel Majerus: Los Angeles*

27 Cary Levine: *Michel Majerus at Friedrich Petzel*. In: *Art in America* (Dec.2002), S.109.

28 Es handelt sich dabei um eine Arbeit, die Majerus 2000 für die *Taipeh Biennale* realisierte.

29 Katrin Wittneven: *Die Absichten des Künstlers*. In: *Der Tagesspiegel*, 8.11.2002.

30 Daniel Birnbaum: *Michel Majerus 1967–2002*. In: *frieze* (Jan./Feb.2003), S.66.

31 Ibid, S.67.

32 Siehe Anm.20.

33 Joachim Jäger: *Check yor answers. Strategien der Offenheit bei Michel Majerus*. In: *Michel Majerus: Los Angeles*. Ausst.Kat. Hamburger Bahnhof, Museum für Gegenwart, Berlin/Tate Liverpool. Köln: König 2004, o.S.

19 Cf. note 14.

20 Udo Kittelmann in a conversation with the author on 15 December 2004.

21 Willem de Kooning, cited from *Michel Majerus* (exh.cat.), Kunsthalle Basel, Basel: Schwabe Verlag, 1996, no page numbers. Perhaps the title which Michel Majerus chose for his third exhibition at neugerriemschneider in 1999 has to be understood in this sense: "his favourite theme was security, his thesis was that it did not exist."

22 Jochen Volz in an e-mail to the author dated 16 December 2004. Volz was a gallery assistant at neugerriemschneider from January 1997 to February 2001. Today he is a curator at Portikus, Frankfurt am Main.

23 Charles Asprey in an e-mail to the author dated 15 December 2004.

24 Michel Majerus in an e-mail to Heike Föll dated 10 April 2001.

25 Under the exhibition title *pop reloaded* forty of these works produced in Los Angeles in late 2003 and early 2004 were shown at the Hamburger Bahnhof, Museum für Gegenwart, Berlin and at the Project Space of the Tate Liverpool. Cf. *Michel Majerus: Los Angeles* (exh.cat.), Hamburger Bahnhof, Museum für Gegenwart, Berlin/Tate Liverpool and Verlag der Buchhandlung Walther König, Cologne 2004.

26 Michel Majerus in an e-mail to neugerriemschneider dated 7 February 2001, quoted from *Cover, Michel Majerus: Los Angeles*

27 Cary Levine, *Michel Majerus at Friedrich Petzel*, in: *Art in America*, Dec.2002, p.109.

28 This is a work Majerus realised in 2000 for the *Taipeh Biennale*.

29 Katrin Wittneven, *Die Absichten des Künstlers*, in: *Der Tagesspiegel*, 8.11.2002.

30 Daniel Birnbaum, *Michel Majerus 1967–2002*, in: *frieze*, Jan./Feb. 2003, p.66.

31 Ibid., p.67.

32 Cf. note 20.

33 Joachim Jäger, *Check your answers. Strategien der Offenheit bei Michel Majerus*, in: *Michel Majerus: Los Angeles* (exh.cat.), Hamburger Bahnhof, Museum für Gegenwart, Berlin/Tate Liverpool and Verlag der Buchhandlung Walther König, Cologne 2004, no page numbers.

Tilman Baumgärtel
Super Mario und die Nacht des Visuellen
Super Mario and the Night of the Visual

Tilman Baumgärtel, geboren 1966 in Würzburg/DE, lebt in Berlin/DE und Manila/PH.

Studium der Germanistik, Medienwissenschaften und Geschichte an der Heinrich-Heine-Universität in Düsseldorf/DE und an der State University of New York in Buffalo/USA.

Als freier Autor verfasst Tilman Baumgärtel seit 1995 Texte über Medienkultur, u.a. für *Telepolis, die tageszeitung, Die Zeit, Die Woche, Intelligent Agent, Kunstforum International.* Tätigkeiten als Gastprofessor u.a. an der Universität Paderborn, der Technischen Universität Berlin, dem Mozarteum, Salzburg und gegenwärtig an der University of the Philippines (Manila). Kurator einer Reihe von Ausstellungen, u.a. Games, eine Präsentation von Computerspielen von Künstlerinnen und Künstlern bei Hartware (Dortmund 2003) und einen Teil der *Seoul Media City Biennale* 2004 in Korea.

Publikationen: *Games. Computerspiele von KünstlerInnen.* Frankfurt 2003. *net.art 2.0 – Neue Materialien zur Netzkunst/net.art 2.0 – New Materials towards Art on the Internet.* Nürnberg 2001. *net.art – Materialien zur Netzkunst.* Nürnberg 1999. *Vom Guerilla-Kino zum Essayfilm: Harun Farocki.* Berlin 1998.

Tilman Baumgärtel, born 1966 in Würzburg/DE, lives in Berlin and Manila/PH.

Studied German, media sciences and history at the Heinrich Heine University in Düsseldorf/DE and the State University of New York in Buffalo/USA.

Tilman Baumgärtel has been writing about media culture as a freelance author since 1995. His articles have appeared in *Telepolis, die tageszeitung, Die Zeit, Die Woche, Intelligent Agent, Kunstforum International,* etc. He has been a visiting professor at the University of Paderborn, the Technical University Berlin and the Mozarteum Salzburg, and is currently at the University of the Philippines in Manila. He has curated a series of exhibitions, including Games, a presentation of computer games by artists at Hartware (Dortmund 2003), and part of the *Seoul Media City Biennial* 2004 in Korea.

Publications: *Games: Computerspiele von KünstlerInnen,* Frankfurt 2003. *net.art 2.0 – Neue Materialien zur Netzkunst/net.art 2.0 – New Materials towards Art on the Internet.* Nuremberg 2001. *net.art – Materialien zur Netzkunst.* Nuremberg 1999. *Vom Guerilla-Kino zum Essayfilm: Harun Farocki.* Berlin 1998.

Fig. 1 *warning: do not strech*, 1998 (Detail)

Fig. 2 *A 1–7, T 1–7, H 1–7, M 1–7*, 1996
Installationsansicht, Galerie Monika Sprüth,
Köln, 1996

Fig. 1 *warning: do not strech*, 1998 (Detail)

Fig. 2 *A 1–7, T 1–7, H 1–7, M 1–7*, 1996
Installation View, Galerie Monika Sprüth,
Cologne, 1996

Tilman Baumgärtel 230 231

In einer berühmt-berüchtigten Passage aus seinen *Jenaer Systementwürfen* beschreibt Hegel das, was er „die Nacht der Welt" nennt: „Der Mensch ist diese Nacht, dies leere Nichts, das alles in ihrer Einfachheit enthält – ein Reichtum unendlich vieler Vorstellungen, Bilder, deren keines ihm gerade einfällt –, oder die nicht[s] als gegenwärtige sind. Dies die Nacht, das Innere der Natur, das hier existiert – reines Selbst, – in phantasmagorischen Vorstellungen ist es rings um Nacht, hier schießt dann ein blutig Kopf, – dort eine andere weiße Gestalt plötzlich hervor, und verschwindet ebenso. – Diese Nacht erblickt man, wenn man dem Menschen ins Auge blickt – in eine Nacht hinein, die furchtbar wird, – es hängt die Nacht der Welt hier einem entgegen."**1**

Ein ähnlich ungestaltes Tohuwabohu herrscht auch auf vielen Bildern von Michel Majerus. Nur dass in Majerus Bildern statt der hochdramatischen blutigen Köpfe und weißen Gestalten Hegels viel banalere, lebensweltlichere Elemente aus dem – meist monochromen – Nichts hervorschießen: Hier ein gigantischer Turnschuh, dort Sven Väth. Hier eine Reihe Waschmaschinen, dort eine Comic-Hand. Hier eine zerquetsche Audiokassette, dort Super Mario?

Gerade Super Mario, eine Figur, die mittlerweile seit 20 Jahren in Videospielen auftritt, taucht immer wieder in den Bildern und Installationen von Michel Majerus auf – so zum Beispiel bei *A 1–7, T 1–7, H 1–7, M 1–7*, 1996, einer Installation, die aus 28 bemalten, viereckigen Kisten besteht, auf denen neben zwei Figuren aus dem Film *Toy Story* auch ein hüpfender Mario zu sehen ist. Im Gegensatz zu vielen anderen Bildelementen bei Majerus, die häufig nur angedeutet oder schnell hingepinselt wirken, sind sie meist sorgfältig ausgeführt und stehen oft im Mittelpunkt des Bildes, wenn sie nicht sogar – wie bei der Installation *Aesthetic Standards* von 1996 – das dominante, visuelle Element sind. Die Arbeiten von Michel Majerus plündern den kollektiven Bildspeicher der Alltagskultur, und man könnte das Auftauchen des fidelen Videospiel-Helden Mario als eine weitere Figur in der langen Reihe der Referenzen an Pop und Jugendkultur lesen, die Majerus in seiner Malerei immer wieder anführt. Dann würde er in einer Reihe stehen mit den Teletubbies, mit den Spielzeug-Figuren und Animationsfilm-Gestalten, die aus der „Nacht des Visuellen" auf Majerus' Bildern gelegentlich auftauchen; die Gruselgestalt „Dark Force" aus der „He-Man"-Serie und der Cowboy aus dem Trickfilm *Toy Story,* die Schriftzüge, die Manga-Comics entliehen zu sein scheinen; die Verweise auf die Subkultur der Skater oder auf die deutsche

In a notorious passage in his *Jenaer Systementwürfe,* Hegel describes what he calls the "night of the world": "Man is this night, this empty nothing that contains everything in its simplicity – a wealth of infinitely many imaginings and images, none of which have just occurred to him – or which are nothing but present-time. This same night, the inner being of nature that exists here – pure self – in phantasmagorical imaginings it is all around night, here a bloody head, there another white shape shoots up suddenly and as suddenly vanishes. We glimpse this night when we look man in the eye – look into a night that waxes terrible – the night of the world looms towards us here."**1**

A similar chaotic disorder prevails in many of Michel Majerus' pictures. Except that in these, instead of the highly dramatic bloody heads and white figures, much more banal elements of the real world shoot forth from a (mostly monochrome) void. A huge sneaker here, Sven Väth there. A series of washing machines here, a cartoon hand there. A crushed audio cassette here, Super Mario there?

Especially Super Mario, a figure familiar from video games for 20 years or so, crops up again and again in Majerus' pictures and installations, for example *A 1–7, T 1–7, H 1–7, M 1–7*, 1996, an installation consisting of 28 painted rectangular boxes showing two figures from the film *Toy Story* plus a bouncy Mario. In contrast with many other pictorial elements in Majerus, which are often only sketchy or look like a few hasty brushstrokes, they are generally executed with care and often stand mid-picture, or even constitute the dominant visual element, as in the *Aesthetic Standards* installation of 1996. The works of Michel Majerus plunder the collective stock of images in our everyday culture, and we might take the appearance of the jolly video game hero Mario as another figure in the long series of references to pop and youth culture that Majerus repeatedly introduces into his paintings. He would thus be of the same order as the Teletubbies, toy figures and animation film shapes that occasionally turn up in Majerus' pictures out of the "night of the visual" – the horror figure of Dark Force from the "He-Man" series and the cowboy from the *Toy Story* cartoon, the handwriting apparently borrowed from Manga comics, or the references to the subculture of skaters and the German

Fig. 3 *ohne Titel (8)*, 1996

Fig. 4 *ohne Titel (28)*, 1996

Elektronik-Band Kraftwerk; das MTV-Logo oder die großäugigen Märchen-Figuren, die so niedlich sind, dass man sich vor ihnen ekelt.

Jenseits des Kraftwerk-Zitats beziehen sich die meisten Pop-Referenzen in Majerus Bilderuniversum auf Material aus der untersten Schublade. Irgendwie fehlen bei diesem Pandämonium des Pop-Trash nur noch die „Teenage Mutant Ninja Turtles" oder „Hello Kitty".

Die meisten dieser Charaktere sind „Franchises" (also „Konzessionen", wie sie im internationalen Jargon der Unterhaltungsbrache genannt werden), die von den Medienkonzernen, die die Rechte an ihnen besitzen, gnadenlos zu Merchandising in jeder erdenklichen Form verarbeitet worden sind. Bevor sie sich auf Majerus' Bildern wiederfanden, traten diese Figuren nicht nur in Trickfilmen, Computerspielen und Comics auf, sondern schmückten auch Aufkleber und Schlüsselanhänger, T-Shirts und Bettbezüge, Kugelschreiber und Lunch Boxes. Im Vergleich zum Bildarchiv von Michel Majerus wirken etwa Jeff Koons Ausflüge ins Plebejische relativ „sophisticated". Sie sind Ausdruck eines kleinsten, gemeinsamen Nenners, wie er von Berlin bis Manila, von Luxemburg bis Bangladesh als durchgesetzt zu betrachten ist.

Super Mario erscheint im Verhältnis mit anderen Figuren in Majerus' Bildreservoir geradezu respektabel. Nicht, dass seine Popularität nicht auch zum forcierten Abverkauf von Krempel aller Art herhalten musste und muss. Aber im Vergleich mit den meisten anderen Pop-Ikonen, die Majerus zitiert, ist Mario eine eingeführte Größe, die nicht nur bei Kindern, sondern auch Erwachsenen ohne Computerspiel-Background einen gewissen Wiedererkennungs-Effekt auslösen.

Super Mario ist heute nicht nur eine der bekanntesten, sondern auch langlebigsten Figuren in der kurzen Geschichte des Videospiels. Laut Umfragen ist Mario bei Teenagern in den USA inzwischen bekannter als Mickey Mouse. Seit seinem ersten Auftritt in einem Videospiel im Jahr 1981 ist er in weit über hundert Spielen aufgetaucht. Und bis heute sind es nicht zuletzt die Spiele mit ihm als Helden, mit denen sich Nintendo immer wieder gegen die Konkurrenz anderer Spiel-Firmen durchsetzen kann. Mario war der Held von Comicbooks und einer Fernsehserie. Und er trat (gespielt von Bob Hoskins) in einem – gefloppten – Spielfilm über die *Super Mario Brothers* auf.

electronic band Kraftwerk. Or indeed the MTV logo or wide-eyed fairy tale figures that are so cute as to be nauseating.

Apart from the Kraftwerk citation, most of the pop references in Majerus' picture universe refer to material from the bottom drawer. Somehow, the only things that seem missing from this pandemonium of pop trash are the "Teenage Mutant Ninja Turtles" or "Hello Kitty".

Most of the characters involved are franchises (or concessions, as they are generally known in the international jargon of the entertainment business) that are relentlessly turned into merchandising of every conceivable shape and size by the media groups that own the rights to them. Previous to their appearance in Majerus' pictures, the figures turned up not only in cartoons, computer games and comics but also adorned stickers and key rings, T-shirts and bed linen, ball-point pens and lunch boxes. (In comparison with the pictorial archive of Michel Majerus, the escapades of someone like Jeff Koons into the plebeian seem relatively sophisticated.) They are expressions of a lowest common denominator that has become common from Berlin to Manila and Luxembourg to Bangladesh.

Yet, compared with some of the other figures in Majerus' repertoire, Super Mario himself appears almost respectable. Not that his popularity was (or is) not subject to the high-pressure selling of junk of all kinds. But relative to most other pop icons that Majerus quotes, Mario has achieved an established dimension with a certain awareness factor among not only children, but also adults with no computer background.

Super Mario is these days one of the best-known and longest-lived figures in the brief history of video games. Surveys show that he is now better known to US teenagers than Mickey Mouse. Since he first appeared in a video game in 1981, he has featured in over 100 games. And even now, the games with him as hero are still a major reason why Nintendo continues to make headway against rival games companies. Mario has been the hero of comic books and a TV series, and was played by Bob Hoskins in a feature film about the *Super Mario Brothers,* though the film was a box-office flop.

Fig. 5 *Einschiffung*, 1996 (Detail)　　　　　　　　　　　　　　　　　　　Tilman Baumgärtel　232　233

Wenn ich im Folgenden ausführlich auf die Bedeutung und die Geschichte von Super Mario eingehe, dann ist dies nicht nur ein Versuch, einem wiederkehrenden Motiv in der Malerei Majerus' auf die Spur zu kommen. Vielmehr will ich die auffallende Präsenz der Videospiel-Figur Super Mario zum Anlass nehmen zu überprüfen, ob bildgebende, digitale Techniken (wie Computerspiele) einen Einfluss auf die Kunst von Majerus genommen haben, der über das schlichte, postmoderne Zitieren hinausgeht.

Denn vielleicht kommt man den Bildern von Michel Majerus dann näher, wenn man ihre – mit gelegentlichen Pop-Referenzen durchsetzte – Leere nicht als Horror vor den Lücken des Realen versteht, nicht als schlichte Dekonstruktionen von millionenfach reproduzierten, medialen Bildern, sondern als eine Malerei, die auch neue, digitale Gestaltungsmethoden reflektiert hat, ohne davon viel Aufhebens zu machen.

Mario hatte seinen ersten Auftritt als namenlose Figur in dem Spiel „Donkey Kong", einer Mischung aus King Kong, Popeye und die Schöne und das Biest. Es bedient archetypische Vorstellungen, aber es tut es auf eine Weise, die nur mit dem Computer möglich ist. Im Kampf gegen einen an King Kong gemahnenden Affen, der ihn mit Fässern, Feuerbällen und anderen Hindernissen bombardiert, versucht Mario, ein Baugerüst hinaufzusteigen, um seine Geliebte zu retten. So schlicht der Plot ist, so erfolgreich war das Spiel. In Japan war die Münze, die man für die „Donkey-Kong"-Spielautomaten brauchte, angeblich zeitweilig fast aus dem Umlauf veschwunden und musste von der staatlichen Münze nachgeprägt werden.

Und Mario war das Fundament, auf das Nintendo seine atemberaubende Unternehmensgeschichte vom mittelständischen Spielkarten-Hersteller zum weltweiten Medienkonzern gründete. Mehr als 300 Millionen Mal setzte die Firma ihre Spiele bis heute ab. Allein mit der „Super-Mario"-Serie hat das Unternehmen 7 Milliarden Dollar verdient. (Zum Vergleich: Die „Star-Wars"-Serie hat an der Kinokasse schätzungsweise 3,5 Milliarden Dollar erlöst.) Was immer man sonst von der Figur Super Mario denken mag, Michel Majerus hat mit ihm auf jeden Fall ein erstaunliches, kulturelles Phänomen adressiert.

Auch jenseits der Gamer-Folklore, die sich um seine Figur rankt, ist „Donkey Kong" bis heute ein bemerkenswertes Spiel – nicht nur durch seine Bedeutung für die Entwicklung des Computerspiels, sondern auch durch seine Entstehungsgeschichte. Sein

If I continue to explore the meaning and history of Super Mario in detail below, it is not just an attempt to track down a recurrent motif in Majerus' paintings. My aim is rather to use the conspicuous presence of the video figure Super Mario as a basis for investigating whether visual digital techniques such as those of computer games have had a more extensive influence on Majerus' work that goes beyond mere postmodern citation.

Perhaps we might then get a better understanding of the pictures of Majerus – and discover the emptiness in them – introduced by way of occasional pop references – not as a horror of the gaps in reality or as ordinary deconstruction of media images reproduced by the million, but as a form of painting that has also taken new digital design methods aboard without making a great to-do about it.

Mario made his first appearance as a nameless figure in the game "Donkey Kong", a comination of King Kong, Popeye and Beauty and the Beast. It uses archetypal concepts, but does so in a way that is only possible on the computer. Fighting against apes reminiscent of King Kong, who bombard him with barrels, balls of fire and other obstacles, Mario attempts to climb up scaffolding to save his beloved. As simple as the plot was, the success of the game has been tremedous. In Japan, the coin needed to operate "Donkey Kong" in games machines was apparently virtually out of circulation at one point, requiring the state mint to run off extra supplies.

And Mario was the foundation on which Nintendo established its breathtaking corporate rise from a family concern making playing cards to a world-wide media group. To date, the company has sold over 300 million copies of its games. The "Super Mario" series alone has earned the company over 7 billion dollars. (By way of comparison, the "Star Wars" series is estimated to have earned 3.5 billion dollars at the box office.) No matter what one may otherwise think of the Super Mario figure, Majerus was at any rate addressing an amazing cultural phenomenon.

Even disregarding the game folklore associated with the Mario figure, "Donkey Kong" remains a remarkable game – not only in respect of its importance for the development of computer games but also in the way it

Fig. 6 *Ohne Titel (957)*, 2001
Fig. 7 *Ohne Titel (1038)*, 2002

Schöpfer heißt Shigeru Miyamoto und ist bis heute einer der international erfolgreichsten Game-Produzenten, den Kritiker sogar schon als „Homer der Spielkonsole" bezeichnet haben. Er ist der Kopf hinter sechs der zehn bestverkauften Konsolenspiele aller Zeiten, neben „Donkey Kong" und der „Super Mario"-Serie auch die epischen „Legend-of-Zelda"-Games.

Die Entstehungsgeschichte von „Donkey Kong" ist typisch für die Umstände, unter denen Videospiele in den Pionierjahren der Branche entstanden. Miyamoto bekam bei Nintendo den Auftrag, ein Spiel zu entwickeln, das auf derselben Hardware lief wie ein erfolgloses Weltraum-Spiel: „Rotoscope", einer der ersten Versuche Nintendos, ein Computerspiel zu vermarkten. Miyamoto, damals noch ein vollkommen unbeschriebenes Blatt in der Branche, dachte sich daraufhin das Spiel „Donkey Kong" samt seinem namenlosen Protagonisten aus. Marios Aussehen, das bis heute lediglich mit jeder neuen Konsolen-Generation aktualisiert wurde, basierte auf technischen Einschränkungen. Da für die Figur nur eine begrenzte Zahl von Pixeln zur Verfügung stand, musste Mario mit einfachsten Mitteln charakterisiert werden. Ein Schnauzbart kaschiert die Tatsache, dass Mario keinen Mund hatte, die Mütze verdeckte die – viel Computer-Rechenleistung benötigenden – Haare, die Latzhose gibt dem Körper mit minimalem Aufwand Kontur. Kaum zu glauben, dass aus solchen Voraussetzungen eine Figur hervorging, die heute nicht nur von Kindern auf der ganzen Welt geliebt wird, sondern auch eine der verkaufsträchtigsten Medienmarken ist. Alles, was später über Mario bekannt wurde – dass er ein Klempner ist, dass er aus Brooklyn stammt, dass er Italo-Amerikaner ist etc. –, wurde ihm erst nachträglich angedichtet und geht von den paar Pixeln aus, die für eine Spielfigur auf der ersten Primitiv-Konsole zur Verfügung standen. Heute gilt „Super Mario" als das erste Spiel mit einem identifizierbaren Protagonisten und einem – wenn auch rudimentären – Plot. Vorangegangene Game-Erfolge hatten keine Helden, sondern kreisten um Dinge (Tennisbälle in „Pong", Asteroiden in „Astroids", Raumschiffe in „Defender") oder bestenfalls anonyme außerirdische Monster („Space Invaders"). Statt eine Geschichte zu erzählen, forderten sie beim Schießen, Laufen, Fahren die Geschicklichkeit heraus.

Die Konsequenz, mit der Shigeru Miyamoto seine Idee umsetzte und in folgenden Spielen ausbaute, rechtfertigt es, von ihm als einem der ersten Autoren des Computerspiels zu sprechen. Alle Spiele, die er in der Folge gestaltete, setzten in gewisser Weise die Entwicklung fort, die er mit „Donkey Kong" begonnen

came about. Its creator, Shigeru Miyamoto still remains one of today's most successful international games producers. Critics have even called him the "Homer of the games console". His is the brain behind six of the ten best-selling console games of all time, which along with the "Donkey Kong" and "Super Mario" series also includes the epic "Legend of Zelda" games.

How "Donkey Kong" came into being is typical of the way video games were produced in the pioneering years of the industry. Nintendo commissioned Miyamoto to develop a game to run on the same hardware as the unsuccessful space game "Rotoscope", one of Nintendo's first attempts to market a computer game. At the time completely unknown to industry, Miyamoto thereupon came up with "Donkey Kong" and its nameless protagonist. Mario's appearance, which has hitherto only been updated with each new generation of consoles, was based on technical limitations. As only a limited number of pixels were available for the figure, Mario had to be characterised with the utmost programming economy. A walrus moustache concealed the fact that Mario had no mouth, the cap covered the hair, which demanded too much RAM, and the dungarees gave a body shape without too much expense. It is hard to believe that such were the parameters in the genesis of a figure that is popular not only with children all over the world but is also one of the most successful media brands ever created. Everything that later became known about Mario – that he is a plumber, comes from Brooklyn, and is an Italo-American, etc. – was only credited to him post hoc, and started out from the few pixels available for a game figure on the first primitive consoles. Nowadays, "Super Mario" counts as the first game with an identifiable protagonist and a plot, even if rudimentary. Previous game hits had no heroes but revolved around things (e.g. tennis balls in "Pong", astroids in "Astroids", space ships in "Defender") or at best anonymous extra-terrestrial monsters ("Space Invaders"). Instead of telling a story, they welcomed agility in shooting, running and driving.

The consistency with which Shigeru Miyamoto put his idea into practice and developed it in subsequent games means we can justly call him one of the first authors of computer games. All the games he later designed continued in some way the development he had begun with

Fig.8 *Thälmannkart*, 2001 (Detail)　　　　　　　　　　　　　　　　　　Tilman Baumgärtel　234　235

hatte. Alle stecken sie voll surrealem Aberwitz: Wenn Mario durch unterirdische Höhlen kriecht oder durch Gräben watet, regnen auf ihn Schatzkisten, Gold-Dublonen und Glückskekse nieder, Pilze und „Fire Flowers" dienen als „Power-Ups", als Ladestationen für neue Energie. In „Zelda" muss man Tausendfüßler fangen, um mit ihnen magische Feuer zu löschen, oder Licht über einen Spiegel umleiten, damit sich lila Schleimmonster zu Stein verwandeln. Alle diese Spiele appellieren an eine kindliche Entdeckungs- und Experimentierfreude. Alle liefern eine Welt, in der man Abenteuer erleben kann. Aber es ist auch immer eine kontrollierbare Welt, in der man seine Initiation als Weltenentdecker und Abenteurer durchlebt. Denn so gut wie jedes Spiel von Miyamoto findet in labyrinthischen Welten statt, in denen man sich mit Geschick und List zurechtfinden muss.

Wenn man der Computerspielfolklore glauben will, war es Miyamotos Kindheit, die ihn zu diesen Spielideen führte. Mal soll es nach Auskunft der unzähligen Fan-Websites und „Schreine", die für ihn im Internet eingerichtet worden sind, der Keller im Haus seiner Eltern gewesen sein, mal eine Höhle, die er auf den Streifzügen im Wald entdeckte. In einem Interview beschreibt er seine Faszination mit dem, was sich hinter den Phänomenen der Dingwelt verbergen könnte: „Was, wenn alles, was du siehst, mehr als das ist, was du siehst – wenn die Person neben dir ein Krieger ist, und der Raum, der leer erscheint, eine geheime Tür zu einem geheimen Ort? Was, wenn etwas auftaucht, das nicht auftauchen sollte? Entweder tust du es ab, oder du akzeptierst, dass es mehr auf der Welt gibt als du glaubst. Vielleicht gibt es wirklich einen Eingang, und wenn Du dich dazu entschließt durchzugehen, wirst du viele unerwartete Dinge finden."**2** Diese Verrätselung der Wirklichkeit macht die Faszination von Miyamotos Spielen aus.

Immer wieder geht es in ihnen um den Raum und seine Überwindung, ein Thema, das sich auf eigentümliche Weise mit Majerus' Problematisierung des bildlichen Raums in der Malerei trifft. In „Zelda" wird davon im Ton eines altertümlichen Epos berichtet. In den „Donkey-Kong"- und „Super-Mario"-Spielen ist es der klein gewachsene Mario, der sich – mit den Qualitäten eines Stehaufmännchens ausgezeichnet – durch die Welt schlägt, hüpft und rennt. Die Hartnäckigkeit, mit der er dabei den Widrigkeiten begegnet, die die Natur ihm in den Weg stellt, ebenso wie die schlichte, an die Karikatur gemahnende Charakterzeichnung erinnern dabei an frühe Slapstick-Helden wie Buster Keaton und Charlie Chaplin – kleine Männer, die einfach nicht aufgeben können.

"Donkey Kong". They are all full of surreal lunacies. When Mario crawls through subterranean caves or wades through ditches, treasure chests, gold doubloons and fortune cookies rain down on him, while mushrooms and "fire flowers" serve as "power-ups", i.e. energy recharging points. In "Zelda", the player has to catch centipedes so he can put out magic fires with them or divert light across a mirror to turn purple mud monsters to stone. All these games appeal to a childish delight in discovery and experimentation. They all offer a world of adventure, but it is at the same time also a world that can be controlled, where the player always survives his initiation as a world explorer and adventurer. That is because virtually every one of Miyamoto's games takes place in labyrinthine worlds in which one has to find one's way with skill and cunning.

According to computer game folklore, it was Miyamoto's childhood that gave him the ideas for the games. To believe the countless fan websites and "shrines" devoted to him on the web, it was either the cellar in his parents' house or a cave he discovered while exploring the woods nearby that did the trick. In an interview, he describes his fascination with what might lie behind the phenomena of the material world: "What if everything you see is more than what you see – the person next to you is a warrior and the space that appears empty is a secret door to another world? What if something appears that shouldn't? You either dismiss it, or you accept that there is much more to the world than you think. Perhaps it really is a doorway, and if you choose to go inside, you'll find many unexpected things."**2** This speculation with reality is what makes Miyamoto's games so fascinating.

Time and again, they're about space and overcoming it, a topic that conicides with Majerus' calling in question the pictorial space aof painting strangely. In "Zelda", we are told about it in the manner of an ancient epic. In "Donkey Kong" and "Super Mario" games it is the diminutive Mario who, irrepressible as a rubber ball, always bounces back and hops, skips and runs through the world. The obstinacy with which he counters the adversities that nature thrusts in his path and the simple characterisation reminiscent of caricature call to mind early slapstick heroes such as Buster Keaton and Charlie Chaplin – little men who simply cannot give up.

Fig. 9 *ohne Titel (hello! are you ready for action?)*, 1993

Dass das Klempner gewordene Perpetuum Mobile Mario an den gesammelten Widerständen gegen seine Mission nicht verzweifelt, sondern – nach jedem „Game over" – frohgemut weitermacht, lässt Super Mario liebenswert erscheinen, auch wenn er letztlich nur Resultat eines nach den immer wieder gleichen Regeln funktionierenden Stücks Computercode ist. Miyamotos Genie besteht nicht zuletzt darin, diese Tatsache perfekt zu camouflieren. Alle seine Arbeiten kombinieren das Durchmessen von (virtuellem) Raum und die Suche nach einem schwer zu erreichenden Ziel mit der Akkumulation von Erfahrung und von materiellem Gut. Die Spielfigur verlässt das Spiel nie so, wie sie es betreten hat, auch wenn sie immer wieder von vorne anfängt. Und im Grunde sind alle Spiele von Miyamoto darum gleichzeitig Initiationsritus und Entwicklungsroman. Was die Suche von Zelda und Mario von der vieler anderer Computerspielhelden unterscheidet, ist freilich ihre absurde Komik. Dass ein hüpfender Klempner von den Edelsteinen und Wunderpilzen lebt, die er durch Sprünge gegen in der Luft schwebende Treppen bekommt – das ist Kinderlogik, die wohl nur wenige Erwachsene so perfekt emulieren können wie Miyamoto.

Von der Durchquerung eines Territoriums handelt schon „Super Mario Brothers", und die Spielgestaltung ist ganz durch dieses Thema geprägt. Dieses Game gilt nicht nur als Ausgangspunkt eines ganzen Genres, nämlich der „Jump & Run"-Spiele, bei denen es darum geht, eine Spielfigur laufend und springend durch ein unwegsames Gelände zu bewegen. Es ist auch einer der ersten „Sideways-Scroller" für eine Game-Konsole – also ein Spiel, bei dem sich die Handlung nicht mehr auf einem Bildschirm abspielt, sondern bei dem dadurch, dass im Vordergrund immer neue Spielflächen vorbeiziehen, die Illusion entsteht, die Figur würde sich „vorwärts" durch eine Landschaft bewegen.3 Die Methoden, mit denen in Computerspielen die Illusion von dreidimensionalen Räumen erzeugt wird, spielt auch für die Malerei von Michel Majerus eine Rolle, auf die ich noch zurückkommen werde.

Wer Mario durch seine mehr als 20-jährige Entwicklung verfolgt, kann dabei an einem konkreten Beispiel die Entwicklung der Computergrafik verfolgen – nicht nur, was die Erzeugung einer Raumillusion betrifft. Marios Look und „Charakter" entwickelten sich entlang der Spielkonsolen, die Nintendo in regelmäßigen Abständen von etwa fünf Jahren auf den Markt bringt.

The fact that the perpetuum mobile-turned-plumber Mario does not lose heart at the entrenched resistance to his mission but after every "game over" cheerfully goes his way, makes him a likeable guy, even if he is ultimately only the result of a piece of computer programming operating to unchanging rules. Miyamoto's genius is part that he manages to camouflage this fact perfectly. All his works combine roaming through (virtual) space plus the quest for a hard-to-attain goal with accumulating experience and material goods. Our hero never leaves the game the way he begins it, even though he always starts from scratch. And basically, all Miyamoto's games are rites of both initiation and passage. What distinguishes Zelda's and Mario's quests from many other computer game heroes is of course the element of absurd comedy. The idea that a hopping plumber lives off precious stones and magic mushrooms which he gets from leaping towards steps floating in the air is the logic of children, and probably few adults can emulate it as perfectly as Miyamoto.

"Super Mario Brothers" is about traversing a territory, and the design of the game reflects the topic entirely. It is considered the pioneer of a whole genre, i.e. the "jump and run" games, where a game hero has to get across rough terrain by running and jumping. It is also one of the first "sideways scroller" games for a console, i.e. one where the action takes place not on a single screen but which, by virtue of a rolling supply of new game surfaces scrolling past in the foreground, creates the illusion of the figure moving "forwards" through a landscape.3 The methods by which the illusion of three-dimensional space is generated in computer games are also of interest for the paintings of Michel Majerus, a point to which I will return later.

Anyone who has traced the twenty-year development of Mario has a concrete example of the development of computer graphics to study, and not only in respect of the generation of the illusion of space. Mario's appearance and "character" developed along with the games consoles that Nintendo regularly relaunched in a new version every five years or so.

Fig. 10 *MoM Block II*, 1996 (Detail)　　　　　　　　　　　　　　Tilman Baumgärtel　236　237

Bei „Super Mario Bros." (für das 1985 erschienene Nintendo Entertainment System/NES) ist er noch ein aus wenigen Pixelwürfeln zusammengesetztes, klobiges, flächiges Männchen. Bei der Nachfolge-Konsole Super NES (1991) erscheint Mario „zweieinhalbdimensional" – er selbst, nun schon wesentlich detaillierter, ist zwar immer noch zweidimensional, doch die Spielfelder erscheinen bereits räumlich. Erst mit der Nintendo-64-Konsole von 1996 wird aus Mario eine vollkommen plastische, von allen Seiten zu betrachtende Figur, die sich durch komplette 3-D-Landschaften bewegen kann. Bei den Spielen für den Gamecube, der 2001 erschien, steigern sich nach diesem Durchbruch lediglich die Qualität und die Detailfreude der Game-Grafik noch einmal.

Es würde zu weit führen, die mathematischen Modelle zu erläutern, mit denen die Mario-Spiele Raumillusionen schaffen. Für die Malerei von Majerus ist allerdings bedeutsam, dass er die Bilder, die aus solchen Code-Operationen hervorgehen, aus eigener Erfahrung gut kannte. Ein Mario taucht bereits – bevor er zum ersten Mal ein „Mario"-Game gespielt hatte – in einem Wandbild von 1993 auf, das Michel Majerus in einer Ausstellung in seiner und Stephan Jungs Wohnung in Berlin zeigte. Um 1993 gewann er auf der Internationalen Funkausstellung (IFA) in Berlin ein Super-Mario-Spiel, schaffte sich die dazu gehörige Konsole an (wahrscheinlich Super NES) und daddelte danach regelmäßig.

Er war kein exzessiver, aber ein fanatischer Spieler, der unter anderem „Mario Kart" immer wieder spielte. Wenn er gespielt hat, war er – wie sich sein Freund, der Künstler Stephan Jung, erinnert – „total drin und konnte sich auch wahnsinnig laut aufregen, wenn er einen Fehler gemacht hat, auch mitten in der Nacht." Einmal hätten die beiden gemeinsam eine Woche nichts anderes getan als „Super Mario" zu spielen.

Wie schlägt sich diese Erfahrung in der Malerei von Michel Majerus nieder? Zwar würde es zu weit führen, seine Malerei nach der Entdeckung von Mario als schlichte Reaktion auf dieses Spiel zu betrachten. Aber so, wie sich das Raumgefüge in seinen Bildern in der zweiten Hälfte der 1990er Jahre nach und nach aufzulösen beginnt, erinnern sie auch an die Grenzen, an die Computer bei der Darstellung von dreidimensionalen Räumen zu dieser Zeit noch immer stießen. In seiner Malerei beginnen sich Überlagerungen, Verschiebungen und Raumkonstruktionen in den Vordergrund zu schieben, die nicht mehr den Gesetzen der naturalistischen Wiedergabe von Raum

In "Super Mario Bros." (for the NES/Nintendo Entertainment System of 1985) Mario is still a hefty but flat little fellow made up of a few pixel cubes. In the following Super NES version of 1991 he is "two and a half" dimensional – he himself is still wholly two-dimensional, albeit endowed with much more detail, but the backdrops now have perspective. Mario has become a fully three-dimensional figure seen from all sides only since the Nintendo 64 console of 1996, and there he moves through completely 3D landscapes. In the games for the GameCube that appeared in 2001, it is only the quality and wealth of detail in the graphics that have been enhanced following this major breakthrough.

This is not the place to go into the mathematical models underlying the illusion of space in the Mario games. It is however of significance as far as Majerus' paintings are concerned that he was thoroughly familiar from personal experience with the pictures that these code operations generated. A Mario pops up in a wall painting from 1993 that Michel Majerus showed in an exhibition held in the apartment he shared with Stephan Jung in Berlin even before he had played his first Mario game. Around 1993, he won a Super Mario game at a fair whereupon he bought the console for it (probably a Super NES) and regularly twiddled away at it thereafter.

He was a fanatical player, though not excessively so, a particular favourite being "Mario Kart". When he played, he was – as his friend, the artist Stefan Jung recalls – "totally absorbed in it, and got ridiculously and thunderously upset when he made a mistake, even in the middle of the night." Once, the two of them did nothing for a week except play "Super Mario".

How does all this show up in Michel Majerus' paintings? It would be going too far to regard the works after the discovery of Mario as just a reaction to the game. But just as the spatial order in his pictures gradually begins to break up in the second half of the 1990s, the works also echo the limitations that computers still encountered in representing three-dimensional spaces at the time. Overlapping areas, displacements and spatial constructs that no longer obey the laws of naturalistic rendering begin to come to the fore. Just as – particularly in the Mario games for the Super NES console – the methods

Fig. 11 *always use 2 player mode*, 1998/99

gehorchen. So wie sich – gerade bei den Spielen für die Super-NES-Konsole – die Methoden, wie bei den „Mario"-Spielen die Illusion räumlicher Tiefe erzeugt wird, auf holprige Hilfsmittel und Tricks wie die „Zweieinhalb-Dimensionalität" beschränken mussten, so begann auch in Majerus' Malerei die Darstellung von Räumlichkeit zu stottern oder ganz auszusetzen.

Diese Auflösung von Raumstrukturen ist spätestens seit dem Suprematismus und dem Kubismus ein fest in den Repräsentationskanon der Moderne eingebundenes Verfahren. Die Künstler der Pop-Art haben diese Methoden aktualisiert und ihnen durch die Kombination von verschiedenen Darstellungskonventionen und malerischen Techniken eine neue Wendung gegeben. Dazu gehören zum Beispiel die Siebdrucke eines Robert Rauschenberg, aber auch die Wandgemälde eines James Rosenquist, den mit Majerus nicht nur der eklektische Mix ganz unterschiedlicher Maltechniken, sondern auch die Ausweitung der Malerei in raumgreifende Environments verbinden.

Majerus hat die Art, wie in den virtuellen Spielen physischer Raum repräsentiert wird, zwar nicht direkt aufgenommen und – wie etwa die holländische Netzkunst-Gruppe Jodi oder der britische Künstler Tom Betts – zum Gegenstand seiner Kunst gemacht. Doch in ihrem Auseinanderfallen der Darstellungsmodi ist sie ganz klar von den Spielen geprägt, die ja ihrerseits von modernen Techniken wie der Collage gelernt haben. Gerade die oft als postmodern apostrophierte Methode des „Pastiches", die Frederic Jameson als eine „Kunst der Imitate, denen ihr Original entschwunden ist", definiert hat[4], ist in Computerspielen wohl letztlich radikaler umgesetzt worden als in der High Art.

Bei Majerus werden die Bildflächen immer wieder durch Text-Elemente durchbrochen, deren Typografie an die Party-Flyer der 1990er Jahre oder die Gestaltung der Techno-Zeitschrift *Frontpage* erinnern. Auch hier schieben sich visuelle Elemente in den Vordergrund, die ohne den Computer nicht denkbar wären. Gerade das chaotische Layout der *Frontpage* gilt zu Recht als Produkt des digitalen Desktop-Publishings, das nicht mehr die Formen traditioneller Zeitschriftengestaltung imitiert, sondern zu einer Gestaltung gefunden hat, wie sie nur am Rechner entstehen kann. In den Bildern von Majerus werden sie wahlweise zu Bildern, die man auch lesen kann, oder zu Text, der in erster Linie visuelle Qualitäten hat. In ihrer Textualität erinnern sie auch an die „Screens" in Computerspielen,

for generating an illusion of spatial depth were limited to awkward fudges and tricks such as the "two and a half" dimensions, so the rendering of space began to wobble or wholly fall apart in Majerus' paintings as well.

Breaking up spatial structures was a process integral to the representational canon of Modernism at least from the time of Suprematism and Cubism onwards. The artists of Pop Art updated these methods and gave them a new twist by using various representational conventions and painting techniques in combination. Examples include the silk-screen prints of Robert Rauschenberg or even the wall paintings of James Rosenquist, who is comparable with Majerus not only in the eclectic mix of wholly diverse painting techniques but also in extending the range of painting into space-encompassing environments.

Though Majerus did not directly adopt the techniques of virtual games for representing physical space or make them the subject of his art like the Dutch Net Art group Jodi or British artist Tom Betts, the manner in which the modes of representation are divided up is quite clearly taken over from the games, which themselves learnt a thing or two from modern art techniques such as collages. Notably the "pastiche" – often considered to be a post-modern method, which Frederic Jameson defines as an art of imitations whose originals have vanished[4] – has probably been made more radical use of in computer games than in high art.

In Majerus, pictorial surfaces are constantly interrupted by text elements, the typography of which is reminiscent of the party flyers of the 1990s or the design of techno periodical *Frontpage*. Here too visual elements come to the fore that would be inconceivable without computers. Especially the chaotic layout of *Frontpage* is justly considered a product of digital desktop publishing that no longer imitated the layouts of traditional periodical publications but established a presentation that could only be done on computer. In Majerus' pictures, these text elements become pictures that can also be read or text that has primarily visual qualities, as you choose. Their textual nature is also reminiscent of the windows in computer games that flag information about the state of the game, power-ups or scores. In this, they also correspond to

die über Spielstand, „Power-Ups" oder Punktezahl informieren. Darin korrespondieren sie auch mit vielen grafischen Elementen in Majerus' Gemälden, die an Computer-Icons oder andere Schaltflächen in Computer-Software erinnern.

In der konzeptuellen Malerei der 1980er und 1990er Jahre, zu deren Vertretern auch Majerus gehört, haben solche digitalen Briccolagen immer wieder als Anregung für Bildkompositionen gedient. Hier wurden diese Computer-generierten Bilderwelten jedoch vorwiegend im Zusammenhang mit der Malerei betrachtet, in deren Termini sie solche mathematischen Bilder rückübersetzen und mit deren Vokabular sie diese neuen Bilder abgleichen. Majerus' Arbeiten zeichnet aus, dass sie den Schock, den diese Methoden der Bildproduktion ausgelöst haben, nicht abfedern, sondern unaufgelöst stehen lassen.

Majerus' Bilder erschließen der Malerei ein neues Motiv-Reservoir, aber sie stoßen dort an ihre Grenzen, wo es darum geht, das Funktionieren digitaler Bildmaschinen als konstitutiv für neue und ganz andere Formen der visuellen Produktion zu begreifen. Sie handeln letztlich von dem Verdacht, dass diesen Medien und ihren Mechanismen mit den Mitteln der Malerei vielleicht nicht mehr beizukommen ist. So ist Michel Majerus' Kunst auch ein Symptom der Krise, in die das Aufkommen von nicht-intentionalen, von Rechnern generierten Bildern die traditionelle Malerei gestürzt hat.

many graphic elements in Majerus' paintings evocative of computer icons or other buttons in computer software.

Among the conceptual painters of the 1980s and 1990s – amongst whom Majerus himself must be ranked – such digital Briccolage always acted as a stimulus for picture compositions. In this case, however, the computer-generated pictorial worlds were considered principally in the context of paintings; mathematical images are translated back into terms of painting using traditional vocabulary to smooth out the results. What distinguishes Majerus' work is that the shock that these methods of picture production triggered off was not cushioned but left unresolved.

Majerus' pictures open up to painting a whole new repertoire of motifs, but come up against the limitations involved in seeing the way digital picture machines function as a source of new, wholly different types of visual production. Ultimately, they raise the suspicion that these media and their mechanisms can no longer possibly be handled with the resources of painting. Thus Majerus' art can also be viewed as a symptom of the crisis into which the emergence of non-intentional pictures generated by computers has plunged traditional painting.

Anmerkungen

1 G.W.F. Hegel: *Jenaer Systementwürfe III*. Hamburg: Meiner 1987, S.172.

2 Zitiert nach http://en.wikipedia.org/wiki/Shigeru_Miyamoto.

3 Der amerikanische Künstler Cory Arcangel hat in seiner Version des Spiels einen amüsanten Kommentar zu dieser Form der Bewegungssimulation geliefert. In seiner Arbeit *Super Mario Clouds*, 2002 hat er das Spiel so modifiziert, dass nur der Hintergrund übrig geblieben ist: drei Wölkchen, die sich mit äußerster Langsamkeit auf einem blitzblauen Himmel bewegen.

4 Frederic James: *Postmoderne: Zur Logik der Kultur im Spätkapitalismus*. In: *Postmoderne – Zeichen eines kulturellen Wandels*. Hrsg. von Andreas Huyssen und Klaus R. Scherpe. Reinbek bei Hamburg: Rowohlt 1997.

Notes

1 G.W.F. Hegel. *Jenaer Systementwürfe III*, Hamburg: Meiner 1987, p.172.

2 Quoted from http://en.wikipedia.org/wiki/Shigeru_Miyamoto.

3 In his version of the game, the American artist Cory Arcangel has provided an amusing commentary on this form of simulated movement. In his *Super Mario Clouds*, 2002 he modifies the game so as to leave only the background – three clouds, which move extremely slowly across a brilliant blue sky.

4 In: Frederic Jameson: *Postmodernism, Or, the Cultural Logic of Late Capitalism*. In: *Post-Contemporary Interventions Series*, Duke University 1992.

nstallation

Kunsthaus

Installation

Kunsthaus

sansichten

Graz 05

views

Graz 05

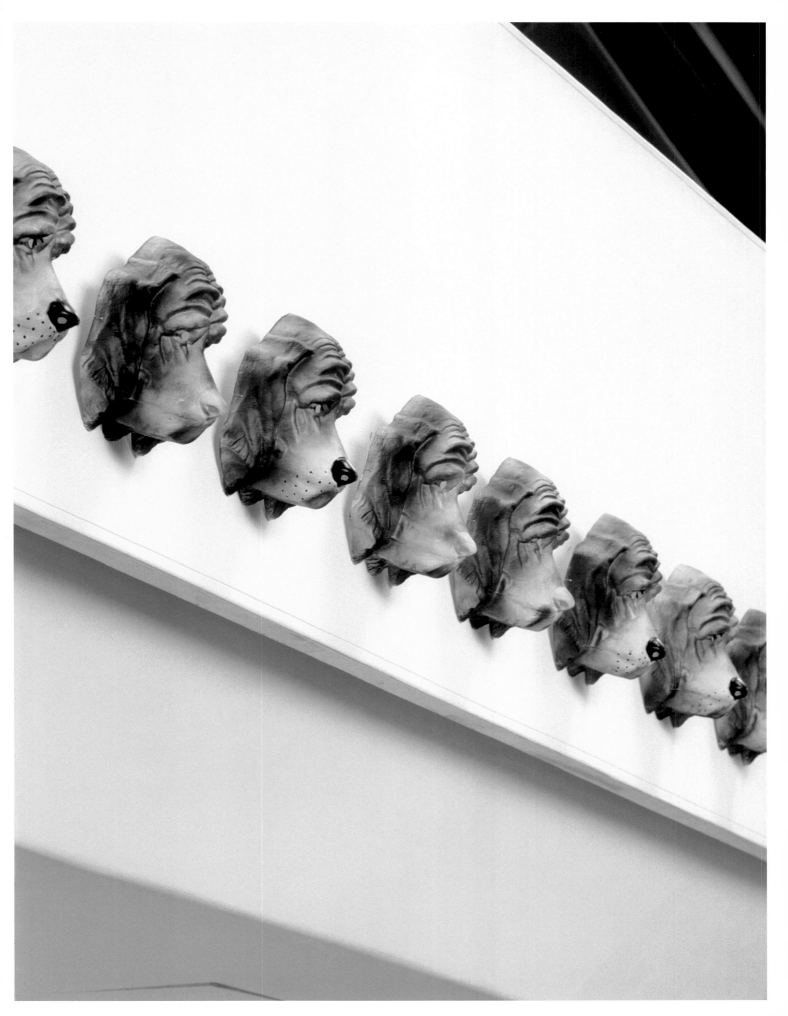

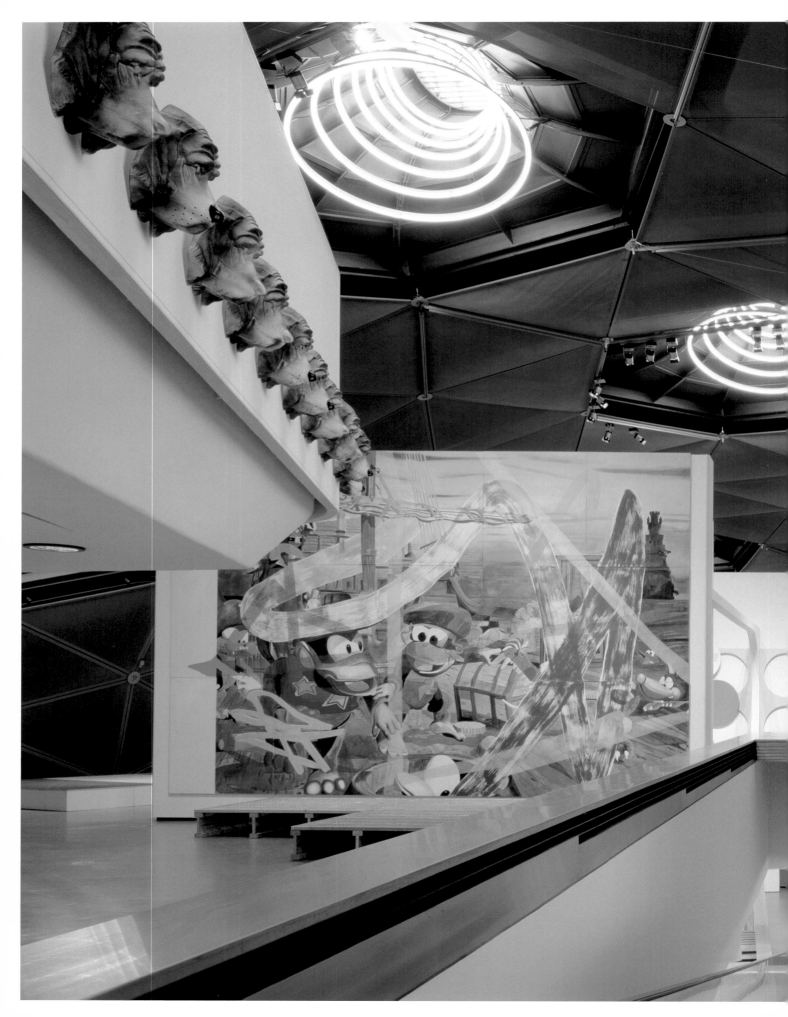

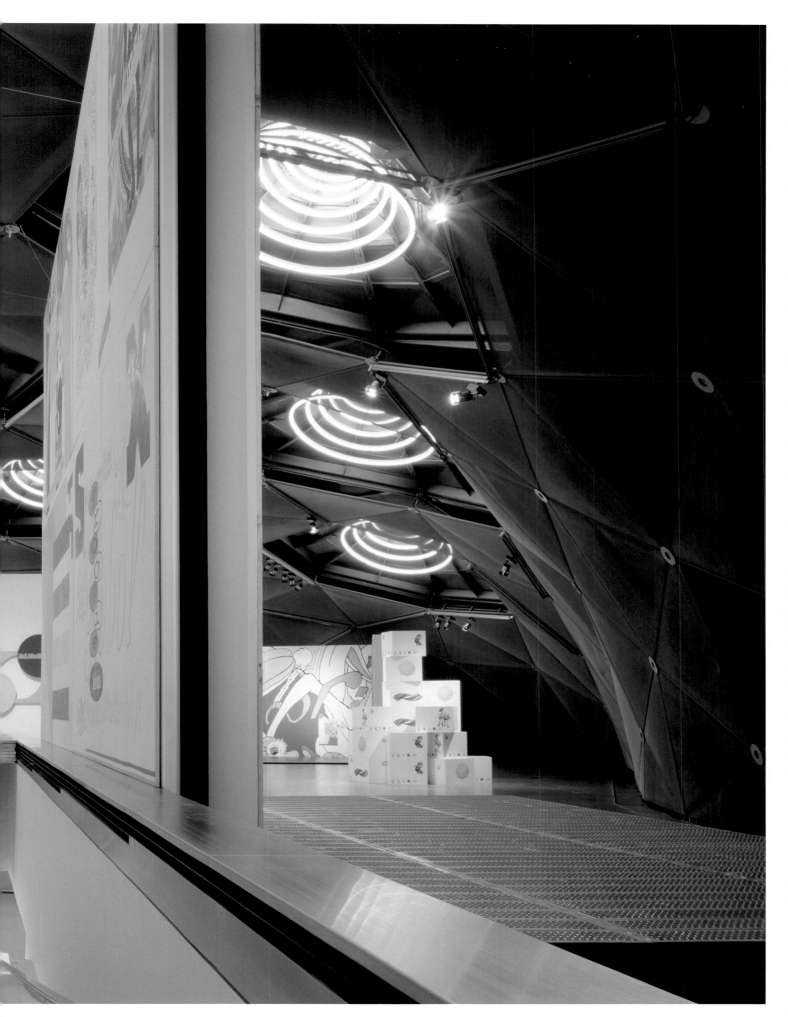

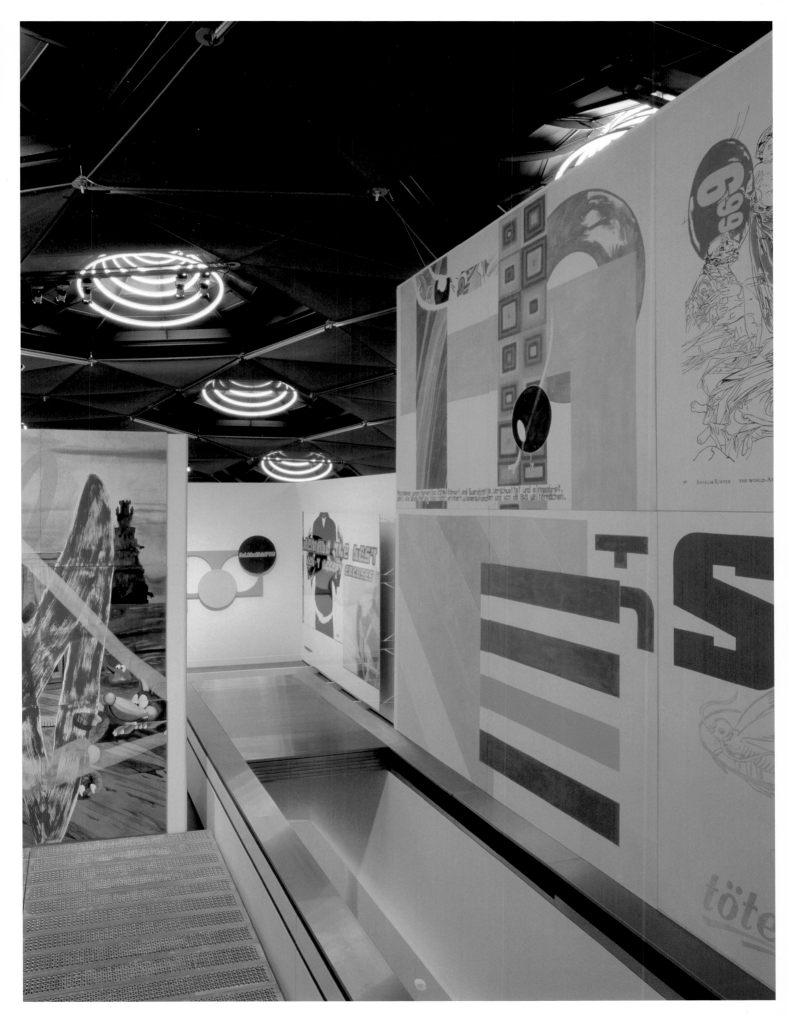

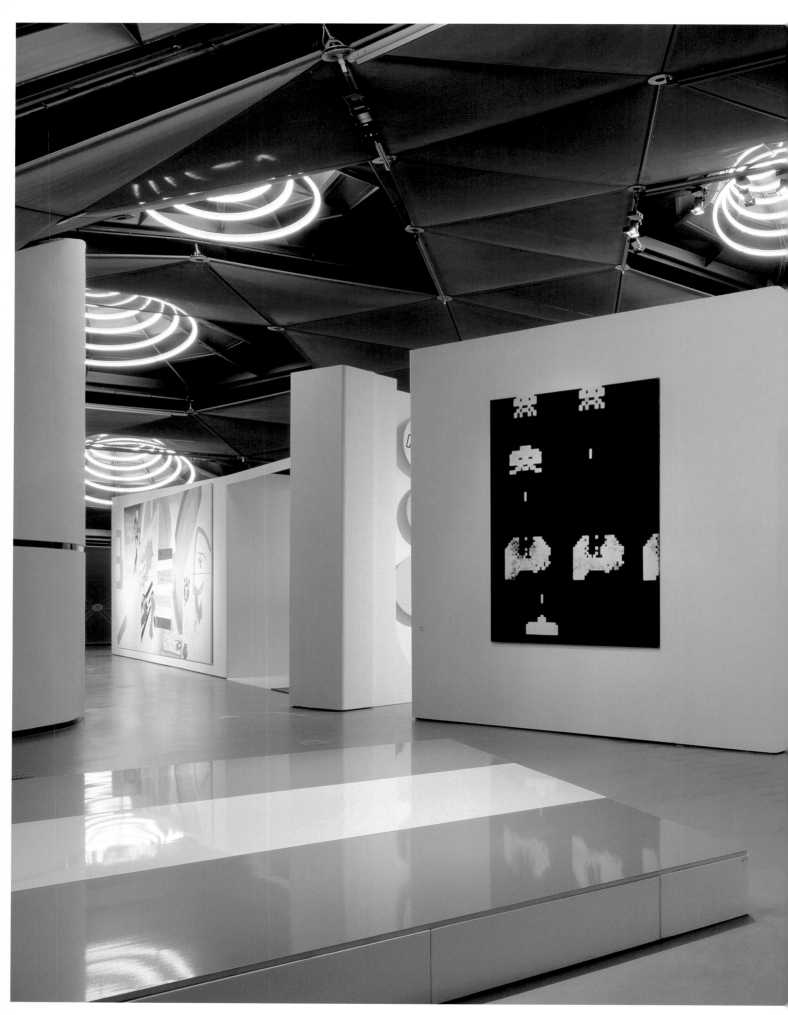

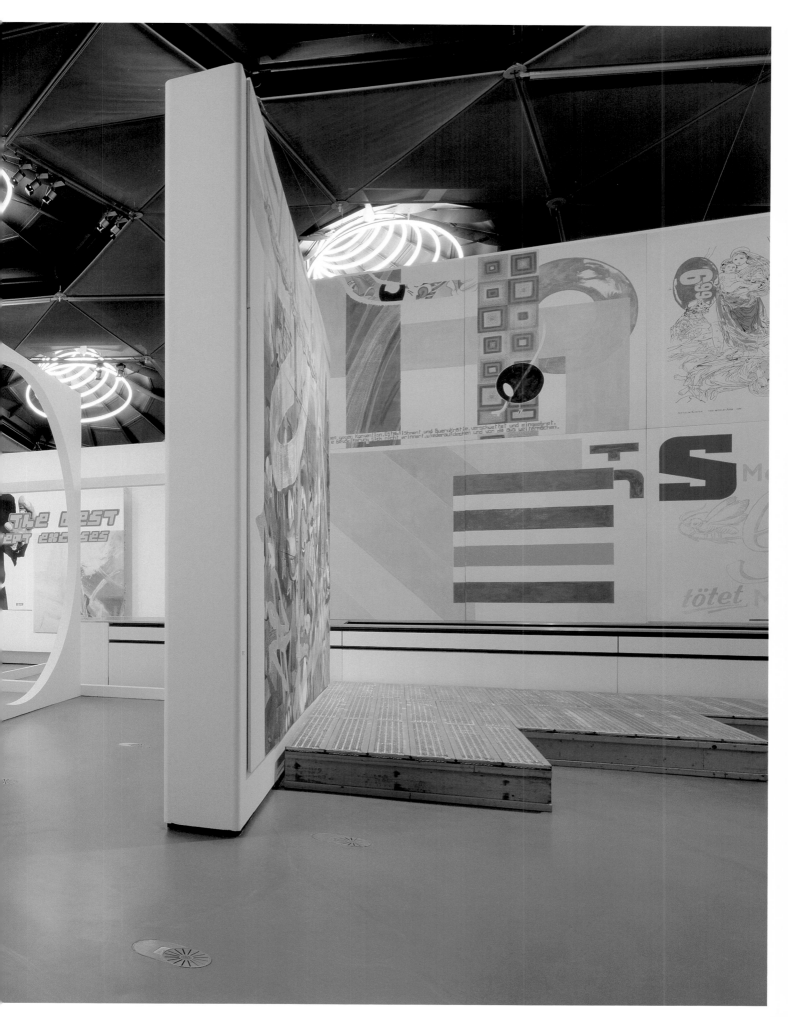

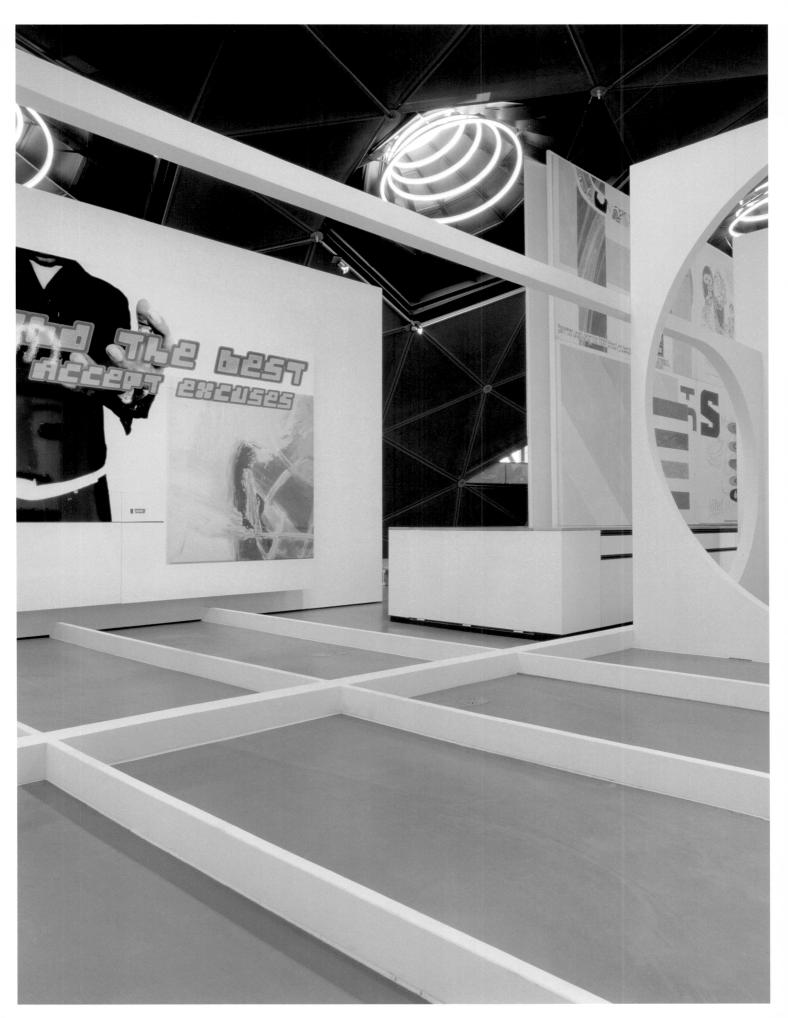

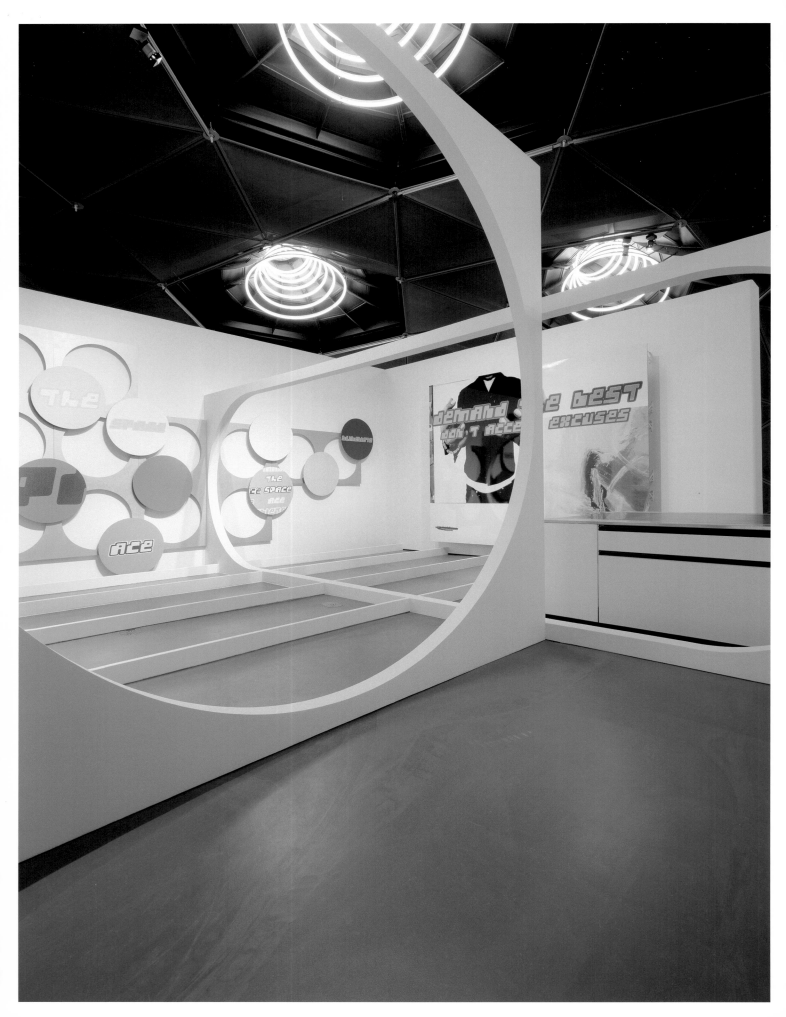

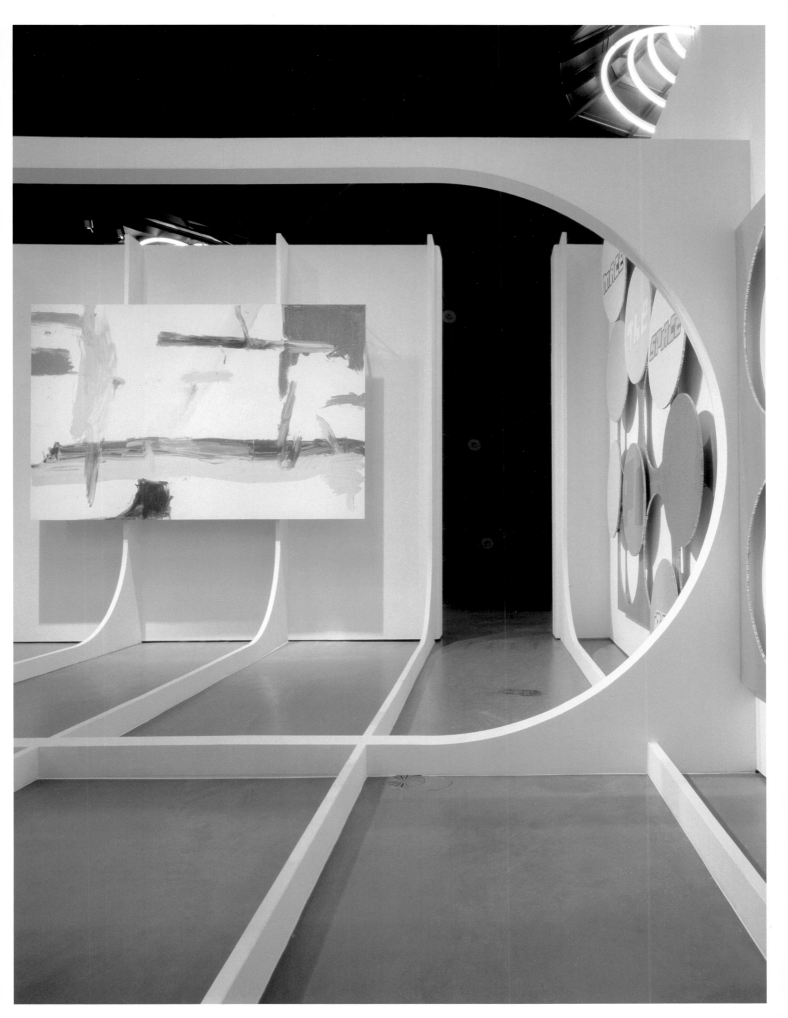

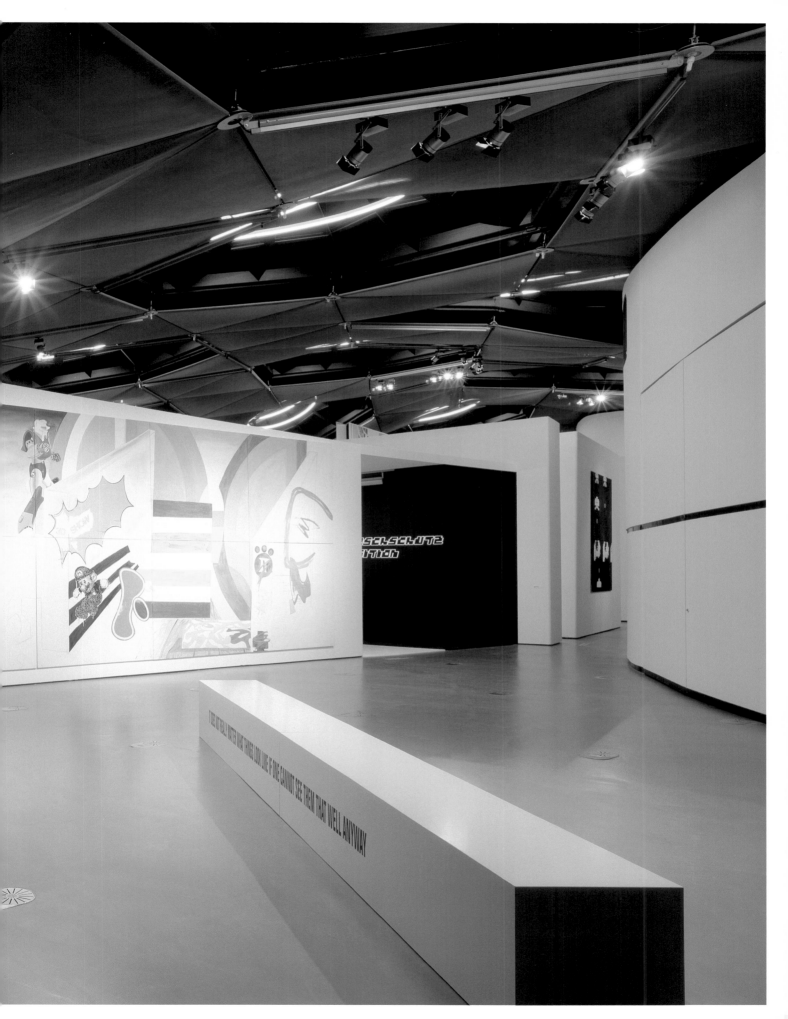

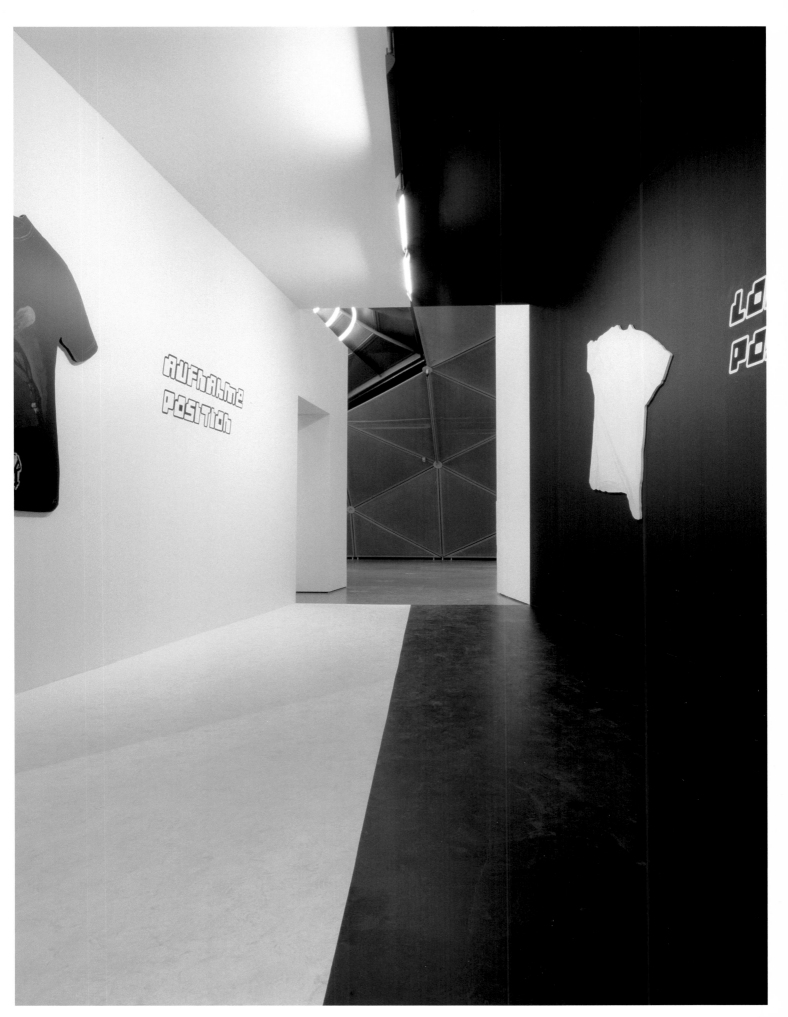

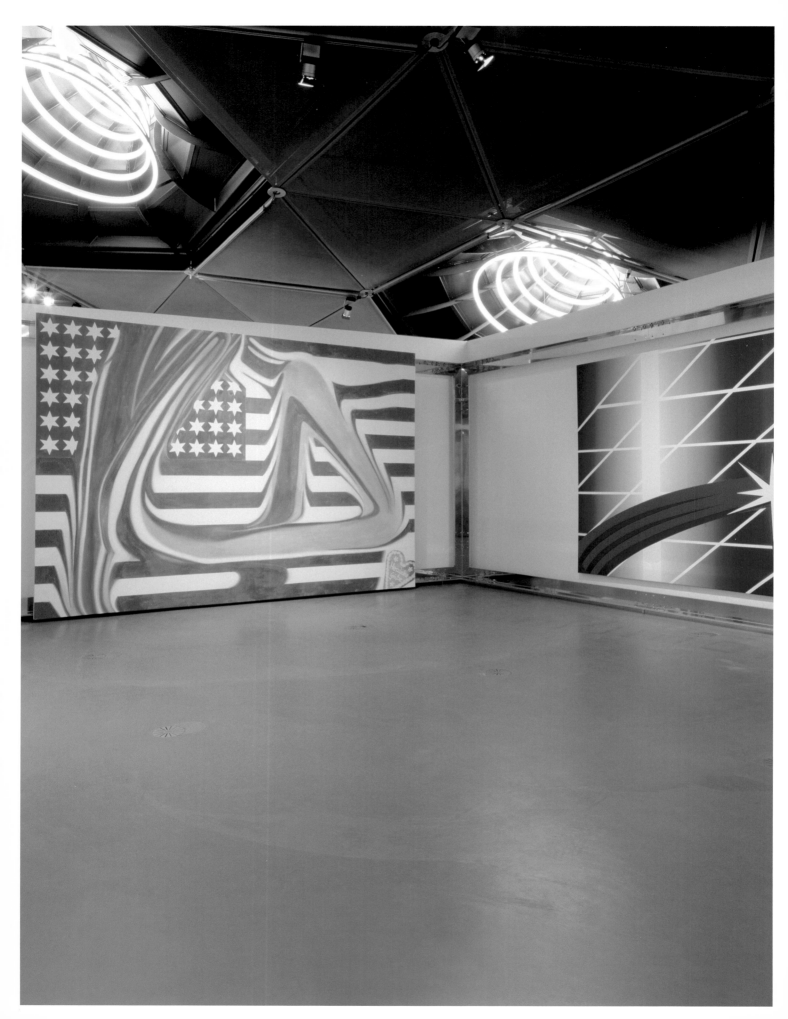

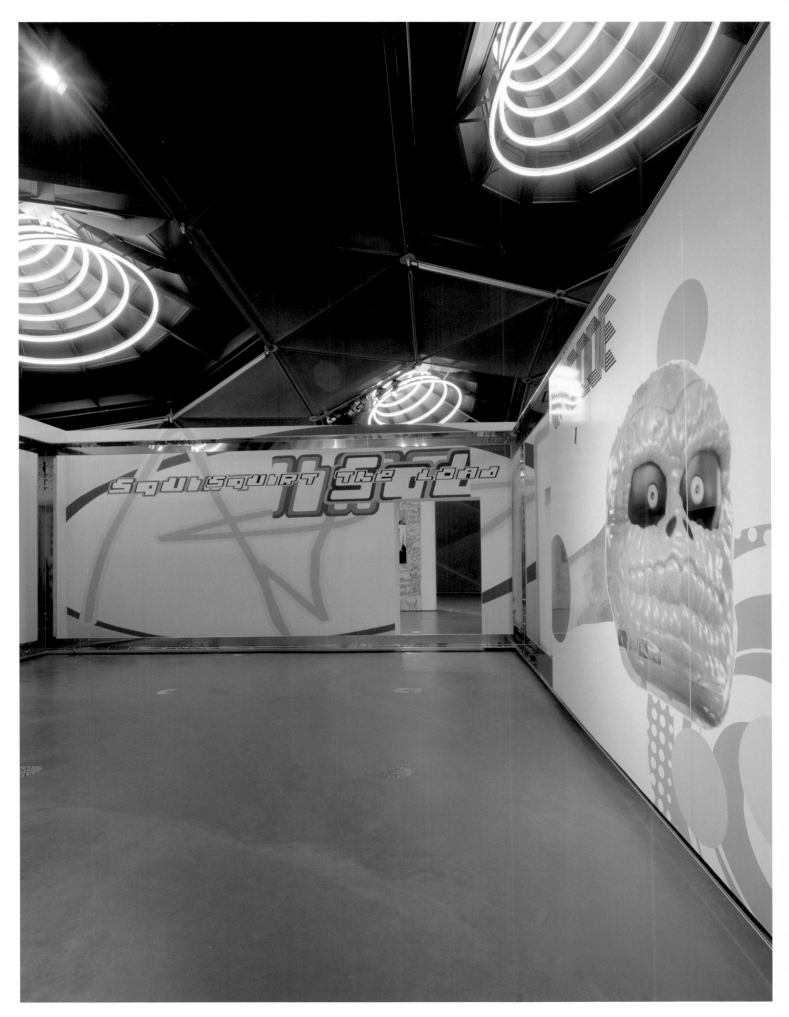

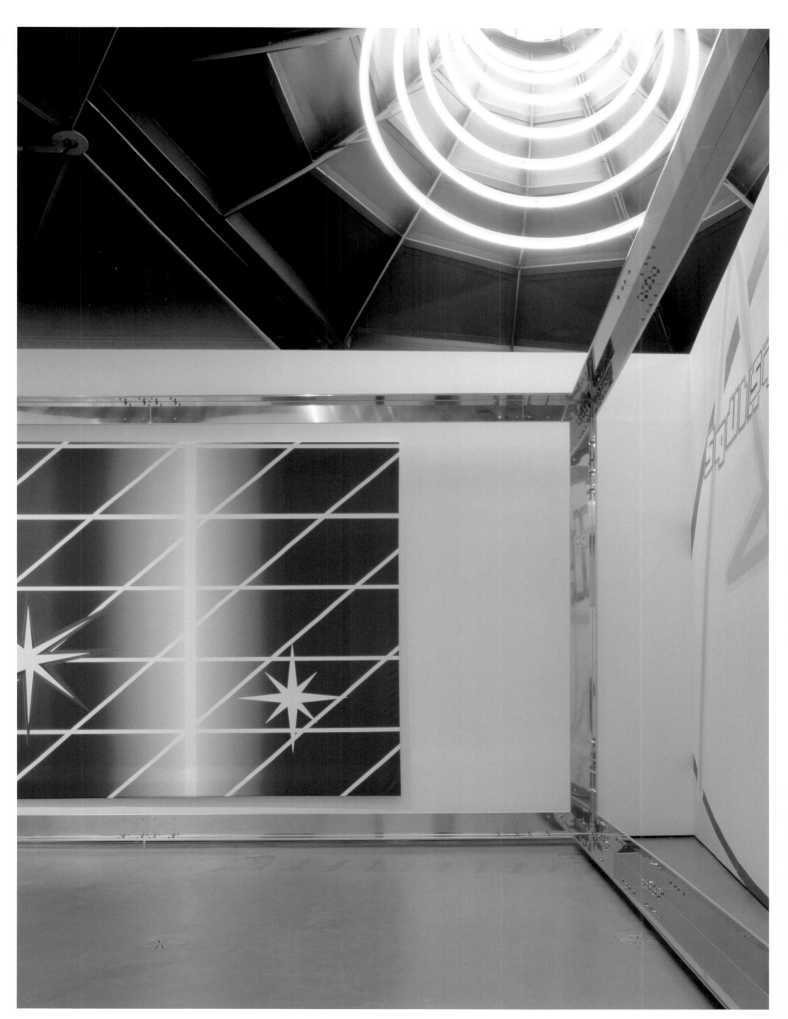

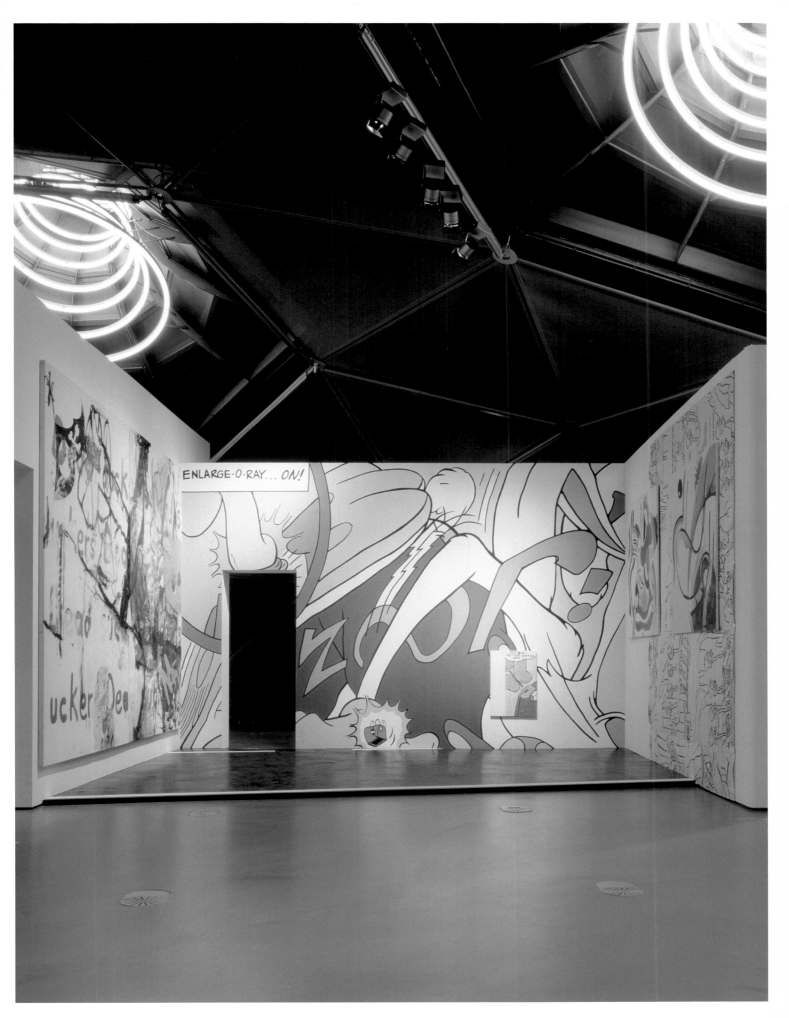

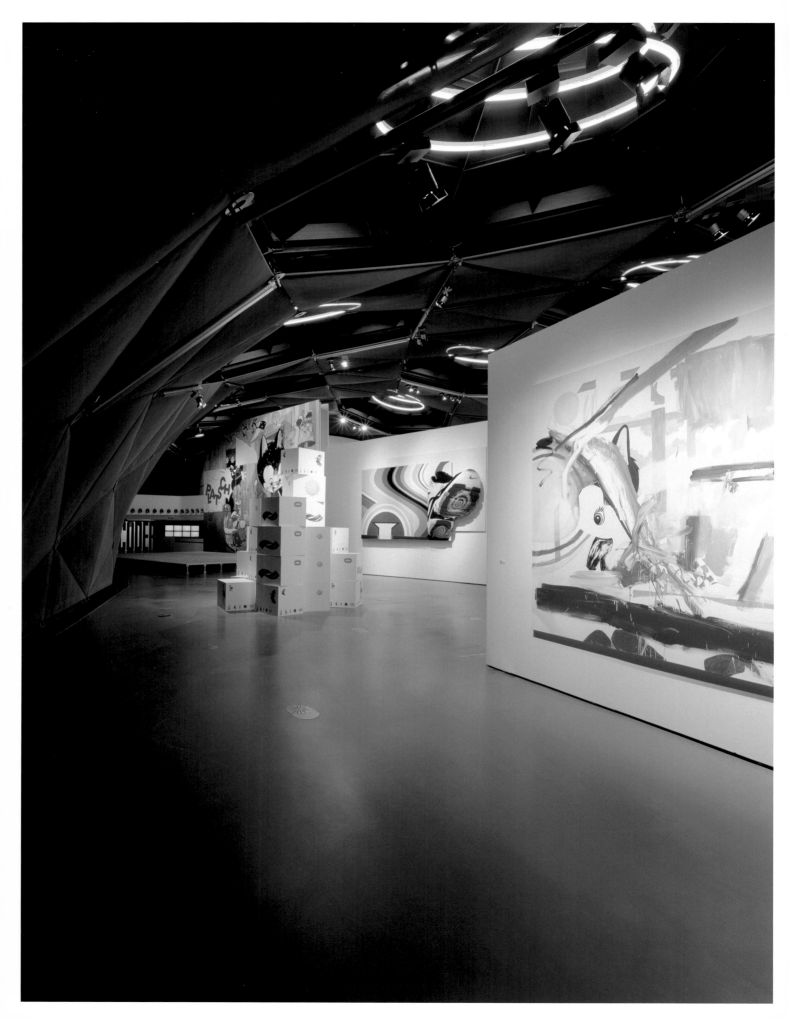

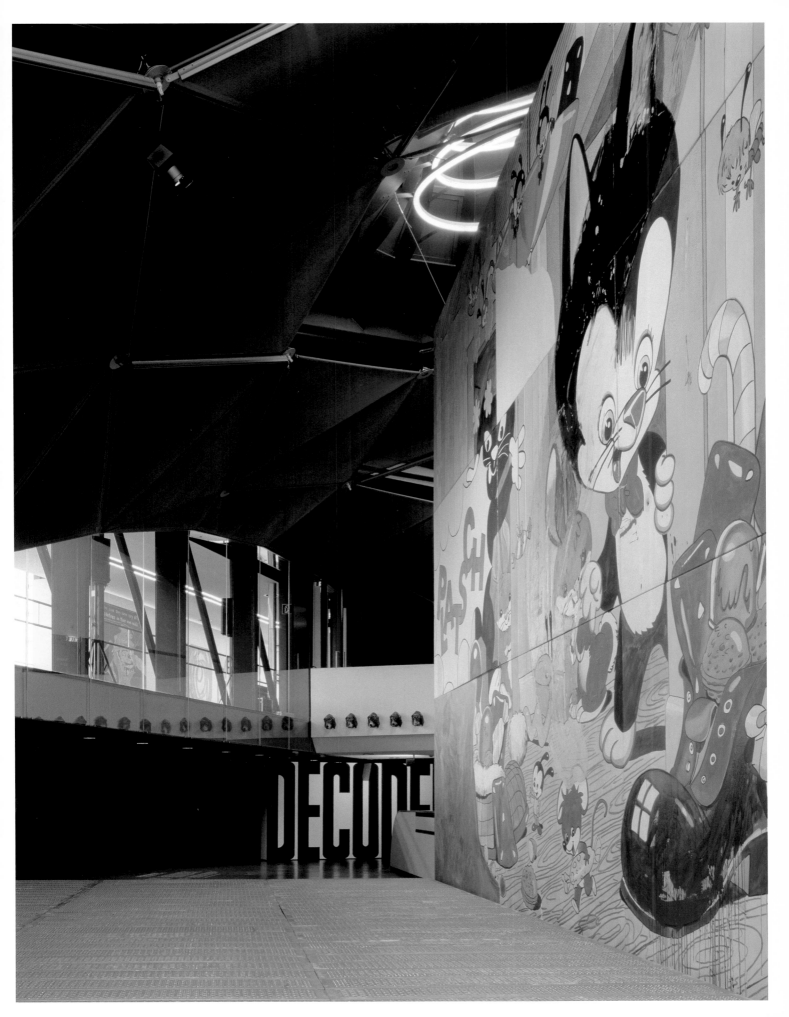

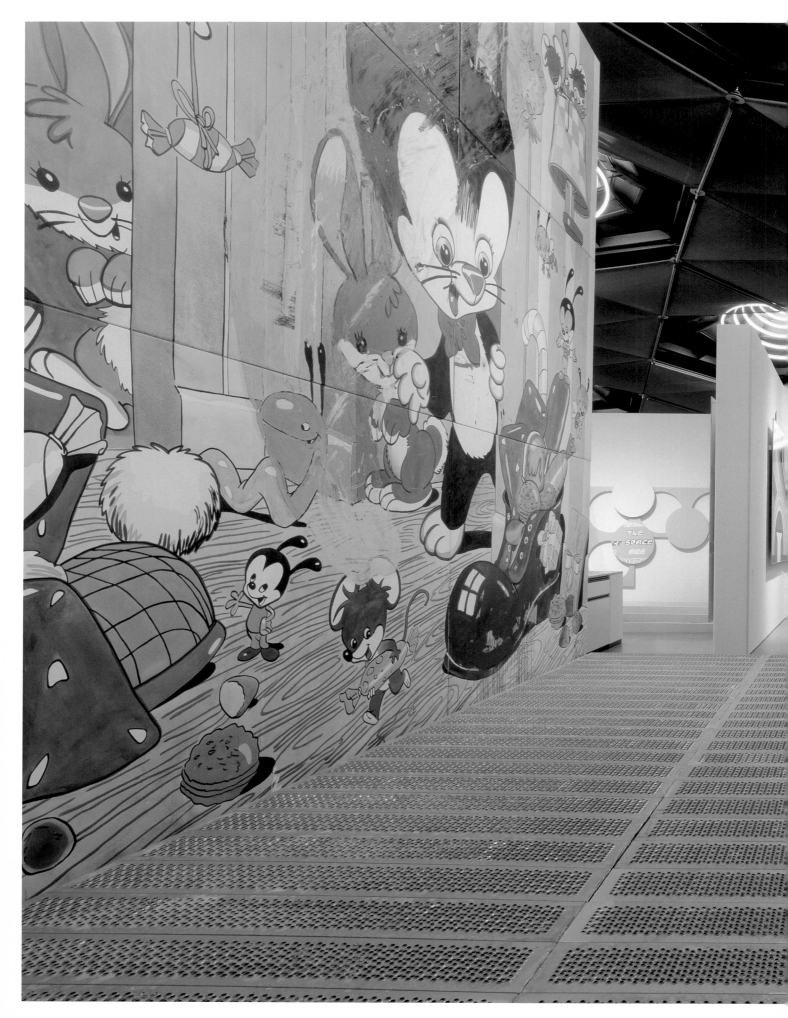

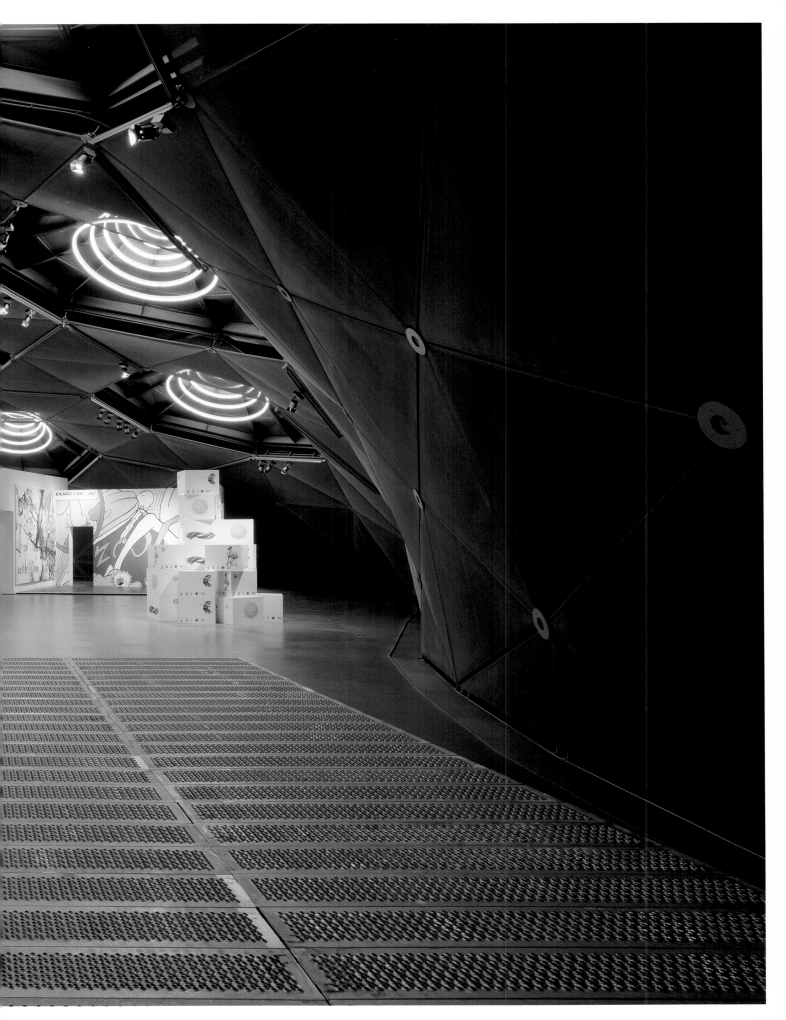

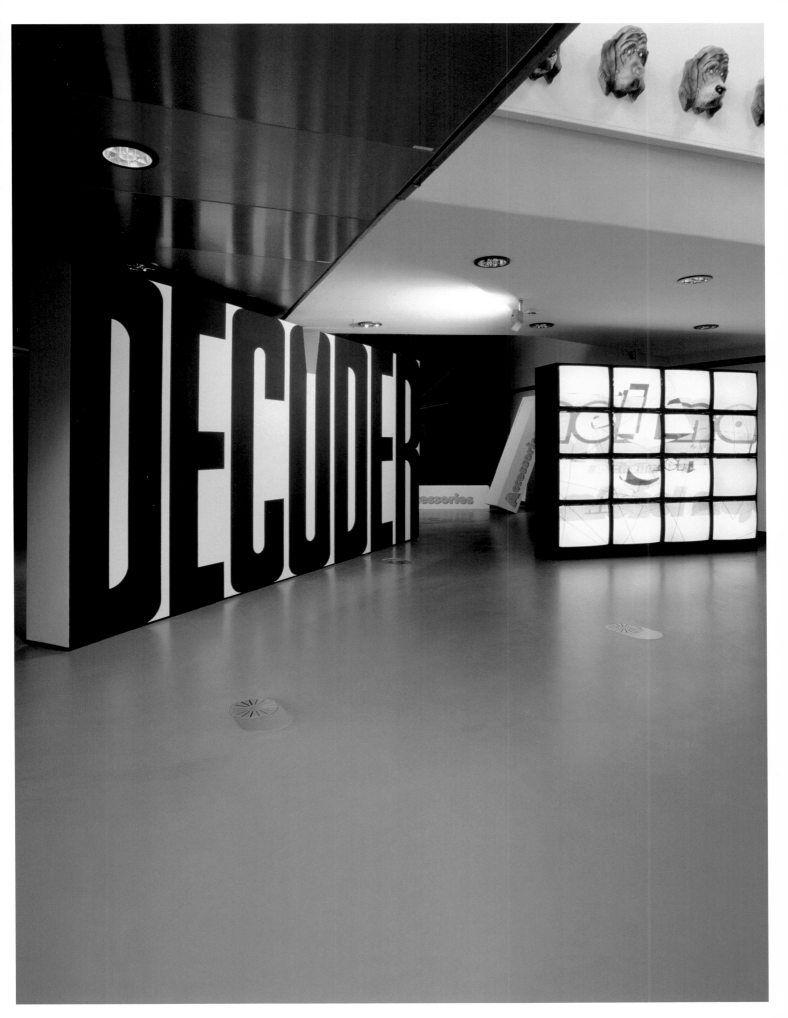

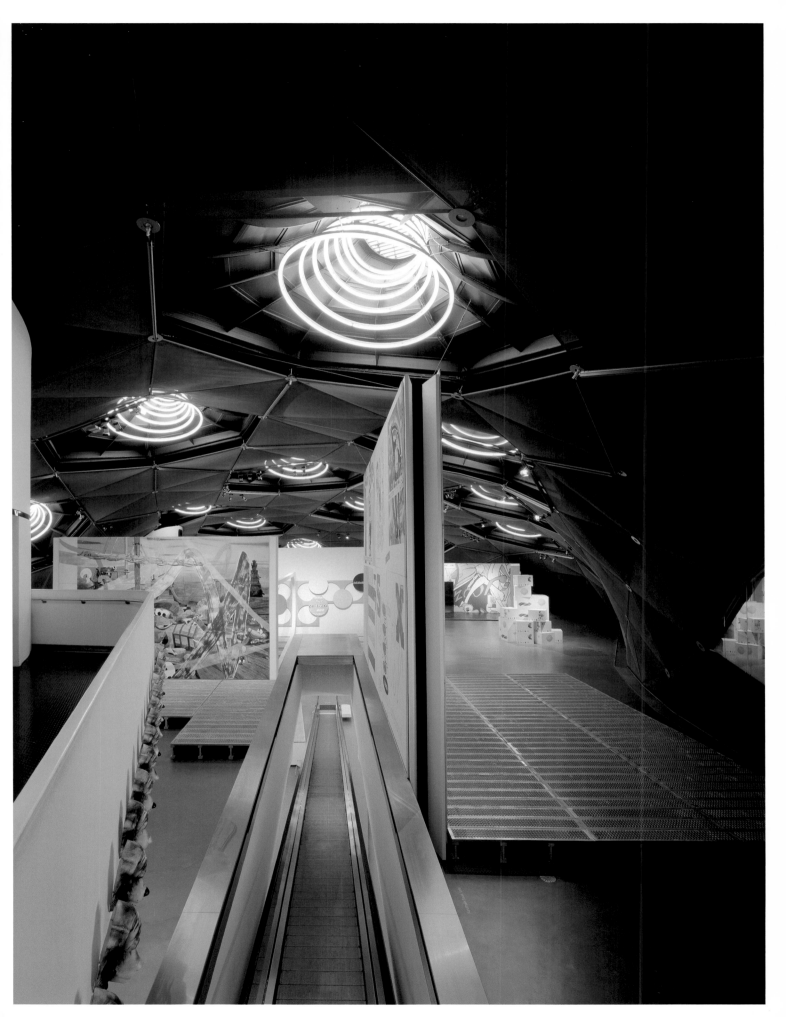

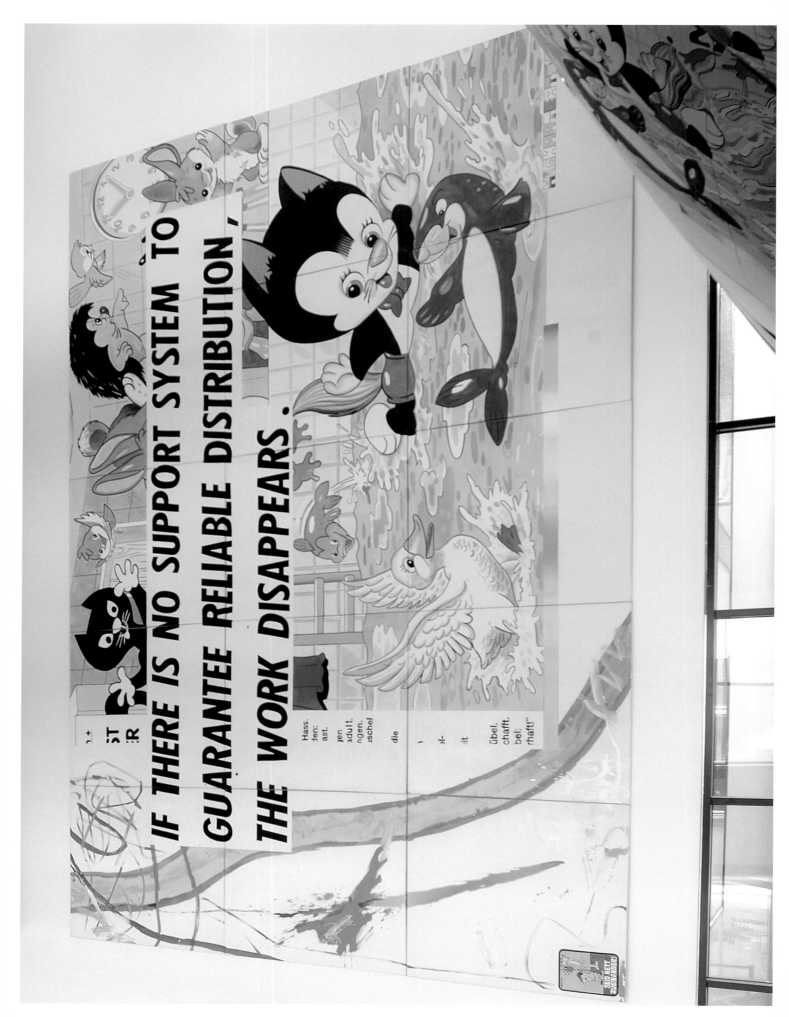

Index
Index

*shown at Kunsthaus Graz

untitled, 1991*
acrylic on canvas; 232×196,5cm
Sammlung Albrecht Kastein, Berlin
p.21

untitled, 1992*
plastic, color; 28 masks,
each 18×31×25cm
Private collection

Katze, 1993*
oil paint and acrylic on canvas;
714×966cm, 9 parts, each
238×322cm
Estate Michel Majerus, courtesy
neugerriemschneider, Berlin
shown at Kunsthalle Basel, 1996
see p.37

untitled (loss of self-confidence),
around 1993
acrylic on canvas; 213×310cm
Estate Michel Majerus, courtesy
neugerriemschneider, Berlin
see p.25

Der innere Schweinehund, 1994*
acrylic on canvas; 160×160cm
Sammlung Albrecht Kastein, Berlin
shown at Kunsthalle Basel, 1996
see p.39

enlarge-o-ray… on!, 1994*
emulsion paint on wall and acrylic
on canvas; 360×520cm,
canavas: 80,5×55cm
Estate Michel Majerus, courtesy
neugerriemschneider, Berlin
shown at neugerriemschneider,
Berlin, 1994
see p.26, 28

Ethyl, Alcohol, Fragrance, 1994*
acrylic on canvas; 160×160cm
Estate Michel Majerus, courtesy
neugerriemschneider, Berlin
shown at Kunsthalle Basel, 1996
see p.39

Geburtstag Heike F., 1994*
acrylic on canvas; 303×476cm,
2 parts, each 303×238cm
Heike Föll, Berlin
shown at Kunsthalle Basel, 1996
see p.35

GLOBOL SPEX groopie de luxe, 1994*
acrylic on canvas; 303×476cm,
2 parts, each 303×238cm
Estate Michel Majerus, courtesy
neugerriemschneider, Berlin
shown at Kunsthalle Basel, 1996
see p.35

Massnahmen…, 1994*
acrylic on canvas; 303×476cm,
2 parts, each 303×238cm
Private collection
shown at Kunsthalle Basel, 1996
see p.35

untitled, 1994*
acrylic on canvas; 160×160cm
Private collection
shown at neugerriemschneider,
Berlin, 1994
see p.27

untitled, 1994*
acrylic on canvas; 160×160cm
Sammlung Jürgen Hetzler
shown at neugerriemschneider,
Berlin, 1994
see p.27

untitled, 1994*
indian ink on paper; 3 parts,
each 104×315cm, 1 part 37×315cm
Estate Michel Majerus, courtesy
neugerriemschneider, Berlin
shown at neugerriemschneider,
Berlin, 1994
see p.27

o.T. (69), 1994*
acrylic on canvas; 303×476cm,
2 parts, each 303×238cm
Estate Michel Majerus, courtesy
neugerriemschneider, Berlin
shown at Kunsthalle Basel, 1996
see p.35

Sauerei, 1994*
oil paint and acrylic on canvas;
320×476cm, 2 parts,
each 320×238cm
Private collection
shown at neugerriemschneider,
Berlin, 1994
see p.28/29

strasse, 1994*
asphalt, traffic markings;
4,5×520×425cm
Estate Michel Majerus, courtesy
neugerriemschneider, Berlin
shown at neugerriemschneider,
Berlin, 1994
see p.26–28

Klosterfrau Melissengeist, 1995*
oil paint on canvas; 160×140cm
Private property, Switzerland
shown at Kunsthalle Basel, 1996
see p.32

Trophäen, die auf Verhandlungs-
geschick deuten 2, 1995*
acrylic on canvas; 160×140cm
Estate Michel Majerus, courtesy
neugerriemschneider, Berlin
shown at Kunsthalle Basel, 1996
see p.33

Aquarell, 1996
acrylic on canvas; 980×960cm,
42 parts, each 140×160cm
Estate Michel Majerus, courtesy
neugerriemschneider, Berlin
Installation view: Michel Majerus,
Kunstverein Hamburg, 1996
see p.30/31

A 1–7, T 1–7, H 1–7, M 1–7, 1996*
lacquer and silkscreen on wood;
28 boxes, each 55×55×75cm
Kunsthalle Mannheim, donation
Rudolf und Ute Scharpff
Installation view: Michel Majerus,
Galerie Monika Sprüth, Cologne,
1996
p.44, 47

Einschiffung, 1996*
acrylic on canvas;
480×700cm, 15-teilig, je 160×140cm
Estate Michel Majerus, courtesy
neugerriemschneider, Berlin
shown at Kunsthalle Basel, 1996
see p.34

Industrieboden, 1996*
metal, wood; 36×600×548cm and
36×980×600cm (variable)
Estate Michel Majerus, courtesy
neugerriemschneider, Berlin
shown at Kunsthalle Basel, 1996
see p.32–39

MoM Block I, 1996
acrylic on canvas; 420×800cm,
15 parts, each 140×160cm
Private collection
p.48

MoM Block II, 1996*
acrylic on canvas; 360×800cm,
8 parts, each 180×200cm
Collection Thea Westreich and
Ethan Wagner
p.50/51

untitled, 1996
acrylic on canvas; 190×190cm
Private collection
p.53

untitled, (16; 28; 92), 1996*
untitled, (121; 132), 1997*
untitled, (207; 264), 1998*
untitled, (506; 525), 1999*
untitled, (567; 657; 663; 671), 2000*
untitled, (731; 733; 750; 756; 764),
2001*
untitled, (1020; 1070; 1119), 2002*
acrylic on canvas; each 60×60cm
Private collection

untitled, (75; 101), 1996*
untitled, (137; 150; 152; 155; 166),
1997*
untitled, (212), 1998*
untitled, (447), 1999*
untitled, (556; 611; 614; 615; 616),
2000*
untitled, (747; 769; 920; 922; 926;
929; 933), 2001*
untitled, (1049), 2002*
untitled, (without number; without
number; without number; without
number), without date*
acrylic on canvas; each 60×60cm
Estate Michel Majerus, courtesy
neugerriemschneider, Berlin

untitled, (246), 1998*
untitled, (1019; 1035; 1039), 2002*
silkscreen on canavs; each 60×60cm
Private collection

untitled, (297), 1999*
untitled, (923), 2001*
untitled, (without number; without
number; without number),
without date*
silkscreen on canavs; each 60×60cm
Estate Michel Majerus, courtesy
neugerriemschneider, Berlin

DECODER, 1997*
emulsion paint on wall;
220×481 cm (variable)
Installation view: *Michel Majerus: Produce-Reduce-Reuse,* Galerie Karlheinz Meyer, Karlsruhe, 1997
there: 325×714 cm
Estate Michel Majerus, courtesy neugerriemschneider, Berlin
p. 54–56

dieser einzelfall an konstruktion ist insofern ein schlüsselbild, als er das irrationale, nämlich der gewohnten räumlichen rationalität widersprechende raumgefüge der nachfolgenden abstrakten bilder fast didaktisch ankündigt, 1997
lacquer, aluminium on stadur, digital print, sheetrock, wood, emulsion paint; 340×1023×870 cm
Estate Michel Majerus, courtesy neugerriemschneider, Berlin
Installation view: *topping out,* Städtische Galerie Nordhorn, 1997
p. 60/61

E.K.f., 1997*
Aluminium on stadur, styrofoam; 33×300×450 cm
Estate Michel Majerus, courtesy neugerriemschneider, Berlin

ohne Titel (accessories, scale 1:24 000 000), 1997*
chipboard, digital print, emulsion paint; 170×40×40 cm
Estate Michel Majerus, courtesy neugerriemschneider, Berlin
see p. 62/63

ohne Titel (accessories, scale 1:32 000 000), 1997*
chipboard, digital print, emulsion paint; 200×40×40 cm
Estate Michel Majerus, courtesy neugerriemschneider, Berlin
see p. 62/63

sinnmaschine, 1997
acrylic on canvas, industrial metal floor; 7 panels, each 450×150 cm
Estate Michel Majerus, courtesy neugerriemschneider, Berlin
Installation view: *Tell me a Story: narration in Contemporary Painting and Photography,* Centre National d'Art Contemporain de Grenoble, 1998
p. 68/69

Beschleunigung, 1998
lacquer, digital print and silkscreen on aluminium; approx. 900×1400×50 cm
Estate Michel Majerus, courtesy neugerriemschneider, Berlin
Installation views: *10 Jahre Open Art München,* central station Munich, 1998
p. 66/67

Higharteatspop, 1998*
acrylic on canvas; 480×700 cm
15 parts, each 160×140 cm
Neue Galerie am Landesmuseum Joanneum, Graz

it's cool man, 1998
lacquer and silkscreen on aluminium; 251×548×15,5 cm
Sammlung Kammermeier, Stuttgart
p. 71

MoM Block 31, 1998
acrylic on canvas; 200×180 cm
Collection of Charline von Heyl and Christopher Wool
p. 75

progressive aesthetics, 1998
acrylic on canvas; 322×476 cm, 2 parts, each 322×238 cm
Centro de Arte Contemporânea Inhotim, Belo Horizonte, Brazil
p. 64/65

reminder, 1998
lacquer on aluminium, acrylic on canvas, silkscreen on canvas, emulsion paint on wall, sheetrock; 670×1700×150 cm
Collection Fonds National d'Art Contemporain, Ministère de la Culture, Paris
Installation view: *Manifesta 2,* Luxemburg, 1998
p. 78/79

unexpected disaster, 1998
varnish on aluminium; 320×750×20 cm
Kunsthalle Mannheim, donation Rudolf and Ute Scharpff
p. 82/83

yet sometimes what is read successfully, stops us with its meaning, no. II, 1998*
varnish and digital print on aluminium; 278,5×485×15,5 cm
Private collection
Installation view: *Manifesta 2,* (Kino Utopolis) Luxembourg, 1998
p. 76/77

all like something, 1999
emulsion paint on wall;
dimension variable
Sammlung Falckenberg, Hamburg
Installation view: Sammlung Falckenberg, Pump Haus, Hamburg, 1999,
there: no mesurement
p. 113
Installation view: Sammlung Falckenberg, Phoenix Stiftung, Hamburg, 2001,
there: 408×690 cm and 408×1210 cm
p. 112

aufnahme position/ löschschutz position – record position/ protected position, 1999*
digital print on chipboard, emulsion paint on wall; 240×610×763 cm (variable)
Estate Michel Majerus, courtesy neugerriemschneider, Berlin
Installation view: *Colour Me Blind!,* Württembergischer Kunstverein, Stuttgart, 1999,
there: 450×1350×180 cm
p. 97
Installation views: *Colour Me Blind!,* Städtische Ausstellungshalle am Hawerkamp, Münster, 2000,
there: 240×610×763 cm;
Colour Me Blind!, Dundee Contemporary Arts, Dundee, 2000,
there: 620×390×cm
p. 96

enough, 1999*
acrylic on canvas; 250×400 cm
Sammlung Sander, Berlin
p. 80/81

erholung verloren, 1999
digital print on depafit;
320×500×300 cm
Estate Michel Majerus, courtesy neugerriemschneider, Berlin
Installation views: Michel Majerus, the better day project, Hamburg, 1999
p. 106/107

eye protection, 1999
digital print on aluminium, polystyrene miorror, emulsion paint on wall; approx. 680×1100×340 cm
Estate Michel Majerus, courtesy neugerriemschneider, Berlin
Installation view: *Le Capital: tableaux, diagramms, bureaux d'études,* Centre Regional d'Art Contemporain, Sète, 1999
p. 90/91

Gradnetz, 1999–2000
lacquer on aluminium;
1400×650×50 cm, 4 parts, each 250×650×50 cm
Sammlung HypoVereinsbank Luxembourg
Installation view: entrance area of HypoVereinsbank Luxembourg
p. 137

it does not really matter…, 1999*
laminated chipboard, bonding sheets; 2 parts, each 52×52×252 cm
Estate Michel Majerus, courtesy neugerriemschneider, Berlin

kick kick kick, 1999
acrylic on canvas; 303×333 cm
Private collection
p. 95

melt piece, 1999
digital print on aluminium, emulsion paint on wood, felt; 380×1000×320 cm
Estate Michel Majerus, courtesy neugerriemschneider, Berlin
Installation view: *kraftwerk BERLIN,* Aarhus Kunstmuseum, 1999
p. 92/93

sein lieblingsthema war sicherheit, seine these – es gibt sie nicht, 1999
Acryl auf Leinwand, Digitaldruck auf Aluminium, Polystyrol-Spiegel, Rigips, Riflex, Dispersionsfarbe; 365×1058×987 cm
The Museum of Contemporary Art, Los Angeles, Gift of Norman and Norah Stone
Installationsansichten: neugerriemschneider, Berlin, 1999
S.100–103

sun in 10 different directions, 1999
Digitaldruck auf Forex, Polystyrol-Spiegel, Dispersionsfarbe auf Wand; ca. 1100×2800×320
Nachlass Michel Majerus, Courtesy neugerriemschneider, Berlin
Installationsansichten: *d'APERTutto, 48. Esposizione Internazionale d'Arte, La Biennale di Venezia* (Fassade des Italienischen Pavillons), Venedig, 1999
S.84–87

what looks good today may not look good tomorrow, 1999
Styropor, Holz, Dispersionsfarbe; ca. 1200×4000×100 cm
Nachlass Michel Majerus, Courtesy neugerriemschneider, Berlin
Installationsansicht: *german open,* Kunstmuseum Wolfsburg, 1999
S.98/99

what looks good today may not look good tomorrow, 1999*
Acryl auf Leinwand; 303×341 cm
Sammlung Kunstmuseum Wolfsburg
S.105

what looks good today may not look good tomorrow, 1999
Dispersionsfarbe auf Wand; 308×504 cm
Nachlass Michel Majerus, Courtesy neugerriemschneider, Berlin
Installationsansicht: *Michel Majerus/Björn Dahlem,* schnitt ausstellungsraum, Köln, 1999
S.108/109

bring the next line up, 2000
Dispersionsfarbe auf Wand, Digitaldruck auf PVC und Forex, Rigips; 410×900×764 cm
Nachlass Michel Majerus, Courtesy neugerriemschneider, Berlin
Installationsansichten: *Taipeh Biennale,* Taipeh, 2000
S.124/125

Das goldene Zimmer, 2000
Zusammen mit Stephan Balkenhol und Rüdiger Schöttle, Aussenwandgestaltung Michel Majerus
Nachlass Michel Majerus, Courtesy neugerriemschneider, Berlin
Installationsansicht: *Hausschau – das Haus in der Kunst,* Deichtorhallen, Hamburg, 2000
S.129

gold, 2000
Acryl auf Leinwand; 303×348 cm
Sammlung Rudolf und Ute Scharpff, Stuttgart
S.111

if we are dead, so it is, 2000
Holz, Digitaldruck, Multiplex, Acrylfarbe, Lack; 300×992×4600 cm
Nachlass Michel Majerus, Courtesy neugerriemschneider, Berlin
Installationsansicht: Kölnischer Kunstverein, Köln, 2000
S.130–131

mace the space ace, 2000*
Digitaldruck und Lack auf Aluminium, Rigips; 484×1443×971 cm
Nachlass Michel Majerus, Courtesy neugerriemschneider, Berlin
Installationsansichten: Monika Sprüth Galerie, Köln, 2000
S.120–123

Michel Majerus, 2000*
DVD 30', 20 Monitore (variabel)
Nachlass Michel Majerus, Courtesy neugerriemschneider, Berlin

ohne Titel, 2000
Acryl auf Leinwand; 260×450 cm
Landesbank Baden-Württemberg
S.118/119

the space is where you'll find it, 2000
Digitaldruck auf Vinyl, Holz; 8 Teile installiert in einem Raum: 310×1862×1535 cm (variabel)
Sammlung Kunstmuseum Wolfsburg
Installationsansicht: Delfina, London 2000
S.114–117

Bin Laden wohnt in Buxtehude, 2001
MDF-Platten, Digitaldruck, Polystyrol-Spiegel, Acryl auf Leinwand; 300×1186×845 cm
Nachlass Michel Majerus, Courtesy neugerriemschneider, Berlin
Installationsansichten: *Casino 2001,* SMAK Gent, 2001
S.138/139

blood allover, 2001
Acryl auf Leinwand; 280×400 cm
Privatsammlung
S.140/141

Errvolk, Everybody Sucks, 2001
Dispersionsfarbe auf Wand, Digitaldruck auf Karton; 376×1000 cm
Nachlass Michel Majerus, Courtesy neugerriemschneider, Berlin
Installationsansicht: Lydmar Hotel, Stockholm
S.132/133

mm1, 2001
Acryl auf Leinwand; 260×300 cm
Privatsammlung
S.159

Thälmannkart, 2001
Acryl auf Leinwand; 480×700 cm, 15-teilig, je 160×140 cm
Privatsammlung
S.134/135

The starting line, 2001*
Neonhochspannungsröhren, Transformator, Metall, Licht; 277×1263×40 cm
Nachlass Michel Majerus, Courtesy neugerriemschneider, Berlin
S.151

controlling the moonlight maze, 2002*
365×1058×987 cm
bestehend aus:
keine zeit, 2000*
Nirosta, Lack, Stahl; 365×957×813 cm;
squirt the load, 2002*
Dispersionsfarbe auf Wand; 420×875 cm;
episode, 2002*
Siebdruck und Lack auf pulverbeschichtetem Aluminium, Wandhalterung; 340×450×33 cm;
the modern age „abstract", 2002*
Acryl und Siebdruck auf Leinwand, Wandhalterung; 370×540×46 cm;
grid, 2002*
Digitaldruck auf PVC; 300×570 cm
Nachlass Michel Majerus, Courtesy neugerriemschneider, Berlin
Installationsansicht: neugerriemschneider, Berlin, 2002
S.146–149

lost forever, 2002
(2-teilig)
Acryl auf Leinwand; 280×400 cm
Dispersionsfarbe auf Wand; 368×627 cm
Nachlass Michel Majerus, Courtesy neugerriemschneider, Berlin
Installationsansicht: Foyer im Stadtkino, Basel, im Rahmen der Ausstellung *Painting on the Move,* (Foyer im Stadtkino, Basel) Kunsthalle und Kunstmuseum Basel, 2002
S.152/153

Pathfinder, 2002*
Digitaldruck auf Vinyl; 380×290 cm
Nachlass Michel Majerus, Courtesy neugerriemschneider, Berlin

Sozialpalast, 2002
Digitaldruck auf Kunststoff; 1700×3900 cm
Nachlass Michel Majerus, Courtesy neugerriemschneider, Berlin
Installationsansicht: *Thomas Bayrle/Michel Majerus,* Brandenburger Tor, Berlin, 2002
S.142/143

splash bombs 3, 2002
Acryl auf Leinwand; 370×540 cm
Nationalgalerie im Hamburger Bahnhof, Museum für Gegenwart, Berlin
S.144/145

tex mex, 2002
Acryl auf Leinwand; 370×540 cm
Nachlass Michel Majerus, Courtesy neugerriemschneider, Berlin
S.154/155

Biografie

Michel Majerus

1967–2002
Staatliche Akademie der Bildenden Künste, Stuttgart

Einzelausstellungen

2004
pop reloaded, Tate Liverpool, Liverpool, GB (Kat.).

2003
pop reloaded, Hamburger Bahnhof, Berlin, DE (Kat.).

2002
letzte tage, Kollaborationen mit Hans-Jörg Mayer, neugerriemschneider, Berlin, DE;
Sozialpalast, Brandenburger Tor (mit Thomas Bayrle), Berlin, DE;
Leuchtland, Friedrich Petzel Gallery, New York, USA;
controlling the moonlight maze, neugerriemschneider, Berlin, DE.

2001
Eleni Koroneou Gallery, Athen, GR.

2000
if we are dead, so it is, Kölnischer Kunstverein, Köln, DE (Kat.);
demand the best don't accept excuses, Monika Sprüth Galerie, Köln, DE;
The space is where you'll find it, Delfina, London, GB.

1999
Schnitt Ausstellungsraum (mit Björn Dahlem), Köln, DE;
sein lieblingsthema war sicherheit, seine these – es gibt sie nicht, neugerriemschneider, Berlin, DE;
Thai-Ming, asprey jacques, London, GB;
erholung verloren, the better day project, Hamburg, DE;
Galerie Rüdiger Schöttle (mit Jenny Holzer), München, DE;
Giò Marconi, Mailand, IT;
Galeria Mário Sequeira, (mit Stefan Hirsig), Braga, PL.

1998
never trip alone. always use 2 player mode, Eleni Koroneou Gallery, Athen, GR.

1997
Space Safari, Anders Tornberg Gallery, Lund, SE;
qualified, Giò Marconi, Mailand, IT;
Produce-Reduce-Reuse, Galerie Karlheinz Meyer, Karlsruhe, DE.

1996
Aesthetic Standard, Grazer Kunstverein, Graz, AT;
Monika Sprüth Galerie, Köln, DE;
fertiggestellt zur zufriedenheit aller, die bedenken haben, neugerriemschneider, Berlin, DE;
Summer Hits 96, The Museum of Modern Art Syros, Cycladen, GR;
Kunsthalle Basel, CH (Kat.);
Aquarell, Kunstverein in Hamburg, Hamburg, DE.

1994
gemälde, neugerriemschneider, Berlin, DE.

1993
polish women, allgirls gallery, Berlin, DE.

1992
Mr. Propers und anderes, Zellermayer Galerie, Berlin, DE.

Gruppenausstellungen

2005

Just do it, Lentos Kunstmuseum, Linz, AT (Kat.);
Colours and Trips, Künstlerhaus Palais Thurn und Taxis, Bregenz, AT (Kat.);
Exit, Ausstieg aus dem Bild, Museum für neue Kunst, ZKM, Karlsruhe, DE;
Willem de Kooning, Kunstforum Wien, Wien, AT (Kat.).

2004

Strips and Characters, Kunstverein Wolfsburg, Wolfsburg, DE (Kat.);
Direkte Malerei/Direct Painting, Kunsthalle Mannheim, Mannheim, DE;
paintings, Galleri K, Oslo, NO;
1. Internationale Biennale für zeitgenössische Kunst Sevilla, Sevilla, ES (Kat.);
Looking at painting 2, Galerie Tanit, München, DE (Kat.);
Wunderkammer Privatsammlung 1, Kunsthalle Mannheim, Mannheim, DE;
Kunst, ein Kinderspiel, Schirn Kunsthalle, Frankfurt am Main, DE (Kat.);
Heisskalt. Aktuelle Malerei aus der Sammlung Scharpff, Staatsgalerie Stuttgart, Stuttgart, DE (Kat.);
Was Malerei heute ist, Opelvillen, Rüsselsheim, DE (Kat.);
Treasure Island, 10 Jahre Sammlung Kunstmuseum Wolfsburg, Kunstmuseum Wolfsburg, Wolfsburg, DE;
Werke aus der Sammlung Boros, Museum für neue Kunst, ZKM, Karlsruhe, DE (Kat.);
No more reality, Nils Staerk Contemporary Art, Kopenhagen, DK.

2003

SUPERNOVA: Art of the 1990s from the Logan Collection, San Francisco Museum of Modern Art, San Francisco, USA (Kat.);
Heisskalt. Aktuelle Malerei aus der Sammlung Scharpff, Hamburger Kunsthalle, Hamburg, DE (Kat.);
A New Modernism for a new Millennium: Abstraction and Surrealism are Reinvented in the Internetage, The Logan Collection, Vail, USA (Kat.);
Sitings: Installation Art 1969–2002, Museum for Contemporary Art MOCA, Los Angeles, USA;
SUPPORT. Die Neue Galerie als Sammlung, Neue Galerie Graz am Landesmuseum Joanneum, Graz, AT;
some things we like…, asprey jacques, London, GB;
actionbutton. Neuerwerbungen zur Sammlung zeitgenössischer Kunst der Bundesrepublik Deutschland 2000–2002, Hamburger Bahnhof, Berlin, DE (Kat.);

20th anniversary show, Monika Sprüth – Philomene Magers, Köln, DE;
Interview with Painting, Fondazione Bevilacqua La Masa, Venedig, IT (Kat.);
Painting Pictures. Malerei und Medien im Digitalen Zeitalter, Kunstmuseum Wolfsburg, Wolfsburg, DE (Kat.);
Talking Pieces. Text und Bild in der neuen Kunst, Museum Morsbroich, Leverkusen, DE (Kat.);
Perfect Timeless Repetition, c/o Atle Gerhardsen, Berlin, DE.

2002

The Starting Line, Pinakothek der Moderne, München, DE;
Hossa. Arte Alemán del 2000, Centro Cultural Andratx, Mallorca, ES;
Kunst nach Kunst, Neues Museum Weserburg, Bremen, DE (Kat.);
Lila, Weiss und andere Farben, Galerie Max Hetzler, Berlin, DE;
asprey jacques, London, GB;
Palais de Tokyo, Paris, FR.

2001

Wiedervorlage D5 – Eine Befragung des Documenta-Archivs zur Documenta 1972, Documenta-Archiv, Kassel, DE (Kat.);
Casino 2001, S.M.A.K., Gent, BE (Kat.);
gravures de peintres, Niels Borch Jensen Verlag und Druck, Berlin, DE;
Sammlung Falckenberg, Phoenix Kulturstiftung, Hamburg, DE;
Poetry in Motion, MindBar, Lund, SE;
Viel Spass; Espace Paul Ricard, Paris, FR;
M Art In(n), Helsingborg, SE;
Freestyle, Werke aus der Sammlung Boros, Museum Morsbroich, Leverkusen, DE.

2000

Pflummi, Brix-Kunstraum, Berlin, DE (Kat.);
Salon, Delfina Project Space, London, GB;
Malkunst, Fondazione Mudima, Mailand, IT (Kat.);
The Sky is the Limit, Taipeh-Biennale, Taipeh, RC;
Négociations, Centre Régional d'Art Contemporain, Languedoc-Roussillon, Sète, FR;
at your service, kuratiert v. Karin Pernegger, gasser & grunert, New York, USA; Kunsthalle Exnergasse, Wien, AT;
mission impossible, Charim Klocker, Wien, AT;
HausSchau – das Haus in der Kunst, Deichtorhallen Hamburg, DE (Kat.);
Colour Me Blind!, Städtische Ausstellungshalle Am Hawerkamp, Münster, DE; Dundee Contemporary Arts, Dundee, GB (Kat.).

1999

Colour Me Blind!, Württembergischer Kunstverein, Stuttgart, DE (Kat.);
German Open, Kunstmuseum Wolfsburg, Wolfsburg, DE (Kat.);
Die Schule von Athen, Municipality of Athens – Technopolis, Athen, GR (Kat.);
Sammlung Falckenberg, Pump Haus, Hamburg, DE (Kat.);
kraftwerk BERLIN, Aarhus Kunstmuseum, Aarhus, DK (Kat.);
Originale echt/falsch, Neues Museum Weserburg Bremen, Bremen, DE (Kat.);
Le Capital: tableaux, diagrammes, bureaux d´études, Centre Régional d'Art Contemporain, Languedoc-Roussillon, Sète, FR (Kat.);
Objects in the Rear View Mirror may Appear Closer than They are, Galerie Max Hetzler, Berlin, DE;
d'APERTutto, 48. Esposizione Internazionale d'Arte, La Biennale di Venezia, Venedig, IT (Kat.);
Nach-Bild, Kunsthalle Basel, Basel, CH (Kat.);
zoom, Sammlung Landesbank Baden-Württemberg, Stuttgart, DE; Museum Abteiberg, Mönchengladbach, DE; Kunsthalle zu Kiel, Kiel, DE (Kat.);
Galleri Nicolai Wallner, Kopenhagen, DK;
de coraz(i)on, Tecla Scala, Barcelona, ES (Kat.);
expanded design, Salzburger Kunstverein, Salzburg, AT;
Made in Berlin, House of Cyprus, Athen, GR (Kat.).

1998

Made in Berlin, Rethymnon Centre for Contemporary Art, Kreta, GR (Kat.);
Open Art, München, DE (Kat.);
Manifesta 2, Luxemburg, LU (Kat.);
Malerei, Galerie Karlheinz Meyer, Karlsruhe, DE;
Das Jahrhundert der künstlerischen Freiheit. 100 Jahre Wiener Secession, Secession, Wien, AT (Kat.);
Tell Me a Story: Narration in Contemporary Painting and Photography, Magasin, Centre National d'Art Contemporain de Grenoble, FR (Kat.).

1997

Topping Out, Städtische Galerie, Nordhorn, DE (Kat.);
Faustrecht der Freiheit, Sammlung Volkmann, Kunstsammlung, Gera, DE;
Manfred Pernice – Fiat, Künstlerhaus Stuttgart, Stuttgart, DE.

1996

Alle Neune, ACC Galerie, Weimar, DE;
Malerei III, 1996, Monika Sprüth Galerie, Köln, DE;
something changed, Helga Maria Klosterfelde, Hamburg, DE;
Wunderbar, Hamburger Kunstverein, Hamburg, DE; Kunstraum Wien, AT.

1992

3K-NH, Ausstellungsraum von J.Koshuth, Stuttgart, DE;
Under Thirty, Galerie Metropol, Wien, AT (Kat.).

Biography

Michel Majerus

1967–2002
Staatliche Akademie der Bildenden
Künste, Stuttgart

Solo Shows

2004
pop reloaded, Tate Liverpool,
Liverpool, GB (Cat.).

2003
pop reloaded, Hamburger Bahnhof,
Berlin, DE (Cat.).

2002
letzte tage, collaborations with Hans-
Jörg Mayer, neugerriemschneider,
Berlin, DE;
Sozialpalast, Brandenburger Tor (with
Thomas Bayrle), Berlin, DE;
Leuchtland, Friedrich Petzel Gallery,
New York, USA;
controlling the moonlight maze,
neugerriemschneider, Berlin, DE;

2001
Eleni Koroneou Gallery, Athens, GR.

2000
if we are dead, so it is, Kölnischer
Kunstverein, Cologne, DE (Cat.);
*demand the best don't accept
excuses,* Monika Sprüth Galerie,
Cologne, DE;
The space is where you'll find it,
Delfina, London, GB.

1999
Schnitt Ausstellungsraum (mit Björn
Dahlem), Cologne, DE;
*sein lieblingsthema war sicherheit,
seine these – es gibt sie nicht,*
neugerriemschneider, Berlin, DE;
Thai-Ming, asprey jacques,
London, GB;
erholung verloren, the better day
project, Hamburg, DE;
Galerie Rüdiger Schöttle (with Jenny
Holzer), Munich, DE;
Giò Marconi, Milan, IT;
Galeria Mário Sequeira, (with Stefan
Hirsig), Braga, PL.

1998
*never trip alone. always use 2 player
mode,* Eleni Koroneou Gallery,
Athens, GR.

1997
Space Safari, Anders Tornberg
Gallery, Lund, SE;
qualified, Giò Marconi, Milan, IT;
Produce-Reduce-Reuse, Galerie
Karlheinz Meyer, Karlsruhe, DE.

1996
Aesthetic Standard, Grazer
Kunstverein, Graz, AT;
Monika Sprüth Galerie, Cologne, DE;
*fertiggestellt zur zufriedenheit aller,
die bedenken haben,* neuger-
riemschneider, Berlin, DE;
Summer Hits 96, The Museum of
Modern Art Syros, Cycladen, GR;
Kunsthalle Basel, CH (Cat.);
Aquarell, Kunstverein in Hamburg,
Hamburg, DE.

1994
gemälde, neugerriemschneider,
Berlin, DE.

1993
polish women, allgirls gallery,
Berlin, DE.

1992
Mr. Propers und anderes, Zellermayer
Galerie, Berlin, DE.

2005

Just do it, Lentos Kunstmuseum, Linz, AT (Cat.);
Colours and Trips, Künstlerhaus Palais Thurn und Taxis, Bregenz, AT (Cat.);
Exit, Ausstieg aus dem Bild, Museum für Neue Kunst, ZKM, Karlsruhe, DE;
Willem de Kooning, Kunstforum Wien, Vienna, AT (Cat.).

2004

Strips and Characters, Kunstverein Wolfsburg, Wolfsburg, DE (Cat.);
Direkte Malerei/Direct Painting, Kunsthalle Mannheim, Mannheim, DE;
paintings, Galleri K, Oslo, NO;
1st International Bienial for contemporary art Sevilla, Sevilla, ES (Cat.);
Looking at painting 2, Galerie Tanit, Munich, DE (Cat.);
Wunderkammer Privatsammlung 1, Kunsthalle Mannheim, Mannheim, DE;
Kunst, ein Kinderspiel, Schirn Kunsthalle, Frankfurt on the Main, DE (Cat.);
Heisskalt. Aktuelle Malerei aus der Sammlung Scharpff, Staatsgalerie Stuttgart, Stuttgart, DE (Cat.);
Was Malerei heute ist, Opelvillen, Rüsselsheim, DE (Cat.);
Treasure Island, 10 Jahre Sammlung Kunstmuseum Wolfsburg, Kunstmuseum Wolfsburg, Wolfsburg, DE;
Werke aus der Sammlung Boros, Museum für neue Kunst, ZKM, Karlsruhe, DE (Cat.);
No more reality, Nils Staerk Contemporary Art, Copenhagen, DK.

2003

SUPERNOVA: Art of the 1990s from the Logan Collection, San Francisco Museum of Modern Art, San Francisco, USA (Cat.);
Heisskalt. Aktuelle Malerei aus der Sammlung Scharpff, Hamburger Kunsthalle, Hamburg, DE (Cat.);
A New Modernism for a new Millennium: Abstraction and Surrealism are Reinvented in the Internetage, The Logan Collection, Vail, USA (Cat.);
Sitings: Installation Art 1969–2002, Museum for Contemporary Art MOCA, Los Angeles, USA;
SUPPORT. Die Neue Galerie als Sammlung, Neue Galerie Graz am Landesmuseum Joanneum, Graz, AT;
some things we like…, asprey jacques, London, GB;
actionbutton. Neuerwerbungen zur Sammlung zeitgenössischer Kunst der Bundesrepublik Deutschland 2000–2002, Hamburger Bahnhof, Berlin, DE (Cat.);

20th anniversary show, Monika Sprüth – Philomene Magers, Cologne, DE;
Interview with Painting, Fondazione Bevilacqua La Masa, Venice, IT (Cat.);
Painting Pictures. Malerei und Medien im Digitalen Zeitalter, Kunstmuseum Wolfsburg, Wolfsburg, DE (Cat.);
Talking Pieces. Text und Bild in der neuen Kunst, Museum Morsbroich, Leverkusen, DE (Cat.);
Perfect Timeless Repetition, c/o Atle Gerhardsen, Berlin, DE.

2002

The Starting Line, Pinakothek der Moderne, Munich, DE;
Hossa. Arte Alemán del 2000, Centro Cultural Andratx, Mallorca, ES;
Kunst nach Kunst, Neues Museum Weserburg, Bremen, DE (Cat.);
Lila, Weiss und andere Farben, Galerie Max Hetzler, Berlin, DE;
asprey jacques, London, GB;
Palais de Tokyo, Paris, FR.

2001

Wiedervorlage D5 – Eine Befragung des Documenta-Archivs zur Documenta 1972, Documenta-Archive, Kassel, DE (Cat.);
Casino 2001, S.M.A.K., Gent, BE (Cat.);
gravures de peintres, Niels Borch Jensen Verlag und Druck, Berlin, DE;
Sammlung Falckenberg, Phoenix Kulturstiftung, Hamburg, DE;
Poetry in Motion, MindBar, Lund, SE;
Viel Spass, Espace Paul Ricard, Paris, FR;
M Art In(n), Helsingborg, SE;
Freestyle, Werke aus der Sammlung Boros, Museum Morsbroich, Leverkusen, DE.

2000

Pflummi, Brix-Kunstraum, Berlin, DE (Cat.);
Salon, Delfina Project Space, London, GB;
Malkunst, Fondazione Mudima, Milan, IT (Cat.);
The Sky is the Limit, Taipeh Bienial, Taipeh, RC;
Négociations, Centre Régional d'Art Contemporain, Languedoc-Roussillon, Sète, FR;
at your service, curated by Karin Pernegger, gasser&grunert, New York, USA; Kunsthalle Exnergasse, Vienna, AT;
mission impossible, Charim Klocker, Vienna, AT;
HausSchau – das Haus in der Kunst, Deichtorhallen Hamburg, DE (Cat.);
Colour Me Blind!, Städtische Ausstellungshalle Am Hawerkamp, Münster, DE; Dundee Contemporary Arts, Dundee, GB (Cat.).

1999

Colour Me Blind!, Württembergischer Kunstverein, Stuttgart, DE (Cat.);
German Open, Kunstmuseum Wolfsburg, Wolfsburg, DE (Cat.);
Die Schule von Athen, Municipality of Athens – Technopolis, Athens, GR (Cat.);
Sammlung Falckenberg, Pump Haus, Hamburg, DE (Cat.);
kraftwerk BERLIN, Aarhus Kunstmuseum, Aarhus, DK (Cat.);
Originale echt/falsch, Neues Museum Weserburg Bremen, Bremen, DE (Cat.);
Le Capital: tableaux, diagrammes, bureaux d'études, Centre Régional d'Art Contemporain, Languedoc-Roussillon, Sète, FR (Cat.);
Objects in the Rear View Mirror may Appear Closer than They are, Galerie Max Hetzler, Berlin, DE;
d'APERTutto, 48. Esposizione Internazionale d'Arte, La Biennale di Venezia, Venice, IT (Cat.);
Nach-Bild, Kunsthalle Basel, Basle, CH (Cat.);
zoom, Sammlung Landesbank Baden-Württemberg, Stuttgart, DE;
Museum Abteiberg, Mönchengladbach, DE;
Kunsthalle zu Kiel, Kiel, DE (Cat.);
Galleri Nicolai Wallner, Copenhagen, DK;
de coraz(i)on, Tecla Scala, Barcelona, ES (Cat.);
expanded design, Salzburger Kunstverein, Salzburg, AT;
Made in Berlin, House of Cyprus, Athens, GR (Cat.).

1998

Made in Berlin, Rethymnon Centre for Contemporary Art, Crete, GR (Cat.);
Open Art, Munich, DE (Cat.);
Manifesta 2, Luxemburg, LU (Cat.);
Malerei, Galerie Karlheinz Meyer, Karlsruhe, DE;
Das Jahrhundert der künstlerischen Freiheit. 100 Jahre Wiener Secession, Secession, Vienna, AT (Cat.);
Tell Me a Story: Narration in Contemporary Painting and Photography, Magasin, Centre National d'Art Contemporain de Grenoble, FR (Cat.).

1997

Topping Out, Städtische Galerie, Nordhorn, DE (Cat.);
Faustrecht der Freiheit, Sammlung Volkmann, Kunstsammlung, Gera, DE;
Manfred Pernice – Fiat, Künstlerhaus Stuttgart, Stuttgart, DE.

1996

Alle Neune, ACC Galerie, Weimar, DE;
Wunderbar, Hamburger Kunstverein, Hamburg, DE;
Malerei III, 1996, Monika Sprüth Galerie, Cologne, DE;
something changed, Helga Maria Klosterfelde, Hamburg, DE;
Wunderbar, Hamburger Kunstverein, Hamburg, DE; Kunstraum Wien, AT.

1992

3K-NH, Ausstellungsraum von J.Kosuth, Stuttgart, DE;
Under Thirty, Galerie Metropol, Vienna, AT (Cat.).

Bibliografie

2004

Lucien Kayser: *Michel Majerus ou l'étoilement de la peinture.* In: *D'Letzenburger Land,* 19. November 2004;

Hans-Joachim Müller: *Michel Majerus.* In: *The Joy of my Dreams. 1. International Biennial of Contemporary Art of Seville.* Ausst.Kat. Sevilla 2004, S. 98–101;

Kent und Dean Scobel: *A new Modernism for a new Millennium: Abstraction and Surrealism are Reinvented in the Internetage.* Ausst. Kat. The Logan Collection, Vail 2004;

Joachim Jäger: *Michel Majerus: Los Angeles.* In: *Michel Majerus pop reloaded.* Ausst.Kat. Hamburger Bahnhof, Berlin 2003, Tate Liverpool 2004, Köln 2004;

Daniel Birnbaum: *Sampling the Globe.* In: *Artforum* (Oktober 2004), S. 241–244/29–299;

Gabriela Walde: *Des Kanzlers neue Bilder.* In: *Berliner Morgenpost,* 9. Juni 2004;

Looking at Painting 2. Ausst.Kat. Galerie Tanit, München 2004;

Katrin Wittneven: *Hunger nach Trends. Vom Exportschlager zur Saisonware: Warum die herausragende junge Kunst aus Deutschland ein Label wie „Kraut Art" gar nicht nötig hat.* In: *Der Tagesspiegel,* 10. April 2004, S. 26;

Kate Zamet: *On the Verge of World Domination. Michel Majerus: pop reloaded. Tate Liverpool until 18 April 2004.* In: *Blueprint* (April 2004);

Ralf Christofori: *Brücken über den Fluss. Der Kunstsammler Rudolf Scharpff zeigt ab heute aktuelle Malerei aus seiner Kollektion in Stuttgart.* In: Der Tagesspiegel, 20. März 2004, S. 24;

N.N.: *Pop Reloaded.* In: *Blueprint* (März 2004);

N.N.: *Michel Majerus exhibition at the Tate.* In: *Merseymart,* 4. März 2004;

Brigitta Melten: *Das Leben aus zweiter Hand. Rüsselsheimer Opelvillen zeigen die Ausstellung „Was Malerei heute ist".* In: *Main-Spitze,* 10. Februar 2004;

Christoph Schütte: *Horrorszenen im Seerosenreich. „Was Malerei heute ist": Eine Ausstellung in den Rüsselsheimer Opelvillen.* In: *FAZ,* 12. Februar 2004;

Chris Brown: *Tate Gallery tribute to plane crash artist. Majerus collection on show at Albert Dock.* In: *Daily Post,* 27. Januar 2004;

Ingrid Ehrhardt: *Michel Majerus.* In: *Was Malerei heute ist.* Ausst.Kat. Opelvillen, Rüsselsheim, S. 32–37;

Silke Immenga: *Michel Majerus. Werke aus der Sammlung Boros.* Ausst.Kat. ZKM Karlsruhe, 2004;

2003

Dave Allen, Harald Fricke: *Michel Majerus. Hamburger Bahnhof.* In: *Neue Review,* (Oktober 2003), Nr. 3, S. 28–29;

Christine Macel: *à l'Est, du nouveau. actualité de la peinture en Allemagne/ New Painting in Germany.* In: *artpress* (Oktober 2003), Nr. 294, S. 39–46;

Ingeborg Ruthe: *Sicherheit? Es gibt sie nicht. Michel Majerus' „pop reloaded" im Hamburger Bahnhof.* In: *Berliner Zeitung,* 19./20. Juli 2003, S. 10;

Harald Fricke: *Aus Freude am Photo-Shopping.* In: *die Tageszeitung,* 15. Juli 2003, S. 16;

Christina Tilmann: *Held der inneren Unsicherheit.* In: *Der Tagesspiegel,* 12. Juli 2003;

Gabriela Walde: *Der Sampler.* In: *Berliner Morgenpost,* 11. Juli 2003. S. 11;

Boris Hohmeyer: *Kandinsky trifft auf Omo-Reklame.* In: *Art* (Juli 2003), S. 96/97;

Michael Stoeber: *Painting Pictures.* In: *Kunstforum International* (Juni/Juli 2003);

Andreas Schlaegel: *Reviews.* In: *Contemporary* (Sommer 2003);

Martha Schwendener: *Michel Majerus.* In: *artindex* (Frühling/ Sommer 2003), Nr. 3, S. 96–97;

Axel Lapp: *Review.* In: Art Monthly (April 2003);

Belinda Grace Gardner: *Wolfsburg: „Painting Pictures".* In: *Kunstzeitung* (April 2003);

Harald Fricke: *Never mind the Pollocks.* In: *Die Tageszeitung,* 5. März 2003, S. 15;

Elke Buhr: *Alles gleich glatt.* In: *Frankfurter Rundschau,* 4. März 2003;

Vera Görgen: *Malen nach Zahlen.* In: *Financial Times Deutschland,* 4. März 2003;

Wulf Winter: *Painting Pictures.* In: *Indigo* (März 2003);

Michael Stroeber: *Der Wille zum Bild.* In: *Hannoversche Allgemeine,* 3. März 2003;

Daniel Birnbaum: *Michel Majerus 1967–2002.* In: *frieze* (Januar/Februar 2003), S. 60–61;

Corinna Daniels: *„Zeitlose Wiederholungen" bei Atle Gerhardsen.* In: *Die Welt,* 21. Februar 2003, S. 34;

Wolf Günter Thiel: *Michel Majerus.* In: *Flash Art* (Januar/Februar 2003), S. 46;

Justin Hoffmann: *„The Starting Line" der Pinakothek der Moderne.* In: *Kunst Bulletin* (Januar/Februar 2003), S. 50–51;

Luc Marteling: *Pinakothek der Moderne. Mehr Licht.* In: *Telecran,* 1.–7. Februar, S. 34–37;

M.A.: *Apocalypse Now.* In: *Berliner Morgenpost,* 24. Januar 2003, S. 13;

Artist News. In: *Artist Kunstmagazin* (2003), Nr. 54, 1, S. 12;

Andreas Schlaegel: *News Berlin.* In: *Contemporary* (2003), Nr. 47–48, S. 21;

Ute Riese: *Michel Majerus.* In: *Talking Pieces, Text und Bild in der neuen Kunst.* Ausst.Kat. Museum Morsbroich, Leverkusen 2003;

Andrea Domesle: *Zur Erinnerung an Michel Majerus, MAYERus. letzte tage,* online: www.artmagazine.cc, 7. Januar 2003;

Katrin Luz: *„Bilder sind wie Viren, die sich an Bestehendes anheften." Interview.* In: *newsletter galerienkoeln,* Jänner 2003, S. 8–10;

Patricia Ellis: *Michel Majerus.* In: *„Interview with Painting".* Ausst.Kat. Hrsg. von Gianni Romano. Fondazione Bevilacqua La Masa, Venedig 2003.

2002

Corinna Daniels: *Die letzten Bilder von Michel Majerus bei neugerriemschneider.* In: *Die Welt,* 27. Dezember 2002;

Kathrin Wittneven: *Innehalten in der Bilderflut.* In: *Der Tagesspiegel,* 14. Dezember, S. 24;

N.N.: *Michel Majerus 1967–2002.* In: *Art Monthly* (Dezember 2002), S. 262;

Cary Levine: *Michel Majerus at Friedrich Petzel.* In: *Art in America* (Dezember 2002), S. 109;

Raimar Stange: *Adventures of Uncertainity.* In: *Modern Painters* (Winter 2002), S. 98–101;

Daniel Birnbaum: *Seine Zeit war immer jetzt.* In: *Frankfurter Rundschau,* 11. November 2002;

N.N.: *Paläste und Sprechblasen.* In: *Frankfurter Rundschau,* 9. November 2002;

Kathrin Wittneven: *Die Absichten des Künstlers.* In: *Der Tagesspiegel,* 8. November 2002;

Ingeborg Ruthe: *Malen im Freistil.* In: *Berliner Zeitung,* 8. November 2002;

Jörg Heiser: *Hier, jetzt.* In: *Süddeutsche Zeitung,* 8. November 2002;

Peter Richter: *Welten aus Malerei.* In: *FAZ,* 8. November 2002;

Klara Wallner: *Die Engel in der Halfpipe.* In: *die tageszeitung,* 8. November 2002;

Katja Blomberg: *Der Künstler Michel Majerus unter den Opfern.* online: www.faz.net;

N.N.: *Michel Majerus, freischaffender Künstler.* In: *Tageblatt, Zeitung für Letzenburg,* 7. November 2002;

David Ryan: *Michel Majerus in Berlin.* In: *Art Papers* (September/Oktober 2002), S. 52;

Maika Pollack: *Michel Majerus at Friedrich Petzel.* In: *Flash Art* (Oktober 2002), Nr. 226, S. 101–102;

John Reed: *Space Invaders.* online: www.artnet.com, 10. Oktober 2002; *Michel Majerus, Art Guide.* In: *New York Times,* 11. Oktober 2002; David Ryan: *Michel Majerus in Berlin (Reviews International Berlin).* In: *Art Papers* (September/Oktober 2002), S. 52; Meghan Dailey: *Artforum Picks: Michel Majerus/Friedrich Petzel Gallery.* online: www.artforum.com; I. L.: *Ansichtssachen: Die Verwandlungen des Brandenburger Tors.* In: *FAZ,* 9. September 2002; N. N.: *Provokation: Sozialpalast statt Brandenburger Tor.* In: *Berliner Morgenpost,* 7. September 2002, S. 17; N. N.: *Berlins Gute Stube.* In: *Der Tagesspiegel,* 7. September 2002, S. 9; N. N.: *Schöneberg liegt in Mitte.* In: *Berliner Zeitung,* 7./8. September 2002, S. 28; *Vitamin P. New Perspectives in Painting.* London: Phaidon Press 2002; Fernando Castro: *2002 BC Before Collecting Latin American Art.* In: *Art Nexus* (April–Juni 2002), Nr. 44, Vol. 2; Jörg Ebner: *Das Kreuz mit den Jünglingen.* In: *FAZ,* 2. März 2002, S. 58; Bernhard Schulz: *Antennen in alle Welt.* In: *Der Tagesspiegel,* 19. Februar 2002, S. 25; Raimar Stange: *Interview mit Michel Majerus.* In: R.S.: *Sur.Faces, Interviews 2001/02.* Hrsg. von Christoph Keller. Frankfurt am Main: Revolver 2002, S. 17–20;

2001

Dimitri Nohé: *Viel Spaß.* In: *Chronic Art,* 27. Juni 2001; *Casino 2001.* Ausst.Kat. S.M.A.K., Gent; Marco Meneguzzo: *Avventura oltre il Muro.* In: *AD/Antiques & Collectors* (März 2001), Nr. 238, S. 120–125; Francesca Bonazzoli: *Malkunst, pittura oggi a Berlino.* In: *corriere delle sera/Vivi Milano,* 2. Jänner 2001; N. N.: *Christian Boros.* In: *artinvestor* (3/2001), S. 56–57; Miriam Bers: *Berlin, from neo pop to crossculture.* In: *tema celeste* (Januar/Februar 2001), S. 70–75; Holger Liebs: *Generation Klecks.* In: *Süddeutsche Zeitung,* 9. Januar, S. 15; Catrin Backhaus: *666 – Animierte Probefarten.* In: *Blitz-Review,* 2001; Thomas Wagner: *Michel Majerus.* Diplomarbeit Kunsthochschule Berlin-Weißensee, 2001.

2000

Noemi Smolik: *Die Absichten des Künstlers werden überbewertet.* In: *FAZ,* 3. November 2000, S. 49; Gerrit Gohlke: *Panorama und Revierkampf.* In: *BE, Künstlerhaus Bethanien Berlin* (September 2000), Nr. 6, S. 21–26; *The Sky is the Limit.* Ausst. Kat. Taipeh Biennial, 2000, S. 82–83.; Noemi Smolik: *Michel Majerus: If We Are dead, So It Is.* In: *Artforum* (September 2000), S. 81; Anja Lösel; Kerstin Ehmer (Fotos): *Glühende Bilderlust.* In: *stern,* 28. September 2000, S. 90, S. 94; Jens Peter Koerver: *New Painting. Der Stand der Bilder.* In: *frame* (Juli/August 2000), Nr. 3, S. 46; Frank Frangenberg: *Leere Unwirklichkeit und Popkultur.* In: *Kölner Stadt Anzeiger,* 6. Mai 2000; Martin Herbert: *Michel Majerus.* In: *Time Out,* 19.–26. April 2000; Laura Dago: *Gió Marconi.* In: *Gioia,* 7. März 2000; Dana Horáková: *Schönheit gibt es nicht, nirgendwo.* In: *Welt am Sonntag,* 27. Februar 2000, S. 45; Niru Ratnam: *kunst*.* In: *The Face* (Jänner 2000), Nr. 36, S. 96–99.

1999

Noemi Smolik: *Michel Majerus.* In: *Kunstforum International* (Dezember 1999/Jänner 2000), Nr. 148, S. 316–317; Ulrike Knöfel: *„Gefühl der Stärke" Die Wolfsburger Schau „German Open" feiert eine neue, höchst lebendige Kunstszene. Der Nachwuchs träumt nicht mehr vom Umsturz: Er inszeniert frech und bunt die eigene Größe.* In: *Der Spiegel* (1999), Nr. 46, S. 296–299; Raimar Stange: *Never Trip Alone.* In: *Kunstbulletin* (November 1999), Nr. 11, S. 12–17; Giancarlo Politi: *The Venice Biennale.* In: *Flash Art* (Oktober 1999), Vol. 32, Nr. 208, S. 76; Peter Herbstreuth: *Alles hängt mit allem zusammen.* In: *Der Tagesspiegel,* 25. September 1999, S. 34; Stefan Heidenreich: *Genug, genug, genug. Paradox: Michel Majerus in der Galerie neugerriemschneider.* In: *FAZ,* 11. September 1999, S. BS 4; Roberta Bosco: *Abstracción y decoración.* In: *El periodico del arte* (März 1999), Nr. 20; Susanne Küper: *Michel Majerus, MoM Block,* In: *Nach-Bild.* Ausst. Kat. Kunsthalle Basel, Basel 1999, S. 60–61; Christine Standfest: *Michel Majerus.* In: *dAPERTutto,* Ausst. Kat. 48. Esposizione Internazionale d'Arte, La Biennale di Venezia, S. 282–285;

Jacqueline Ceresoli: *Gió Marconi.* In: *Juliet* (Juni 1999), Nr. 93, S. 75; Susanne Titz: *Michel Majerus.* In: *Art at the Turn of the Millennium.* Hrsg. von Burkhard Riemschneider und Uta Grosenick. Köln: Taschen 1999, S. 330–333; Kathrin Luz: *Michel Majerus (Interview).* In: *Noëma* (Jänner–März 1999), Nr. 50, S. 80–81; Robert Fleck: *Michel Majerus.* In: *German Open.* Ausst. Kat. Kunstmuseum Wolfsburg, Wolfsburg 1999; Heike Föll: *Michel Majerus.* In: *kraftwerk Berlin.* Ausst. Kat. Aarhus Kunstmuseum, Aarhus 1999, S. 119.

1998

Claudia Posca: *Manifesta in Luxemburg.* In: *Kunstforum International* (Oktober–November 1998), Nr. 142, S. 311–315; Wolf-Günter Thiel: *Cover Story. Flash Art International* (Oktober 1998) S. 74 und Cover; Horst Richter: *Geschichte der Malerei im 20. Jahrhundert.* Köln: Dumont 1998, S. 283; Franz Kotteder: *Kunst ist für alle da.* In: *Süddeutsche Zeitung,* 11. September 1998, S. 17; *Manifesta 2 – Ein Fotorundgang.* In: *Kunstforum International* (Oktober–November 1998), Nr. 142, S. 316–353; Sven Drühl: *Verstrickungen.* In: *Kunstforum International* (Juli–September 1998), Nr. 141, S. 172–183; Alfred Nemeczek: *Luxemburg: Manifesta 2. Der documenta entgegen,* In: *Art* (August 1998), Nr. 8, S. 90; Christoph Tannert: *Wie Sisyphos auf der Tonleiter.* In: *Berliner Zeitung,* 10. Juli 1998, S. 11; Ingeborg Wiensowski: *Michel Majerus.* In: *Spiegel Kultur extra* (Juni 1998), S. 24; *Luxemburg. Manifesta 2.* In: *Spiegel Kultur extra* (Juni 1998), S. 26; *Manifesta 2 in Luxemburg.* In: *Art* (Juni 1998), Nr. 6, S. 6.

1997

Michel Majerus im Kunstverein, Graz. In: *Kronen Zeitung,* 15. Dezember 1997; Lars Bang Larson: *Pop-maleri i højeste gear.* In: *Politiken,* 24. Oktober 1997, S. 32; Daniel Birnbaum: *Grällt visuellt kaos.* In: *Dagens Nyheter,* 10. Oktober 1997, S. B3; Alexander Agrell: *Stor spännvidd hos ung tysk.* In: *Sydsvenskan,* 4. Oktober 1997, S. D4;

I Warhol anda. In: *Dagbladet,* 4. Oktober 1997, S. 21; Susanne Kleine: *Persönliche Sicht auf Polke.* In: *Bonner Rundschau,* 6. September 1997; Kim Hall: *Samtida konst i starka färger.* In: *Skånska Dágbladet,* 4. Oktober, S. 21; Silke Müller: *Das hat Ray nicht verdient.* In: *art* (August 1997); Noemi Smolik: *Michel Majerus.* In: *Artforum* (April 1997), S. 102; Raimar Stange: *Michel Majerus.* In: *artist Kunstmagazin* (2/1997), Nr. 31, S. 18–21; *Michel Majerus – Galerie Meyer.* Klappe auf: *Karlsruher Kultur Magazin* (Februar 1997); Daniel Birnbaum: *The power of now.* In: *frieze* (1997), Nr. 34, S. 54–55; m. b.: *Malerische Entzauberung. Wenn die Zitate frei flottieren.* In: *Salzburger Nachrichten,* 8. Jänner 1997.

1996

A.H.: *Wie „high" und „low" zusammenfanden.* In: *Neue Zeit,* 12. Dezember 1996; Walter Titz: *Weniger ist viel mehr.* In: *Kleine Zeitung,* 12. Dezember 1996; Eva Karcher: *Junge Kunst. Statt neuer Ideen am liebsten neue Bilder.* In: *Art* (10/1996), S. 47; Frank Frangenberg: *Malerei III,* In: *Kunstforum* (Oktober 1996–Jänner 1997), Nr. 135; Hanno Rauterberg: *Der Funkturm sind wir.* In: *Die Zeit,* 1. November 1996; Peter Herbstreuth: *Muffelt nach Käse.* In: *Der Tagesspiegel,* 8. Juli 1996, S. 19; Ludwig Seyfarth: *Mein wunderbarer Malsalon.* In: *Szene Hamburg* (6/1996), S. 88–89; Ralf Poersche: *kabinett des schönen scheins.* In: *Hamburger Rundschau,* 6. Juni 1996; Sumi Kawai: *Michel Majerus.* In: *BT* (Juni 1996), S. 62–63, 76–77; Sabine Müller: *Der Trend zum Träumen.* In: *Kölner Stadtanzeiger,* 15./16. Juni 1996, S. 39; Hans-Joachim Müller: *Die Wände verstellt, der Boden weich.* In: *Basler Zeitung,* 12. März 1996; Simon Maurer: *Duftende Fotografie, verschenkte Malerei.* In: *Tages Anzeiger;* WeC: *Hundert Quadratmeter Kandinsky mit „Dash" Reklame.* In: *Die Welt,* 24. Februar 1996

1994

Brigitte Werneburg: *Roger Rabbit sprengt das Format.* In: *tageszeitung,* 26. November, S. 36; Harald Fricke: *Wieder aus der Natur schöpfen.* In: *Tageszeitung Berlin,* November 1994.

Bibliography

2004

Lucien Kayser: *Michel Majerus ou l'étoilement de la peinture.* In: D'Letzenburger Land, November 19, 2004;

Hans-Joachim Müller: *Michel Majerus.* In: *The Joy of my Dreams. 1. International Biennial of Contemporary Art of Seville.* Exhib. Cat. Sevilla 2004, p. 98–101;

Kent and Dean Scobel: *A new Modernism for a new Millennium: Abstraction and Surrealism are Reinvented in the Internetage.* Exhib. Cat. The Logan Collection, Vail 2004;

Joachim Jäger: *Michel Majerus: Los Angeles.* In: *Michel Majerus pop reloaded.* Exhib. Cat. Hamburger Bahnhof, Berlin 2003, Tate Liverpool 2004, Cologne 2004;

Daniel Birnbaum: *Sampling the Globe.* In: *Artforum* (October 2004), p. 241–244/296–299;

Gabriela Walde: *Des Kanzlers neue Bilder.* In: *Berliner Morgenpost,* June 9, 2004;

Looking at Painting 2. Exhib. Cat. Galerie Tanit, Munich 2004;

Katrin Wittneven: *Hunger nach Trends. Vom Exportschlager zur Saisonware: Warum die heraus-ragende junge Kunst aus Deutschland ein Label wie „Kraut Art" gar nicht nötig hat.* In: *Der Tagesspiegel,* April 10, 2004, p. 26;

Kate Zamet: *On the Verge of World Domination. Michel Majerus: pop reloaded. Tate Liverpool until 18. April 2004.* In: *Blueprint* (April 2004);

Ralf Christofori: *Brücken über den Fluss. Der Kunstsammler Rudolf Scharpff zeigt ab heute aktuelle Malerei aus seiner Kollektion in Stuttgart.* In: *Der Tagesspiegel,* March 20, 2004, p. 24;

N. N.: *Pop Reloaded.* In: *Blueprint* (March 2004);

N. N.: *Michel Majerus exhibition at the Tate.* In: *Merseymart,* March 4, 2004;

Brigitta Melten: *Das Leben aus zweiter Hand. Rüsselsheimer Opelvillen zeigen die Ausstellung „Was Malerei heute ist".* In: *Main-Spitze,* February 10, 2004;

Christoph Schütte: *Horrorszenen im Seerosenreich. „Was Malerei heute ist": Eine Ausstellung in den Rüsselsheimer Opelvillen.* In: *FAZ,* February 12, 2004;

Chris Brown: *Tate Gallery tribute to plane crash artist. Majerus collection on show at Albert Dock.* In: *Daily Post,* January 27, 2004;

Ingrid Ehrhardt: *Michel Majerus.* In: *Was Malerei heute ist.* Exhib. Cat. Opelvillen, Rüsselsheim, p. 32–37;

Silke Immenga: *Michel Majerus. Werke aus der Sammlung Boros.* Exhib. Cat. ZKM Karlsruhe, 2004;

2003

Dave Allen, Harald Fricke: *Michel Majerus. Hamburger Bahnhof.* In: *Neue Review,* (October 2003), No. 3, p. 28–29;

Christine Macel: *à l'Est, du nouveau. actualité de la peinture en Allemagne/New Painting in Germany.* In: *artpress* (October 2003), No. 294, p. 39–46;

Ingeborg Ruthe: *Sicherheit? Es gibt sie nicht. Michel Majerus' „pop reloaded" im Hamburger Bahnhof.* In: *Berliner Zeitung,* July 19/20, 2003, p. 10;

Harald Fricke: *Aus Freude am Photo-Shopping.* In: *die Tageszeitung,* July 15, 2003, p. 16;

Christina Tilmann: *Held der inneren Unsicherheit.* In: *Der Tagesspiegel,* July 12, 2003;

Gabriela Walde: *Der Sampler.* In: *Berliner Morgenpost,* July 11, 2003. p. 11;

Boris Hohmeyer: *Kandinsky trifft auf Omo-Reklame.* In: *Art* (July 2003), p. 96/97;

Michael Stoeber: *Painting Pictures.* In: *Kunstforum International* (June/July 2003);

Andreas Schlaegel: *Reviews.* In: *Contemporary* (summer 2003);

Martha Schwendener: *Michel Majerus.* In: *artindex* (spring/summer 2003), No. 3, p. 96–97;

Axel Lapp: *Review.* In: *Art Monthly* (April 2003);

Belinda Grace Gardner: *Wolfsburg: „Painting Pictures".* In: *Kunstzeitung* (April 2003);

Harald Fricke: *Never mind the Pollocks.* In: *Die Tageszeitung,* March 5, 2003, p. 15;

Elke Buhr: *Alles gleich glatt.* In: *Frankfurter Rundschau,* March 4, 2003;

Vera Görgen: *Malen nach Zahlen.* In: *Financial Times Deutschland,* March 4, 2003;

Wulf Winter: *Painting Pictures.* In: *Indigo* (March 2003);

Michael Stroeber: *Der Wille zum Bild.* In: *Hannoversche Allgemeine,* March 3, 2003;

Daniel Birnbaum: *Michel Majerus 1967–2002.* In: *frieze* (January/ February 2003), p. 60–61;

Corinna Daniels: *„Zeitlose Wieder-holungen" bei Atle Gerhardsen.* In: *Die Welt,* February 21, 2003, p. 34;

Wolf Günter Thiel: *Michel Majerus.* In: *Flash Art* (January/February 2003), p. 46;

Justin Hoffmann: *„The Starting Line" der Pinakothek der Moderne.* In: *Kunst Bulletin* (January/February 2003), p. 50–51;

Luc Marteling: *Pinakothek der Moderne. Mehr Licht.* In: *Telecran,* February 1–7, p. 34–37;

M. A.: *Apocalypse Now.* In: *Berliner Morgenpost,* January 24, 2003, p. 13;

Artist News. In: *Artist Kunstmagazin* (2003), No. 54, 1, p. 12;

Andreas Schlaegel: *News Berlin.* In: *Contemporary* (2003), No. 47–48, p. 21;

Ute Riese: *Michel Majerus.* In: *Talking Pieces, Text und Bild in der neuen Kunst.* Exhib. Cat. Museum Morsbroich, Leverkusen 2003;

Andrea Domesle: *Zur Erinnerung an Michel Majerus, MAYERus. letzte tage,* online: www.artmagazine.cc, January 7, 2003;

Katrin Luz: *„Bilder sind wie Viren, die sich an Bestehendes anheften." Interview.* In: *newsletter galerienkoeln,* January 2003, p. 8–10;

Patricia Ellis: *Michel Majerus.* In: *Interview with Painting.* Exhib. Cat. ed. by Gianni Romano. Fondazione Bevilacqua La Masa, Venice 2003.

2002

Corinna Daniels: *Die letzten Bilder von Michel Majerus bei neuger-riemschneider.* In: *Die Welt,* December 27, 2002;

Kathrin Wittneven: *Innehalten in der Bilderflut.* In: *Der Tagesspiegel,* December 14, p. 24;

N. N.: *Michel Majerus 1967–2002.* In: *Art Monthly* (December 2002), p. 262;

Cary Levine: *Michel Majerus at Friedrich Petzel.* In: *Art in America* (December 2002), p. 109;

Raimar Stange: *Adventures of Uncertainity.* In: *Modern Painters* (winter 2002), p. 98–101;

Daniel Birnbaum: *Seine Zeit war immer jetzt.* In: *Frankfurter Rundschau,* November 11, 2002;

N. N.: *Paläste und Sprechblasen.* In: *Frankfurter Rundschau,* November 9, 2002;

Kathrin Wittneven: *Die Absichten des Künstlers.* In: *Der Tagesspiegel,* November 8, 2002;

Ingeborg Ruthe: *Malen im Freistil.* In: *Berliner Zeitung,* November 8, 2002;

Jörg Heiser: *Hier, jetzt.* In: *Süddeutsche Zeitung,* November 8, 2002;

Peter Richter: *Welten aus Malerei.* In: *FAZ,* November 8, 2002;

Klara Wallner: *Die Engel in der Halfpipe.* In: *die tageszeitung,* November 8, 2002;

Katja Blomberg: *Der Künstler Michel Majerus unter den Opfern.* online: www.faz.net;

N. N.: *Michel Majerus, freischaffender Künstler.* In: *Tageblatt, Zeitung für Letzenburg,* November 7, 2002;

David Ryan: *Michel Majerus in Berlin.* In: *Art Papers* (September/October 2002), p. 52;

Maika Pollack: *Michel Majerus at Friedrich Petzel.* In: *Flash Art* (October 2002), No. 226, p. 101–102;

John Reed: *Space Invaders.* online: www.artnet.com, October 10, 2002; *Michel Majerus, Art Guide.* In: *New York Times,* October 11, 2002; David Ryan: *Michel Majerus in Berlin (Reviews International Berlin).* In: *Art Papers* (September/October 2002), p.52; Meghan Dailey: *Artforum Picks: Michel Majerus/Friedrich Petzel Gallery.* online: www.artforum.com; I.L.: *Ansichtssachen: Die Verwandlungen des Brandenburger Tors.* In: *FAZ,* September 9, 2002; N.N.: *Provokation: Sozialpalast statt Brandenburger Tor.* In: *Berliner Morgenpost,* September 7, 2002, p.17; N.N.: *Berlins Gute Stube.* In: *Der Tagesspiegel,* September 7, 2002, p.9; N.N.: *Schöneberg liegt in Mitte.* In: *Berliner Zeitung,* September 7/8 2002, p.28; *Vitamin P. New Perspectives in Painting.* London: Phaidon Press 2002; Fernando Castro: *2002 BC Before Collecting Latin American Art.* In: *Art Nexus* (April–June 2002), No.44, Vol.2; Jörg Ebner: *Das Kreuz mit den Jünglingen.* In: *FAZ,* March 2, 2002, p.58; Bernhard Schulz: *Antennen in alle Welt.* In: *Der Tagesspiegel,* February 19, 2002, p.25; Raimar Stange: *Interview mit Michel Majerus.* In: R.S.: *Sur.Faces, Interviews 2001/02.* Ed. by Christoph Keller. Frankfurt on the Main: Revolver 2002, p.17–20.

2001
Dimitri Nohé: *Viel Spaß.* In: *Chronic Art,* June 27, 2001; *Casino 2001.* Exhib.Cat. S.M.A.K., Gent; Marco Meneguzzo: *Avventura oltre il Muro.* In: *AD/Antiques & Collectors* (March 2001), No.238, p.120–125; Francesca Bonazzoli: *Malkunst, pittura oggi a Berlino.* In: *corriere delle sera/Vivi Milano,* January 2, 2001; N.N.: *Christian Boros.* In: *artinvestor* (3/2001), p.56–57; Miriam Bers: *Berlin, from neo pop to crossculture.* In: *tema celeste* (January/February 2001), p.70–75; Holger Liebs: *Generation Klecks.* In: *Süddeutsche Zeitung,* January 9, p.15; Catrin Backhaus: *666 – Animierte Probefarten.* In: *Blitz-Review,* 2001; Thomas Wagner: *Michel Majerus.* MA Paper, Kunsthochschule Berlin-Weißensee, 2001.

2000
Noemi Smolik: *Die Absichten des Künstlers werden überbewertet.* In: *FAZ,* November 3, 2000, p.49; Gerrit Gohlke: *Panorama und Revierkampf.* In: *BE, Künstlerhaus Bethanien Berlin* (September 2000), No.6, p.21–26; *The Sky is the Limit.* Exhib.Cat. Taipeh Biennial, 2000, p.82–83; Noemi Smolik: *Michel Majerus: If We Are dead, So It Is.* In: *Artforum* (September 2000), p.81; Anja Lösel; Kerstin Ehmer (Fotos): *Glühende Bilderlust.* In: *stern,* September 28, 2000, p.90, p.94; Jens Peter Koerver: *New Painting. Der Stand der Bilder.* In: *frame* (July/August 2000), No.3, p.46; Frank Frangenberg: *Leere Unwirklichkeit und Popkultur.* In: *Kölner Stadt Anzeiger,* May 6, 2000; Martin Herbert: *Michel Majerus.* In: *Time Out,* April 19.–26., 2000; Laura Dago: *Gió Marconi.* In: *Gioia,* March 7, 2000; Dana Horáková: *Schönheit gibt es nicht, nirgendwo.* In: *Welt am Sonntag,* February 27, 2000, p.45; Niru Ratnam: *kunst*.* In: *The Face* (January 2000), No.36, p.96–99.

1999
Noemi Smolik: *Michel Majerus.* In: *Kunstforum International* (December 1999/January 2000), No.148, p.316–317; Ulrike Knöfel: *„Gefühl der Stärke". Die Wolfsburger Schau „German Open" feiert eine neue, höchst lebendige Kunstszene. Der Nachwuchs träumt nicht mehr vom Umsturz: Er inszeniert frech und bunt die eigene Größe.* In: *Der Spiegel* (1999), No.46, p.296–299; Raimar Stange: *Never Trip Alone.* In: *Kunstbulletin* (November 1999), No.11, p.12–17; Giancarlo Politi: *The Venice Biennale.* In: *Flash Art* (October 1999), Vol.32, No.208, p.76; Peter Herbstreuth: *Alles hängt mit allem zusammen.* In: *Der Tagesspiegel,* September 25, 1999, p.34; Stefan Heidenreich: *Genug, genug, genug. Paradox: Michel Majerus in der Galerie neugerriemschneider.* In: *FAZ,* September 11, 1999, p.BS 4; Roberta Bosco: *Abstracción y decoración.* In: *El periodico del arte* (March 1999), No.20; Susanne Küper: *Michel Majerus, MoM Block,* In: *Nach-Bild.* Exhib.Cat. Kunsthalle Basel, Basle 1999, p.60–61; Christine Standfest: *Michel Majerus.* In: *dAPERTutto,* Exhib.Cat. 48. Esposizione Internazionale d'Arte, La Biennale di Venezia, p.282–285;

Jacqueline Ceresoli: *Gió Marconi.* In: *Juliet* (June 1999), No.93, p.75; Susanne Titz: *Michel Majerus.* In: *Art at the Turn of the Millennium.* Ed. by Burkhard Riemschneider and Uta Grosenick. Cologne: Taschen 1999, p.330–333; Kathrin Luz: *Michel Majerus (Interview).* In: *Noëma* (January–March 1999), No.50, p.80–81; Robert Fleck: *Michel Majerus.* In: *German Open.* Exhib.Cat. Kunstmuseum Wolfsburg, Wolfsburg 1999; Heike Föll: *Michel Majerus.* In: *kraftwerk Berlin.* Exhib.Cat. Aarhus Kunstmuseum, Aarhus 1999, p.119.

1998
Claudia Posca: *Manifesta in Luxemburg.* In: *Kunstforum International* (October–November 1998), No.142, p.311–315; Wolf-Günter Thiel: *Cover Story. Flash Art International* (October 1998) p.74 und Cover; Horst Richter: *Geschichte der Malerei im 20.Jahrhundert.* Cologne: Dumont 1998, p.283; Franz Kotteder: *Kunst ist für alle da.* In: *Süddeutsche Zeitung,* September 11, 1998, p.17; *Manifesta 2 – Ein Fotorundgang.* In: *Kunstforum International* (October–November 1998), No.142, p.316–353; Sven Drühl: *Verstrickungen.* In: *Kunstforum International* (July–September 1998), No.141, p.172–183.; Alfred Nemeczek: *Luxemburg: Manifesta 2. Der documenta entgegen.* In: *Art* (August 1998), No.8, p.90; Christoph Tannert: *Wie Sisyphos auf der Tonleiter.* In: *Berliner Zeitung,* July 10, 1998, p.11; Ingeborg Wiensowski: *Michel Majerus.* In: *Spiegel Kultur extra* (June 1998), p.24; *Luxemburg. Manifesta 2.* In: *Spiegel Kultur extra* (June 1998), p.26; *Manifesta 2 in Luxemburg.* In: *Art* (June 1998), No.6, p.6.

1997
Michel Majerus im Kunstverein, Graz. In: *Kronen Zeitung,* December 15, 1997; Lars Bang Larson: *Pop-maleri i højeste gear.* In: *Politiken,* October 24, 1997, p.32; Daniel Birnbaum: *Grällt visuellt kaos.* In: *Dagens Nyheter,.* October 10, 1997, p.B3; Alexander Agrell: *Stor spännvidd hos ung tysk.* In: *Sydsvenskan,* October 4, 1997, p.D4;

I Warhol anda. In: *Dagbladet,* October 4, 1997, p.21; Susanne Kleine: *Persönliche Sicht auf Polke.* In: *Bonner Rundschau,* September 6, 1997; Kim Hall: *Samtida konst i starka färger.* In: *Skånska Dágbladet,* October 4, p.21; Silke Müller: *Das hat Ray nicht verdient.* In: *art* (August 1997); Noemi Smolik: *Michel Majerus.* In: *Artforum* (April 1997), p.102; Raimar Stange: *Michel Majerus.* In: *artist Kunstmagazin* (2/1997), No.31, p.18–21; *Michel Majerus – Galerie Meyer.* Klappe auf: *Karlsruher Kultur Magazin* (February 1997); Daniel Birnbaum: *The power of now.* In: *frieze* (1997), No.34, p.54–55; m.b.: *Malerische Entzauberung. Wenn die Zitate frei flottieren.* In: *Salzburger Nachrichten,* January 8, 1997.

1996
A.H.: *Wie „high" und „low" zusammen fanden.* In: *Neue Zeit,* December 12, 1996; Walter Titz: *Weniger ist viel mehr.* In: *Kleine Zeitung,* December 12, 1996; Eva Karcher: *Junge Kunst. Statt neuer Ideen am liebsten neue Bilder.* In: *Art* (10/1996), p.47; Frank Frangenberg: *Malerei III,* In: *Kunstforum* (October 1996–January 1997), No.135; Hanno Rauterberg: *Der Funkturm sind wir.* In: *Die Zeit,* November 1, 1996; Peter Herbstreuth: *Muffelt nach Käse.* In: *Der Tagesspiegel,* July 8, 1996, p.19; Ludwig Seyfarth: *Mein wunderbarer Malsalon.* In: *Szene Hamburg* (6/1996), p.88–89; Ralf Poersche: *kabinett des schönen scheins.* In: *Hamburger Rundschau,* June 6, 1996; Sumi Kawai: *Michel Majerus.* In: *BT* (June 1996), p.62–63, 76–77; Sabine Müller: *Der Trend zum Träumen.* In: *Kölner Stadtanzeiger,* June 15/16, 1996, p.39; Hans-Joachim Müller: *Die Wände verstellt, der Boden weich.* In: *Basler Zeitung,* March 12, 1996; Simon Maurer: *Duftende Fotografie, verschenkte Malerei.* In: *Tages Anzeiger;* WeC: *Hundert Quadratmeter Kandinsky mit „Dash" Reklame.* In: *Die Welt,* February 24, 1996.

1994
Brigitte Werneburg: *Roger Rabbit sprengt das Format.* In: *tageszeitung,* November 26, p.36; Harald Fricke: *Wieder aus der Natur schöpfen.* In: *Tageszeitung Berlin,* November 1994.

Quellenverzeichnis und Übersetzungen

Marie-Claude Beaud,
Robert Fleck, Veit Görner,
Peter Pakesch, Gijs van Tuyl
Vorwort
(übersetzt von Paul Aston)

Peter Pakesch
Malerei, um den Raum zu verstehen
(übersetzt von Paul Aston)

Günther Holler-Schuster
Von hier aus können wir überall hingehen. Michel Majerus und die Erweiterung der Malerei
(übersetzt von Paul Aston)

Robert Fleck
Von der Malerei zur Installation und retour
(übersetzt von Paul Aston)

Veit Loers
Splash Bombs. Zur Malerei von Michel Majerus
(übersetzt von Paul Aston)

Raimar Stange
DisPLAYer auf Zeit. Zu den (Raum-)Installationen von Michel Majerus
(übersetzt von Pauline Cumbers)

Ralf Christofori
No Logo (No Style No Points). Einige Stationen im Leben und Werk von Michel Majerus
(übersetzt von Pauline Cumbers)

Tilman Baumgärtel
Super Mario und die Nacht des Visuellen
(übersetzt von Paul Aston)

First Publications and Translations

Marie-Claude Beaud,
Robert Fleck, Veit Görner,
Peter Pakesch, Gijs van Tuyl
Foreword
(translated by Paul Aston)

Peter Pakesch
Painting as an Explanation of Space
(translated by Paul Aston)

Günther Holler-Schuster
From here we can go anywhere. Michel Majerus and the Extension of Painting
(translated by Paul Aston)

Robert Fleck
From Painting to Installation and Back Again
(translated by Paul Aston)

Veit Loers
Splash Bombs. On the Painting of Michel Majerus
(translated by Paul Aston)

Raimar Stange
Temporary DisPLAYer. Michel Majerus'(Room)Installations
(translated by Pauline Cumbers)

Ralf Christofori
No Logo (No Style No Points). A Few Stations in the Life and Work of Michel Majerus
(translated by Pauline Cumbers)

Tilman Baumgärtel
Super Mario and the Night of the Visual
(translated by Paul Aston)

Diese Publikation erscheint
anlässlich der Ausstellungen

Kunsthaus Graz am
Landesmuseum Joanneum

Michel Majerus
Installationen 92–02
12.02.–16.05.2005

Stedelijk Museum
Amsterdam

Michel Majerus
25.06.–16.10.2005

Deichtorhallen Hamburg
Haus der Photographie
Aktuelle Kunst

Michel Majerus
Demand the Best
25.11.2005–05.02.2006

kestnergesellschaft

Michel Majerus
what looks good today may
not look good tomorrow
26.11.2005–26.02.2006

**Musée d'Art Moderne
Grand-Duc Jean Luxembourg**

Michel Majerus
13.12.2006–16.04.2007

This catalog is published
on the occasion of the exhibitions

Kunsthaus Graz am
Landesmuseum Joanneum

Michel Majerus
Installations 92–02
Feb 12–May 16, 2005

Stedelijk Museum
Amsterdam

Michel Majerus
June 25–Oct 16, 2005

Deichtorhallen Hamburg
Haus der Photographie
Aktuelle Kunst

Michel Majerus
Demand the Best
Nov 25, 2005–Feb 05, 2006

kestnergesellschaft

Michel Majerus
what looks good today may
not look good tomorrow
Nov 11, 2005–Feb 26, 2006

**Musée d'Art Moderne
Grand-Duc Jean Luxembourg**

Michel Majerus
Dec 13, 2006–Apr 16, 2007

Kunsthaus Graz am
Landesmuseum Joanneum

Michel Majerus
Installationen 92–02
12.02.–16.05.2005

Kuratoren
**Günther Holler-Schuster,
Peter Pakesch**
Ausstellungsarchitektur
Niels Jonkhans

Peter Pakesch,
Intendant Landesmuseum Joanneum
Gabriele Hofbauer, Assistentin Intendanz
Katrin Bucher, Kuratorin
Adam Budak, Kurator
Katia Schurl, Kuratorische Assistenz
Elisabeth Haas, Registrarin
Mihaela Barbu, Registratur Assistenz
Margot Maas-Goettsberger,
Leitung Kunstvermittlung
Astrid Bernhard,
Assistenz Kunstvermittlung
Eva Ofner, Sigrid Rachoinig, Personal-
koordination Aufsicht/Kunstvermittlung
Doris Lind, Presse
Anna Schleiffer, Presse
Sabine Bergmann, Office Management
Elisabeth Weixler, Marketing
Bärbel Hradecky, Marketing Assistenz
Andreas Schnitzler, Sponsoring
Gabriele Filzwieser,
Veranstaltungsmanagement
Doris Psenicnik,
Assistenz Veranstaltungsmanagement
Tanja Gurke, Leitung Shop
Sabine Suppan, Leitung EDV
Andreas Graf, Assistenz EDV
Erik Ernst, Technischer Leiter
Irmgard Knechtl, Leitung Reinigung
Robert Bodlos, Leitung Werkstatt
**Erich Aellinger, Markus Ettinger, Bernd
Klinger, Christian Reinprecht, Klaus
Riegler, Peter Rumpf, Michael Saupper,
Peter Semlitsch, Andreas Zerawa,**
Aufbauteam

Kunsthaus Graz am
Landesmuseum Joanneum

Michel Majerus
Installations 92–02
Feb 12–May 16, 2005

Curators
**Günther Holler-Schuster,
Peter Pakesch**
Architecture of exhibition
Niels Jonkhans

Peter Pakesch,
Director Landesmuseum Joanneum
Gabriele Hofbauer, Director's Assistant
Katrin Bucher, Curator
Adam Budak, Curator
Katia Schurl, Assistent Curator
Elisabeth Haas, Registrar
Mihaela Barbu, Registrar Assistant
Margot Maas-Goettsberger,
Head of Educational Team
Astrid Bernhard, Educational Assistant
Eva Ofner, Sigrid Rachoinig, Supervision
education and staff coordination
Doris Lind, Press
Anna Schleiffer, Press
Sabine Bergmann, Office Management
Elisabeth Weixler, Marketing
Bärbel Hradecky, Marketing Assistant
Andreas Schnitzler, Sponsoring
Gabriele Filzwieser, Event Management
Doris Psenicnik,
Event Management Assistant
Tanja Gurke, Shop Management
Sabine Suppan, System Administrator
Andreas Graf,
Assistance System Administrator
Erik Ernst, Head of Technical Team
Irmgard Knechtl, Head of Cleaning Team
Robert Bodlos,
Head of Construction Team
**Erich Aellinger, Markus Ettinger, Bernd
Klinger, Christian Reinprecht, Klaus
Riegler, Peter Rumpf, Michael Saupper,
Peter Semlitsch, Andreas Zerawa,**
Construction Team

Kunsthaus Graz dankt
Kunsthaus Graz thanks
Paul Aston; Crew 8020; Pauline
Cumbers; Günther Diem; Heike Föll;
Jürgen Hetzler; Albrecht Kastein;
Bastian Krondorfer; Ekkehard Kneer;
Holger Broeker, Kunstmuseum
Wolfsburg; Martha Konrad;
Rolf Lauter, Kunsthalle Mannheim;
Edith und Jean Majerus; Alfred
Tapler, Claudia Haring, Roland Lind,
Medienfabrik Graz; Christa Steinle,
Neue Galerie am Landesmuseum
Joanneum; Tim Neuger, Burkhard
Riemschneider, Christiane Rekade,
Philipp Muras, neugerriemschneider,
Berlin; Hans-Joachim Sander,
Sammlung Sander; Adam Szymczyk,
Klaus Hänisch, Sammlung des
Basler Kunstvereins; Stefan Schwar;
Thea Westreich und Ethan Wagner;
Monika Pessler, Kiesler Stiftung Wien;
sowie allen PrivatleihgeberInnen,
die nicht namentlich genannt werden
möchten und den MitarbeiterInnen
des Kunsthaus Graz, des
Stedelijk Museum Amsterdam,
der Deichtorhallen Hamburg, der
kestnergesellschaft und des
Musée d'Art Moderne Grand-Duc
Jean Luxemburg.

Kunsthaus Graz am
Landesmuseum Joanneum
Lendkai 1, A–8020 Graz
T +43-316/8017-9200
F +43-316/8017-9212
info@kunsthausgraz.at
www.kunsthausgraz.at

Kunsthaus Graz am
Landesmuseum Joanneum
Lendkai 1, A–8020 Graz
T +43-316/8017-9200
F +43-316/8017-9212
info@kunsthausgraz.at
www.kunsthausgraz.at

Mit Unterstützung von:
Supported by:
Stadt Graz, Land Steiermark,
A1, Zumtobel Staff

**Kunsthaus
Graz**

ZUMTOBEL STAFF

Stedelijk Museum
Amsterdam

Michel Majerus
25.06.–16.10.2005

Gijs van Tuyl, Direktor
Leontine Coelewij, Kuratorin
Ben van Heesbeen, Jelle
Bouwhuis, Öffentlichkeitsarbeit

Katalognummer: 883

Stedelijk Museum
PO Box 75082
1070 AB Amsterdam

Oosterdokskade 5
1011 AD Amsterdam
info@stedelijk.nl
www.stedelijk.nl

Stedelijk Museum
Amsterdam

Michel Majerus
June 25 – Oct 16, 2005

Gijs van Tuyl, Director
Leontine Coelewij, Curator
Ben van Heesbeen,
Jelle Bouwhuis, Communications

Catalogue number: 883

Stedelijk Museum
PO Box 75082
1070 AB Amsterdam

Oosterdokskade 5
1011 AD Amsterdam
info@stedelijk.nl
www.stedelijk.nl

Mit Unterstützung von:
Supported by:
ABN AMRO

Deichtorhallen Hamburg
Haus der Photographie
Aktuelle Kunst

Michel Majerus
Demand the Best
25.11.2005 – 05.02.2006

Robert Fleck,
Direktor Deichtorhallen Hamburg
F. C. Gundlach,
Gründungsdirektor Haus der
Photographie in den Deichtorhallen
Helmut Sander,
Kaufmännischer Geschäftsführer
Deichtorhallen-Ausstellungs GmbH
Linda Eckardt-Salaemae, Sekretariat
Angelika Leu-Barthel,
Presse- und Öffentlichkeitsarbeit
Annette Sievert, Projektkoordination
Ingo Taubhorn, Rahmenprogramm
Sebastian Lux,
Assistent Haus der Photographie
Birgit Hübner,
Kunstpädagogik, Internet
Goesta Diercks,
Buchshop, Kunstpädagogik
Christine Fichtner,
Buchhaltung, Shop
Sabine Poerschke, Personal
Rainer Wollenschläger,
Technische Leitung
Nils Handschuh,
Thomas Heldt-Schwarten,
Klaus Rossa,
Technische Assistenz
Andreas Wirszints, Parkplatz
Dieter Lohmann, Aufsichtsdienste
Maria Costa Rodriguez, Reinigung
Christian Andres, Leiter Aufbauteam
Sara Fichtner, Sabine Kuehnle,
Gisbert Lange, Boris Meise,
Wolfgang Scheerer, Martin
Schneider, Johannes Speder,
Franziska Vollborn,
Aufbauteam

Deichtorhallen Hamburg
Haus der Photographie
Aktuelle Kunst
Deichtorstraße 1–2
20095 Hamburg
Deutschland
info@deichtorhallen.de
www.deichtorhallen.de

Deichtorhallen Hamburg
Haus der Photographie
Aktuelle Kunst

Michel Majerus
Demand the Best
Nov 25, 2005 – Feb 05, 2006

Robert Fleck,
Director Deichtorhallen Hamburg
F. C. Gundlach,
Founding Director House of
Photography in the Deichtorhallen
Helmut Sander,
Managing Director
Deichtorhallen-Ausstellungs GmbH
Linda Eckardt-Salaemae, Secretary
Angelika Leu-Barthel, Press Officer
Annette Sievert, Projectcoordinator
Ingo Taubhorn, Associated Programs
Sebastian Lux,
Assistant to the House
of Photography
Birgit Hübner,
Educational Programs, Internet
Goesta Diercks,
Bookshop, Educational Programs
Christine Fichtner, Accountant, Shop
Sabine Poerschke, Staff
Rainer Wollenschläger,
Technical Director
Nils Handschuh,
Thomas Heldt-Schwarten,
Klaus Rossa,
Technical Assistant
Andreas Wirszints, Parking space
Dieter Lohmann, Supervisory staff
Maria Costa Rodriguez, Cleaning
Christian Andres,
Head of Construction Team
Sara Fichtner, Sabine Kuehnle,
Gisbert Lange, Boris Meise,
Wolfgang Scheerer, Martin
Schneider, Johannes Speder,
Franziska Vollborn,
Construction Team

Deichtorhallen Hamburg
Haus der Photographie
Aktuelle Kunst
Deichtorstraße 1–2
20095 Hamburg
Germany
info@deichtorhallen.de
www.deichtorhallen.de

Deichtorhallen Hamburg dankt
Deichtorhallen Hamburg thanks
Veit Görner, Philipp Muras, Tim
Neuger, Peter Pakesch, Christiane
Rekade, Burkhard Riemschneider,
Katia Schurl

deichtorhallen hamburg
haus der photographie
aktuelle kunst

kestnergesellschaft

Michel Majerus
what looks good today may
not look good tomorrow
26.11.2005–26.02.2006

kestnergesellschaft

Michel Majerus
what looks good today may
not look good tomorrow
Nov 11, 2005 – Feb 26, 2006

Vorstand
Uwe Reuter, 1. Vorsitzender
Dr. Klaus F. Geiseler, 2. Vorsitzender
Christian Knoke, Schatzmeister
Klaus Stosberg, Schriftführer
Dr. h.c. Manfred Bodin, Dr. Michael Kunst,
Reinhard Mühl, Dr. Thomas Noth,
Wilhelm Zeller

Kuratorium
Wilhelm Zeller, Vorsitzender
Dr. Max-Georg Büchner, Dieter Brusberg,
Prof. Dr. Carsten P. Claussen,
Albrecht Hertz-Eichenrode,
Dr. Alexander Erdland, Norbert H. Essing,
Sepp D. Heckmann, Walter Kleine,
Dr. Martin Künnemann, Detlev Meyer,
Dr. Erhard Schipporeit,
Dr. Bernd Thiemann, Georg Zaum

Veit Görner, Direktor
Anne Prenzler, Ausstellung
Mairi Kroll, Projektmanagerin
Anne Prenzler, Maik Schlüter,
Hilke Wagner, Kuratoren
Christiane Hein,
Presse und Kommunikation
Jörg-Maria Brügger, Rainer Walter,
Ausstellungsinstallation
Angela Pohl, Irmela Wilckens,
Empfang, Shop
Helga Dietrich, Petra Lücke,
Rechnungswesen
Sabine Sauermilch,
Mitgliederverwaltung
Violeta Castro, Ahmet Ercihan,
Sina Hempel, Isabelle Flicker,
Eike Freese, Linda Randt, Maria Vahidi,
kestnerlabor
Juana Bartels, Marco Bernhagen,
Guido Bode, Sigrid Didjurgis,
Christoph Dirkes, Jürgen Fischer,
Friederike Haeußler, Nadia Hettich,
Dr. Brigitte Kirch, Robert Knoke,
Gabi König, Johanna Land,
Eddie Lange, Waltraut Meinecke,
Johanna Meisner, Germaine Mogg,
Rémy Musema, Beatrix Nagy-Meier,
Anne Pienkny, Carsten Schlaefke,
Christel Sternhagen, Michael Stoeber,
Carsten Wolf, Marcus Wolters,
Erweitertes Team

Members of the Board
Uwe Reuter, President
Dr. Klaus F. Geiseler, Vice President
Christian Knoke, Treasurer
Klaus Stosberg, Secretary
Dr. h.c. Manfred Bodin, Dr. Michael
Kunst, Reinhard Mühl. Dr. Thomas Noth,
Wilhelm Zeller

Advisory Board
Wilhelm Zeller, President
Dr. Max-Georg Büchner, Dieter Brusberg,
Prof. Dr. Carst en P. Claussen,
Albrecht Hertz-Eichenrode,
Dr. Alexander Erdland, Norbert H. Essing,
Sepp D. Heckmann, Walter Kleine,
Dr. Martin Künnemann, Detlev Meyer,
Dr. Erhard Schipporeit,
Dr. Bernd Thiemann, Georg Zaum

Veit Görner, Director
Anne Prenzler, Exhibition
Mairi Kroll, Projectmanager
Anne Prenzler, Maik Schlüter,
Hilke Wagner, Curators
Christiane Hein,
Public Relations
Jörg-Maria Brügger, Rainer Walter,
Installation of Exhibition
Angela Pohl, Irmela Wilckens,
Front Desk, Shop
Helga Dietrich, Petra Lücke,
Accounting Department
Sabine Sauermilch,
Member Administration
Violeta Castro, Ahmet Ercihan,
Sina Hempel, Isabelle Flicker,
Eike Freese, Linda Randt, Maria Vahidi,
Interns
Juana Bartels, Marco Bernhagen,
Guido Bode, Sigrid Didjurgis,
Christoph Dirkes, Jürgen Fischer,
Friederike Haeußler, Nadia Hettich,
Dr. Brigitte Kirch, Robert Knoke,
Gabi König, Johanna Land,
Eddie Lange, Waltraut Meinecke,
Johanna Meisner, Germaine Mogg,
Rémy Musema, Beatrix Nagy-Meier,
Anne Pienkny, Carsten Schlaefke,
Christel Sternhagen, Michael Stoeber,
Carsten Wolf, Marcus Wolters,
Extended Team

kestnergesellschaft
Goseriede 11
30159 Hannover
Deutschland
Fon +49-511/701-200
Fax +49-511/701-2020
kestner@kestner.org
www.kestner.org

kestnergesellschaft
Goseriede 11
30159 Hannover
Germany
Fon +49-511/701-200
Fax +49-511/701-2020
kestner@kestner.org
www.kestner.org

kestnercorporatepartner
kestnercorporatepartner
Verlagsgesellschaft Madsack, Hannover
NORD/LB
TUI AG
HANNOVER Finanz GmbH
DKS Real Estate
VHV Versicherungen

kestnercorporateförderer
kestnercorporatepatrons
AWD

Die kestnergesellschaft wird durch
das Land Niedersachsen unterstützt.
The kestnergesellschaft is supported
by the federal state of Lower Saxony.

kestnergesellschaft

Musée d'Art Moderne
Grand-Duc Jean Luxembourg

Michel Majerus
Dec 13, 2006 – Apr 16, 2007

Board
Jacques Santer, President
Jean Hoss, vice-president
Paul Reiles, vice- president

Scientific committee
Carmen Giménez, Paul Reiles,
Dr Stephan Schmidt-Wulffen,
Sir Nicholas Serota

Mudam Team
Marie-Claude Beaud, Director
Zuzana Fabianova, Director's PA
Björn Dahlström,
curator (exhibitions)
Mónica Portillo, curator (publics)
Clément Minighetti, collection
David Brognon, registrar
Louis Bestgen,
design and museography
Valérie Conrot, communication
Nadine Clemens, publications
Valério D'Alimonte, press
Pascale Claren,
development and external relations
Fabienne Carnoy,
accounting department
Henriette Larbière, logistics
Bob Mersch, administrative assistent
Magali Weirich, reception

Musée d'Art Moderne
Grand-Duc Jean Luxembourg
Place de l'Europe
Luxembourg-Kirchberg
info@mudam.lu
www.mudam.lu

**Musée d'Art Moderne
Grand-Duc Jean
Luxembourg dankt**
Ministère de la Culture,
de l'Enseignement Supérieur
et de la Recherche;
Luxemburg und die Großregion,
Kulturhauptstadt Europas 2007;
Allen Sponsoren und Mäzenen

**Musée d'Art Moderne
Grand-Duc Jean
Luxembourg thanks**
Ministère de la Culture,
de l'Enseignement Supérieur
et de la Recherche;
Luxembourg and the Greater Region,
European Capital of Culture 2007;
All sponsors and patrons

Musée d'Art Moderne
Grand-Duc Jean
Luxembourg

LE GOUVERNEMENT
DU GRAND-DUCHÉ DE LUXEMBOURG
Ministère de la Culture, de l'Enseignement
supérieur et de la Recherche

Die Deutsche Bibliothek – CIP-Einheitsaufnahme
Ein Titelsatz für diese Publikation ist bei der Deutschen Bibliothek erhältlich

Vertrieb außerhalb Europas
D.A.P./Distributed Art Publishers, Inc., 155 Sixth Avenue
New York, NY 10013
Tel +1-212/627-1999
Fax +1-212/627-9484

Erschienen im
Verlag der Buchhandlung
Walther König, Köln
ISBN 3-88375-930-9

Gedruckt in Österreich

CIP data applied for

Distribution outside Europe
D.A.P./Distributed Art Publishers, Inc., 155 Sixth Avenue
New York, NY 10013
Tel +1 212-627-1999
Fax +1 212-627-9484

Published by
Verlag der Buchhandlung
Walther König, Cologne
ISBN 3-88375-930-9

Printed in Austria

Herausgeber
Peter Pakesch,
Robert Fleck,
Veit Görner,
Marie-Claude Beaud,
Gijs van Tuyl
Redaktion
Katrin Bucher,
Katia Schurl
Übersetzungen
Paul Aston,
Pauline Cumbers
Lektorat
Martha Konrad,
Stefan Schwar

Editors
Peter Pakesch,
Robert Fleck,
Veit Görner,
Marie-Claude Beaud,
Gijs van Tuyl
Assistant Editor
Katrin Bucher,
Katia Schurl
Translation
Paul Aston,
Pauline Cumbers
Lectorship
Martha Konrad,
Stefan Schwar

Grafische Konzeption
und Gestaltung
Lichtwitz – Büro für
visuelle Kommunikation:
Kriso Leinfellner,
Stefanie Lichtwitz,
Harald Niessner,
Kasimir Reimann,
Benedikt Flüeler,
Simona Nascimento da Silva
3D-Visualisierung
Nils Jonkhans
Drucküberwachung
Michael Neubacher

Druck
Medienfabrik Graz
(FM-Raster, 5c plus
Dispersionslack)
Schutzumschlag
Austriaplastics, Wels
Papier
Ikonosilk 170g,
Biotop 3 100g,
Invercote 300g
Schrift
KunsthausGraz

Art Direction and Design
Lichtwitz – Büro für
visuelle Kommunikation:
Kriso Leinfellner,
Stefanie Lichtwitz,
Harald Niessner,
Kasimir Reimann,
Benedikt Flüeler,
Simona Nascimento da Silva
3D-Visualisierung
Nils Jonkhans
Print supervision
Michael Neubacher

Print
Medienfabrik Graz
(FM-Raster, 5c plus
dispersion varnish)
Cover
Austriaplastics, Wels
Paper
Ikonosilk 170g,
Biotop 3 100g,
Invercote 300g
Font
KunsthausGraz